WOMEN IN MEDIEVAL ITALIAN SOCIETY
500-1200

WOMEN AND MEN IN HISTORY

This series, published for students, scholars and interested general readers, will tackle themes in gender history from the early medieval period through to the present day. Gender issues are now an integral part of all history courses and yet many traditional texts do not reflect this change. Much exciting work is now being done to redress the gender imbalances of the past, and we hope that these books will make their own substantial contribution to that process. We hope that these will both synthesise and shape future developments in gender studies.

The General Editors of the series are *Patricia Skinner* (University of Southampton) for the medieval period; *Pamela Sharpe* (University of Bristol) for the early modern period; and *Penny Summerfield* (University of Lancaster) for the modern period. *Margaret Walsh* (University of Nottingham) was the Founding Editor of the series.

Published books:

Imperial Women in Byzantium, 1025–1204: Power, Patronage and Ideology *Barbara Hill*

Masculinity in Medieval Europe *D. M. Hadley (ed.)*

Gender and Society in Renaissance Italy *Judith C. Brown and Robert C. Davis (eds)*

Widowhood in Medieval and Early Modern Europe *Sandra Cavallo and Lyndan Warner (eds)*

Gender, Church and State in Early Modern Germany: Essays by Merry E. Wiesner
Merry E. Wiesner

Manhood in Early Modern England: Honour, Sex and Marriage *Elizabeth W. Foyster*

English Masculinities, 1600–1800 *Tim Hitchcock and Michele Cohen (eds)*

Disorderly Women in Eighteenth-Century London: Prostitution in the Metropolis, 1730–1830
Tony Henderson

Gender, Power and the Unitarians in England, 1760–1860 *Ruth Watts*

Practical Visionaries: Women, Education and Social Progress, 1790–1930
Mary Hilton and Pam Hirsch (eds)

Women and Work in Russia, 1880–1930: A Study in Continuity through Change
Jane McDermid and Anna Hillyar

More than Munitions: Women, Work and the Engineering Industries 1900–1950
Clare Wightman

The Family Story: Blood, Contract and Intimacy, 1830–1960
Leonore Davidoff, Megan Doolittle, Janet Fink and Katherine Holden

Women and the Second World War in France 1939–1948: Choices and Constraints
Hanna Diamond

Men and the Emergence of Polite Society, Britain 1660–1800 *Philip Carter*

Everyday Violence in Britain, 1850–1950: Gender and Class *Shani D'Cruze (ed.)*

Women and Ageing in British Society Since 1500 *Lynn Botelho and Pat Thane (eds)*

WOMEN IN MEDIEVAL ITALIAN SOCIETY 500–1200

PATRICIA SKINNER

An imprint of **Pearson Education**

Harlow, England · London · New York · Reading, Massachusetts · San Francisco
Toronto · Don Mills, Ontario · Sydney · Tokyo · Singapore · Hong Kong · Seoul
Taipei · Cape Town · Madrid · Mexico City · Amsterdam · Munich · Paris · Milan

Pearson Education Limited
Edinburgh Gate
Harlow
Essex CM20 2JE
England

and Associated Companies throughout the world

Visit us on the World Wide Web at:
http://www.pearsoneduc.com

First published 2001

© Pearson Education Limited 2001

The rights of Patricia Skinner to be identified as author of
this Work have been asserted by her in accordance with
the Copyright, Designs and Patents Act 1988.

All rights reserved; no part of this publication may be reproduced,
stored in a retrieval system, or transmitted in any form or by any
means, electronic, mechanical, photocopying, recording, or otherwise
without either the prior written permission of the Publishers or a
licence permitting restricted copying in the United Kingdom issued by
the Copyright Licensing Agency Ltd, 90 Tottenham Court Road,
London W1P 0LP.

ISBN 0 582 27368 4 (pbk)

British Library Cataloguing-in-Publication Data
A catalogue record for this book is available from the British
Library

Library of Congress Cataloging-in-Publication Data
Skinner, Patricia, 1965–
 Women in Medieval Italian society 500–1200 / Patricia Skinner.
 p. cm. — (Women and men in history)
 Includes bibliographical references and index.
 ISBN 0-582-27362-9 — ISBN 0-582-27368-4 (pbk.)
 1. Women—Italy—History—Middle Ages, 500–1500. 2. Family—Italy—History.
 3. Italy—Social life and customs. I. Title. II. Series.

HQ1147.I8 S58 2001
305.4′0945′0902—dc21 00–051492

10 9 8 7 6 5 4 3 2 1
05 04 03 02 01

Typeset by 35 in 11/13pt Baskerville MT
Produced by Pearson Education Asia Pte Ltd
Printed in Malaysia , PJB

CONTENTS

Maps, tables and figures ... vii
Acknowledgements ... viii
Abbreviations .. ix
Introduction: Where are the Women? ... 1
 Historiographical problems ... 3
 Development of women's history in Italy .. 5
 Organisation: the sources .. 7

1. The End of the Roman World, 508–602 .. 18
 Women in Cassiodorus's letters ... 19
 The *Liber Pontificalis* and the letters of Gregory I 23

2. Lombard Life, 568–774 ... 34
 Women in the Lombard laws .. 35
 Charter evidence: the 'real' picture? .. 43
 Women and the Church: an ambivalent relationship 49
 Paul the Deacon: writing misogyny? ... 54
 Epigraphy .. 59
 Conclusions ... 62

3. Rise of the Dynasties, 774–888 ... 68
 Political change: Carolingian emperors and empresses 68
 The sources: narrowing horizons ... 70
 Women's religious houses: dynastic rule and the Church 80
 The legal evidence: fluid laws and jurisdictions 82
 Women's land and women's work ... 85
 Conclusions ... 92

4. The Long Tenth Century, 888–1000 .. 97
 The fragmentation of power .. 97
 Women and family politics: sex and the struggle for power 99
 Bishops and women: Rather of Verona ... 109
 Women and work in the tenth century ... 111
 Reform of the religious life .. 113
 Women and the saints: the southern hagiography 118
 The minority view: female sainthood .. 122
 Conclusions ... 123

CONTENTS

5. **The Age of Great Women or a Great Age for Women? 1000–1115** .. 127
 Sources .. 129
 Women and power: the early eleventh century 130
 Marriage and power: repudiation and remarriage 132
 Sons and mothers: Sikelgaita of Salerno 134
 Women as rulers: Matilda of Tuscany 136
 Women, property and power .. 141
 Women, property and law .. 143
 Women and inheritance rights: the beginnings of exclusion .. 146
 Economic opportunities: women and work 147
 Religious life: reform, revival and resistance 149
 Conclusions .. 152

6. **The Twelfth Century: Renaissance or Repression?** 159
 Dynastic politics: the south .. 160
 Dynastic politics: the north .. 162
 Marriage, lineage and property ... 164
 Women's property and women's work 167
 Women and the guilds .. 169
 Marginal workers: slaves and children 173
 Religious life .. 174
 Conclusions .. 184

7. **The Thirteenth-century Epilogue** .. 191
 Communal laws and women's status 191
 Case study: Bologna ... 193
 City and countryside: the case of Umbria 195
 The rural situation: Sassovivo .. 197
 A different framework? The south 199
 Case study: Sicily ... 201
 Women's work and opportunity: a regional picture 202
 Marginal workers: slaves .. 203
 Marginal groups: prostitutes ... 204
 Religious life .. 205
 Epilogue: women in medieval Italian society 206

Bibliography .. 211
Index .. 225

MAPS, TABLES AND FIGURES

MAPS

Medieval Italy x

TABLES

Table 3.1 Women as main actors in Cava charters to 900 90

FIGURES

Figure 4.1 Family ties and the kingship of Italy 101
Figure 4.2 The Theophylactan dynasty of Rome 104
Figure 5.1 The Canossa family 136

ACKNOWLEDGEMENTS

The idea for this book emerged from a British Academy-sponsored research project into the lives of southern Italian women prior to the Norman conquest of that region. That it has grown into something rather larger in scope is owing in no small measure to the encouragement of various colleagues and friends, past and present. Thanks therefore go to Ross Balzaretti, Tom Brown, Katrinette Bodarwé, Giovanna Casagrande, Joanna Drell, Sarah Hamilton, Tim Reuter, Hilary Shaw and Chris Wickham, all of whom have generously commented on or offered advice about parts of the book. Any errors or omissions remain my own.

That I have reached the end of the project is due to the constant support of my husband, Michael Brooks, and my mum, Irene Skinner. This book is for them.

Editorial note

The place of publication in notes is London unless otherwise stated.

ABBREVIATIONS

ASPN	*Archivio Storico per le Province Napoletane*
BISIAM	*Bullettino dell'Istituto Storico Italiano e Archivio Muratoriano*
CDA	*Codice Diplomatico Amalfitano*, ed. R. Filangieri di Candida, I (Naples, 1917), II (Trani, 1951)
CDC	*Codex Diplomaticus Cajetanus*, I–II (Montecassino, 1887, 1891)
CDL	*Codice Diplomatico Longobardo*, I–II, ed. L. Schiaparelli (FSI 62–63, Rome, 1929, 1933)
CodCav	*Codex Diplomaticus Cavensis*, I–VIII, ed. M. Morcaldi et al. (Milan, Naples and Pisa, 1873–1893); IX–X, ed. S. Leone and G. Vitolo (Badia di Cava, 1984, 1990)
FSI	Fonti per la Storia d'Italia
MEFRM	*Mélanges de l'École Française de Rome, Moyen Age*
MGH SRL	*Monumenta Germaniae Historica, Scriptores Rerum Langobardorum*
MGH SS	*Monumenta Germaniae Historica, Scriptores*
Molfetta	*Codice Diplomatico Barese VII: Le Carte di Molfetta*, ed. F. Caraballese (Bari, 1912)
PC	*Codice Diplomatico Pugliese, XX: Le Pergamene di Conversano*, ed. G. Coniglio (Bari, 1975)
PBSR	*Papers of the British School at Rome*
RIS	*Rerum Italicarum Scriptores*
RNA	*Regii Neapolitani Archivii Monumenta*, Ii, III, IV, ed. M. Baffi et al. (Naples, 1845–1854)
SNN	*Codice Diplomatico Barese V: Le Pergamene di S. Nicola di Bari, Periodo Normanno*, ed. F. Nitti (Bari, 1902)

Medieval Italy

INTRODUCTION

Where are the Women?

Their language waits to be uncoded and their actions interpreted.[1]

The year is 1077. The political and religious tapestry of medieval Europe is threatening to unravel in the bitter dispute between the German emperor, Henry IV, and the pope, Gregory VII, over the issue of episcopal investiture, that is, the right to give bishops their insignia of office and, by implication, their position. Henry's position as emperor, and as king of Germany, has been fatally undermined by his excommunication from the Church. Only penance before the pope will restore his position, and the drama of reconciliation is played out at the north Italian castle of Canossa, under the auspices of its mistress, Matilda, marchioness of Tuscany. In a subsequent depiction of the meeting, it is she who is centre-stage, emphasising her pivotal role in bringing together her distant relative and the pope whom she and her mother had long supported. Yet, in all but specialist studies, Matilda's intervention is largely confined to one-line references, as the spotlight follows the two male protagonists. This is not an uncommon phenomenon, as historians of women have noted many times, yet it reduces to insignificance women's often critical role in bringing together competing parties, or participating in major shifts of political power. This book seeks to investigate that role more fully in Italian history.

Medieval Italy remains under-represented in English-language studies, and features often peripherally in many undergraduate survey courses of the period 900–1200. And, despite the explosion of research interest in the lives of medieval women during the past four decades, women are still represented only sporadically on university syllabi. Medieval Italian women are therefore rendered doubly invisible to students and general readers, and usually do not feature in medieval histories except where their intervention

as locally powerful rulers affects the outcome of wider political developments, as in the case of Matilda. Even among Italian scholars, however, the social and political role of women is treated at best infrequently and more often not at all. This book, therefore, aims to explore women's lives between the sixth and thirteenth centuries in Italy, and to make accessible the limited Italian historiography on the subject, in order to illustrate the changes and continuities in medieval Italian society during the period.

Such a task is not without its hazards. Italy ceased to be a unified political entity in the sixth century. The ensuing fragmentation into ever smaller political entities until the end of the period under study has the effect, if not of fragmenting women's experiences, then of fragmenting the sources of information available to build up a picture of those experiences. Diversity of political rule, ethnic identity and even language and religion throughout the peninsula ensure that reconstructing an integrated and comprehensive survey of women's lives in Italy is still many years away.

Yet medieval Italy is, ironically, one of the best documented areas of early medieval Europe for the period under review. The richness of sources in comparison with other regions renders Italy of major importance for historians of women, in that the detailed evidence available may shed new light on less well documented areas elsewhere in Europe. The sources are, however, unevenly distributed – Sicily and Sardinia are still imperfectly understood despite Michele Amari's translations of Arabic sources in the late nineteenth century and more recent studies by Denis Mack Smith and Jeremy Johns.[2]

Although it could now be argued that there was far less difference between the Roman and early medieval worlds than had previously been thought, the book's start date is influenced by the arrival of the Gothic, and then Lombard, hosts in Italy and the appearance of numerous written sources documenting these upheavals. The end date is rather more contentious, but it seems that the thirteenth century did see a fall-out from changes in political organisation in Italy which had a direct and long-lasting effect on women's lives, even if the sources, which determine the book's internal organisation, continue unbroken after 1250. The establishment of the Norman kingdom in the south in the twelfth century certainly marked a new administrative monarchy which tried to break old family allegiances in that area, whilst the aggressive development of communal government in the north had the effect of crystallising political structures to the detriment of women's previously informal role, even if family relationships still played a major part in political manoeuvring. This drift towards administrative rule (by male administrators) was not limited to Italy; nevertheless, it provides an apt point at which to leave the histories of women. The epilogue outlines some of the major trends of the thirteenth century. Women's role in late

medieval and early Renaissance Italy has been studied more intensively in monograph works, and a synthesis of these would take another book (see Bibliography).

Historiographical problems

Annamaria Padrone Nada, in a rare attempt to write the history of women in southern Italy, highlighted the problem of believing that documents reflect reality, also of synthesising culturally diverse areas like the south.[3] Ecclesiastical and moralistic works, she stated, were the least original sources and reflected the eleventh-century anti-feminist outlook more than the lives they purported to recount. Literary, treatise and iconographic works were only expressions of the collective psychology, whilst legislative and private documents showed women as passive – a 'testimony of their family's social prestige'. Such sources could not record what did not exist, that is, self-conscious and socially active women. Her assessment, which is based largely on the southern sources, seems a little too pessimistic. As this book demonstrates, the social constraints on women's activities were often negotiable, and women sometimes exploited their apparent passivity to gain advantages in property or prestige.

Diane Owen Hughes has argued that Italian historical consciousness – particularly with reference to the Middle Ages – has been nourished by civic pride: since women were excluded from public office in medieval cities so they were deprived of a place in the historical record. Lombard laws may have given way to Roman legal personality, but Roman law sanctioned woman's essentially 'private' nature, with Justinian's *Digest* stating: 'Woman are excluded from all civil and public offices; and thus they may not be judges, nor magistrates, nor advocates; nor may they intervene on another's behalf, nor act as agents'.[4]

This situation needs to be nuanced: yet again the neatness of legal codification can seduce historians into believing the frameworks thus created, when it is clear that the history of women often inhabits the grey area between law and practice. Even if 'public' administration excluded women – and there appear to be few cases which challenge this model, especially when we reach the histories of the city-republics of the twelfth century – women continued to act in and occupy very 'public' roles. Hughes's viewpoint also, like many others in the secondary literature, privileges the north. In the south, where the hegemony of urban and civic structures was by no means the dominant political pattern, the historiography of women may take on a rather different shape.

A second problem raised by Rao, which this book will attempt to explore, is the plurality of historical eras. That is, women's history and that of men may move in completely different rhythms. This idea is not new: women's historiography has long taken on board ideas of the continuity and unchanging nature of women's history, or whether women could have a history that was not centred around their access to political power of some sort. Judith Bennett has taken this approach furthest, arguing that women's history has 'stood still' in the face of the forces of patriarchy. These have ensured that whilst women's activities might have changed over time, their basic subordination to male-centred and male-dominated frames has remained unchanged and thus they have not moved forward as social beings. Whether this line of enquiry is useful in medieval studies, where there is little sign of feminist consciousness among even those few female writers we encounter, has been the subject of some debate.

Bennett's more recent work has nuanced this viewpoint to distinguish between periods of temporary change in women's functions, and more deep-seated shifts in their status which might (or might not) be caused by those changes. This seems to be a useful framework to assess Italian women's history, and in particular allows for the 'exceptional' woman to illustrate limitations which she sometimes challenged but which more often her career highlighted. The most valuable lesson of Bennett's work, however, is that women's history may not be linear; it has silences and omissions, particularly in this early period, and the reasons for these must be explored.[5]

The book will necessarily consider the relationships between the women of Italy and their male relatives, friends and associates, and in taking a gendered approach will reveal the expectations and pressures on both sexes to conform to social norms. It aims to demonstrate how the status of women differed according to their wealth, their geographical location and their urban or rural world and, more contentiously, their race or religion. Because Italy was never a unified political or social entity in the Middle Ages, it is essential to clarify these differences between groups of women. The book therefore locates itself within a tradition of arguing that class, wealth, religion and race are as important as gender difference when considering the history of women, and that 'women' cannot be taken simply as a homogeneous group, or assumed to have the same experiences, aspirations or goals. The issue of women's oppression by other women is an uneasy one to confront, but notions of sisterhood are at best anachronistic when dealing with early medieval evidence. At the same time, the present study may well find that, whereas the above factors conditioned and shaped men's lives, women's experiences had far more in common across political and social divisions. This acknowledgement of and confrontation with the issue of difference or similarity may well also modify the usual historiographical treatment of

INTRODUCTION

Italy in two separate halves, the heavily urbanised north and the relatively underdeveloped south.

Development of women's history in Italy

Feminist politics have had an important role in the development of women's history as a discipline,[6] but the pace of change in historiography differs from region to region.

Women's history in Italy had a first flowering after the Second World War, followed by more intense study as a product of the 1970s when the feminist movement was at its height. De Clementi cites the foundation of two journals, *Memoria: Rivista di Storia delle Donne* and *DWF: Donna Woman Femme*, as major steps forward in gaining women's history a place in academe.[7] Now there is a great deal of activity and support for the discipline, as reflected in the decision by the publisher Laterza to bring out the Italian version of Duby and Perrot's multi-volume history of western women.[8] The volumes themselves were patchily received, which may explain the subsequent commissioning by the same publisher of a multi-volume history of women in Italy based on a thematic approach and written by Italian and non-Italian scholars.[9]

However, the development of women's studies in Italy was relatively late, as Cicioni and Prunster argue, and feminist studies in history have tended to focus on either the Renaissance or on self-reflexive histories of the growth of the Italian feminist movement in the 1960s and 1970s.[10] The Middle Ages have all but been passed over in this process, with the notable exception of more recent work by Padrone Nada and Maria Teresa Guerra Medici (see below) in the 1980s and 1990s. Indeed, the majority of works on medieval women's history currently available in Italian consist of collections of essays, often translations of earlier work by non-Italian scholars, underlining the need for more work to be done. Gabriella Piccinni usefully outlines the state of play in her contribution to one of the most recent essay collections.[11] She shows how the early medieval period has been ignored in relation to the later Middle Ages, and how the south has not received as much attention as the north in any period. She calls for more, detailed monograph studies. Piccinni's comments have resonance for more than the world of women's work, and could apply to the historiography on medieval women in general in Italy. Her criticism of using words expressing qualitative judgements – the 'progress' of women into the world of paid work, for example – and her dismissal of the absence of documentation as an 'alibi' for not undertaking more research are a direct challenge to historians within

and outside Italy. She also offers an approach to women's work which rejects the notion of marginalisation from work – again a qualitative judgement about what type of work is best – and instead suggests that the concept of women's marginalisation *within* paid work, with its pay and task differentials, may offer a more fruitful line of enquiry.

In the absence of more than a handful of the type of monographs Piccinni calls for, we are reliant mainly on older historiography on the Middle Ages whose attitude to women is, to say the least, ambivalent. In her study of the historiography of medieval Italian women, Diane Owen Hughes points up a tendency to write moralistically, for example Pasquale Villari's early twentieth-century treatment of Theodora of Rome and her daughters, describing their careers in the tenth century as 'the political ascendancy of dissolute women'. Villari's judgement was based on and compounded the prejudice of his sources, and he saw no need to question the image presented. Hughes also criticises later historians for following the influential models of their predecessors and not challenging the frameworks within which they worked. For example, economic historians of the postwar period have not restored women's activities to view because they have tended to focus on the urban, institutional and large commercial enterprises – areas where women are less likely to have been represented.

Another early area of Italian historiography where women have appeared is the strong tradition of the legal history of the family in the peninsula, dating from the nineteenth century. But the early work of Leicht, and the later studies by Calasso, Marongiu and Bellomo and others aimed to examine the development of the *law* surrounding the family rather than of women's status *per se*, and information about the latter often emerges as a by-product of the research rather than its focus.[12]

There remains, therefore, a need for greater precision in mapping women's role at the intersection of the public and private worlds of the Middle Ages, and for more case studies based on regional and thematic research such as the recent conference on demographic patterns in medieval Italy.[13] The *Annales* historians (most notably Christiane Klapisch-Zuber for Italy, albeit rather later[14]) have started by emphasising the *longue durée*, the rhythms of household, the life guided by structure rather than event. This generates endless repetitions and ahistorical rhythms. Does this once again relegate women into the generational timespan as against the historical – or confine their histories to that of the non-event? 'The constant impulse to see woman in iconic rather than in narrative terms inevitably reduced their historical presence, perhaps almost as much as those legal barriers that had kept them from a public life.'[15] Further investigation will reveal that it is precisely within the family that the bulk of Italian political and social developments took place. Women, therefore, often found themselves at the centre of

politics through their domestic relationships. If the conduct of wives and daughters was always a matter for regulation and debate, it seems that the binary divide between 'active' public world and majority of 'private' individuals is not a helpful one.

Organisation: the sources

The original aim of the book was to synthesise the work which had already been done on Italian women's lives in the early medieval period and to provide a general overview for students. What has emerged – owing largely to the paucity of such secondary literature – is a survey which is far more heavily reliant on the primary sources than originally envisaged, particularly for the period to 900. Nevertheless, little of the source material has been read with a view to writing women's history, and this first attempt to do so in a comparative way will, it is hoped, provide a stimulus for further research appraising the sources in a fresh light. This study should be read, therefore, as a guide to the state of play in Italian medieval women's history. At the time of writing, that state is one of incompleteness in the systematic study of the sources and of unevenness in the regions which have been examined in any depth.

All histories of medieval women are to a large extent reliant on sources that were not primarily concerned with the women they record. Even materials with an apparently more direct focus on women, for example legislation about their status or charters recording their transactions in property, were shaped largely by external concerns or formulaic structures which can often bleach out any individuality in the parties recorded. Sources therefore not only reflect but also shape women's social roles. This book is organised chronologically to follow the flow of the sources, basing its narrative and commentaries on the patterns created by the primary materials and accompanying secondary works. This, to my knowledge, represents an uncommon approach to the history of women, eschewing preconceived themes in women's lives or notions of what the historian considers to be important to find out about, and instead allowing the sources to reveal patterns of change in attitudes towards and actions of women in medieval Italy.[16] All too often, studies of women's history have been divided into chapters which appear to segregate groups of women from each other: countrywomen, townswomen, landowning women and religious women seems to be a favourite scheme.[17] These divisions seem not to allow for interactions between groups, or indeed overlap between the categories (the common division between wives and widows is a more justifiable one in

that it often reflects a real change in status). Another common approach is to mix such groups with other, thematic chapters, moving from 'townswomen', 'countrywomen' and 'wives' to 'work and occupations' and 'education' without any obvious acknowledgement that these are not mutually exclusive categories. Such an approach seems at best unnecessarily complicated, and ironically features in several books of sources for medieval women's history.[18]

Following the sources in more-or-less chronological order has the advantage of demonstrating the effect of outside events on the production and conservation of materials, as well as changes in genre, authorship and levels of literacy. All of these factors affect the visibility of women to the historian before social attitudes even begin to be explored, a factor which is all too often overlooked. A fresh examination of the primary evidence may also reveal women in surprising and unexpected contexts. To concentrate on women's issues can sometimes limit the scope of enquiry: the feminist project of assessing women's access to education and literacy skills through the works of female authors, for example, while entirely essential, has led to a concentration on the 'stars' of such enterprise, at the cost of research into more modest (with all the reservations that such a qualitative adjective raises) forms of women's writing. Nevertheless, the book recognises the pitfalls of 'adhering to a male-centred approach' by following male-centred sources. It does not necessarily follow that using the chronology of women's experience presented by these sources implies adopting the dominant ideology they represent; on the contrary, exclusions and omissions of women are worthy of note, and such absences can tell us a great deal about the limitations of written texts and the boundaries placed on women's appearance in them.

There is no escaping the fact, however, that almost all of the sources are male-authored. With the possible exception of early epitaphs composed by nuns, no female voices reach us from medieval Italy except via reported speech. As Anna Maria Rao has argued, however, it is not sufficient simply to acknowledge the male bias of sources without investigating the processes by which those sources were produced and conserved, and asking what excluded women from those processes.[19] A start has been made by Janet Nelson, who questions the assumption that all anonymous sources are written by men, and by Elisabeth van Houts, whose work has focused on the oral contributions that women might have made to works written by male authors.[20] Both of these approaches open up new possibilities to access women's voices alongside the more established studies of women's literacy,[21] and the Italian sources present a rich sample on which further work of this type might be undertaken.

The sources drawn upon for this book fall into several categories of genre, and display all the limitations associated with each type. Medieval

writers were often bound by literary traditions rather than a desire to 'tell it as it was'. Historical narratives, produced almost exclusively by clerical authors, exist from the eighth century onwards, and provide in varying levels of consistency and reliability perhaps some of the most idealised and the most extremely negative views of women of their times.

The south furnishes the most coherent series of histories, even if the earliest, Paul the Deacon's *History of the Lombards*,[22] written in the latter decades of the eighth century and narrating events up to the death of king Liutprand in 735, focuses more often on northern issues. It has been used extensively to discuss the Lombard invasion and settlement of Italy, and in discussions of Lombard origin traditions with particular reference to the tribal foremother Gambara,[23] but his history has not until recently been read with gender as its focus, and has still to receive a complete treatment on these lines. Paul has continuators,[24] short texts adding only minimally to our knowledge, then the history of the Lombards in the south is taken up by Erchempert's *History of the Lombards of Benevento*[25] and histories based around individual cities or communities, such as the *Chronicon Salernitanum* of the tenth century.[26] There follow accounts of the Norman conquest of the south from Amatus, monk of Montecassino, William of Apulia and Geoffrey Malaterra,[27] and 'Hugo Falcandus'[28] and twelfth-century civic chronicles from Bari and Benevento.[29] In addition, the histories of monasteries written by their inmates, such as the Chronicles of St Benedict and Montecassino for that house, and the Chronicle of San Vincenzo al Volturno, provide another perspective on the interaction of secular and lay life.[30]

The north had its chroniclers too, but often with a more limited scope to their writings, for example Andreas Agnellus of Ravenna's *Liber Pontificalis Ravennatis*, a localised chronicle of the city's bishops, interspersed with Agnellus's didactic sermons, which, although considered historically inaccurate, has been held up as a good source for exploring ninth-century mentalities.[31] A wider picture was covered in the works of Liutprand, bishop of Cremona and ambassador for the German emperor Otto I.[32] His use of language and gender stereotypes has received attention from a number of scholars (see below, Chapter 4), and his writing conveys valuable images of tenth-century Italian aristocratic women and contemporary ways of portraying them. Bishop Rather, Liutprand's contemporary at Verona, left a copious amount of written work in a number of genres which offers insights into secular and ecclesiastical politics in the tenth century, often played out around the figures of women.[33] Later history is transmitted via civic chronicles such as those from Venice (John the Deacon) and Genoa (Caffaro)[34] but, with their civic focus, such works may have been responsible for narrowing our view of women in the north by concentrating historiographical attention on the urban milieu.

Another narrative tradition which demands cautious use is hagiography, accounts of saints' lives whose subjects might be distant figures from late antiquity, or were near-contemporaries of their biographers and could have only recently died. The south has a substantial number of contemporary saints, and the opportunity to examine the role of the saint within his or her community is one which has been largely overlooked. The two main groups of sources used in this book are a series of hagiographies and translation stories (the latter recounting the movement of saints' relics from one place to another) from the city of Naples, including a history of its bishops, and a cluster of ninth- and tenth-century saints' lives from Sicily and Calabria. The Lombard region of the south furnishes the life of the Beneventan bishop St Barbatus. Later, the career of William of Montevergine (1085–1142) is also of relevance for the history of women in the south.

Further north, living saints became popular a century later than their Calabrian counterparts, with cults growing up around Romuald of Ravenna (c.950–1027) and his disciple Peter Damian (1007–1072). At the same time, the cult of long-dead saints remained vibrant, with churches in the north and south being dedicated to the apostles and to male and female martyr saints of late antiquity, such as the early cult of the Roman martyr St Agnes (d. c.305) at Rome from the fourth century.

It is striking, however, how few female saints feature in the early medieval sources, a theme which would have rewarded more attention in Diana Webb's work on the political use of local cults.[35] The cult of the local saint provided an opportunity for the community to come together in worship and to celebrate festivals, and hagiographies sometimes include stories surrounding such celebrations which reveal women's participation and roles. However, it appears that no female saints were central to the civic rituals of Italy until the thirteenth century. Why this should be is examined through the course of the book.

Not quite hagiographical is the compilation known as the *Liber Pontificalis*, a ninth-century compilation of papal biographies. This source has been used extensively by historians of the papacy and, by virtue of its numerous descriptions of moveable goods, by art historians. But although it includes numerous allusions to how women were viewed and the part they played in the history of Rome before the ninth century, its value as a source of information for women has hitherto been overlooked.[36]

If narrative sources enable us to establish a picture of the mentalities of their writers, legislation provides an image of the ideals that the legislators sought to live up to, and only secondarily provides an indication of the ideals that their subjects were expected to match. Until the end of the sixth century, the lives of Italy's inhabitants were governed by Roman law. From the edict of the Gothic king Theoderic, issued in 508, through the codification of

INTRODUCTION

Roman law into a more usable form by the Byzantine emperor Justinian and his legal advisor Tribonian, to the enormous bodies of laws issued by the Lombard kings from 643 onwards,[37] and thence to Carolingian capitularies (for the north) and Byzantine laws (applicable to parts of the south), and to civic legislation from the twelfth century onwards, there is a mass of material to explore. All too often, however, such laws have been held up as a framework for understanding the roles that early medieval women were expected to play in society. This is exemplified by the use which has been made of the Lombard king Rothari's edict of 643. It dealt at great length with ownership, marriage, inheritance and slaves, and thus includes many clauses relating to women; but as well as expounding custom it functioned as a way of boosting royal prestige and income, and must therefore be used circumspectly.

Lawcodes are also taken to be uniformly applicable to the territory controlled by the legislator. For example, Carolingian legislation, in the form of capitularies, was supposed to be applicable to the whole territory controlled by the Franks, irrespective of the personal law of their subjects. But the capitularies' statement to that effect betrays unease and is evidence of a persistence of personality of law and inconsistencies in practice. People could also change their law; hence the swift revival of Roman law and its victory over Lombard law in the twelfth century. Italy, though, was for a long time dominated by a form of Lombard law which only legislative innovations of the twelfth and thirteenth centuries, mainly in the form of northern civic statutes, began to dismantle (although it persisted in parts of the south until the sixteenth century). One of the earliest civic codifications was made in Pisa in the mid-twelfth century; Genoa was not far behind in legislating, particularly regarding familial issues and inheritance. Women, who had substantial property rights under Lombard law, could not fail to feature in such sources.

Alongside secular prescriptive sources, the Church was from its earliest inception attempting to impose its views of correct moral behaviour not just in Italy, but across Europe. Early evidence of the role of the papacy is furnished in the letters of Pope Gregory I between 590 and 604,[38] over a hundred of which deal in some way with women in Italy. Canonical material was gathered from biblical and patristic texts, from synods, and from practical experience where a papal decision set a precedent. It presents a rather chaotic picture until the systematic studies of Gratian in the 1140s. It is striking how the same themes recur in later papal letters and clerical authors, and this raises the issue of textual transmission and the problems of reading through a conservative literary tradition to reach the real lives of those it referred to.

Lawcodes are temptingly systematised and invite the unwary to use them as models of behaviour for women. Maria Teresa Guerra Medici has written

two substantial books which usefully synthesise the early and later medieval legal frameworks.[39] In order for their true potential as sources to be realised, however, they need to be used in conjunction with documents of practice. Fortunately, Italy is well served by the latter in the form of charter material.

Italian charters, or documents of property transactions, survive in great numbers from the eighth century onwards, and more sparsely before that date. Ravenna has sixth- and seventh-century papyrus charters which, taken together with the local chronicle by Andreas Agnellus, provide a few insights into that limited locality. The enormous archive of primary source material from Italy, numbering documents in their thousands, awaits effective exploitation. Some studies have been made of individual archives, or relating to individual cities or their territories, but little work has been done to synthesise such studies and discover whether useful conclusions can be drawn for Italy as a whole. An exception to this is Bougard's survey of surviving private acts relating to northern Italy up to the 1050s for his study of justice in the kingdom of Italy. He estimates that less than 500 charters survive for the late eighth century (265 of which appear in Luigi Schiaparelli's edition[40]), some 2,300 for the ninth, 3,000 for the tenth and over 4,000 for the first half of the eleventh.[41] The number of charters doubles if southern material is added. His is one of the few studies which has not clustered at the latter end of the period under review in the present study; but few studies have taken women, let alone gender, as their focus. A return to the primary material is therefore required to ask new questions of it.

The urge to make global connections may not be the most useful way of approaching medieval Italian women's lives. The work of David Herlihy on women's ownership of property across Europe,[42] whilst raising important methodological questions, may have over-generalised, at the expense of recognising regional variations, in its keenness to demonstrate the efficacy of early information technology techniques in analysing large bodies of data. The charter material from each locality had its own customs and peculiarities in social hierarchy and legal formulae. The tendency for people to change their law and custom has already been noted, and is documented in the charter evidence examined in this book. The diversity of experience in the peninsula that they reveal may be the key feature in a history of women here.

Since one book cannot hope to deal with the immense amount of charter material, I have taken a selective approach with the intention that the sample chosen should be broadly representative of the chronological and regional differences. All of the documents used are published, and the geographical range covered is outlined in the first section of the bibliography.

Charters include land sales, gifts, exchanges, divisions, wills and court records. They are sometimes useful in that they include formulae citing the laws of specific kings – at least some use was made of the lawcodes,

therefore, even if charters are simply the product of the same tradition of written administration. Such citations, though, may tell us more about the notary's education than about the legal knowledge or practice of his clients. A more fruitful approach is to map such references against the actors in the document: how far explicit citations of the law coincided with women's transactions is explored during the course of the book.

The preservation of charters is a more difficult issue, for the majority of archives have their origins in monastic or episcopal houses. At first sight they may be distinctly unpromising as sources for anything other than the community's interaction with the particular monastic house, but the practice of handing over gifts of land to ecclesiastical institutions accompanied by any written documents relating to that land often permits an insight into transactions between laymen and women and their friends and family. Charter material can also be used in conjunction with the few estate surveys we have to examine the lives of sections of the rural population.

Miscellaneous other written sources may also provide information about women's lives. City descriptions – for example the early medieval verses composed about Milan and Verona – provide not only an insight into the intellectual and cultural life of those cities, but can also furnish data on the physical shape and spaces of the city. The Milanese and Veronese examples date to the eighth and early ninth centuries respectively, but they have echoes in later examples, such as that of Bonvesin of Milan 1288. Linked to such urban material are fiscal documents, the best known of which is the so-called *Honorantie Civitatis Papie*, an early eleventh-century text claiming to describe the tenth-century situation in the royal capital of Pavia. This has been cited as evidence of women's involvement in the highest levels of fiscal activity in the kingdom of Italy, a claim which is explored in Chapter 5. But even if it does not fulfil this lofty ambition as a source, it nevertheless provides evidence of the movement of goods and consumables into and through the peninsula. Letters, too, offer important information, and this study looks at some of the earliest, written by the Roman senator Cassiodorus, as well as at those left by Rather of Verona and Gerbert, later Pope Silvester II.[43]

Finally, and possibly the most fruitful source of future information, our knowledge of early medieval Italian life is now being increased by archaeological investigations, both in urban contexts (the re-excavation of the forum in Rome is revealing new insights into medieval housing[44]) and at sites such as San Vincenzo al Volturno.[45] This is complemented by epigraphy, both the inscriptions erected by patrons of buildings and the epitaphs of women and men. In addition, there is a certain amount of early medieval iconographic material in both documents and buildings which can be analysed within the limitations of a non-specialist in art history. The scenes of agricultural life depicted in the grander scheme of the twelfth-century apse

mosaic at the church of St Clement in Rome, provide an example of the often surprising places where information about everyday life and practices can be found.

By following the sources as they appear and disappear across time, any attempt to recount a changing history (or indeed a continuous one) may fall foul of the differences in genre, place of production and purpose of the source. The 'history' of women in Italian medieval society may be better characterised as a series of 'histories', sometimes touching and overlapping, but mostly existing alongside each other within each period.

There is also a need to acknowledge that sources which are hostile or complimentary to women, which have those sections extrapolated to demonstrate the author's stance, may not have been directed at women as a central theme at all. It is important to tease out the male voice from the clerical one, and to explore political motivations, particularly in narrative sources. Texts are institutional, juridical and express power relationships, but women are not always at the bottom of the hierarchy.

Notes

1. Diane Owen Hughes, 'Invisible Madonnas? The Italian historiographical tradition and the women of medieval Italy', in Susan Mosher Stuard (ed.), *Women in Medieval History and Historiography* (Philadelphia, 1987), pp. 25–57, at p. 50.

2. Michele Amari, *Biblioteca Arabo-Sicula* I (Rome and Turin, 1880); Denis Mack Smith, *A History of Sicily. 2: Medieval Sicily, 800–1713* (1968); Jeremy Johns, *Early Medieval Sicily* (1994).

3. A. Padrone Nada, 'La donna', in G. Musca (ed.), *Condizione Umana e Ruoli Sociali nel Mezzogiorno Normanno-Svevo* (Bari, 1981), pp. 103–130.

4. Owen Hughes, 'Invisible Madonnas?'

5. Judith Bennett, 'History that stands still: women's work in the European past', *Feminist Studies*, 14 (1988), pp. 269–283; critiqued by Bridget Hill, 'Women's history: a study in change, continuity or standing still?', *Women's History Review*, 2 (1993), pp. 5–22; Bennett's reply in the same volume, 'Women's history: a study in continuity and change', pp. 173–184.

6. Joan Kelly, *Women, History and Theory* (Chicago, 1984); Gerda Lerner, *The Creation of Patriarchy* (Oxford, 1986) and the same author's *The Creation of Feminist Consciousness* (Oxford, 1993); Judith Bennett, 'Feminism and history', *Gender and History*, 1 (1989), pp. 251–272; Joan Scott (ed.), *Feminism and History* (Oxford, 1996).

INTRODUCTION

7. A. De Clementi, 'Sulla storia delle donne in Italia', in M. R. Pelizzari (ed.), *Le Donne e la Storia: Problemi di Metodo e Confronti Storiografici* (Naples, 1995), pp. 17–23.

8. Georges Duby and Michelle Perrot (eds), *A History of Women in the West*, 5 vols (Cambridge, Mass., 1992–1996).

9. *Storia delle Donne in Italia*. Already published are Lucetta Scaraffa and Gabriella Zarri (eds), *Donne e Fede* (Rome and Bari, 1994) and Angela Groppi (ed.), *Il Lavoro delle Donne* (Rome and Bari, 1996). Further volumes planned are Michela de Giorgio and Christiane Klapisch-Zuber (eds), *Storia del Matrimonio* and Marina D'Amelia (ed.), *Storia della Maternità*.

10. M. Cicioni and N. Prunster (eds), *Visions and Revisions: Women in Italian Culture* (Oxford, 1993).

11. G. Piccinni, 'Le donne nella vita dell'Italia medievale', in Groppi (ed.), *Lavoro delle Donne*, pp. 5–46.

12. Diego Bellacosa, *Il 'Mundio' sulle Donne in Terra di Bari dall'anno 900 al 1500* (Naples, 1906); Camillo Giardina, '*Advocatus* e *mundoaldus* nel Lazio e nell'Italia meridionale', *Rivista di Storia del Diritto Italiano*, 9 (1936), pp. 291–310; F. Calasso, '*Ius publicum* e *ius privatum* nel diritto comune classico', *Annali di Storia del Diritto*, 9 (1965), pp. 57–87 (first published in 1943); P. S. Leicht, *Storia del Diritto Italiano*, 5 vols (Milan, 1948–1960); Manlio Bellomo, *Profili della Famiglia Italiana nell'Età dei Comuni* (Catania, 1966).

13. Irma Naso and Rinaldo Comba (eds), *Demografia e Società nell'Italia Medievale* (Cuneo, 1994).

14. Christiane Klapisch-Zuber, *Women, Family and Ritual in Renaissance Italy*, trans. Lydia G. Cochrane (Chicago, 1985).

15. Owen Hughes, 'Invisible Madonnas?', p. 29.

16. Judith Jesch, *Women in the Viking Age* (Woodbridge, 1991) also uses a source-centred, but not chronological, approach.

17. For example Shulamith Shahar, *The Fourth Estate: A History of Women in the Middle Ages* (1983), and (the more comparable example in that it is restricted to one region of Europe) Helen Jewell, *Women in Medieval England* (Manchester, 1996).

18. For example Emilie Amt (ed.), *Women's Lives in Medieval Europe: A Sourcebook* (1993); Carolyne Larrington (ed.), *Women and Writing in Medieval Europe* (1995); and P. J. P. Goldberg (ed. and trans.), *Women in England, c.1275–1525* (Manchester, 1995).

19. A. M. Rao, 'Medioevo al femminile? Le sfide mancate della storia delle donne', in Pelizzari (ed.), *Le Donne e la Storia*, pp. 87–104.

20. Janet Nelson, 'Gender and genre in women historians of the early Middle Ages', in *L'Historiographie Médiévale en Europe* (CNRS, Paris, 29 March–1 April

1989) (Paris, 1991), pp. 149–163; Elisabeth van Houts, *Memory and Gender in Medieval Europe, 900–1200* (Basingstoke, 1999); eadem (ed.), *Medieval Memories: Men, Women and the Past in Europe, 700–1300* (2000).

21. See above, n. 18; Peter Dronke, *Women Writers of the Middle Ages* (Cambridge, 1984); Karen Cherewatuk and Ulrike Wiethaus (eds), *Dear Sister: Medieval Women and the Epistolary Genre* (Philadelphia, 1993); Marcelle Thiébaux (ed.), *The Writings of Medieval Women: An Anthology* (2nd edn, New York, 1994); Patricia Skinner, 'Women, literacy and invisibility in southern Italy, 900–1200', in Lesley Smith and Jane Taylor (eds), *Women, the Book and the Worldly* (Woodbridge, 1995), pp. 1–11; Lesley Smith and Jane Taylor (eds), *Women, the Book and the Godly* (Woodbridge, 1995).

22. L. Bethmann and G. Waitz (eds), *Pauli Historia Langobardorum*, in *MGH SRL*, pp. 12–187. English translation: William D. Foulke (trans.), *History of the Langobards by Paul the Deacon* (Philadelphia, 1907).

23. Arrival and integration: D. Harrison, *The Early State and the Towns: Forms of Integration in Lombard Italy, 568–774* (Lund, 1993). Origin myths: Huguette Taviani-Carozzi, *La Principauté Lombarde de Salerne IXe–XIe Siècle*, 2 vols (Rome, 1991), I, pp. 98–169.

24. *Continuatio Casinensis, Continuatio Romana, Continuatio Tertia* and *Continuatio Lombarda*, in *MGH SRL*, pp. 198–219.

25. Erchempert, like many other early Italian writers, is edited in *MGH SRL*, pp. 231–264. An English translation of this important work is currently in progress.

26. U. Westerbergh (ed.), *Chronicon Salernitanum* (Stockholm, 1956); Italian translation by A. Carucci, *Il Chronicon Salernitanum (sec. XI)* (Salerno, 1988).

27. V. De Bartholomeis (ed.), *Storia de' Normanni di Amato di Montecassino* (Rome, 1935); M. Mathieu (ed.), *Guillaume de Pouille, La Geste de Robert Guiscard* (Palermo, 1961); E. Pontieri (ed.), *De Rebus Gestis Rogerii Calabriae et Siciliae Comitis auctore Gaufredo Malaterra* (Bologna, 1927–1928); L. De Nava (ed.), *Alexandrini Telesini Abbatis Ystoria Rogerii Regis Siciliae, Calabriae atque Apuliae* (FSI 112, Rome, 1991).

28. Graham A. Loud and Thomas Wiedemann (trans.), *The History of the Tyrants of Sicily by 'Hugo Falcandus', 1154–69* (Manchester, 1998).

29. Bari: the three main chronicles are now collected with facsimiles of their original editions in Gerardo Cioffari and Rosa Lupoli Tateo (eds), *Antiche Cronache di Terra di Bari* (Bari, 1991); G. Del Re (ed.), *Falconis Beneventi Chronicon*, in *Cronisti e Scrittori Sincroni napoletani*, I (Naples, 1845), pp. 161–252, on which see G. A. Loud, 'The genesis and context of the chronicle of Falco of Benevento', *Anglo-Norman Studies*, 15 (1993), pp. 177–198.

30. *Chronica Sancti Benedicti Casinensis*, in *MGH, SRL*, pp. 467–489; H. Hoffmann (ed.), *Die Chronik von Montecassino (Chronica Monasterii Casinensis)* (*MGH SS* 34,

INTRODUCTION

Hanover, 1980); *Chronicon Vulturnense del monaco Giovanni*, 3 vols (FSI 58–60, Rome, 1925).

31. Joaquín Martínez Pizarro, *Writing Ravenna: The Liber Pontificalis of Andreas Agnellus* (Ann Arbor, 1995).

32. F. A. Wright (trans.), *The Works of Liudprand of Cremona* (1930), reprinted as J. J. Norwich (ed.), *Liudprand of Cremona: The Embassy to Constantinople and other Writings* (1993).

33. Peter L. D. Reid (trans.), *The Complete Works of Rather of Verona* (Binghamton, NY, 1991).

34. Venice: G. Monticolo (ed.), *Cronache Veneziane Antichissime*, I (FSI 1, Rome, 1890); Genoa: L. T. Belgrano (ed.), *Annali Genovesi di Caffaro e de' suoi continuatori*, I (Rome, 1890). C. J. Wickham, 'The sense of the past in Italian communal narratives', in P. Magdalino (ed.), *The Perception of the Past in Twelfth-Century Europe* (1992), pp. 173–189, emphasises the limited scope of the chronicles.

35. Diana Webb, *Patrons and Defenders: The Saints in the Italian City-states* (London, 1996).

36. The source is available in a modern English translation in three volumes by Raymond Davis: *The Book of Pontiffs* (Liverpool, 1989); *The Lives of the Eighth-Century Popes* (Liverpool, 1992); and *The Lives of the Ninth-Century Popes* (Liverpool, 1995).

37. K. F. Drew (trans.), *The Lombard Laws* (Philadelphia, 1973).

38. Most recent edition, with concordance to older ones: Dag Norberg (ed.), *S. Gregorii Magni Registrum Epistularum*, 2 vols (Corpus Christianorum Series Latina CXL and CXLa, Turnhoult, 1982).

39. Maria Teresa Guerra Medici, *I Diritti delle Donne* (Naples, 1986); eadem, *L'Aria di Città: Donne e Diritti nel Comune Medievale* (Naples, 1996).

40. *Codice Diplomatico Longobardo*, I–II (FSI 62–63, Rome, 1929, 1933).

41. François Bougard, *La Justice dans le Royaume d'Italie* (Rome, 1995), p. 76.

42. David Herlihy, 'Land, family and women in continental Europe, 701–1200', *Traditio*, 18 (1962), pp. 89–120, reprinted in Susan Mosher Stuard (ed.), *Women in Medieval Society* (Philadelphia, 1976), pp. 13–45.

43. Cassiodorus: S. J. B. Barnish (trans.), *Cassiodorus: Variae* (Liverpool, 1992); Rather: see above, n. 33; Gerbert/Silvester: Harriet Pratt Lattin (trans.), *The Letters of Gerbert with his Papal Privileges as Sylvester II* (New York, 1961).

44. Sauro Gelichi (ed.), *I [Primo] Congresso Nazionale di Archeologia Medievale* (Florence, 1997). See also Richard Hodges and Brian Hobley (eds), *The Rebirth of Towns in the West, AD700–1050* (CBA Research Report 68, 1988), pp. 16–42.

45. Richard Hodges (ed.), *San Vincenzo al Volturno*, I–II (1993, 1995).

CHAPTER ONE

The End of the Roman World, 508–602

> Early medieval Italy was never, probably, a very pleasant place for women to be... What they really did or thought is unknown.[1]

Wickham's rather pessimistic outlook has resonance for the early medieval researcher. The political history of Italy in the period 508–774 is one of almost continual upheaval. After a period of Gothic rule which has the character of a golden age under King Theoderic, the ill-starred Byzantine campaign against the Goths after the murder of Theoderic's daughter Amalasuntha was followed in short order by the eruption of the Lombards into northern Italy in 568, and finally by the arrival of Frankish armies and their defeat of the last Lombard king, Desiderius, in 774. Warfare was endemic, with consequent disruption not only to people's lives, but also eventually to the written sources which record them. This and the following chapter trace the sources of the period, and the roles they project onto women.

Our sources for the sixth century are quite numerous,[2] and overwhelmingly Roman in character. They include the letters of the Roman senator, Cassiodorus, written for the Gothic kings; the collection of papal biographies known as the *Liber Pontificalis*; the copious letters of Pope Gregory I and both the codification of Roman law undertaken by the Byzantine emperor Justinian and applicable to the whole peninsula before the mid-seventh century,[3] as well as the legal prescriptions of the Gothic rulers. Taken together, they illustrate the transitional process which was still taking place between Roman Italy and its new political make-up as a Gothic kingdom over which the Byzantine emperors claimed sovereignty. During that process, women appear as actors in and as victims of upheaval at both local and national level. They are particularly visible when used as the measure of social disorder. For example, the life of Pope Symmachus I (r. 498–514)

in the *Liber Pontificalis* includes as an indicator of the lay and clerical discontent which he faced the statement that 'even dedicated women and virgins were displaced from their monasteries and houses; women were stripped, injured with cuts and wounded with blows'.[4] The implication appears to be that the disorder was such that even politically powerless women were targeted. This theme is repeated throughout the Middle Ages.

Women in Cassiodorus's letters

The sixth century was one of transition between Roman and barbarian rulership in Italy, but the letters or *Variae* of the senator Cassiodorus, written for the Ostrogothic king Theoderic and his successors, are thoroughly Roman in character.[5] Cassiodorus's own career may have waxed and waned according to how strong or weak the Gothic party was at court, but his letters tell us about more than just court business at the time. For example, in a letter written for Theoderic in 510–512, introducing a new patrician to the Roman senate, the patrician's widowed mother is praised for her efforts in managing her estates alone and bringing up so many sons. 'My judgement [says Theoderic] ... has ... looked into these achievements; it seeks out even the good of domestic virtue, that it may bestow public honours on those praised in private'.[6] In other words, the son was a credit to his mother, but her status was gained very much through remaining out of the public eye.

The theme of praiseworthy women continued a longstanding tradition of extolling model qualities in Roman women, particularly on their gravestones, and would be mirrored in later Roman sources (for example, the *Liber Pontificalis* mentions the mother of Pope Gregory II, Honesta, 'whose name truly reflected her character'[7]). It is taken up again in a letter written around the same time, 510–512, when Theoderic married off his niece to Herminafrid, king of the Thuringians. Theoderic points out that Herminafrid will be receiving 'a woman learned in letters, schooled in moral character, glorious not only for her lineage, but equally for her feminine dignity'. In return, he acknowledges the gift of horses which had been sent as 'the destined price – the purchase is, in fact, priceless, but international custom requires it'. Note here the dismissal of any idea that Herminafrid has bought his wife: Theoderic's letter concludes by stressing that the bride far surpasses all the gifts the Thuringian has sent.[8]

Early medieval sources referring to the price of brides have fuelled the assumption among feminist historians that early medieval marriage was little more than a trade in women: a financial transaction where brides were

bought and sold with little choice over their prospective husband. The controversy has been particularly acute in studies of women's rights in Anglo-Saxon England.[9] However, Theoderic's letter to Herminafrid suggests a rather different interpretation. Firstly Theoderic, trying to be a thoroughly Roman king, was underlining that whilst *he* did not approve of the custom of brideprice, less civilised peoples (a swipe at the Thuringians?) still adhered to it. In addition, the letter appears to stress that the gifts made by Herminafrid simply honoured the woman whom he was receiving – it was not a fair exchange, but the gifts were suitably rich as to partly compensate Theoderic for his loss and to recognise Herminafrid's debt to the king in being given her as a wife.[10]

Notable too is that the bride is said to have received an education. She shared her learning in letters with the king's daughter and heir Amalasuntha. A panegyric of the latter woman, discussed below, makes clear that her education consisted of more than simply knowing how to read and/or write. It is possible that the royal women were privileged in some way above their contemporaries, but other written sources of this and an earlier period suggest that elite women were assumed to be able to read: we might cite the correspondence of St Jerome in the fourth century with a number of wealthy and pious women.[11] The association of women with literacy would vary between region and period.[12]

King Theoderic died in 526. His daughter Amalasuntha had earlier married the Visigoth Eutheric and had a son, Athalaric, and a daughter named Matasuentha. Amalasuntha came to power (it is unclear whether Eutheric had died) and ruled as regent for her minor son Athalaric for eight years. During this time letters were issued in the king's name which were, presumably, moved by his mother. Of particular interest is his edict of 533/534, which includes strictures against adultery and concubinage. The latter places any free concubine taken by a married man into slavery under the ownership of the man's wife. A female slave in the same position is placed at the wife's mercy, and any penalty can be exacted except death.[13] Whilst this does little to punish the husband, and may not fulfil any other function than that of portraying Athalaric as a genuine king able to legislate for his kingdom, upholding Christian values as he does so, the edict might still offer some compensation to the wife. To interpret it as Amalasuntha's attempt to help other women might be over-reading the source, but its effects may have been beneficial for a few.

The edict does, however, introduce a major theme which recurs throughout the history of women in early medieval societies: the flexibility of marital arrangements and the regular appearance of slave or free concubines who shared the husband's bed. The repetition of legislation concerning this issue, and its persistence as a perceived problem well into the twelfth century and

beyond, are testimony to the difficulties which secular and ecclesiastical authorities had in suppressing this aspect of domestic life.[14]

Cassiodorus's picture of Amalasuntha is coloured by her patronage of him. A letter of 533 reveals Athalaric appointing Cassiodorus as praetorian prefect, after a period in which he had remained 'obscure and unhonoured'.[15] He reciprocated by writing a letter to the senate in the same year acknowledging its congratulations. In effect it is a panegyric, praising Athalaric for his continued obedience to his mother, who continued to govern as a 'wise mistress'. Cassiodorus notes her fluency in her own tongue, Latin and Greek, and adds that Amalasuntha is also learned in literature. Later in the letter he says that her firmness of mind surpasses that of the philosophers. Unlike Placidia (the early fifth-century empress Galla Placidia, half-sister of Honorius), he says, Amalasuntha is a skilled diplomat in her relations with the empire and has pursued effective wars with the Franks and Burgundians. 'Our fortunate mistress has achieved the glory of either sex: for she has both borne us a glorious king, and has secured a spreading empire by the courage of her soul'.

The literary theme of the praiseworthy woman taking on male qualities had a long history before Cassiodorus used it, and frequently recurred in later imagery of powerful women. During the course of this book further examples are examined, but here it is worth noting the mindset that the theme betrays. Amalasuntha cannot be praised simply as a woman: her achievements lift her *above* that status into having male qualities as well. In fact Cassiodorus places her in a limbo between these poles; later authors would not be so sophisticated, and images of virile women, which did not acknowledge the possibility that the female sex might also have 'glory', would become the norm.

On Athalaric's death in 534, Amalasuntha married her cousin Theodahad, who ruled from 534 to 536. The *Variae* include letters from Amalasuntha written in these difficult and tense years. The first, written in 534, informs the Byzantine emperor Justinian of Athalaric's demise and her choice of Theodahad as her co-ruler. The language of the letter reveals that Amalasuntha still assumed the dominant role, stating that she had 'brought [Theodahad] to the sceptre' to 'uphold the royal rank together with us'.[16] She repeats that she has chosen Theodahad in her letter praising him to the Roman senate of the same year.[17] Her confidence was misplaced, however, as Theodahad imprisoned her and had her killed in 535. Her death precipitated Justinian's declaration of war on the Goths. Theodahad was meanwhile overthrown by Witigis, who married Amalasuntha's daughter in 536 (another Roman source, the *Liber Pontificalis*, states that he took her forcibly[18]), but his reign was brief in the face of the Byzantine onslaught.

A rather different version of Amalasuntha's life emerges from the Frankish bishop Gregory of Tours' account of these years. Gregory gives a thoroughly

disapproving account of Amalasuntha's early years, relating that she defied her mother and eloped with a slave named Traguilla. When the couple were captured by her mother's men, the slave was killed and Amalasuntha beaten. In revenge, she poisoned her mother; only to be killed in turn by her husband 'Theudat'.[19] Gregory presents this garbled version of events as justification for a Frankish incursion into Italy to punish Theodahad for the murder. Whether much of value can be gleaned is open to question. In all sources, however, Amalasuntha appears to have attracted attention as a resourceful and strong-minded woman, as accounts of her death illustrate.

The Byzantine writer Procopius claims that Amalasuntha was murdered in a plot engineered by the Byzantine empress Theodora, who feared that if Amalasuntha sought refuge at the Byzantine court, this woman of 'splendid and extraordinarily masculine bearing' (note here again the use of the male as a laudatory quality) would prove a rival for her husband Justinian's affections.[20] Given Procopius's propensity for attributing evil deeds to Theodora (it is interesting that he sets her up as jealous of a manly woman – does Procopius see two very similar rivals here?), we should perhaps not be too quick to believe his account. A surviving letter of Amalasuntha to Theodora suggests at least superficial relations between the two women,[21] but some of Cassiodorus's other letters of 535 seem to contain veiled hints to some plot involving Theodahad and the Byzantine envoy Peter, discussed by Thiébaux.[22] If the Byzantines were involved in Amalasuntha's death, it may have been more a case of tidying up a difficult political situation or finding/provoking a reason to justify the ensuing attack.

Amalasuntha's career demonstrates the role that royal women might have in acting as a route to power for ambitious men through marriage. As the female heiress, she does not appear to have had sufficient authority to rule alone except as regent for her son, and on the death of the latter swiftly married another male candidate for the throne. Whilst the tenor of the letters of the period emphasises her as the senior partner in this arrangement, her inability to maintain her position without a partner is clear. Her life is an early example of a pattern familiar to historians of female rulers, which would often be repeated in Italian history.

The political instability in the early sixth century was mirrored, and perhaps exacerbated, by religious disputes which show up in the documentation in different ways. Chief among the controversies of the early medieval period was the problem of Arianism, a form of Christianity named after the fourth-century Alexandrian bishop Arius, whose adherents had been responsible for the conversion of the Germanic peoples outside the Roman empire. When the Goths and the Lombards in turn moved into Italy, they brought their Arian Christianity with them.[23] The *Liber Pontificalis*, a collection of early papal biographies, perhaps not surprisingly calls the Arian king

Theoderic a heretic, but women are also clearly visible negotiating the difficult waters of religious controversy. A letter of King Theodahad of 535 to the emperor Justinian alludes to a certain Ranilda who had changed her religion: Theodahad comments that it happened a long time ago and that he would not presume to pronounce judgement 'since the Deity allows various religions to exist'.[24] This may also reflect the numerous theological controversies which were raging in Byzantium at the time but whose fall-out was felt in Italy too. Their impact is seen also in a document of a certain Hildevera, in which she specified that her gift of property in 524 should go to the *Catholic* church of Ravenna.[25]

The *Liber Pontificalis* and the letters of Gregory I

It is from the Catholic church that two of our major sources of the period emanate. The *Liber Pontificalis*, read with one eye to its overwhelmingly Roman and localised point of view, gives a sense of the difficulties faced by the popes against a background of almost constant warfare, whilst the letters of Pope Gregory I reveal the wider politics and pastoral care in which the bishop of Rome was expected to engage at the end of the sixth century. Both provide useful contemporary models of idealised Christian womanhood, and less direct evidence of women's work on the ground to promote the Catholic, Christian life.

The Byzantine campaign during the Gothic wars included replacing Pope Silverius with a new candidate, Vigilius (r. 537–555). The latter is accused by the Romans in the *Liber Pontificalis* of marrying off his niece Vigilia to a consul named Asterius, 'son of a widow', and then having Asterius arrested and beaten to death.[26] Whether this story is apocryphal, it nevertheless underlines the sometimes dangerous political uses which could be made of marriages, but what happened to Vigilia is not recorded.

The *Liber Pontificalis* provides dramatic evidence of the misery caused by the Byzantine general Belisarius's campaigns in Italy. In 536 he entered Naples and sacked the city: 'he killed husbands by the sword in their wives' presence and eliminated the captured sons and wives of nobles. No one was spared, not *sacerdotes* [priests], not God's servants, not virgin nuns'.[27] In the same period, the *Liber* reports that famine struck in Milan and Rome, and in two separate passages that women were driven to eat their own children, so bad was the famine.

There is no doubt that the prolonged wars left Italy exhausted, but the image conveyed to us by the *Liber Pontificalis* opens up one of the ways that

women were used to 'think with' in late antique and early medieval society. As in the earlier report of opposition to Pope Symmachus, it is through including the trials suffered by women, particularly (but not just) religious women, that the author is able to convey the scale of the disorder. Women eating their own children is a still more serious level of disruption, as normal taboos against cannibalism are broken down and the strongest emotional bond, between a mother and her child, is reported to be under threat. As such, we are beginning to enter into an ideological framework which, although excluding women from public political life, uses their lives as a measure of social order or disruption. The themes of the nun being raped (which seems to have occurred regularly in times of war) or the mother eating her baby (which also occurs in Cassiodorus) may be overused, but their very familiarity in the literary culture of medieval Italy (or medieval Europe) should signal strongly that they are not simply throwaway lines. They are designed to shock the Christian reader, but the groups discussed – women and children – are thus reinforced in the mind of the reader as vulnerable social beings. The same effect is achieved by the repeated emphasis on popes and other clergy as the 'protectors' of widows and orphans. At the same time, the implication for the men supposed to guard and feed them is stark – they were not doing their job.

One of the main outcomes of the Gothic wars was to splinter Italy into areas of Byzantine and Gothic control, with neither side strong enough to withstand further pressure from outside. The south, Rome and Ravenna remained Byzantine, and have been studied in depth by Tom Brown.[28] In 568 the Lombards arrived in northern Italy and swiftly mopped up large parts of the peninsula at Gothic and Byzantine expense. From this point onwards the history of Italy can no longer be treated as a relatively unified whole.

The political vicissitudes of the time and devastation and dislocation caused by the Gothic wars are relatively well known through narrative sources, chiefly the Byzantine writer Procopius's *Gothic Wars*, but may also be glimpsed in the small number of charters surviving from the era, most notably the Ravenna papyri, our earliest documentary source. Wickham cites an example from 553 in which Ranilo, a Gothic noblewoman, gave land near Urbino and Lucca to the church of Ravenna, including slaves, 'if in this barbaric time those who have fled can be brought back'.[29] The language of this charter sums up the general feeling of insecurity which war provoked, and underlines the vulnerability of women in such periods.

The history of Byzantine Italy in the late sixth and early seventh centuries is also illuminated by the copious register of Pope Gregory I.[30] These letters show the members of the old Roman aristocracy meeting with different fates as the Gothic wars and then the Lombard invasions disrupted and

changed the social landscape. Brown, however, contrasts the war-torn north with the south, which was relatively secure in this early period. The senatorial aristocrats making endowments to the Church and featured in Gregory's letters are almost exclusively landowners in the south, and include several women.[31]

The endowments recorded took several forms, and offer an insight into women's piety in this period. A letter of 591 records the nunnery of St Vitus founded by Vitula on Sardinia, with Iuliana as abbess, but women might also, as in the case of Pompeiana recorded in the same letter, become nuns in their own homes, donated to the Church (I, 46). Both Iuliana and Pompeiana, however, were in this instance engaged in disputes over their respective houses' properties, and the latter woman was commended to the care of the archbishop of Cagliari, Ianuarius (I, 61). This does not appear to have worked, if she is the same Pompeiana as a religious woman recorded in 593 along with another, Theodosia, as having unspecified grievances against the bishop which Gregory ordered to be brought to Rome for settlement (II, 36). The matter must have been settled in some way, for Ianuarius is ordered in the same year to assist Theodosia to complete the construction of a nunnery for which her husband Stephen had left instructions (IV, 8).

From the last letter it is clear that not all nunneries were founded by women; but the letter raises the possibility that even women founders may not always have been acting voluntarily. The bishop's 'assistance' may have taken on an air of coercion. In a similar case the rector of Syracuse was ordered in 599 to encourage the heirs of a certain Felix, including his wife Rustica, to get on with the monastic foundation he had willed twenty-one years previously (IX, 165).

Nevertheless, women's donations to the Church were often used for female monastic foundations. Gregory handed over a house left by the patrician Campana to the abbess Flora and her congregation in 593 (III, 17), and Fortunatus, the bishop of Naples, was ordered to assist in two foundations in his city in 593 and 597. The first was the nunnery of St Mary and Jesus founded by Rustica with a certain Gratiosa as abbess, which was to be consecrated and given four ounces of gold (III, 58). The second testifies to one barrier facing female founders: Fortunatus and the rector of Campania, Anthemius, were to release any property they unjustly held to help the widow of Stephen turn her house into a monastery (VII, 20).

As well as monetary gifts, Gregory's letters reveal that new foundations might also receive gifts of relics. Two letters of 599 order that Ianuaria, religious woman, should have her oratory of SS Severinus and Iuliana consecrated by the bishop of Tindari (presumably the oratory lay in this Sicilian diocese), and that Fortunatus, bishop of Naples, was to provide

relics of these saints (IX, 181–182). Financial support of new houses may have been a regular obligation: Decius, the bishop of Lilybitano near Ravenna, was ordered to consecrate the nunnery founded by Adeodata and to endow it with money, vineyards and livestock 'according to custom' in 599 (IX, 233). If Gregory's letter of 600 is to the same woman, she was also expecting some relics to be provided and received an apology from him about the delay in getting them to her (XI, 5).

The prominence of some of the female landowners in Gregory's letters is due to several interlocking factors. Firstly, almost all are aristocrats who were able to use their influence in local matters. Wemple comments that Gregory's direct letters to them, as laywomen or abbesses, assumes that they themselves could read.[32] Secondly, as recognisably 'public' offices were gradually replaced by the local, privatised power and influence of the aristocratic families who had often held the offices, members of those families might prove useful contacts and intercessors. For example, the patrician woman Italica co-operated in 593 with Cyprianus, rector of Sicily, in matters affecting the poor (III, 57). In 597, Theoctista, patrician woman, and Andreas were jointly responsible for money sent by Gregory to Crotone in Calabria to ransom captives and give bedding to Greek nuns in the city (VII, 23). And, in 600, the patrician Clementina, with whom Gregory appears to have had an ambivalent relationship, was asked to ensure that Amandus, bishop-elect of Sorrento, came to Rome to receive his *pallium* or episcopal cloak (X, 6).

Gregory's own care for papal estates and the focus on landed property in many of his letters often reveal women in possession of widespread estates which might be adjacent to or a cause of problems for the papal see. The absentee landlord Rusticiana is recorded several times with extensive properties in Syracuse and around Rome, lands which appear to have been managed for her by her *vicedominus* Peter.[33]

The common feature here is that all of the women apparently had discretion over how they managed their property and actions in a local context; and this is not a phenomenon restricted to the elite, for all of these women lived according to Roman law, which permitted them a legal personality and considerable liberty in the management of their property. This is borne out by the evidence of the Ravenna papyri. In *c.*600 the freedwoman Sisivera donated land to the church at Ravenna,[34] and although the documentation begins to dry up in the seventh century, Flavia Xanthippi, the daughter of an imperial secretary, makes a substantial donation of property near Segni to the church of St Maria Maggiore in Rome.[35]

The obverse to wealthy women endowing the Church and interceding in local matters for Gregory was the papacy's care in these years for the vulnerable members of the community, especially in areas such as Campania, Sardinia and Sicily where the Church still controlled extensive estates. There

are numerous examples of helping poor widows, an obligation which Gregory spells out explicitly in a letter of 590 to Dominic, bishop of Centumcellae (Civitavecchia): 'it is your job as a priest to offer solace to widows and those deprived of the guidance of marriage', thus Dominic is to care for the widow Luminosa (I, 13). Three other widows, including Gregory's aunt, are commended to the care of Anthemius, rector of Campania, who is to give each of them money and grain. The aunt receives double the amount of cash given to the others on account of her need to put her children in shoes (I, 37). One of the other women, however, may have experienced difficulties in persuading Anthemius to pay up. In a letter of 591, Gregory instructs Anthemius to pay the woman an annual stipend of 30 solidi and adds, somewhat peremptorily, 'Ita ergo fac [so do it]' (I, 57).

This letter may convey the tensions inherent in the rector's economic function, which was to preserve and increase the papal patrimony, and his charitable one, to care for the vulnerable and needy alongside the bishop. Thus it is not uncommon to find Gregory ordering local officials to release land which they have unjustly seized: in 591, Anthemius is ordered to restore the house of a deceased Roman notary to the notary's widow Theodora (I, 63).

The papacy's protection might also extend to intervening in family disputes. Thus the rector of Sicily, Peter, was asked to protect the widow of Felix against her son-in-law in 592 (III, 5), and Anthemius, rector of Campania, was to perform a similar function in aiding the widow Theodora to regain lands defrauded from her by her son and son-in-law (IX, 36). The frustrating aspect of these letters, however, is that they rarely provide any more than this level of information about the circumstances which had led Gregory to intervene (although he does refer quite frequently to male and female petitioners), nor do they include any details of the disputes or family backgrounds of the actors.

Individuals might come under papal protection for other reasons than widowhood. For example, Catella the religious woman, whose son was working in Rome for the church (and who may, even so, have been a dependant, widowed mother), was to receive the protection of the bishop of Cagliari, Ianuarius (I, 60). When Gregory freed Thomas and Montana, two slaves (*famuli*) of the Church, they each received endowments, he to become a notary, she to enter a nunnery. Women under threat from named persecutors were also protected, whether widowed or not, in Ravenna in 598 and Syracuse in 599 (VII, 20, and IX, 210). Finally, a special group to receive papal protection were converts from Judaism. In 591, Peter, rector of Sicily, was asked to look after Cyriacus and his wife Iohanna after she, a convert, had been subject to abuse (I, 69). Although the letter does not say, it is most likely that she had converted before or on her marriage.

As well as individuals, groups of ex-Jews and nuns also feature as recipients of papal protection and beneficence. We have already seen that Gregory encouraged his bishops and staff to aid the foundation of new religious houses for women, but he also, it seems, took an active interest in their affairs. Suzanne Wemple points up his involvement with over fifteen different women's foundations.[36] The poverty of nunneries was of concern: petitioned by its abbess, Domina, in 598, Gregory ordered that the convent of St Stephen in Agrigento be provided with sufficient to live on by the papal rector of Sicily, Fantinus (VIII, 23). Abbess Bona and her congregation, whose house was in ruins, were granted a house near the Agrippan baths in Rome and properties attached to it (IX, 138). Such examples would suggest, and later papal evidence from the *Liber Pontificalis* concurs, that female houses could be in real difficulties in attracting sufficient gifts to keep going. This would explain why Gregory was keen to have relics transferred to them as a means to solicit visitors and offerings. His interventions in these two cases suggest limited success, however.

The evidence is also taciturn in outlining Gregory's administrative interventions, as when he notifies the bishop of Luni in 599 that he is sending a nun to be abbess of the convent there (does the lack of specific name indicate that Luni had only one convent at this time?) (IX, 115), or his instruction to Maximianus, bishop of Syracuse, that no abbess under 60 years of age is to be appointed (IV, 11). In 599 he orders that the will made by Abbess Syrica of SS Gavini and Luxurius should be nullified by Ianuarius bishop of Cagliari, since she had given up her right to make a will when she took up the religious life (IX, 198).

In none of these three cases are we told anything further about the circumstances of Gregory's intervention, but the last document reveals some of the tensions inherent in accommodating the wishes of pious, but still wealthy and aristocratic, women. All of these women were able to act as benefactors because Roman law allowed them to. Their documents survive to attest to their piety because the Church benefited from their donations. But gift-giving to the Church was not always motivated by pious feelings alone. Much of the Roman idea of ostentatious patronage was redirected from secular public buildings into ecclesiastical projects, and writers of the time recognise this.[37] Gregory's description of two founders in Terracina as 'too conscious of their former wealth to practise true humility'[38] reveals the underlying tensions between Christian charity and the demands of lay life. Indeed, his letters reveal other examples of aristocratic women unable to maintain their monastic life. Syrica clearly enjoyed her role as abbess, but wished also to remain partly in the world of lay life. Other women are seen failing in their wish to remain nuns either through apparent lack of commitment, as in the case of the daughter of a *magister militum* who 'threw off

her habit' and 'debauched herself' with laymen,[39] or through the malice of others, for example Petronella of Lucania, who had become a nun on the bidding of her local bishop but had been ravished by the bishop's nephew on the bishop's death (IV, 6).

Gregory was clearly conscious of the dangers of lapsed monastic vows, but his letters reveal him attempting to repair the damage where possible: women who fled their nunneries in Cagliari were to be released from excommunication if they repented (and presumably returned) (IV, 24), and the nun Marcia, who had left her monastery of St Martin in or near Palermo was to be returned to that house by the bishop, although Gregory adds that he had heard of many problems in the house from her informant (V, 4). Whether returning a recalcitrant nun would improve matters is open to question, but Gregory asserted this to be a matter for the Church authorities rather than the secular one: Romanus, the *exarch* or ruler of Byzantine Italy, was asked in 594 not to defend women who had taken the veil and then returned to their husbands (V, 19).

Nevertheless, there were also cases of women cloistered against their wishes, whom Gregory allowed to leave. For example, Leo, bishop of Catania, was ordered to allow the widow Honerata, illegally cloistered, to return to her second husband (IV, 34). In a rare case where the bare bones of the background story are told, Gregory instructs the bishop of Turin to allow the wife of Leo the archivist (*cartarius*) to leave the nunnery she had entered when he had left her on suspicion of adultery ('quae eo relicto pro fornicationis crimine') (IX, 3). The petitioner in the case is Leo himself, and the letter raises questions about whether he had forcibly cloistered his wife, or whether this release from the convent would itself have represented a less welcome prospect for his wife. Did she enter willingly? The source does not say. Nor can Roman law provide any clues about the case. Under the influence of Christianity the *Lex Iulia*, which had previously considered only women capable of adultery, had been extended by Constantine to apply to both men and women, and claustration was not, apparently, considered as a penalty.[40]

As in the case of his interventions on behalf of women threatened economically by their family, so Gregory tried also to help them in religious matters. Peter, the rector of Campania, was asked to find a solution to the case of Catella, daughter of Felix, who wished to become a nun against her father's wishes (III, 39). Whilst willing to try to persuade the father in this case, such support of women only went so far. In the case of spouses, said Gregory, only if both were willing could one enter the cloister, 'for if marriage makes one body of two, then it is improper to then convert one part and leave one part in the world'. This statement follows his instruction in 596 to Urbicus, the abbot of St Hermas in Palermo, to accept a certain Agatho as monk only if his wife becomes a nun (VII, 1). It is unclear

whether his wife, unnamed in this document, is the same woman as a complainant named Agathosa in a letter of 601, but Urbicus's abbacy was clearly not without its problems, as Adrian, notary of Palermo, was told to return to Agathosa her husband, who had entered St Hermas without her consent and against the law (XI, 30).

Gregory's letters contain a great deal of interesting evidence for women's lives in this early period. The problem with such evidence is that it more often privileges cases where things have gone wrong, rather than documenting the many hundreds of women in this early Christian age who kept their vows and attract little attention. Focusing on the exceptional is a commonplace of medieval writings about both men and women, but particularly in the case of the latter. Gregory's letters reveal the concerns of a pope to correct the errors of his flock, and certain men are his target as well. For example, he wrote to the bishop of Taranto, Andrea, in July 593 imposing a penance for keeping a concubine (III, 45). Marriage was still common among the minor clerical orders (a later document from 724 calls the wife of a priest a *presvytera*),[41] and some archbishops are recorded with wives as well, including Agnellus of Ravenna (r. 557–570) and a later successor, Sergius (r. 744–769).[42] A substantial number of Gregory's letters refer to the lack of clerical and monastic chastity and discipline, with specific cases in Cagliari, Syracuse, Catania and Spoleto, and a general letter sent out in 599 to all of his papal rectors ordering them to urge their bishops not to live with women or allow their clergy to do so (IX, 111). There is not, as yet, any judgement in Gregory's letters of the women concerned, a situation which would soon change.

The course of the Gothic wars required that manpower be drafted in from other parts of the Byzantine empire, and there is some evidence to suggest that many soldiers settled in Italy after the campaigns. One means by which they acquired land, it appears, was through marriage into the existing community, as well as the more disruptive *hospitalitas* arrangement of billeting which might become a rather more permanent arrangement. Pope Gregory was especially concerned when a troop was billeted on a nunnery in Naples, and ordered Fortunatus, bishop of the city, not to permit such arrangements to continue (IX, 208). The inevitable outcome appears to have occurred by 603, when Gregory asked Guduin, duke of Naples, to make an example in punishing one of his soldiers who had raped a nun (XIV, 10). How female landowners reacted to these twin forms of accommodation is not recorded, but some of the possibly resultant marriages are. For example, Rusticiana the Roman wife of an Armenian soldier is documented at Ravenna in 591.[43]

The Gothic wars, whose disruptive effects appear in Gregory's letters in the form of references to money raised to ransom male and female hostages,

left the Italian peninsula weak and vulnerable to attack, and the arrival of the Lombards, opened up a new chapter in Italian history. The Lombards inherited a territory whose twin traditions of written culture and urban life, although severely damaged, still had a profound effect. The *Liber Pontificalis* reports that some cities surrendered to the invaders through sheer hunger. Authari, the Lombard king from 584 to 590, established an alliance with the Bavarians through his marriage to Theodelinda. Gregory's letters to the latter focus mainly on the continuing Arian controversy and her apparently difficult relationship with the Catholic bishop of Milan, Constantius. Theodelinda appears to have been converted to the Catholic rite by 603, when Gregory congratulates her on the birth of her son Adaloald and the child's baptism as a Catholic (XIV, 12). Theodelinda's political role is explored below (see pp. 55–56).

Roman sources present an Italy in the sixth century in which women often appear as literate, aristocratic patrons of ecclesiastical projects, and as managers of their own property. *Romanitas* is the watchword here: Justinian's campaigns to regain control of the peninsula when the client rulers of the Byzantine empire appeared to be drifting away from that role was in essence a futile attempt to restore the status quo. The written texts of the period were already, for the northern and central regions at least, describing a disappearing world. After the devastation of the Gothic wars, only small islands of Roman culture were to survive the Lombard onslaught of the 560s.

Notes

1. C. J. Wickham, *Early Medieval Italy* (1980) pp. 118–119.
2. A useful survey is included as an appendix to T. S. Brown, *Gentlemen and Officers: Imperial Administration and Aristocratic Power in Byzantine Italy, AD554–800* (Rome, 1984), pp. 223–226.
3. Alan Watson (ed. and trans.), *The Digest of Justinian*, 2 vols (Philadelphia, 1998).
4. Raymond Davis (trans.), *The Book of Pontiffs (Liber Pontificalis)* (Liverpool, 1989), p. 44.
5. S. J. B. Barnish (trans.), *Cassiodorus: Variae* (Liverpool, 1992) (hereafter *Variae*).
6. *Variae*, Book III, letter 6.
7. Raymond Davis (trans.), *The Lives of the Eighth-Century Popes* (Liverpool, 1992), p. 9.
8. *Variae*, Book IV, letter 1.

9. Anne L. Klinck, 'Anglo-Saxon women and the law', *Journal of Medieval History* 8 (1982), pp. 107–121, and Joan Nicholson, '*Feminae gloriosae*: women in the age of Bede', in Derek Baker (ed.), *Medieval Women* (Oxford, 1978), pp. 15–30, accept at face value references to 'owning' the wife in early laws. Alternative views are presented in Marc A. Meyer, 'Land charters and the legal position of Anglo-Saxon women', in Barbara Kanner (ed.), *The Women of England from Anglo-Saxon Times to the Present* (Hamden, Conn., 1979), pp. 37–82; J. T. Rosenthal, 'Anglo-Saxon attitudes: men's sources, women's history', in J. T. Rosenthal (ed.), *Medieval Women and the Sources of Medieval History* (Athens, Ga., 1990), pp. 259–284, and C. Fell, *Women in Anglo-Saxon England and the Impact of 1066* (1984).

10. See Diane Owen Hughes's useful article, 'From brideprice to dowry in Mediterranean Europe', *Journal of Family History*, 3 (1978), pp. 263–296.

11. F. A. Wright (trans.), *Select Letters of St Jerome* (Cambridge, Mass., 1963).

12. Peter Dronke, *Women Writers of the Middle Ages* (Cambridge, 1984), chapter 1; Gillian Cloke, '*This Female Man of God': Women and Spiritual Power in the Patristic Age, AD350–450* (1995), chapter 8; Benedicta Ward, '"To my dearest sister": Bede and the educated woman', in Lesley Smith and Jane Taylor (eds), *Women, the Book and the Godly* (Woodbridge, 1995), pp. 105–112; Janet L. Nelson, 'Women and the Word in the earlier Middle Ages', in W. J. Sheils and Diana Wood (eds), *Women in the Church* (Studies in Church History 27, Oxford, 1990), pp. 53–78. For a later overview, P. Skinner, 'Women, literacy and invisibility in southern Italy, 900–1200', in Lesley Smith and Jane Taylor (eds), *Women, the Book and the Worldly* (Woodbridge, 1995), pp. 1–11.

13. *Variae*, Book X, letter 18.

14. See below, pp. 40–41.

15. *Variae*, Book IX, letter 24.

16. This letter, from the *Variae*, Book X, is translated in M. Thiébaux (ed. and trans.), *The Writings of Medieval Women: An Anthology* (2nd edn, New York, 1994), pp. 79–80. See also the brief introduction to the queen's life in the same volume, pp. 71–79.

17. *Variae*, Book X, letter 3.

18. Davis (trans.), *Book of Pontiffs*, p. 54.

19. L. Thorpe (trans.), *Gregory of Tours: The History of the Franks* (Harmondsworth, 1974), Book III, chapter 31, p. 188.

20. G. A. Williamson (trans.), *Procopius: The Secret History* (Harmondsworth, 1966), Book XVI, chapter 5, p. 119.

21. Thiébaux (ed. and trans.), *Writings*, pp. 82–3.

22. *Variae*, Book X, letters 20–22.

23. Joseph Lynch, *The Medieval Church: A Brief History* (1992), p. 40.
24. *Variae*, Book X, letter 26.
25. Brown, *Gentlemen*, p. 76.
26. Davis (trans.), *Book of Pontiffs*, p. 57.
27. Ibid., p. 54.
28. Brown, *Gentlemen*.
29. Wickham, *Early Medieval Italy*, p. 25.
30. Dag Norberg (ed.), *S. Gregorii Magni Registrum Epistularum*, 2 vols (Corpus Christianorum Series Latina CXL and CXLa, Turnhoult, 1982). The numbering used in the following discussion follows Norberg's edition, which has a concordance to earlier ones.
31. Brown, *Gentlemen*, p. 23 and appendix.
32. Suzanne F. Wemple, 'Female monasticism in Italy and its comparison with France and Germany from the ninth through the eleventh century', in W. Affeldt (ed.), *Frauen in Spätantike und Frühmittelalter* (Sigmaringen, 1990), pp. 291–310, at p. 293.
33. Brown, *Gentlemen*, p. 191.
34. Ibid., p. 76
35. Ibid., p. 186.
36. Wemple, 'Female monasticism'.
37. Bryan Ward-Perkins, *From Classical Antiquity to the Middle Ages: Urban Public Building in Northern and Central Italy, AD300–850* (Oxford, 1984); Paolo Delogu, 'The rebirth of Rome in the eighth and ninth centuries', in Richard Hodges and Brian Hobley (eds), *The Rebirth of Towns in the West, AD700–1050* (CBA Research Report 68, 1988), pp. 32–42.
38. Brown, *Gentlemen*, p. 35.
39. Ibid., 183.
40. James Brundage, *Law, Sex and Christian Society in Medieval Europe* (Chicago, 1987), pp. 29–31, 104.
41. *CDL*, I, nos 34, 45. For an alternative view of the meaning of *presvytera*, see Mary Ann Rossi, 'Priesthood, precedent and prejudice: on recovering the women priests of early Christianity', *Journal of Feminist Studies in Religion*, 7 (1991), pp. 73–94; Brent Shaw, 'Women and the early Church', *History Today*, 44(2) (1994), pp. 21–28; Cloke, '*This Female Man of God*'.
42. O. Holder-Eggar (ed.), *Agnelli qui et Andreas Liber Pontificalis Ecclesiae Ravennatis*, in *MGH SRL*, pp. 265–391, chapters 84 and 154, respectively.
43. Brown, *Gentlemen*, p. 104.

CHAPTER TWO

Lombard Life, 568–774

> No free woman who lives according to the law of the Lombards... is permitted to live under her own legal control..., but she ought always to remain under the control of some man or the king.[1]

The Lombard invasion and expansion caused the inevitable dislocations associated with war. The newcomers penetrated the peninsula as far south as Spoleto and Benevento, and only the far south, Rome and Ravenna remained out of their grasp. Capturing prisoners for ransom or for sale into slavery appears to have been a common tactic, and one in which women may have found themselves regular targets. Although the clerical rhetoric surrounding the Lombard campaigns needs to be read with care – the Lombards inspired a terror which exaggerated the threat they posed – there were clearly episodes of extreme violence well after the initial invasion of the north, as when Aistulf's armies are reported devastating the Roman hinterland and raping nuns outside Rome in 755.[2] Pope Stephen II, who reports these atrocities, is presented in the *Liber Pontificalis* as the protector of men and women in the face of the latter onslaught.

The exact means by which the Lombards settled in Italy is unclear.[3] Fragments of southern evidence refer to *tertiatores*, or those who held one-third, prompting speculation that some form of land or revenue-sharing was introduced. But the sources are too scanty to allow any definitive answer. Indeed, the early to mid-seventh century is the scarcest in terms of information. But the Lombard kings' aspirations to be accepted as legitimate rulers are summed up by the enormous body of legislation issued by the Lombard king Rothari and his successors from 643 onwards, which would have a profound effect on women's lives in the Lombard-controlled regions.

Women in the Lombard laws

Early medieval legal material is a temptingly systematised source for women's lives in the face of irregular and unevenly distributed charter evidence which is often far harder to gain access to. Since we have very little mid-seventh century charter material in Italy, greater reliance may have been placed than warranted on the evidence from the extensive and detailed Lombard laws. Studies have been made of women's lives in other parts of early medieval Europe incorporating contemporary legal collections, for example in Francia,[4] Anglo-Saxon England[5] and the Celtic world.[6] To a greater or lesser extent, all have acknowledged the problems of working with normative material issued by rulers who were in essence trying to fit into a mould of rulership: the Romans, their predecessors, had made laws, hence they did too. So how much use can the Lombard laws be in illuminating the lives of women in early medieval Italy? A survey of their provisions is followed by a discussion of their effects.

The edict of King Rothari, promulgated in 643, is the longest of the codes in terms of clauses. This is not surprising: later kings state that they issued laws when a situation was not covered by Rothari, or when his edict appeared to them insufficient or unfair. The later material is therefore more a supplement than a replacement.[7]

As in other early medieval lawcodes, the subjects of the kingdom were ranked according to whether they were free or unfree, and in some cases by the role or function they performed. This ranking produced the *wergild*, an amount of money to be paid to the king and relatives of the person in the case of their death or injury; its purpose was to avoid a feud.[8] Although the Lombard laws are not as explicit as those of Francia in assigning a different *wergild* to women of different ages according to their child-bearing capacity, women's honour and fertility is still clearly a commodity to be protected, and clauses relating to women therefore occur frequently throughout Rothari's code.

The protection that surrounds women is often minutely detailed, as in Rothari's clause 26 on blocking a woman's way (*wegworin*); simply placing oneself in the way of a woman or girl could attract a huge penalty, payable to the king and to the woman herself 'or him who holds her *mundium*'.[9] This clause indirectly introduces one of the central elements of Lombard law regarding women: their legal guardianship or *mundium* held by the *mundoald*. This is not dealt with in Rothari's code until clause 204 on the legal competence of women:

> No free woman who lives according to the law of the Lombards within the jurisdiction of our realm is permitted to live under her own legal control, that

is, to be legally competent, but she ought always to remain under the control of some man or the king. Nor may a woman have the right to give away or alienate any of her movable or immovable property without the consent of him who possesses her *mundium*.

This clause was an important and lasting element in women's lives long after the fall of the Lombard kingdom, and formed the major plank on which women's social visibility and competence rested.

The *mundium* was held by the *mundoald*, usually the woman's father until she married, her husband until she was widowed, and then either her son(s) or another male relative. The *mundium* could be transferred between any or all of these (Rothari 165). In the absence of male relatives, her *mundium* fell to the royal court (Rothari 385). It could also be bought and sold (Rothari 183). But, as in the case of the Gothic king Theoderic's letter cited in Chapter 1, money was proffered not for the woman herself, but for the right to her guardianship. This is a subtle difference, but an important one. Because it carried with it substantial say over a woman's property, it was inevitable that abuses of this power could occur, and both Rothari and his later successor King Liutprand legislated against the mistreatment of the woman by her *mundoald* (Rothari 182, Liutprand 120).

Marriage and inheritance

Although Lombard women's freedom to manage or alienate property was curtailed by the necessity of seeking their *mundoald*'s permission, they nevertheless enjoyed the ownership or tenure of substantial amounts of land and moveable goods, as laws relating to inheritance and marriage appear to indicate.

The Lombard laws often go into minute detail about family life and the rights of women within that framework. The father's paternal authority over his children is underlined in Rothari's law 170, and control over daughters was particularly strict. For example, the husband of a woman who married without her relatives' permission was obliged to pay 20 solidi compensation for illegal intercourse and another 20 to avert a feud (Rothari 188); if he had only fornicated with her, however, the fine went up to 100 solidi unless he agreed to marry her (Rothari 189). The same king's law 183 underlines the temporary nature of the transfer of the *mundium* to a husband: he was held to have purchased it, and it reverted to her family on his death.

Marriages were accompanied by what could be a large transfer of property to the bride via the groom. The *faderfio* (which seems to equate to the Roman dowry) was handed to the groom for his new wife by her family: Rothari 181 orders that he be satisfied with the amount offered. He was

expected to respond with the *meta* or counter-dowry (also called the *meffio*) given by him or his family, again ostensibly to the bride (Rothari 167).

The point at which a union was contracted was the betrothal, and a man had up to two years after the betrothal agreement to claim his bride (Rothari 178). The betrothal was a binding contract, breakable only in the case of the woman going mad, blind or leprous (Rothari 180). Marongiu has commented on the legal aspects of marriage in the south later on, and it would appear that, apart from the unusual situation in Apulia, where the father is seen retaining the *mundium* over his daughter even after marriage, little changed in the four hundred years following the passing of the legislation.[10] Indeed, the most radical revisions to Rothari's code came in the laws of his immediate successors, Grimoald (legislating in 668), Liutprand (in 713 to 735 – the most extensive revisions), Ratchis (in 745/746) and Aistulf (in 750–755).

Once the marriage had been celebrated, a further property transfer took place, as the groom formally transferred to his wife the *morgengab* or morning-gift, a portion of his property acknowledging the successful consummation of the marriage. This is dealt with in several of Rothari's laws, but is explicitly mentioned in the laws of Liutprand, whose seventh law limits the amount of the *morgengab* to one-quarter of the man's total wealth, permitting him to give less if he wishes. Further limitations are imposed later in Liutprand's laws: Liutprand 89 limits the amount of the *meta* to 400 solidi if the husband is a judge, 300 if not. Finally, the same king's law 103 states that a wife must not receive any gifts from her husband beyond the *meta* and her *morgengab*.

The property transferred to a woman was, ostensibly, to support her and any children of the marriage if she were widowed, and if the legislation is anything to go by, husbands were keen to ensure that their families were well provided for. If they were not permitted to make any permanent transfers of property to their wife above the limits set by Liutprand, they could allow her a lifetime interest or usufruct of their property after their deaths. King Aistulf's law 14 was forced to limit the usufruct allowable to half of the residual property, presumably in the face of complaints from the husband's family that a large portion of their property could be out of their hands for a long time.

However, more problematical must have been the situation when a woman was left widowed with no children, for she still, apparently, had the right to return to her family taking her dowry provided by them and her *meta* and *morgengab* from her husband. This had repercussions in later documents of practice, as we shall see.

A woman's fertility was thus a prized asset, as it enabled her husband's family to claim property on behalf of children who were the true heirs of

her husband. Rothari's law 75 deals with the accidental death of a child in its mother's womb. The woman's value was assessed, if she was free and survived, and half paid for the child; if the woman died too that fine was paid plus all of her value, and no feud was to ensue since the deaths were accidental. Such was the provision for free women. That for a slave was rather more explicit about the economic value of her offspring. Following clauses on cows in calf and mares in foal, the death of a baby in a slave woman's womb is worth 3 solidi (free women's *wergild* is rated at 900 solidi in Rothari's edict on murder); her own death was compensatable to her owner as well.[11]

Slaves, concubines and natural children

The difference between the two clauses in terms of the value of the woman and child is self-evident, but the second offence is assumed to be as the result of a deliberate act ('he who strikes a woman slave large with child and causes a miscarriage'). Here we begin to see how the life of the slave was perceived by the royal legislators, and a series of over fifty provisions is made for deliberate injuries to male and female field slaves and *aldii*, the latter being a semi-free group who, nevertheless, were classed with those of servile status throughout the code. The concern for injured servants was entirely economic, as is underlined by the composition paid by the perpetrator of the injury to the *owner*. If the code is to be believed, physical violence was a part of everyday life for those of servile status.

More evidence for the view of female slaves as a valuable item of property is provided by the juxtaposition of Rothari's clause 231 on the purchase and theft of female slaves immediately before similar procedures on the sale of stolen horses, emphasising again the view of women slaves as livestock.

The linkage of servile children with their mother is important, however, since they took their status from her. The complications that could arise are documented in Rothari's provision for 'natural' sons, that is, children that a man had by a woman other than his wife. When the mother was a slave woman belonging to another man, the father was responsible for purchasing the boy and freeing him, otherwise he would follow his mother's status and belong to the slave's owner.[12] Compensation was also payable at the rate of 20 solidi for sexual intercourse with a Lombard slave, but only 12 solidi if the slave was Roman. Among the provisions which acknowledge the racial divide in the Lombard kingdom, this is the most evocative of the Roman majority's subject position in Lombard eyes.

When the child was born to a man's own slave, which later evidence reveals to have been a common occurrence, he again had to free him and

acknowledge him as a natural son. Rothari 222 also provides for the man marrying the mother: he had to free her before doing so in order that her children by him could be his heirs. This would become important in later disputes when slaves and others of servile status are documented attempting to gain emancipation. The laws of Rothari's successor, Grimoald, illustrate how servile status was already being challenged in 668: his first law states that a male or female slave who had served thirty years could not claim him/herself from her lord on the thirty-year property rule (outlined in Grimoald's law 4). Not only does this suggest a surprising (and perhaps unlikely) awareness of the law surrounding property on the part of slaves, but it was only the first of many instances where servile status would be challenged.

It is important to note here that most of the clauses relating to natural children relate to sons, and this may or may not imply only male natural heirs (some laws are explicit in listing legitimate sons and daughters followed by natural sons with no reference to natural daughters). Social elevation may only have come to boy babies, therefore.

Free male/unfree female sexual relationships appear to have been acknowledged and provision made for the child, sometimes, it could be argued, to the detriment of the father's legitimate offspring. Particularly affected were the rights of legitimate daughters, whose prospects were especially limited if they were their father's sole heir (that is, he had no legitimate sons). Rothari's laws 158–160 reveal that natural sons were to receive one-third of their father's property, the same as a single daughter; the father's legitimate relatives also lost out to natural sons, who in addition were able to claim a one-third share in their half-sisters' *mundium* (another important acknowledgement by their father of their integration into the family).[13] A comparison with law 154, dealing with natural sons' rights as distinct from legitimate sons', shows that the natural sons still received one-third of the property if there was just one legitimate son, but this proportion diminished sharply the more legitimate sons there were. There is, therefore, already a clear distinction between the rights of sons and daughters to inherit in the lawcodes.

The early Lombard laws, therefore, appear to have condoned multiple sexual liaisons for a man, provided they were not with another man's wife, and sought ways of accommodating the inevitable children born of such relationships. They did not, apparently, discourage the competing presence of a female slave as concubine in the marital home, in contrast to the earlier Gothic attempt to deal with this issue.

The opposite sexual liaison, however, was condemned: children born to free women by male slaves were not natural but illegitimate, and the disgrace appears to have affected all three persons. This reflects earlier Roman

law and attitudes, which we have already seen in Gregory of Tours' tale of Amalasuntha and her slave partner. Rothari's law 221 orders that the man be killed and the woman either killed or sold outside the country by her relatives or be enslaved by the court (and thus her children, too, would have been counted slaves). Liutprand modified this in law 24 to make both parties palace slaves if the relatives did not take action within a year of the offence. Ratchis's law 6 restated the penalty to be exacted against the man, but added that if such a liaison was undetected for sixty years, the children should not suffer enslavement but should remain free: a clear instance of Christian teaching that the sins of the parents not be visited on the children. As early as the third century, Pope Calixtus I had ruled that the Church should accept free woman/slave man unions as marriages, even though civil law forbade them.[14] This element of Christian teaching clearly did not filter into the Lombard legislation. The clear message in all the Lombard laws relating to sexual liaisons, however, was that a free, married woman could have only one sexual partner whilst her husband could enjoy any woman not already married with (relative) impunity. If a husband caught his wife in adultery, he had the right to kill both offenders (Rothari 212).

Remarriage appears to have been sanctioned, if references to stepmothers are to be believed (for example in Rothari 169). The amount of property involved meant tight legal restrictions on wives, but these slackened somewhat on widowhood. A widow could remarry if her second husband paid to the relatives of her deceased partner half the value of the *meta* she had received. If the relatives refused this, she had the right to take *meta*, *faderfio* and *morgengab* to her second husband. Her *mundium*, meanwhile, reverted to her natal family, and arrangements would be put in place for its transfer as in a first marriage, that is, at the betrothal or marriage itself.

The laws of Rothari's successor Grimoald return to the theme of competing women in a household. The problem of free concubines and the claims they (or their children) generated on property seem to have been pressing:

> Abandoned wives – if anyone puts aside his wife without legal cause and receives over her another woman into his house, he shall pay 500 solidi as compensation, half to the king and half to the relatives of the wife; moreover he shall lose the *mundium* of the woman he put aside. If the wife does not wish to return to her husband she and property and *mundium* return to her relatives.
>
> (Grimoald law 6)

Furthermore, Grimoald's next law sought to close off the temptation to falsely cite a 'legal cause' to justify abandoning an unwanted spouse:

> If a man accuses his wife of adultery or conspiring against his life, she may defend herself through the oaths of relatives or by combat. He must then swear he did not accuse her maliciously, otherwise he pays the *wergild* of his wife as compensation, half to the king and half to her relatives.
>
> (Grimoald law 7)

Nevertheless, Grimoald's revisions did not completely condemn an adulterous man:

> A woman who goes to a man knowing he already has a wife shall lose all her property, half to the king and half to the relatives of his injured wife. *Blame shall be imputed on the woman who went to him, not the husband.*
>
> (Grimoald law 8, emphasis added)

Again we see an attempt to curb the extramarital liaisons of husbands, but it is interesting to see that the onus of blame remained with the woman involved as third party, who was penalised in a similar way to the competing woman dealt with in Athalaric's earlier Gothic edict.

Violence and subversive acts

The Lombard kings were concerned to maintain order within the family and the community, and their codes deal with other offences against public order. The use of poison is severely punished in a group of clauses. The penalties were the same whether the poisoner was male or female – the laws do not characterise poisoning as a feminine crime, unlike contemporary narrative sources (see below, p. 55). Female violence, however, was reviled, as Ross Balzaretti's recent study of the relevant clauses in the code has underlined.[15] Women who participated in brawls or fights were not protected if they were injured, since their presence was seen to be against the laws of nature.[16] Liutprand reinforced Rothari's measures in this area with laws 123 and 141: women's passivity was being increasingly asserted. Even women thieves were treated differently from their male counterparts: both male and female thieves were forced to return the value of the goods stolen ninefold, but whereas a man risked losing his life if he failed to do so, a woman's punishment was the 'shame on her who did this disgraceful deed' (Liutprand laws 253 for men, 257 for women).

Disgrace therefore accompanied a woman out of place, and similarly a woman who remained passive was protected: if a male slave stole, his wife and children were not automatically held accountable for his actions, since they were held to be legally incompetent (Rothari 261). Laws against hitting a woman crouching to relieve herself (Liutprand 125), stealing the clothes

of a woman bathing (Liutprand 135) and throwing dirty water on a wedding party (Aistulf 15) all seem to continue the idea of women needing particular protection from shameful or shaming acts.

The association of women with magic arts, however, began early, and Rothari deals with it in an interesting way:

> 376 No one may presume to kill another man's *aldia* or woman slave as if she were a vampire (*striga*), which the people call witch (*masca*), because it is in no wise to be believed by Christian minds that it is possible for a woman to eat a living man from within. [Compensation for the loss of the slave was payable plus a fine to the king.]

The striking feature of this clause is the way in which it assumes the most likely candidates for witchcraft are female. At the same time, this particular clause concentrates on the financial implications of a belief that a slave or *aldia* could be a witch. As Valerie Flint has highlighted, belief in cannibalistic witches of this type was documented by several early medieval lawcodes, each presumably concerned to promote Christianity (or rather, to be seen to do so) and stamp out belief in magic arts.[17] Thus Rothari 368 stated that a man in a duel was not to have witch's herbs about his person. Liutprand 85 reveals a continued belief in the existence of sorcerers and witches, and charges local officials with their discovery and, if they do not cease their practices after one warning, their enslavement.

The impact of Christianity

King Liutprand's legislation against the magic arts reveals a king on the threshhold of a new type of legislation, not really wishing, as a Christian, to credit tales of witches and sorcerers but still, as other laws against pagan practices make clear, not sufficiently convinced of his people's adherence to Christianity (let alone Catholic Christianity) to abandon entirely such measures. Many of his laws are clearly influenced by the growing power of the Church, both ideologically (as in clauses which lift the exclusion on daughters inheriting from their father: laws 1 to 4 and 65), morally (as in the law, set down twice, against marrying off girls under 12 years old: laws 12 and 112; and the concern about incestuous marriage: laws 33 and 34) and economically, as in legislation surrounding women's property when they chose to take the veil.

Indeed, the prominence of nuns in Liutprand's laws speaks of an urgent need to set up some guidelines in response to an existing situation in the early eighth century, and it is striking how his precepts echo the letters of Gregory I from over a century before: law 30 orders that women taking the

veil should remain that way on pain of losing their property (law 95 says that if a female slave is made a nun she should remain so); and law 76 sets the penalty for sexual intercourse with a nun at a 200 solidi fine if she is professed, 100 if not, and she loses her property if she consents. This suggests that Liutprand was supportive of the decision to take the veil and keen as a king to uphold the position of those who did so.

However, along with their increasing rights to property came increasing regulation of women's management of it. Liutprand's law 22 sets out clear procedures by which a woman could alienate her land: it had to be done in the presence of relatives and a judge, with the consent of her husband and without any violence or compulsion on the part of the men. In the case of a woman wishing to take the veil, she could only take one-third of her property with her to her religious house if she had children (either sex), half if she did not, and only one-third in either case if she was remaining at home as a vowess (law 101). A widow was not allowed to take the veil within a year of her husband's death, as Liutprand feared that she might make a rash decision under the malign influence of her *mundoald*, who stood to benefit from the decision by obtaining up to two-thirds of the property if she had no children (law 100). These laws of Liutprand regarding women's property and taking the veil were key factors in the legal practice of the next four centuries.

Charter evidence: the 'real' picture?

The early eighth century sees the emergence of more documents of practice which allow some knowledge of how the laws were put into effect, if at all. The earliest documents are from the archive of Lucca, with documents from the eighth century. Although the Lombards ruled most of northern Italy there were also still Byzantine outposts where Roman law continued. The Exarchate of Ravenna, for example, survived until 751, but the pressure it was under is conveyed by a passage in the *Liber Pontificalis* telling how the visit of Pope Zacharias (r. 741–752) was welcomed by the men and women of all ages.

The great Roman estates of the sixth century gradually dissolved into smaller landholdings in the seventh and eighth. Brown cites examples of these smaller landowners,[18] and it may simply be coincidence that all four cases are of women. Women with more modest landholdings are documented making gifts to the Church, receiving papal holdings, and founding their own convents. The Lombard laws provide some clues to the types of roles and functions that women were held to be engaging in in early medieval

Italy. Liutprand's rulings about their limited capacity to give property to the Church, for instance, suggest that women were visible making such gifts, and the charter evidence (skewed to favour ecclesiastical matters since preserved mainly in ecclesiastical houses) bears this out.

Lombard and Roman regions were not tightly defined, and their laws often overlapped. King Liutprand had acknowledged this in his law 127, which stated that if a Roman man married a Lombard woman, she could as a widow go to another husband without the consent of the heirs of her first husband as she and her children were considered to have become Romans. As Diane Owen Hughes has pointed out, conflict between Roman and Germanic laws was more often than not expressed in their treatment of women.[19] The impact of the new code of law was felt particularly in women's documents, where a profession of which custom she followed became a necessity if a woman wished to continue managing her property alone. In Piacenza in 758, therefore, a certain Gunderada identified herself as 'an honest woman and Roman woman/wife', when she sold land with the consent of her husband.[20]

As well as charter evidence relating to Ravenna and its territories, discussed in Chapter 1, we also have charters from the Lombard kingdom, which include documented transactions by women. Here we can see which, if any, of the legal dispositions made by the Lombard kings permeated through into notarial practice and the lives of those engaged in land transactions. Luigi Schiaparelli published his edition of the Lombard documents from 650 to 774 as the *Codice Diplomatico Longobardo* in the early 1930s.[21] Excluding those he considered false (one or two of his 'genuine' documents have since come under suspicion), there are some 265 documents to consider. Of these, 77 mention women in some way, reducing to 23 in which women are the main actors. What is immediately striking is how little the Lombard laws are cited in the documents: hardly surprising given that they were still in the process of being issued and revised. Indeed, Brigitte Pohl-Resl has argued that 'daily legal practice influenced the laws'.[22] How, then, were women featured?

Marriage and property

Women's property was at the centre of most documents recording them, either the *morgengab* or other unspecified properties which women are seen buying, selling or, frequently, giving to churches. Since the *morgengab* was intended for the support of the widow and any children she might have, it is unsurprising to see it being used in an early document as a donation by a widower to his monastic foundation for their daughters.[23] What such a

portion might consist of is listed in a memo of 739: a bed worth 10 solidi, three named, female slaves worth a total of 30 solidi, a tunic (10 solidi), a mantle (10 solidi), gold (30 solidi), a horse (100 solidi – note the animal's high value compared with the slaves), and a house worth 100 solidi.[24] Women used their *morgengab* in pious donations, as in the case of a widow in 755 with her son's consent.[25]

The issue of consent divides the early Lombard charters: approximately half of the women authors act with no apparent male consent,[26] and are frequently widowed, as in the cases of Candiana of Treviso and Auda of Varsi, making sales in 725 and 742, respectively, and Rachiperta and (possibly) Forcolana the nun, buying land in Lucca and Verona in 765 and 774.[27] The slight majority, however, have one or more male relatives' consent included in the body of the document or as signatures at the end of it.[28] However, these start later, in 739/740, and we might tentatively suggest that the legal provision for the inclusion of a consenting relative had begun to affect notarial practices. Indeed, a document written at the royal capital, Pavia, in 769, attests to the accelerated penetration of legal clauses into documents of that city, for it is the first to include a woman, Natalia, professing not to have suffered violence or coercion in making her transaction.[29] None of the men, however, calls himself *mundoald*, even if he is clearly acting in that capacity, and the women acting with consent included widows, suggesting that widowhood did not automatically bring emancipation.

Natalia's statement, via her notary, is clearly evoking Lombard law on women's transactions. Brigitte Pohl-Resl has argued that the profession of laws in Lombard documents, that is, where the author stated which law he or she adhered to, was an eleventh-century interpolation into the Lombard documents, since very few of the charters survive as originals.[30] She further suggests that such citations were a product of Frankish rule in the late eighth and ninth century. However, the location of this document, in the heart of the Lombard administrative world where notaries might be expected to have adopted legal citations more rapidly, and the fact that eighth- and ninth-century original charters from further south (relatively unscathed by the Frankish intervention) also include citations and professions of law, suggest that we should not discount the possibility of some genuine citations existing in the Lombard material, alongside the clear forgeries which Pohl-Resl identifies.

References to *mundium*, while starting early, are quite rare and relate to women (including in marriage agreements, as when the brothers Agepert and Gaifrit sold the *mundium* of their sister to Ansoald in Bergamo in 774[31]) whether free or unfree. For example, in Pisa in 748 the freeing of two *coloni* (tied peasants) was arranged on condition that the *mundium* of their daughters should remain with the Pisan church.[32] In 771, the royal official Autpert

sold the *mundium* of the *aldia* (half-free) Hermetruda to the master of the *aldius* she was marrying for 3 solidi.[33]

In an extraordinary document of 721 written at Piacenza, Anstruda, with the consent of her father, sold her *mundium* to her brothers for 3 solidi and took their slave in marriage. Any children born of the union would have to pay the same price for the *mundium* of any daughters they married off.[34] In essence this document flies in the face of the cultural attitudes which we have met thus far regarding male slave and free woman relationships. Fourteen years later it may be the same men who paid 2 solidi and 1 tremissus (where 1 tremissus is equivalent to $^1/_3$ solidus) to the brother of a certain Scolastica when she married their slave (*mancipium*).[35] What was going on here? What was persuading these women to marry slaves and what repercussions might such unions have? If these cases are treated within the letter of Lombard law, both women were in effect disinheriting themselves, Anstruda apparently willingly (she received the money), Scolastica perhaps less so. However, they may not have been condemning their children to slavery, as children were held to follow their mother's status. We cannot know the circumstances of either union, and both women might have been under intense pressure from their male relatives to settle for marriages of convenience which offered them continued protection (marrying a slave presumably guaranteed some form of shelter and food). Whatever the background, these two cases are a timely reminder that legal and cultural prescriptions could be very different from the situation on the ground.

Because of the properties that they held, the control of women's *mundium* could be a lucrative asset, notwithstanding the restrictions on *mundoalds* to discharge their duties honestly. In the will of a certain David of Lucca in 773, his wife's *mundium* was bequeathed to the church of St Salvator, their son being dead.[36] This document is of interest, as David clearly did not envisage his wife's *mundium* and control of her property falling to either another male relative or the public authority. Instead, he arranged her 'protection' by the Church, which might have expected to do well from the arrangement.[37]

A cluster of early documents continues this theme of wives having their future decided in their husbands' wills, particularly in relation to property. They are seen as executors, as in the case of Rodoara, requesting the sale in 759 of some of her late husband's property to provide alms,[38] and, more frequently, as beneficiaries with strings attached. For example, the wife of David, mentioned above, received the usufruct of his property plus her servants and moveable goods. In the same year, 773, Serbulo of Lucca left his wife half the usufruct in his property provided 'she guards my bed and observes marital fidelity to me [meum lectum custodierit et de me fidem maritalis observaverit]'.[39] The same stipulation is placed on Taido of Bergamo's transfer of usufruct to his wife, who furthermore was charged

in 774 with feeding the poor and freeing their slaves on her death.[40] The financial constraints thus imposed on a woman who wished to remarry are obvious, and the clause continues to appear in later documents. Here we may see direct evidence of legislation reaching the charter material: King Aistulf had limited the amount of usufruct a widow might enjoy in a law of 755, and had further stipulated that it would revert to her husband's heirs or their children should she remarry. The wills, therefore, were reinforcing the message of chaste widowhood bringing benefits.

The impact of the later Lombard laws might also be seen in charter evidence of daughters inheriting, something which in theory was sanctioned only under King Liutprand. In the will of Rotpert, written at Monza in 745, his two daughters received the usufruct of his property and the third received the right to live in his house until her marriage, when she would get 300 solidi.[41] The daughter of David, mentioned above, would receive her deceased brother's portion once her parents died. Nieces, too, were the beneficiaries of wills.[42]

Lombard laws specified that women should not receive any further property beyond their dowry, the *meta/meffio* and the *morgengab*, and forbade husbands from making gifts. Nevertheless, in Verona in 763 Lopoald the cleric gave a plot of land measuring 20 feet by 11 feet to Forcolana 'my most dear and always beloved honest woman [dilectissima mihi semper atque amantissima honesta femina]'. It is possible that Lopoald's son signed the document.[43] There is no indication in the document that this is *morgengab*, and the conclusion may well be that the limitations on women's property were only partly effective. There are many indirect references in the *Codice Longobardo* to women's property now being used for another purpose,[44] and it may well be that not all of this was connected to their rights as wives.

Slaves and female servants

As we have already seen, a woman's *morgengab* might include slaves, and domestic slaves seem to have been a constant feature in Italian life in this early period. In Milan in 725, Ermentruda daughter of Laurentius sold a Gallic slave (*puero*) named Satrelano 'or whatever other name he might be known by [sive quo alio nomine nuncupatur]' for 12 solidi.[45] The boy was clearly a valuable asset: his price is four times that of other transactions in female slaves in the same century. In 763, for example, Candido sold to his brothers a woman named Boniperga, called Teudirada, and her baby to be their *ancilla* and *servo* for 2 solidi.[46] Female slaves or *ancillae* seem most frequently to be documented with female owners, however, reflecting their role as personal servants. Tassilo's will of 768 in Lucca gave each of his

nieces an *ancilla*,[47] and David's will, mentioned above, includes the bequest of six servants including three women who were to be freed on his wife's death. It is possible that the *ancilla* Alvara and her two infants, whom Braifred of Pisa had received from his father-in-law and exchanged for another woman with two children in 766, had also originally formed part of a dowry for Braifred's wife.[48] Female slaves might also, as we have seen from laws relating to their offspring, become the sexual partners of their masters. Such a situation may lay behind a document of 760, in which Amolcari left to his *obsequiale* Sindruda the usufruct of his property protected from his heirs.[49]

The freeing of slaves was a pious act and features in wills of the period. That of Grato the deacon, drawn up in Pavia in 769, offers a twist, however. He made four named slaves, including three women, 'free Roman citizens'.[50] In doing so he exhibits a conscious decision to free the slaves not only from their servile status, but also ensures that the women were not, unlike the daughters of the *coloni* in Pisa in 748 discussed above, subject to anyone's *mundium*.

Slave or free? Documenting female peasants

As well as domestic servants, the Lombard charters reveal the subject position of peasant families in this period. Peasants and their wives and children were often associated with pieces of land in transactions,[51] and when they were not included in the transaction the document says so.[52] The overwhelming impression, however, is that all of the peasants mentioned were subject to the will of the landowners whose property they tilled.

Similar servile status appears further south in documents from the monastery of San Vincenzo al Volturno and elsewhere. In 703 or 748 at Benevento, the widow Selberada and her son Leo received 24 solidi from Peter the subdeacon of the Neapolitan Church for the *tertiatores* Mauremundi and Colosse his wife and their newborn son working on a named estate in the territory of Nola.[53] The San Vincenzo chronicle preserves a document of ?752, in which Liutprand and Scauniperga, at the request of Abbess Eufemia, confirmed to the oratory of St Maria Locosano where Albileopa was now abbess a group of *condome* (plots of land held by *coloni*) with their resident families. In ?753 from the same archive, Liutprand and Scauniperga, at the request of Atenolf, gave to Punnuni, their *scaffardo* (a court servant), a woman named Fusa and her two small children, and a house and lands belonging to her.

These documents are instructive in that they provide a brief glimpse of the subject lives of cultivators in northern and southern Italy, controlled and tied to the land by aristocratic lords. A list surviving from Lucca, dated

761, names over seventy adults with their children featuring in a division and manumission by the bishop and his nephew.[54] Their status is probably equatable to that of the *aldii* mentioned in the Lombard laws, co-existing alongside slaves whose personal liberty as well as their working lives were in the hands of their masters and mistresses. We should note the inclusion of children as potential economic assets, even if they were still too young to work at the time of the charter. In these circumstances, establishing rights by birth were crucial, which may explain why the cultivators in an agricultural contract of 736 were keen to emphasise that they were born of a free mother, despite the fact their father was tied.[55]

A ducal charter from Benevento dated 752, however, outlines one of the rituals by which a slave might be freed. The woman Cunda, her daughter Liuperga and the priest Ansprando were to be passed through four pairs of hands from their patron, after which they were led to a crossroads and given an arrow as the token of their freedom with the ritual pronunciation: 'You may choose freely between these four roads which way you want to go'. The document cites almost verbatim Rothari's law 224, suggesting strongly that the notary had a copy available to him. Alternatively, a slave might be led to a church altar and freed there: the latter method became more popular as the Church increased its influence, and is alluded to in Liutprand's laws 9 and 23, the latter of which equates a freeing before the altar with the older method, and adds that raising a slave to the status of an *aldius* should not happen in church.[56] In 774, Taido of Bergamo's will, mentioned above, refers to freeing slaves 'by means of the altar [erga altario]' by the bishop of Bergamo.[57]

Slavery or semi-servility appears to be entrenched in these and other early documents. Although didactic in its approach, we should take seriously the report of the *Liber Pontificalis* that Venetian traders were in Rome during the pontificate of Zacharias (r. 741–752) buying up male and female slaves for export to Africa. The pope, predictably, is shown buying and freeing the unfortunate slaves – a pious act perhaps, but one which reinforced the trade. Zacharias did not go so far as to berate the Venetians for their actions.

Women and the Church: an ambivalent relationship

New monastic houses

Suzanne Wemple characterises the Lombard period as very rich in new monastic and other ecclesiastical foundations as the Lombard rulers and

their aristocrats converted to Catholicism.[58] Many of the most illustrious monasteries of this age went on to become the wealthiest and most powerful in medieval Italy, and women's houses were among them. As in earlier examples, the monasteries appear to have been small-scale and designed to accommodate family members, as in the case of that founded in their house by Senator and his wife at Pavia in 714: their daughter Sinilinda and Senator's sister were to be in charge.[59] It is less clear whether the nuns Rotperga and Perticunda, who in 720 received a house from Aunefrid for their use and that of anyone else wishing to take the veil, were related to him, but a relationship of some sort is likely.[60] Founding houses in which daughters or other female family members were abbesses was a common pattern,[61] and the documents may conceal the daughters' own instigation of such projects.

Among her examples of Lombard foundations, Wemple lists St Agatha on the Mount and St Maria Theodota (whose abbess Risinda received a royal gift in c.688) at Pavia; St Maria d'Aurona and St Vincentianus at Milan; St Maria Assumpta at Cairate; and other, unnamed houses at Lodi, Pistoia, Florence, Verona and Friuli. We have already seen that Rome, too, had female houses by this time, including houses close to the basilicas of St Paul, St Maria Maggiore and St Laurence. But the creation of such houses also opens up to us a rich source of documentary evidence, as foundation privileges and gifts were recorded in writing and deposited at the churches themselves. Sometimes the early charters survive only in abbreviated form, copied into later chronicles such as that of San Vincenzo al Volturno, which records the foundation of the nunnery of St Maria in Castagneto near Pipiano in c.692 by Theoderada.[62]

The eighth century brought with it a second wave of church and monastic foundations, as well as enriching those already in existence. In 730, three brothers used their maternal inheritance to found a church and *diaconia* (charitable institution) to SS Secondus, Gaudentius and Colombanus outside the walls of Lucca.[63] Women were also founders, as they had been in earlier centuries, using their own property. For example, in Lucca in 738 Anstrualda the nun endowed the church founded by her after the death of her husband, using her *morgengab* and with the permission of her son.[64] In 755, Cleonia founded St Cassiano at the order of her husband Ostripert, and with the consent of her son gave it half of her usufruct left by him and one-third of her *morgengab*.[65] Since this amounted to a considerable portion of her property it is possible that she intended to retire to the house she was founding. A court case of 762 shows the difficulty that one widow, Rottruda, had in carrying out her husband's wishes. He had left property to found a hostel (*xenodochium*) for pilgrims and the poor, but she had to defend this against the claims of his brother, ultimately succeeding.[66]

The documents reveal very strongly the expansion of the institutional Church in this period, as new monastic houses and churches were founded and endowed. In 764, Teuprand and his wife Gumpranda founded an urban church in Lucca and gave it hugely fragmented and detached properties to support it.[67] Gumpranda and their daughters were to live chastely in the house and to choose its priest. Not only pious motives were involved in the creation of new foundations, therefore: a well placed church could act as a focus for the increasingly fragmented properties of a family, relieving the donors of responsibility for pieces of land which might be far-flung and so small as to be uneconomical to manage. Family houses could also provide support and refuge for female family members.[68] Linked to this, male donors to the Church frequently reserved the property for their widow's use before it was finally alienated.[69]

As we have seen, the Lombard laws catered increasingly under Liutprand for women who wished to make pious donations, and the charter evidence shows them as active patrons of the church.[70] In 742, Manigunda the nun founded a monastery to Jesus and Mary in Cariadae near the river Olona in the county of Seprio (today Castelseprio, north-west of Milan). The nuns were to live there and hold its property, be subject to the bishop of Pavia, and their abbess was to be consecrated in the church at Milan.[71]

Three years later the sisters and nuns Autconda and Nazaria, with Nazarius their brother-in-law and husband, founded the oratory of St Maria in Verona. They gave it all of their property including the house which they had used for its foundation. If the monastery was successful, the abbess was to be elected by the nuns after the founders' death. If not, the new monastery and all its property was to go to St Maria outside the Organi gate and the abbot there, who would dispose of all its goods to the poor. The founders placed their monastery under St Maria Organi's present abbot, Andrea. Their daughter and niece Nazirimda became a nun, although it is unclear from the document whether they intended her to be the first abbess. All the sisters' slaves were manumitted, but obliged to serve their former mistresses for the duration of the latters' lives. Gigelpert the duke and Sigipert the bishop of Verona were among the witnesses to the document.[72]

This foundation document has much of interest, not least the worry by the founders about whether their new house would survive, and their attachment of it to a presumably more secure and wealthy male house, just as earlier founders, including Pope Gregory, had done.

Further south, the register of the powerful and wealthy central Italian abbey of Farfa includes a gift of a convent to the abbey by Guntarius and his wife in 744. Also preserved in the Farfa archive is a document of 751 written at Spoleto, in which the duke, Lupo, and Ermelinda his wife gave the monastery of St George near the walls of Rieti to a congregation of

nuns, Lombard or Frank (note the early Frankish presence), who were to live according to a rule and elect an abbess.[73] The house was made subject to Farfa, and a certain Domnolina was appointed as its first abbess.

The pattern of attachment to a more powerful house is repeated in a document of 747 from further south in Benevento. Duke Gisolf and Scauniperga his wife confirmed the monastery of St Maria in Cingla to its abbess, Gausani, and to the nuns Lancritude and Gariperga, but also confirmed that the house was under the protection of Abbot Petronax of Montecassino. Graham Loud highlights this as one of the earliest foundations for women in the territory around Capua.[74] A few years later, Tasia, the wife of King Ratchis, and their daughter endowed the convent of the Virgin at Plumbarola. In 760, Prince Arechis founded the female houses of St Sophia at Benevento and St Salvator at Alife.

One of the best known and studied female houses in Italy was also founded in this period. St Salvator (formerly St Maria and then, by the tenth century, St Julia) at Brescia[75] was founded after 757 by Ansa, queen of the Lombards, and richly endowed by King Desiderius and their son Adelchis. Her daughter Anselberga was the first abbess, and the house had over forty Benedictine nuns. Considered against the more normal number of ten to twelve, we can see that this house was conceived on a much grander scale. Ansa commissioned new iron doors and saw to the development of the monastery's holdings. Using her position, the queen saw to it that major properties were willed to the house, and arranged that penalties of forfeiture of lands to the royal fisc were instead commuted to a donation to St Salvator. The royal family were the single largest source of grants to the house, Desiderius and Adelchis both making substantial grants, and it continued to attract patronage even after the fall of the Lombard kingdom in 774. The house attracted patrons outside the royal family too: in 767, eight named men made a gift to it.[76] Although Desiderius was captured and taken into exile in 774, it is possible that Ansa retired to their family foundation.

The wealth of the monastery is apparent from the documents recording Anselberga's management. In 759, the house bought up half a *curtis* or estate for the enormous sum of 3,850 solidi from the bishop of Lodi; two years later Anselberga secured the other half in an exchange worth 4,000 solidi. It is clear that the abbess had a policy with regard to the region in which this enormous property lay, for she is documented buying up smaller pieces of land in the same area in 769.[77]

Her property transactions also involved other high-ranking officials. In 768, she gave the abbot of Farfa a cell and church in the Sabina and near Viterbo in exchange for an estate in the territory of Rieti, and in 772 she bought land from the duke of Persiceta (near Bologna) which had been granted to him by the king.[78] The monastery also enjoyed a running water

supply, which Anselberga negotiated by paying landowners through whose land the monastery's aqueduct ran.[79]

We have already seen that the Lombard dukes and then princes of Benevento followed a similar pattern to their royal overlords in patronising new foundations at Benevento. Further south, new houses continued the long tradition of Roman foundations so visible in the register of Pope Gregory I, but they were all inspired by much the same motives and followed similar, family-centred, patterns. They have been studied to a limited extent by Anna Maria Valerio in her broader study of women and southern Italian religious movements.[80]

In Naples, the convent of SS Marcellinus and Peter was founded in 753 by Theodonanda, widow of Duke Sergius, and enriched by subsequent Neapolitan dukes and laymen. In a document of 763, Eufrosina, *diaconessa* and abbess, is seen managing the property of the convent, leasing out a house and garden in Naples to the consul Stephen and his wife, and their sons and grandsons to the third generation, at an annual rent of 8 solidi.[81] The same period sees the foundation of SS Gaudiosus and Festus by the Neapolitan bishop Stephen, probably also a member of the ruling house of Naples.

Limits on women in the Church

Women were documented in this period as both benefactors and beneficiaries of monastic foundations. Northern documents, as we have seen, take specific care of female family members, but also echoed the earlier aim of papal letters in a general promise to succour the poor, widows and orphans.[82] However, along with an intensified emphasis on monastic life for men and women came a heightened consciousness of the need to separate the sexes. Two Lucchese foundation documents of 750 and 758 explicitly agree to ban women from new monastic houses; and when three brothers chose to honour SS Mary, John the Baptist and Peter from the monastery of Nonantola in 762, they did so by founding one male and one female house, each with the same dedication but physically separate.[83]

In a document of 749 edited by Troya, Lupo, duke of Spoleto, petitioned by Abbot Fulcoald of Farfa, ordered that no woman was to walk in the abbey territory or its precincts except along the via Salaria from St Pancratius to the bridge of St Vito in Sala. Neither were they to go to the cells of St Angelus or St Peter. They were allowed only to go and pray 'per vias antique et loca que ... designari feci [by the old routes and those which I have had pointed out]'.[84] This is an important document, for it states expressly a limitation on women's movement around the area of the monastery. It is also one of the earliest examples of preventing women from

visiting monastic houses, with echoes of the earliest desert fathers' horror of encountering women.

Women's room to move in and around ecclesiastical spaces appears to have been constricted within some churches as well. The *Liber Pontificalis* clearly shows St Peter's in Rome with a 'women's section' in its account of the papacies of Sergius I (r. 687–701) and Gregory III (r. 731–741).

Another sign of the Church's uneasy relationship with women emerges in the language used in its texts. We have met statements which equate admirable women with male qualities. The reverse scenario was not as flattering to its subject: an anti-pope raised against Stephen III in 768 was defeated: 'they fixed a huge weight to his feet and made him sit on a horse in a saddle designed for a woman',[85] before putting him in a monastery.

In contrast to the prevailing rhetoric on the matter, however, the charters do provide evidence of married priests in this early period. Romuald is documented in Lucca with his wife, 'praesbitera nomine Ratperga', in 724, and in 768 in the same city Anecardo the priest made a gift to the church reserving the usufruct for himself and his wife Auriperta, 'presbiteria mea'.[86]

Paul the Deacon: writing misogyny?

Having looked at the idealised pictures of Roman and Lombard society portrayed in the papal sources and lawcodes, and how these fed into an as yet limited charter sample, we are better equipped to place the major narrative source of the period, the *History of the Lombards* of Paul the Deacon. Paul was born in Friuli *c.*720/730 and may have been educated at the court of King Ratchis (r. 744–749) or Ratchis's father, Duke Pemmo. He was later attached to Duke Arechis of Benevento and the duke's wife, the daughter of King Desiderius. Paul became a monk before 782, probably at Montecassino, to which monastery Ratchis had retired. On the capture of Paul's brother by the invading king Charlemagne, Paul presented himself at court, where he wrote epitaphs for Frankish royal women and taught Greek. By 787 he was back at Benevento, and wrote the epitaph of Duke Arechis. The *History of the Lombards* was his last work, but he died before it was completed. Paul was in essence a compiler from other sources, including the *Liber Pontificalis*, and his chronology is sometimes astray; nonetheless his work includes striking episodes of women's involvement in the violence and politics of the time.

The first episode is when Lombards are on their way to Italy. Their king Agelmund is killed and his daughter, 'whom the Lombards had wanted as their queen', was taken captive. This passage has been taken to imply that women had succession rights in this early nomadic society. There are strong echoes here of the earlier treatment of the Gothic princess Amalasuntha.

Many of the women in Paul engage in or are victims of violence. King Tato's daughter Rumetruda stabbed the Herule leader who had retorted rudely when she mocked his shortness (I, 20). Although her actions go unpunished, they are cited by Paul as the reason for bitter warfare between the Lombards and the Heruli.

Marital alliances were useful, and multiple marriages are recorded in Paul. Whether these were consecutive is a moot point. King Waccho had three wives: the first, Ranicunda, was daughter of the king of the Thuringians (note here another Thuringian alliance). By the second, Austrigusa, daughter of the Gepid king, he had two daughters who both married Frankish kings. By the third, Salinda, he had a son, Waltari, who succeeded him (I, 21).

A similar pattern is visible slightly later. King Audoin married Rodelinda, by whom he had a successor, Alboin. Alboin married a daughter of the Frankish king Lothar and had a daughter named Alpsuinda. However, when his first wife died, Alboin remarried, taking the daughter of the defeated king of the Gepids, Rosemund, as his wife (I, 27). He had unwisely made the head of Rosemund's father into a skull-cup, and Paul recounts the tale of how Rosemund, forced to drink from it at a banquet, hatched a plot to kill her husband. She tricked a certain Peredeo into sleeping with her, so that either he or Alboin had to die. Peredeo and another accomplice, Helmechis, subsequently killed Alboin whilst he was taking a siesta, thus 'this most warlike and very brave man ... perished by the scheme of one little woman' (II, 28). It was 572/573. Then Helmechis married Rosemund 'but could not remain king', so the pair fled with the royal treasure to Ravenna with Alpsuinda. The prefect of Ravenna persuaded Rosemund to kill Helmechis and to marry him instead, so she attempted to poison Helmechis whilst he was in his bath. He, realising the danger, forced Rosemund to drink the rest of the draught, and Alpsuinda was sent with the treasure that her mother had stolen to Constantinople.

This story, which is reworked by at least one later author,[87] intertwines two of Paul's favourite themes, murder and sex. His distaste for Rosemund is apparent, but it is a distaste which, ironically, reveals Rosemund as central to the political manoeuvres of the time. Helmechis cannot remain king because he has no military support to keep him in power, but he gains his authority by marriage to the queen (the parallel with the case of Amalasuntha, discussed above in Chapter 1, is strong). The prefect of Ravenna may be thinking in similar terms. We see here a direct continuation between the political world of the sixth century and Paul's eighth-century one, in which legitimation of a military takeover by marital ties was still a necessity.

Another marriage of which Paul makes much is that of Theodelinda, daughter of the Bavarian king Garibald, to King Authari. Intent on marrying her, Authari secretly came to the Bavarian court to look at his prospective

bride: he 'gazed upon her with silent approval since she was of a very beautiful figure and pleased him much in every way' (III, 30). Authari died at Pavia in 590. 'Because queen Theodelinda pleased the Langobards greatly, they allowed her to remain in her royal dignity, advising her to choose for herself whomsoever she might wish from all the Langobards; such a one, namely, as could profitably manage the kingdom. And she, taking counsel with the prudent, chose Agilulf, duke of the people of Turin, as her husband and king of the nation of the Langobards' (III, 35). How far this account can be trusted is open to speculation, but even if Theodelinda did not enjoy the right to choose the king, marriage to her was, yet again, a prerequisite of Agilulf gaining authority. As Ross Balzaretti has recently shown, Paul's image of the queen radically adds to and reshapes her aura of power when compared with earlier sources.[88]

Paul presents Queen Theodelinda as the propagator of the Catholic faith among the Arian Lombards, but is probably wrong to suggest that Agilulf, too, was a Catholic. However, her son Adaloald was baptised a Catholic, and she was the founder of the church of St John the Baptist at Monza (IV, 21). Nearby, Paul relates, she built herself a palace with richly decorated walls. Very little of Theodelinda's building work survives, although Troya published her inscriptions recording her foundation of the Monza church in 604 and another at her church of St John the Baptist at Brescia, *c.*?615. A rather less reliable inscription at St Michael, Monza, *c.*628 states that it too was founded by the queen.

Meanwhile, Agilulf's daughter and her husband had been taken prisoner by the patrician Callinicus, who had taken the couple to Ravenna. This caused Agilulf to besiege and take centres ever closer to the Byzantine city until the family were returned. The daughter, however, who is never named throughout the story, later died in childbirth at Parma (IV, 20, 28). Adaloald was associated in power with his father and betrothed to the daughter of King Teudepert of the Franks.

Paul digresses from his narrative of the royal house into the most violent story of a woman. Duke Gisulf of Friuli having been defeated by the Avars, his wife Romilda escaped with her four (named) sons and four daughters (only two are named 'but of two we do not preserve the names'), and other wives and children, and closed themselves up in the city of Cividale. However, Paul tells us, Romilda the 'abominable harlot' offered to trade the city if the Cagan of the Avars would marry her. He agreed and the gates were opened: all the adult men were killed and the women and children divided up in captivity. The Cagan spent one night with Romilda, and then turned her over to his soldiers before impaling her on a stake with the words 'It is fit you should have such a husband'. Her daughters, however, maintained their chastity by putting rotting chicken flesh in their dresses and 'handed

down a useful example for preserving chastity if any such thing should happen to women thereafter'. They were sold into slavery and eventually made worthy marriages on account of their noble birth (IV, 37).

Paul then resumes his history of the kings with the information that King Agilulf died (615/616), leaving Adaloald in the care of his mother and Theodelinda as regent. Churches were restored and gifts made to holy places. After ten years in power he became insane and was deposed by Arioald, duke of Turin (IV, 41). This is the last chapter in which Theodelinda features alive, but why has Paul inserted such a horrifying tale about Romilda into the middle of his account of her life? Was he pointing up the difference between a queen who transferred power legitimately and one who was a 'detestable betrayer of her own country' in order to exalt Theodelinda all the more?

Joaquín Pizarro characterises Paul's stories of Rumetruda, Rosemund and Romilda as 'extremely misogynistic', asserting that Paul treats them as evil 'on account of their gender; each one of them embodies a specific vice'.[89] If so, Paul's other portrayals of women act as models to good behaviour, similarly embodying good qualities. Since Theodelinda was praised for her efforts on behalf of Catholicism, it is understandable that Paul terms the Arian king Rothari (r. 636–652) a heretic. Rothari's successor was Rodoald, who married Gundiperga, daughter of Agilulf and Theodelinda. The modern translator of Paul suggests that this marriage could not have taken place, since Gundiperga would have been over 50 years old if the account is compared with the Frankish chronicler Fredegar's. I am less inclined to think such a union out of the question: we have seen women as transmitters of authority throughout the chronicle, and it is not too fantastic to suppose that women could be married for more than their childbearing abilities even this early.[90] As a direct heir of the king and queen, Gundiperga was a valuable ally. Indeed, she is paralleled by Paul with her mother through her foundation of the church of St John the Baptist at Pavia. Falsely accused of adultery (itself an indicator that she was perceived to be powerful), she was vindicated in a trial by combat.

Rodoald was killed *c*.653 and Aripert, a nephew of Theodelinda (note the further association with the *queen*), became king. His death in 661 led to war between his sons Perctarit and Godepert. As always at such moments, the women came to the fore as marriage allies: Godepert offered his sister to Grimoald of Benevento in return for help: encouraged by Godepert's ambassador, Grimoald killed his ally and became king, marrying Aripert's daughter in 662. Perctarit fled leaving his wife Rodelinda and son Cunincpert who were sent into exile at Benevento (IV, 51).

Grimoald meanwhile also married off a daughter to Transamund, Duke of Capua, subsequently of Spoleto. When Duke Lupus of Cividale died, his daughter Theoderada was married to Grimoald's son Romoald, who had

been in charge at Benevento (V, 25). Theoderada is in some ways set up as a later parallel of Theodelinda. She is credited with establishing the Catholic faith in the duchy of Benevento. The brief ninth-century *vita* of Theoderada's contemporary, St Barbatus of Benevento, provides details.[91] Grimoald had been persuaded by Barbatus, then bishop, to convert to Catholicism in exchange for the city of Benevento not falling to Byzantine forces, but when the duke lapsed back into worshipping a snake figure, Barbatus asked the Catholic Theoderada to aid him in melting down the statue and making liturgical items instead. Faced with a *fait accompli* on return from a hunting trip, Grimoald agrees to convert, but not before one of his companions is quoted as saying 'If any wife of mine did that, I'd cut off her head'.

On Grimoald's death, Perctarit, portrayed as a 'pious Catholic', deposed his under-age son and brought Rodelinda and Cunincpert back from Benevento. He founded a new convent to SS Mary and Agatha at Pavia, and Rodelinda founded her own church of St Mary outside the city (V, 34). On Perctarit's death Cunincpert became king, marrying the Anglo-Saxon Hermelinda. Paul uses this marriage to digress again into an anecdotal tale, in which Hermelinda praises the slave-girl Theodote, 'sprung from a very noble stock of Romans, of graceful body and adorned with flaxen hair almost to the feet'. He summons the girl to his bed, then sends her to a monastery in Pavia which bears her name (V, 37 – perhaps a clumsy attempt to explain the monastery's name, St Maria Theodota).

Meanwhile Romoald was conquering parts of southern Italy and his wife Theoderada built a church to St Peter outside the walls of Benevento and established a convent of nuns there (VI, 1). When Romoald and his eldest son (who had married Perctarit's daughter Wigilinda) died in quick succession, it was Theoderada who acted as regent with her younger son Gisulf, duke of Benevento.

Cunincpert died 700/701 and his son Liutpert was overthrown by Raginpert, duke of Turin, whose son Aripert overcame all his rivals when Raginpert died, to become king. In a rather odd episode, Aripert caused the wife and daughter of his rival Ansprand to be seized and disfigured.

Again Paul uses the structure of his text to point up opposites in women's behaviour. Ansprand's wife had been wilful and boasted that she would be queen, hence her punishment. Although no direct comparison is drawn, this story (VI, 22) is followed almost immediately by that of Ratperga, wife of Paul's patron, Duke Pemmo. She:

> who was boorish in appearance, often asked her husband to send her away [and marry someone more fitting]. Being wise, he refused and said that her behaviour and humility and reverent modesty pleased him more than beauty

of body. [She had three sons by him] whose birth raised the humiliation of their mother to high honour.

(VI, 26)

For Paul, therefore, the lesson was that the physical appearance of women was not their most important quality (and the mutilation of Theoderada and Aurona in chapter 22 is a permanent lesson) though he implies that Ratperga and possibly his readers might think it was. Women's primary function is presented as childbearing: good looks were not absolutely necessary. Indeed, Paul's narrative accords with the legal and charter evidence in its description of men's liaisons with (often pretty) concubines.

Although Ansprand's wife had not been Paul's ideal woman, his account of her son, King Liutprand (r. 712–744), more than compensates as he extols this Catholic king's qualities. He married and had just one daughter. His niece, Aurona's daughter Gumperga, meanwhile married Romoald son of Gisulf, duke of Benevento, and had a son, Gisulf, by him. Romoald subsequently married the daughter of the duke of Brescia, perhaps as insurance against the uncertainty of who would succeed Liutprand. Romoald's own early death in 731/732 left his young son Gisulf vulnerable: Liutprand substituted his own nephew Gregory as duke of Benevento and removed Godelscalc, who claimed the duchy after Gregory's death, restoring Gisulf, by now grown. Liutprand himself died in 744.

Paul's account of the Lombards teems with named women. They are there not just to make moral points: they function also as markers in Paul's enhanced sense of genealogical legitimacy, and as propagators of the Catholic faith. At the same time they are also the partners in men's casual sexual relations, but the requirement of absolute fidelity of women to their husbands is underlined. This is what makes Paul's presentation of Rosemund's story so interesting: the Lombard legal double standard is used to her advantage in entrapping Peredeo – he knows that he has either to kill her husband or to be killed for his adultery with the queen. Whilst she is shown eventually receiving her come-uppance, Paul inadvertently reveals how even the most oppressive laws might be subverted by women who knew how to use them. Read with a gendered eye, Paul's apparent misogyny can therefore be very informative.

Epigraphy

A final and valuable resource for documenting women in this early period is inscription evidence, usually (though not exclusively) in the form of epitaphs

on graves. One inscription commemorating Gundeberga *spectabilis*, who died at Modena in 570, raises an important methodological problem of women's history which will recur in later chapters. For it is clear that Gundeberga had a second or baptismal name by which she was known ('Gundeberga qui et Nonnica').[92] This phenomenon was not restricted to women, but nevertheless it should alert us to the distinct possibility that women like Gundeberga could be known by different names in different sources, and unless the names were used together a prosopography would not pick up that this is the same woman.

Some epitaphs of women feature little more than the bare bones of their name, age and the date of their death, such as that of Honerata, dated 620:

> Here lies in peaceful sleep Honerata of blessed memory who lived forty years. She died in the eighteenth year of the reign of king Adoald in the eighth indiction, on the eighth of the ides of February [6 February] on a Wednesday. If anyone should be tempted to violate this tomb may he suffer the ire of God and be anathema.[93]

Marciana's headstone of 658 is even more succinct:

> Here lies in peaceful sleep Marciana of blessed memory who lived 50 years and died on the sixth day of the ides of March [8 March], in the fifth year of king Aripert and in the first indiction.[94]

Note that neither woman is identified by her marital status. Perhaps they are nuns, or perhaps the nature of the source means that a different frame of reference is in use – unlike in life, they may not have had to link their identity to that of their husbands. They are likely to have been widows, because if a husband was comemorating his dead wife he would surely include himself on the stone, as in the case of the tomb of Madelgrima, wife of Count Radoald, who died in ?732 near Naples:

> Here lies buried Madelgrima, the wife of Radoald the count and of noble birth, in the place where by her habits she lived a decorous life, and always gave care to the honest poor, and whose fragile body was buried by her husband on the last day of May; you who look at this tomb speak of her soul without any sin, O Christ.[95]

Women's epitaphs, however, often illustrate the ideal qualities which their families wished to project onto the deceased woman (similar to the qualities of the mother praised by King Theoderic, discussed above in Chapter 1)

rather than the qualities they themselves might have wished to be remembered for. An exception to this might be those rare examples which furnish evidence of women's literacy or were composed by women, such as that of Abbess Theodota, formerly in St Maria Pusterla, Pavia, c.705–720, apparently composed by one of her nuns:

> I could not describe the terrestrial Theodota/ Dwelling at last in heaven I wrote down her lineage/ She lived a virgin mother for very many years/ in the Lord's flock caring for Christ's/ sheep, whom she ungrudgingly taught to feed, censured, corrected, and loved/ With furrowed brow she lost none of her sheep/ but held onto those with pureness of heart and/ abstained from the whip with gentle hand/ In assigning feasts she was generous to the sick/ An honest woman and generous patron adorned with good morals/ she was patient and magnanimous with a pious heart and right hand/ As was only right given the lineage from which she came/ Growing from the land as the river from the spring/ . . . she grew as a wise woman from her fathers . . . So I Theodota your pupil Theodota/ To whom you left the name and dignity of the abbacy/ Afflicted with many tears on the breast of my lady/ Decorating the beautiful stones I honoured the tomb.[96]

Inscriptions can also pick up women, sometimes of very high status, who are otherwise not well represented in the historical record. Take, for example, the case of Cuniperga daughter of King Cunipert in the monastery of St Agatha at Pavia (date uncertain):

> Know you who wishes to know that this tomb covers and is closed by a stone with a precious image to stand here and contain the pure as snow body of Cuniperga the sweet mother of the handmaidens of God; she was the most beautiful among beautiful women, with serene face and shining eyes and knew nothing about bad things but honey flowed from her lips; she was the daughter of Cunipert the finest king and did everything a daughter should do and was full of sweetness in her father's mind, which is now attested to by her sacred virginal colleagues.[97]

Again, this inscription appears to have been composed by women: the epigraphy may therefore open up new clues as to the cultural activities of quite small monastic houses for women in Italy in the early Middle Ages.

Finally, and importantly, the value of epitaphs in bringing to light unrecorded communities is seen in the case of the Jews of southern Italy, whose presence from the sixth century in Naples and Venosa is attested to by their headstones, including some of women.[98]

Conclusions

This and the previous chapter have dwelt at some length on the early medieval sources, if only because they have rarely been mined for their information about women. What emerges is clearly stereotypical in some cases – the papal sources, in particular, form a textual community or group whose borrowings from each other are self-evident. Legislation was influenced by a mixture of Roman precedents and Christian teaching. Paul the Deacon borrowed material from earlier written sources including the *Liber Pontificalis*, and later writers, as we shall see, would in turn borrow from Paul. It is not surprising, therefore, to find the sources presenting us with strong and common themes.

These themes include the relative looseness of marital ties in this early period and successive attempts to regulate the marriage bond by secular and ecclesiastical rulers. At the same time, men's sexual behaviour was far less regulated than women's, with the notable exception of the opposition to episcopal marriage by successive popes. Women's relationship with the Church varied, from pious benefactors and nuns to the proud and wicked seducers whose ends were described in such gory detail by the monkish Paul.

Politically, though, women were important to diplomatic alliances, and marriages were used to cement relations and transfer power – the key role of heiresses has emerged as a strong theme. With the marital age of girls set at twelve by the Lombard laws, a daughter could be an advantage to her family. But if she was marrying under Lombard law, her new in-laws might find difficulty in dealing with her claims to her husband's lands, hence the persistence of the institution of the *mundium*, and successive legislation to limit both outright gifts of property to women and their right to usufruct of their late husband's estate.

Ideologically, women were praiseworthy if they fulfilled two opposing roles. Powerful, ruling women could be praised using male qualities; but the messages coming across in the majority of these early sources is of submission and modesty. Women out of place were condemned as witches or whores. This emphasis on modesty carries through into legislation about dress, appearance and touching women.

Finally, the nature of the sources has meant we see only certain groups of women in this early period. At one end of the scale were rulers and aristocrats, visible because of their wealth or political power, recorded as donors and patrons. Overlapping with this group were the nuns and abbesses, whose foundations might have only brief lives or might grow into wealthy and well patronised (and thus well recorded) houses. At the other end of the

scale were female slaves and peasants, documented because they were valuable assets in any list of property, or might be the mothers of their master's children and thus had to be dealt with in legislation.

Overwhelmingly, women in the Lombard kingdom were to be protected: by their families, the clergy, and ultimately by popes and the king. Protection could turn into coercion, as the laws of the Lombard kings acknowledged, and violence against women was not unknown. If they fought back, however, they crossed a boundary into a male world. The arrival of the Franks in northern Italy did little to change this situation.

Notes

1. Rothari, Law 204, in K. F. Drew (trans.), *The Lombard Laws* (Philadelphia, 1973).

2. T. S. Brown, *Gentlemen and Officers: Imperial Administration and Aristocratic Power in Byzantine Italy, AD554–800* (Rome, 1984), p. 41.

3. Discussed in Neil Christie, *The Lombards* (Oxford, 1995) and Dick Harrison, *The Early State and the Towns: Forms of Integration in Lombard Italy, 568–774* (Lund, 1993).

4. Suzanne Fonay Wemple, *Women in Frankish Society: Marriage and the Cloister, 500–900* (Philadelphia, 1981); Jo Ann Macnamara, John E. Halborg and E. Gordon Whatley (eds), *Sainted Women of the Dark Ages* (Durham, NC, 1992); Janet L. Nelson, 'Queens as Jezebels: Brunhild and Bathild in Merovingian history', in Derek Baker (ed.), *Medieval Women* (Oxford, 1978), pp. 31–77; eadem, 'The wary widow', in Wendy Davies and Paul Fouracre (eds), *Property and Power in the Early Middle Ages* (Cambridge, 1995), pp. 82–113.

5. In addition to the works cited above in Chapter 1, n. 9, Pauline Stafford, 'Sons and mothers: family politics in the early middle ages', in Baker (ed.), *Medieval Women*, pp. 79–100; eadem, 'The king's wife in Wessex, 800–1066', *Past and Present*, 91 (1981), pp. 3–27; eadem, *Queen Emma and Queen Edith: Queenship and Women's Power in Eleventh-Century England* (Oxford, 1997); Theodore J. Rivers, 'Widows' rights in Anglo-Saxon law', *American Journal of Legal History*, 19 (1975), pp. 208–215.

6. Lisa Bitel, *Land of Women: Tales of Sex and Gender from Early Ireland* (Ithaca, NY, 1996); Wendy Davies, 'Celtic women in the early Middle Ages', in Averil Cameron and Amélie Kuhrt (eds), *Images of Women in Antiquity* (1983), pp. 145–166; Christina Harrington, 'Women of the Church in early medieval Ireland, c.450–1150', PhD thesis (University of London, 1997).

7. English translation: Drew (trans.), *Lombard Laws*.

8. Rothari law 14 on murder provides the clearest outline.

9. Rothari law 28 deals with the same offence against a slave, with far lower penalty.

10. A. Marongiu, *Matrimonio e Famiglia nell'Italia Meridionale (sec. VIII–XIII)* (Bari, 1976), p. 107.

11. Rothari law 334.

12. Rothari law 156.

13. A right reiterated in law 161 on the division of the *mundium*.

14. James A. Brundage, *Law, Sex and Christian Society in Medieval Europe* (Chicago, 1987), p. 71.

15. R. Balzaretti, '"These are things that men do, not women": the social regulation of female violence in Langobard Italy', in Guy Halsall (ed.), *Violence and Society in the Early Medieval West* (Woodbridge, 1998), pp. 175–192.

16. Rothari laws 278 and 378.

17. Valerie Flint, *The Rise of Magic in Early Medieval Europe* (Oxford, 1991), p. 297.

18. Brown, *Gentlemen*, p. 192.

19. Diane Owen Hughes, 'Invisible Madonnas? The Italian historiographical tradition and the women of medieval Italy', in Susan Mosher Stuard (ed.), *Women in Medieval History and Historiography* (Philadelphia, 1987), pp. 25–57, at p. 45.

20. *CDL*, I, 130.

21. L. Schiaparelli (ed.), *CDL*, I–II (FSI 62–63, Rome 1929, 1933).

22. B. Pohl-Resl, 'Legal practice and ethnic identity in Lombard Italy', in W. Pohl and H. Reimitz (eds), *Strategies of Distinction: The Construction of Ethnic Communities, 300–800* (Leiden, 1998), pp. 205–219, at p. 216.

23. *CDL*, I, 30.

24. *CDL*, I, 70.

25. *CDL*, I, 120.

26. Apart from the specific examples cited below, they are documented in *CDL*, I, 84 and 103; *CDL*, II, 249 and 255.

27. *CDL*, I, 37 and 79; *CDL*, II, 191 and 290, respectively.

28. Documented examples: *CDL*, I, 76, 120, 123; *CDL*, II, 129, 157, 226, 234 and 291.

29. *CDL*, II, 226.

30. Pohl-Resl, 'Legal practice', p. 216.

31. *CDL*, II, 284.
32. *CDL*, I, 93.
33. *CDL*, II, 252.
34. *CDL*, I, 29.
35. *CDL*, I, 53.
36. *CDL*, II, 287.
37. Pohl-Resl, 'Legal practice', p. 214, discusses this will as an example of Roman legal traditions influencing Lombard documents in their attitude towards women.
38. *CDL*, II, 137.
39. *CDL*, II, 281.
40. *CDL*, II, 293.
41. *CDL*, II, 182.
42. *CDL*, II, 214 and 233 show them inheriting.
43. *CDL*, II, 172.
44. *CDL*, I, 48 and *CDL*, II, 159 and 228 refer to inheritance from a mother; *CDL*, I, 50 and 73 to deceased wives' property; and *CDL*, II, 149 and 233 to the property of aunts.
45. *CDL*, I, 70.
46. *CDL*, II, 174.
47. *CDL*, II, 214.
48. *CDL*, II, 199.
49. *CDL*, II, 143.
50. *CDL*, II, 231.
51. *CDL*, I, 50; *CDL*, II, 204.
52. *CDL*, I, 105.
53. *RNA*, document 1.
54. *CDL*, II, 154.
55. *CDL*, I, 55.
56. D. Harrison, 'The invisible wall of St John: on mental centrality in early medieval Italy', *Scandia*, 58 (1992), pp. 177–211, at p. 184.
57. *CDL*, II, 293.

58. Suzanne Fonay Wemple, 'Female monasticism in Italy and its comparison with France and Germany through the eleventh century', in W. Affeldt (ed.), *Frauen im Spätantiken und Frühmittelalter* (Sigmaringen, 1990), pp. 291–310.

59. *CDL*, I, 18.

60. *CDL*, I, 27.

61. For example *CDL*, I, 30; *CDL*, II, 230.

62. C. Troya (ed.), *Codice Diplomatico Longobardo dal 568 al 774* (hereafter cited as Troya), III (Naples, 1853), document 361, p. 34.

63. *CDL*, I, 48.

64. *CDL*, I, 67.

65. *CDL*, I, 120.

66. *CDL*, II, 163.

67. *CDL*, II, 178.

68. For example *CDL*, I, 96 (mother, wife, sister and daughter); *CDL*, II, 136 (mother).

69. For example *CDL*, I, 90 (wife), *CDL*, II, 133 (wife and daughter), 171 (wife), 175 (relative), 194 (mother and sisters), 207 (named woman, presumably relative), 218 (brother, sister, nephews and niece) and 254 (daughter).

70. For example *CDL*, I, 103 and 123; *CDL*, II, 234.

71. Troya, IV (Naples, 1854), document 552, p. 96.

72. *CDL*, I, 83.

73. Brown, *Gentlemen*, p. 74, and Troya, IV, document 644, p. 379, respectively.

74. G. A. Loud, 'Nunneries, nobles and women in the Norman principality of Capua', *Annali Canossani*, 1 (1981), pp. 45–62, reprinted with corrections in idem, *Conquerors and Churchmen in Norman Italy* (Aldershot, 1999).

75. Suzanne Fonay Wemple, 'S. Salvatore/S. Giulia: a case study in the endowment and patronage of a major female monastery in northern Italy', in Julius Kirshner and Suzanne Wemple (eds), *Women of the Medieval World* (Oxford, 1985), pp. 85–102, at p. 85.

76. *CDL*, II, 212.

77. *CDL*, II, 137, 155, 226 and 228. For a discussion of the last charter, see Pohl-Resl, 'Legal practice', p. 216 and note 43.

78. *CDL*, II, 217 and 271.

79. *CDL*, II, 151, 152, 153 and 158.

80. Anna Maria Valerio, *La Questione Femminile nei Secoli X–XII* (Naples, 1983).
81. Bartolomeo Capasso, ed., *Monumenta ad Neapolitani Ducatus Historiam Pertinentia*, I (Naples, 1881), p. 262.
82. *CDL*, I, 24 and 28; *CDL*, II, 180.
83. *CDL*, I, 100; *CDL*, II, 138 and 162.
84. Troya, IV, document 628, p. 347.
85. Raymond Davis (trans.), *Lives of the Eighth-Century Popes* (Liverpool, 1992) p. 93.
86. *CDL*, I, 34/35; *CDL*, II, 219.
87. See below, p. 75.
88. Ross Balzaretti, 'Theodelinda "most glorious queen": gender and power in Lombard Italy', *The Medieval History Journal*, forthcoming.
89. Joaquín Martínez Pizarro, *Writing Ravenna* (Ann Arbor, 1995), pp. 130, 137.
90. King Robert I of France would marry the elderly widow of the Count of Flanders in 988, suggesting that political considerations could outweigh the issue of fertility: A. Davids, 'Marriage negotiations between Byzantium and the West and the name of Theophanu in Byzantium (eighth to tenth centuries)', in A. Davids, ed., *The Empress Theophanu: Byzantium and the West at the Turn of the First Millennium* (Cambridge, 1995), pp. 99–120, at p. 109.
91. *Vita Sancti Barbati*, in *MGH SRL*, pp. 557–563.
92. Brown, *Gentlemen*, p. 76.
93. Troya, I (Naples, 1852), document 292, p. 581.
94. Troya, II (Naples, 1853), document 325, p. 499.
95. Troya, III, document 492, p. 581.
96. Troya, III, document 375, p. 66.
97. Troya, III, document 376, p. 78.
98. N. Ferorelli, *Gli Ebrei nell'Italia meridionale dall'Età romana al Secolo XVIII* (Bologna, 1966).

CHAPTER THREE

Rise of the Dynasties, 774–888

Therefore all you men who are married, flatter your wives so that ye may not suffer . . .[1]

Political change: Carolingian emperors and empresses

The year 774 saw a major political change take place in the northern half of the Italian peninsula, as the Frankish king Charlemagne responded definitively to pleas from the papacy to help it against the aggressive (in the papacy's words) Lombards by conquering the kingdom and, in 800, taking the title of emperor. Charles's intervention was to have long-lasting political consequences for the north. Although interaction with the Franks was nothing new – we have already seen how Frankish princesses were often married to Lombard aristocrats – the eighth-century intervention was the first of many from the Transalpine region.

King Desiderius and his wife Ansa were captured, although it is unclear whether Ansa accompanied her husband into exile in Francia or retired to the royal monastery of St Salvator in Brescia. The effect of the Franks' arrival is felt all over the sources of the period, and many Lombards were pushed further south, where new polities were forming. Arechis, duke of Benevento, took the opportunity, in the absence of a king, to call himself prince of the Lombards. The south was in essence split into two political and cultural regions, with Lombards concentrated in the central-south and interior, and 'Romans' – nominally subject to Byzantium – occupying some coastal cities and the far south; Ravenna in the north had fallen to the

Lombard king Aistulf in 751. The late ninth century would also see Arab incursions into the south, the monasteries of Montecassino and San Vincenzo al Volturno destroyed (the latter never fully to recover), and the Arab conquest of Sicily begun. Bari was occupied and ruled by an emir for twenty years from $c.847$,[2] before being expelled by Charlemagne's descendant, the emperor Louis II. Louis' reign might be seen as a highpoint in Frankish rule in Italy: he was the only emperor to maintain a sustained presence in the south, where he and his wife Angelberga feature in local sources. Particularly vivid is the hostility of the tenth-century *Chronicon Salernitanum* to the empress, whom the chronicler accuses of being domineering and of upsetting local Beneventan women. The early chronicle of the abbey of Montecassino, on the other hand, calls her 'pariter gloriosa Angelberga augusta' (Angelberga the equally glorious empress). Her career is worth reviewing.

Angelberga's career has received a certain amount of attention from scholars.[3] When she married Louis II she obtained land from her husband in eastern Lombardy and western Emilia, as her will of 879 shows.[4] She and Louis became the heads of a government which moved round with them, and it is clear that she shared in his power. Odegaard cites her role in diplomatic missions and in warfare as evidence of her prominence. She also intervened in disputes between Louis and his brother Lothar, as well as between the latter and the pope. Her relationship with Pope John VIII was particularly close, and several extant papal letters were addressed to her. In 874 she was commended into papal protection.

Angelberga and the two monasteries of St Salvator at Brescia (the royal convent) and St Clement Casauria (founded in 873) were the only recipients of large land donations from Louis. Louis died in 875 without a son. In his last years his nobles, 'regarding Engelberge as hateful because of her insolence',[5] had petitioned him to divorce Angelberga in favour of the daughter of the count of Siena. This was clearly owing to the fact that she had only two daughters by Louis, Ermengard, who went on to control St Salvator, and Gisela, who predeceased her parents in 868. However, her position was much stronger than such a challenge suggests. Bougard points out that of eighteen precepts issued by Louis between 855 and 874, eight were addressed to Angelberga. She was responsible for the foundation of the female house of St Sistus in Piacenza, and her position as a powerful patron is clear. She also controlled the royal house of St Salvator/St Julia at Brescia (see below, p. 82). Both houses were to function as places of refuge for her and her daughter, if necessary, reflecting earlier patterns of monastic foundations with protective duties towards female kin.

Besides her ecclesiastical contacts, Angelberga also worked for her own family. Her kinsman Suppo was recompensed for his mission to

Constantinople in 869/870 with the duchy of Spoleto, which probably owed as much to his kinship with the empress as to his work there. Angelberga also procured the deposition of the bishop of Piacenza, Seufrid, in favour of her nephew Paul, provoking a reaction from Pope Nicholas I (although the *Liber Pontificalis* is silent on the issue). The southern chronicler Erchempert, of whom more presently, relates that Angelberga and her daughter were briefly kept prisoners when Louis left them in Capua; she fled to Ravenna, but her daughter died in the south (chapter 36). It is clear that Angelberga made enemies, as the taking of hostages from Capua indicates.

Louis died in 875, and Angelberga's vulnerable position, unable to act for a male heir, is revealed by the number of letters written on her behalf by the pope against men who had violated her properties. Recipients included Emperor Charles the Fat; Wigbod, bishop of Parma; the bishops of Como and Novara, and various Italian counts. Her less than cordial relationship with Charles was not aided by her support of the candidature of Boso of Provence as king of Italy, and she was briefly taken into exile (880–882). She died in Italy in 891.

Angelberga's career as an empress may be exceptional, but as a woman her life opens up many of the major themes of this chapter: wealth, marriage, fertility, patronage and widowhood, set against a background of Frankish interventions in northern and southern Italy.

The sources: narrowing horizons

Paul the Deacon's *History* takes us only to the death of King Liutprand in 744, and narrative sources of the subsequent period are more localised in their coverage. Paul's continuators add brief lines about Liutprand's successors and the rulers of the Lombards further south, including the information that King Ratchis's wife Tasia and daughter Rattruda built and entered their convent in Plumbariola when Ratchis decided to retire to Montecassino. Andreas of Bergamo tells us that one daughter of Desiderius married Charlemagne and another Tassilo, king of Bavaria, and that empress Angelberga accompanied Louis II on his campaigns in southern Italy. Erchempert's *History of the Lombards of Benevento* is similarly selective in its coverage, relating events from 774 to 888 in that principality. Although Frankish sources provide more information on their intervention in Italy, they are excluded from this discussion, as they reflect Frankish, rather than local, attitudes towards women.

The picture is fleshed out a little by local chronicles, for example the *Deeds of the Bishops of Naples*, and hagiography from several regions. However,

difficult though it often is to reconstruct a history of the whole of Italy in this period, the narrative sources continue to reflect political, social and cultural values prevalent at the time. Alongside these we can use the documents generated by the newcomers: the donations and privileges issued by the Frankish kings as well as their capitularies, or laws, for the northern half of the peninsula.

None of the local sources presents the newcomers in a positive light. The *Liber Pontificalis* describes the Frankish presence around Rome in the early 840s as 'pestilential destruction' and 'like a thunderbolt'. In its biography of Pope Sergius II, he is acclaimed by all the people of Rome and their wives and children for having made peace with the Franks. The theme is echoed by Erchempert's statement that the Franks under Louis II 'began to cruelly persecute the Beneventans'. In a later series of episcopal biographies written by Agnellus of Ravenna (see below, p. 74) the arrival of the Franks has Archbishop Gratiosus (r. 784–788) bewailing the breakdown of the social hierarchy and predicting disastrous intermarriages between slaves and the daughters of their masters. Whilst this may not refer directly to the incoming threat, the message of female sexual vulnerability and its consequences is clear,[6] and the abhorrence of women/slave liaisons, so evident in earlier narrative sources, continues.

The impact of the Franks and Arabs is also felt in the surviving charter evidence, which increases sharply in the eighth and ninth centuries. Bougard highlights the persistence of a much stronger written tradition in Italy than anywhere else in early medieval Europe, and estimates that some 2,800 documents survive from the area covered by the kingdom of Italy up to the end of the ninth century.[7] This was owing in part to the Franks' encouragement of the use of written records. Archives were in existence from the eighth century in Lucca (as we saw in Chapter 2), and from the ninth century in Asti, Modena and the abbey of Bobbio. Larger collections can sometimes reveal the document collections of quite modest individuals, incorporated into a monastic archive at the point when the individual or his or her family made a donation to the Church. For example, the chapter of St Antoninus at Piacenza preserves twenty-six documents featuring the modest local official Peter, *sculdassius* of Niviano (some 27 kilometres south-east of Piacenza), which record him and his wife from the day of their marriage in 878 to their will in 898.[8] They are seen extending properties through a mixture of buying, leasing and lending money against mortgaged land. Peter professed Roman law, and married his daughter to a Frank related to the Supponids.

In the south, some one hundred documents dating to before 900 are preserved in the abbey of the Holy Trinity at Cava, outside Salerno, reflecting the lively political and economic activity of the region controlled by the Lombards. These are analysed at the end of the chapter in a case study. A

few charters also survive from the Byzantine or ex-Byzantine parts of the south, but in such small numbers that it is possible to discuss their contents individually.

The *Liber Pontificalis*

The *Liber Pontificalis* continues throughout our period but, when used in conjunction with the growing diversity of narrative and charter sources, reflects an extremely conservative literary culture. Motifs from earlier lives were re-used, thus Pope Hadrian I (r. 772–795) had a 'noble mother', Sergius II (r. 844–847) was sprung from an illustrious mother and schooled by her 'pure devices', and many of the popes were credited with caring for widows. The use of such standard devices possibly betrays lack of biographical knowledge. The work's translator, Raymond Davis, comments on the 'slipshod composition' of the ninth-century lives.[9] Whilst the evidence for the popes themselves may be lacking, the *Liber* continues to depict many women as benefactors of the Church. Theodota, the widow of the prefect Dominic, and the unnamed widow of the scribe Agatho had donated half of the estate called Aratiana to the Roman Church.

The *Liber* also continues to record papal patronage of nunneries. Hadrian I established a monastery for girls on the Caelian hill in Rome and gave it male and female slaves. Some thirteen convents are listed as having been cared for by Leo III (r. 795–816) in Rome alone. In the ninth century, the *Liber* also reflects the growing Arab threat: Pope Paschal I (r. 817–824) ransomed men and women and brought them home from Spain. He also restored the church of St Prassede, where his mother Theodora was buried. An inscription on a column within the church states that Paschal built the chapel of St Zeno there to house his mother's relics.[10] This church is significant now in being one of only a few which retains much of its ninth-century decorative scheme, and includes among its mosaics in the oratory of St Zeno a panel depicting Theodora alongside SS Prassede and Pudentiana and the Virgin Mary. She is labelled clearly as 'Theodora episcopa'.

Although the chapel and its decorative scheme are well known and studied,[11] the significance of Theodora's presence has been surprisingly overlooked. For although the life of Paschal credits him with the restoration of the church, such a prominent depiction of his mother with her title and a square nimbus, indicating that she was still alive when the work was carried out, surely suggests that she was a major (or even the major) donor to the project. It might be suggested that Paschal's high regard for his mother explains the image, but a depiction of this type is highly unusual. Theodora's portrait at the very least raises the possibility that women's

contributions to the Church may well be concealed behind the reported actions of their husbands or sons.

Meanwhile, the nunnery of SS Sergius and Bacchus in Rome was described as destitute. Paschal set up a community of monks there and enriched the house with property so that monks and nuns could concentrate on singing prayers. Once again the gender differences inherent in the monastic life are being emphasised: a female house in difficulty, it was reasoned, would be able to function if joined by a community of men. The issue of why the nunnery had got into difficulties is not addressed, but a common reason may have been the death of the original founder, whether male or female, and the failure of his or her heirs to maintain what might have been a very personal and individual project.

Further convent foundations were made by Pope Leo IV (r. 847–855), who founded a convent to SS Symmetrius and Caesarius near St Xystus and 'filled it with God's handmaids and gave rich gifts'. In a rare reference to ordinary laypeople, this pope also helped a group of Corsican refugees by giving them land in Rome: 'we will also give you what you and your wives and children will be able to live on in plenty until you get it by your own labour'.

One issue which continues to feature in the *Liber* is that of restriction on women's spaces within the large basilicas. At St Paul's Outside the Walls in Rome, the *Liber* speaks of men's and women's sides, and the same arrangement persisted at St Peter's in Rome. Such evidence may not reflect reality: the *Liber* is full of divisions between men and women which seem to fulfil its idea of correct earthly hierarchies rather than actuality. For example, whilst it is credible that processions through Rome might be ordered in a certain way, the account of the celebration of the litany of St George lists those welcoming the pope in strict order: the clergy, chief men, senate, whole militia and entire Roman people, the nuns and deaconesses, noble matrons and all the women, and finally foreigners. If such liturgical events were indeed subject to rigid subdivisions of the congregation, we must wonder how public displays of their humble rank in the community conditioned women's own self-image.

Paschal's life is rather more explicit on the issue of women's space in church: he is said to have remodelled the pontiff's seat in St Maria Maggiore and placed it on a platform because women were standing behind it and he could not have conversations with his clergy without their 'close crowding' and 'intruding'. Gregory IV (r. 828–844) rearranged St Maria Trastevere in a similar fashion and constructed a *matroneum* or women's compartment there fenced with a stone wall.

What was the purpose of such works? Are we to take at face value the *Liber*'s picture of crowding women disturbing the popes at their prayers? Or

were Gregory, Paschal and their predecessors copying ideas from the Byzantine world? Hilje Zomer highlights that early liturgical texts had advocated the separation of the sexes in churches, and eastern churches sometimes had wooden partitions.[12] Or was Rome attracting so many pilgrims, male and female, that some form of crowd control was becoming necessary in the large basilicas? The latter would seem reasonable, but perhaps does not explain fully why women should be corralled behind a stone barrier.

We have already seen, however, that the *Liber*'s account of the Christian community placed women low in the hierarchy, and the physical barriers set up by the popes in their basilicas may have been a concrete expression of such a hierarchy. But such separation possibly depended more on the availability of space to divide up. Hence the Roman examples are all in spacious basilicas. The separation itself may not have been all that rigidly enforced: Paschal only acted when women were perceived to be out of place and above their station, that is, around his chair.

The eighth and ninth centuries were a time of the establishment of ruling dynasties in many of the small fragments which made up the political map of Italy, and the papacy was no exception. Hadrian II (r. 867–872), the *Liber* tells us, was closely related to Popes Stephen IV and Sergius II. During his reign the duke of Spoleto, Lambert, son of Guy, entered Rome and gave the city to his troops to plunder. 'He spared no monasteries or churches; he even granted the girls of noble family ... to his followers indiscriminately for ravishing.' Note here the 'even' – women as vulnerable victims are again being used to show just how bad Lambert was, continuing a theme present in the *Liber* from earlier on. The pope, unsurprisingly, excommunicated the Spoletans until they returned the women and made reparation. It would be interesting to speculate whether this was as punishment for their sin of rape, or with a close eye to his relations with the noble families whose daughters had been taken.

Family power: Agnellus's *Liber Pontificalis Ravennatis*

The *Liber Pontificalis* compiled at Rome has a parallel in an arguably more interesting source, Andreas Agnellus's series of biographies of the bishops of Ravenna, written in the mid-ninth century and including lengthy sermons about the state of the clergy in Agnellus's own day.[13] In many ways Agnellus's work is a Ravennate version of the papal biographies: his early bishops, unsurprisingly, founded monastic houses for men and women, cared for widows and orphans and defended their city against both secular and ecclesiastical invaders (particularly acute is the contest with Rome).

However, Agnellus also used his work to attack contemporary problems, and he has a clear agenda which the multi-author Roman compilation could not match. In his useful study of the *Liber Pontificalis Ravennatis*, Joaquín Martínez Pizarro argues that the cleric was implacably opposed to married clergy, and used a number of devices to try to persuade those concerned to give up their wives by showing how dangerous wives were.[14] In his hands, for example, the story of Rosemund told by Paul the Deacon (see above, p. 55) is reworked into a moral tale about the dangers of domineering wives (chapters 96–97). Of his namesake, the sixth-century bishop Agnellus (chapter 84), the author says that he made his grand-daughter his heir, and adds, 'But it might be asked of me, why did this married man obtain the distinguished episcopal throne?' Agnellus replies that the canons had allowed a married bishop, but his disapproval, in including the rhetorical question at all, is clear. Bishop Sergius (742/752–770), on the other hand, whilst elevated to the see as an engaged layman with a hasty entry into clerical orders, did at least then consecrate his betrothed Eufemia as a deaconess, and clearly angered a number of his clerics with his zeal (chapter 154). We are not told what Eufemia might have had to say.

The outcome of clerical marriages was often children with some claim to their father's position. Families had long tried to secure offices – we see several episcopal dynasties emerging in early medieval Europe, and Ravenna was no exception, with Bishop Marinianus (r. 595–606) being the nephew of Bishop John (r. 578–595). At the same time, aristocratic families founded and held onto churches, often in the teeth of episcopal opposition. Agnellus betrays his own family loyalties when he condemns the avarice of a later bishop, John (r. 778–785), for seizing the church of St Martin at Aqua Longa, for the church belonged to Agnellus's maternal great-uncle, Deusdedit, who fell ill and died as a result of the bishop cursing him. But the bishop, reports Agnellus, was cut down by divine wrath (chapter 163).

Not all bishops were cast as wicked: Agnellus uses lively direct speech to recount the almost saintly tale of Bishop Damian (*c*.692), who was forced to pray over a child's dead body to revive it long enough to say the last rites, after his staff had prevented the child's mother from reaching him on account of the fact that the bishop was being shaved (chapter 125). Reading through this tale, we might pick up a moral story about allowing women access to the bishop, and perhaps a criticism by the author of the crowds of staff surrounding the bishop in Agnellus's own day.

Another aspect of Agnellus's work is his report of the scenes of violence in the city as different factions come out to fight each other on Sundays. Although Agnellus recounts the tale of a particularly brutal murder of an entire group, the Tegurienses, by their rivals, in an earlier age, his account

of the mourning rituals and prayers to recover the bodies of the dead are vivid and may reflect practices in his own day. Married women grieved by their beds, widows put on black clothes, and the beauty of the virgins was impaired. Hair was pulled out, and faces scratched and covered with dust. The matrons wore dark tunics, and the virgins took off their fine clothes, earrings, rings, bracelets, anklets, chokers and other jewellery. Leading the citizens in prayer to find the bodies, the bishop organises them into groups reminiscent of the hierarchies of the Roman *Liber Pontificalis*: clergy were followed by laymen, then women, then the poor. When the bodies were found, not only the murderers, but also their wives and children, were punished. We are in a Roman world here, where women's greater personal freedom presumably brought with it the assumption that they had been willingly complicit with their husbands.

Like Paul the Deacon, Agnellus is keen to show the bad behaviour of women resulting in their punishment. The notary Johannicius, a distant ancestor of the author, had been martyred at the hands of the Byzantine emperor Justinian II. When the latter was deposed, his head was carried on a stick around the empire, and Johannicius's sister prayed to see the murderer of her brother. Going upstairs in her house to get a better view, however, she fell from the window to her death (chapter 142).

In a sense Agnellus idealises a Roman and clerical world which no longer existed except in the literary circles of northern Italy. While the north adapted to the Frankish presence, the south remained relatively unaffected until late in the ninth century, and the far south and Sicily begin to provide us with a series of hagiographies which chronicle near-contemporary saints. Da Costa-Louillet has examined these,[15] and whilst all of the biographies he uses are of men, they, like the *Liber Pontificalis*, include a significant female presence.

Saints' lives and women's lives

The earliest biography is that of St Leo of Catania (*fl.* 780), whose life connects the remaining outposts of Byzantine culture in Italy. Born in Ravenna of pious parents, he became bishop of Catania, protecting widows, orphans and the poor. Leo's *Life* is dominated by his competition with the magus Heliodorus, son of the patrician woman Barbara. Heliodorus was so bad that, to make his friends laugh, he persuaded women (presumably by some form of hypnosis) that they had to cross a river and raise their dresses to their knees to avoid getting wet. This is strikingly similar to the shaming crimes set out in the Lombard laws a century earlier: we are beginning to see a thread of women's modesty of dress permeate the sources. Young girls

of good families were led astray by his influence and made foolish by love, going with the first man they met.

Leo eventually triumphs over the magus, but the nature of the latter's misdeeds is revealing in that the victims of his crimes are women, who are again presented as vulnerable and as an index of how bad Heliodorus was. Leo is thus set up as the protector of their modesty and sexual propriety. But his life also includes post-mortem miracles such as curing the wife of a senator from Syracuse who suffered a flux of blood.

The language used to describe the people in this early southern *vita* shows that the idea of a Roman aristocracy had not yet died out: the magus was the son of a patrician woman (does the reference only to a mother signify anything?), and the recipient of a cure was the wife of a senator. As later saints lives from the area show, this was a twilight before the devastation which accompanied the Arab incursions.

A cluster of hagiographic texts from Naples offers the possibility of women's direct testimony being included in their accounts of miracles. The Life of St Athanasius,[16] the ninth-century bishop of Naples, is entirely conventional in its portrayal of his pious parents (his mother, Drosu, vowing the child to God whilst still in her womb) and the good deeds of the saint in protecting widows and orphans and redeeming captives from the Saracens; but the translation story of the same saint[17] includes as one of its most prominent miracles the case of a certain widow named Blattu who was cured of her deafness. It is rare to find the beneficiaries of miracles named, still less if they are women. The miracles of St Agrippinus[18] in the same city mention a woman named Passara who lived in the city of Naples in the region of Erculense. The latter example may belong more precisely to the tenth century than the ninth, but both evince a concern to correctly record the names (and in one case the address) of the recipients of the miracles. This may have more to do with Naples's strong and persistent notarial culture, but does raise the possibility of oral witnesses being recorded.[19]

John the Deacon's account of the translation of St Severinus[20] into the same city tells of men and women butchered by the Saracens in Sicily and the resultant urgent plan to evacuate the tomb of the saint from the resting place built on the Lucullanum peninsula outside Naples by Barbara, 'illustrious woman'. The party sent to open the mausoleum, however, find it empty and discover the saint's remains only by digging further down. Among the miracles at the new tomb site is the releasing of a young son of a woman of Naples from possession by demons.

John's account of the translation of another saint, Sossus,[21] reveals a rather different attitude towards women, as the party sent to collect the saint delay their entry into Naples in order to avoid the 'copiosas asciariarum et insignium feminarum catervas [the copious crowds of distinguished women

welcoming them]'. The moral of this story, and that of John's account of the empty tomb built by Barbara for Severinus, may well be that such distinguished women's patronage and devotion were more about their own glory than that of the saint.[22] In this respect his text carries more than an echo of Gregory I's words and of the *Liber Pontificalis* in its references to crowds of overenthusiastic women.

Not all ecclesiastical sources were concerned solely with ecclesiastical matters. The *Deeds of the Bishops of Naples*,[23] written by John the Deacon in the late ninth or very early tenth century, reveals clearly how family-based politics dominated that city's church and secular life. A century earlier, the consul of Naples, Stephen, had been chosen by the people as bishop (the author is careful to note that the consul's wife had died years before this, reflecting the same concerns as his earlier northern counterpart, Agnellus). On his death in 799/800, his son-in-law, Theophylact, became consul (note here the transfer of power via a daughter's marriage), but refused to appoint a bishop for fear of upsetting his wife Eupraxia. She is reported saying to the Neapolitans, 'You are happy about the death of my father. Believe me, none of you will become bishop'. After a long stand-off the people came and begged for a bishop to be appointed, 'because we cannot be without a pastor'. She appointed a layman, Paul, and when no one opposed this he was tonsured and made bishop.

John does not comment explicitly on the apparent power of Eupraxia to direct the episcopal election. In the tenth century, Neapolitan women, particularly duchesses, would be powerful and even more prominent in their society, owing largely to their living by more liberal Roman laws. Eupraxia's reported speech, a common device used to give an air of authenticity to the episode, may in fact be the very clue that her show of pique is John's fabrication. Indeed, this unusual story may highlight the tensions in Naples at the end of the ninth century rather than the eighth: whether John the Deacon wrote in the 880s or 890s, his account of the troubles which emerged from hereditary rule or the holding of both offices together would have resonance under the rule of Athanasius II (bishop and duke, r. 878–898).

The work also recounts how marriage also featured in the coup of Duke Andreas of Naples, who came to power *c*.834: he promised his daughter Eupraxia to the Frank Contardus, sent by Emperor Lothar to help against the Lombards, in order to persuade Contardus to stay in the south. The engagement agreed, Andreas reneged: Contardus killed Andreas and married the girl, making himself the ruler. However, such legitimation required military support. When the people of Naples discovered the murder, they rose up against the new duke and slaughtered him and his wife.[24] We should note here the unfortunate role of Eupraxia. Although innocent of any misdeed, she nevertheless ended up a victim of her uncle's diplomacy,

and presumably could not be allowed to remain alive to facilitate another foreigner's takeover of the duchy.

Erchempert's *History of the Lombards of Benevento*

The sources discussed so far convey some sense of the dynastic aspirations which were at the centre of much of Italy's apparently anarchic ninth-century political life. A source which vividly conveys the uncertainties of the period in the south is Erchempert's history of the Lombard princes of Benevento,[25] consisting almost entirely of the fierce competition among Lombard and Neapolitan leaders to achieve primacy in the region from Benevento to the coast.

Erchempert was, like Paul the Deacon, a monk at Montecassino.[26] He wrote his history at Capua in *c.*890, and focuses entirely on southern affairs, viewing with increased distaste the violence and instability which surrounded him. Wickham considers him 'the best historian . . . of our entire period in Italy',[27] although Erchempert himself modestly described his short chronicle as a 'little history' to distinguish it from Paul the Deacon's much longer work. Despite its brevity, however, it is our first narrative account of events in the south at this time.

The extremely fluid political alliances of the period were made and unmade through marriage and reproduction. Erchempert's text is full of political and military alliances made and broken through the medium of a marriage,[28] but the seal was often only set on such unions by the birth of children. The need to make agreements, though, occasionally led to extreme measures. Athanasius of Naples in 884 betrothed his niece, with a baby at the breast ('neptem suam adhuc lactantem') to Lando son of Lando, 'so that the thread of a woman could ensnare him [ut fila feminarum illaquearet eum]' (chapter 53: a pun on the similar-sounding Latin words).

Erchempert's work has attracted some attention from historians for an early excerpt which relates that Duke Grimoald of Benevento repudiated his wife Wantia 'more hebreico [in the Hebrew custom]' on account of her childlessness (chapter 5), a phrase which has been taken to indicate a substantial Jewish population in the city. This may be so, but Erchempert's quote surely has more to do with the author reading the Old Testament than Grimoald consciously copying his Jewish neighbours. There may also be a hint of disapproval in his tone, as he classifies Grimoald's action as unchristian. The despair caused by the sudden loss of husbands is a common theme in our sources, as in the case of the women of Naples, seen barracking the *magister militum* (master of the soldiers) of the city after a disastrous battle against Grimoald's forces (chapter 8). At the same time, the capture of wives also features as a legitimate war tactic.

Women's religious houses: dynastic rule and the Church

A major theme in this period is the further establishment of women's monastic houses, which were used politically as royal and aristocratic families placed their daughters as abbesses. Given the evidence of the *Liber Pontificalis*, discussed earlier, it is worth asking whether continued foundations in the ninth century represent real expansion of women's monasticism, or whether many new houses were in fact replacements for those which had failed? The political vicissitudes of the late eighth and ninth centuries may not have been conducive to longevity. Only the largest and most important houses can be traced continuously: a testimony to the continued patronage of each successive wave of rulers.

Generosity to the Church formed a plank of rulership: in documents surviving from the church of St Modestus at Benevento, the abbot stated in 852 that it had received a gift of land in the Canosa region from Adelchisa, wife of Prince Sicard. Women's houses, however, could be a crucial part of establishing legitimacy and authority. A good example is the court nunnery (Loud's description[29]) of St Sofia in Benevento founded by Prince Arechis, and that of St Salvator at Alife. Another was founded and dedicated to St Mary at Teano in 860 but only settled in 887. All of these, as well as the earlier foundations in and around Capua and Benevento, appear to have survived the Arab incursions of the late ninth century which seriously damaged or displaced larger male houses like Montecassino and San Vincenzo al Volturno. St Marta at Capua, like many female houses, was placed under the protection of Montecassino in 847 when the nuns of St Maria of Cingla were transported there. Such transfers, like earlier papal arrangements, may have been designed to consolidate small houses into more economically viable communities.

New monasteries for women elsewhere in this period included St Radegunda and St Maurizio in Milan; St Maria Albiensi in Naples, founded by Eupraxia (possibly the unfortunate duchess) in the early ninth century; St Alexander at Parma, founded by Cunegunde widow of King Bernard in 835, which was confirmed to the Bernardingi family possibly as vassals of Empress Angelberga;[30] St Sistus at Piacenza, where Angelberga herself was both founder and first abbess; St Martin at Pavia founded by Emperor Lothar and his wife Ermengard; and SS Saverius and Alexander near Arezzo founded by Count Winigis and his wife Richilda for their daughter in 867.

Another example is highlighted in the early eleventh-century Venetian Chronicle of John the Deacon,[31] which relates events from the sixth century onwards (drawn largely from Paul the Deacon and Bede for the earliest centuries). Early in its history the rulers of Venice managed to establish

dynastic rule (the earliest case of power being passed on to heirs cited by Brown is 742). This immediately requires women's presence not only as transmitters of blood and producers of heirs, but also as supporters in other ways. Nunneries were essential religious and cultural centres: Doge Justinian of Venice (r. c.827–828) founded the nunnery of St Zaccaria. The will of Justinian survives,[32] and the importance he attached to his new foundation is explicit. He constituted his wife Felicia and daughter-in-law Romana as his heirs (his son Agnellus had died). Of all his property, divided into three portions, they inherited two-thirds and the Church received the rest. Felicia and Romana were to live in St Zaccaria with all their property. A list of properties for St Zaccaria was included.

St Zaccaria was clearly being set up as a family house, to provide a place of refuge or repose for the women of the family, and to act, perhaps, as a mausoleum of the doges (although Justinian does not appear to give instructions about his burial, and we must remember that the ducal chapel of St Mark was founded in this period[33]). It certainly acted as a burial place after the assassination of Doge John c.863, when the nuns 'carefully procured his body to bury in the church's atrium [cuius corpore sanctae moniales in eiusdem ecclesie atrio sepellire studiose procuraverunt]'. Note the adverb and verb: it is a political manoeuvre. It is entirely possible that the nuns saw the martyred doge as a future saint, hence their care for his body.

Doge Ursus continued the ruler's control of St Zaccaria when he placed his daughter Joanna there as abbess. But daughters were important in other ways as well. Ursus married his other daughter Felicia in about 878 to Rodoald, son of Duke John of Bologna. Slight evidence of the transfer of some form of inheritance rights via women is hinted at when Doge Peter was killed in battle in 887: his successor was another Peter, son of a certain Dominic and a niece of the deceased doge, Agnella.

The above list of convents emphasises the close link between royal and ducal families and the Church in a mutual tie of dependence. By no means all such foundations were for women, but those which were played an important strategic role in establishing and keeping power. In the family-based politics of the early Middle Ages, daughters had high value as potential marriage partners, but their sexual status was paramount. A bride was, from the era of Germanic laws which rewarded her with a substantial morning-gift, expected to be a virgin on her wedding night unless previously widowed. (The anxiety surrounding Lambert of Spoleto's invasion of Rome, referred to earlier, centred precisely on the defilement of *noble* daughters by his soldiers.) Nunneries provided a protected place for this virginity to be conserved until its surrender was required. At the same time, religious foundations provided support and an income to those destined not to marry, including laywomen who held them as rectors.

Where a convent figured as an important part of an incoming ruler's claim to authority, it might receive many grants and thus may have a more detailed history. The formerly Lombard house of St Salvator/St Julia in Brescia is a prime example of this phenomenon.[34] When the daughter of King Desiderius was repudiated by Charlemagne, she retired to her family's house there. Charlemagne, however, was keen to maintain a link with this prestigious female house after his conquest. In 781 he issued a reiteration of its immunity from royal control. This was later confirmed by Louis the Pious at the request of his wife, Judith, who held possession of the monastery as a benefice.

Imperial women continued to have an interest in the royal nunnery. Ermengard, the wife of the next emperor, Lothar, was appointed its rectrix, or lay abbess. She was succeeded by her daughter Gisla. The abbess during their rule was Amalberga, to whom Louis II, Gisla's brother, issued three charters. Three further charters of Louis dealt with Gisla's position. The rectrix supervised the monastery's wealth whilst the abbess looked after its spiritual health. When Amalberga died in 861, Gisla became abbess. Gisla died in 862, but no new abbess was appointed until 879. The office of rectrix, meanwhile, was given to Angelberga, wife of Louis II. Her control appears to have been played out against a background of increasing tension over lay interference in monastic houses: Pope John VIII wrote to the emperor Charles the Bald in 877 demanding that property taken from St Salvator by Angelberga be restored. In 879, the new king of Italy, Carloman, reiterated the house's immunity and donations, and the emperor Charles the Fat made a donation in 886 at the behest of Angelberga.

The picture painted of the Carolingian royal family's interactions with St Salvator/St Julia is at odds with the so-called Carolingian reform of ecclesiastical life going on elsewhere. There is no doubt that the convent benefited indirectly from royal patronage, as Italian and Frankish aristocrats, such as the dukes of Friuli, sought royal favour by giving gifts and sending their daughters to be nuns. The ninth-century necrology surviving from the house records the dead for whom prayers were to be said.[35] Wemple's valuable study of female monasticism in Italy compared with France and Germany[36] attributes the slowness of reform in Italy to the fact that many Italian monasteries were still so new. Nevertheless, the Carolingians imposed large financial demands on the nunneries they 'protected'.

The legal evidence: fluid laws and jurisdictions

The histories and external relationships of monastic houses look remarkably similar in different areas of political rule. However, at the level of more

modest aristocrats and their transactions, charter evidence reveals the changing interaction between Roman and Lombard law and practice, and often highlights the differing jurisdictions of lay and ecclesiastical courts. In northern Italy we see the early development of local customs which took elements from both Roman and Lombard law. For example, Wickham cites the case of Felix of Treviso, who gave property to his daughter in 780, receiving back 'a handkerchief, as *launegild* [the Lombard countergift], according to Roman law'. Nevertheless, it is clear that the notarial tradition in Italy was beginning to encompass some key elements of the Lombard codes, and it is striking that almost all direct citations of the law are made in the case of minors (including women), as we have already seen in the case of the Beneventan emancipation discussed in Chapter 2. An example from 880 at Pistoia in which the nun Roteruda is seeking to make a legally dubious gift to a certain Widulprand, quoted the whole of Liutprand's law 101 (regarding the property that nuns were allowed to have and donate) verbatim.

Alongside the survival of Lombard law, Bougard has demonstrated the issue and use of Frankish capitularies in the north, some issued for the whole of the Carolingian empire, others relating only to Italy. Justice was administered by local officials and by bishops. The biography of the Carolingian *missus* (judge) Wala (*fl.* 822–825), who was first abbot of Corbie and then of Bobbio, gives a dramatic account of how every level of the Italian judicial system and aristocracy conspired to prevent a widow from receiving justice *c.*822. Whilst the example given reads as another quasi-hagiographic indictment of the injustice suffered by a vulnerable woman, it is worth asking what conditions this tale highlights. It is possible that cases of injustice were linked to the fact that, as in other institutions, judicial officials under the Franks were attempting to cling onto their offices and make them hereditary. This may explain the capitulary of Herstal of 779, which expressly made bishops (who in theory could not marry) responsible for the moral conduct and protection of widows. Indeed, marital matters were held far more to be a matter for the bishop than they had been under the Lombards. For example, in 794, Bishop Paulinus of Aquileia sent a letter to Aistulf, who had murdered his wife on suspicion of adultery, but Paulinus's letter was an exhortation to the husband, not an imposed penance. The limitations of the bishop's actions may lie in the fact that under Lombard law, if the adultery was proven, Aistulf had the right to take his wife's life.

A later case cited by Bougard demonstrates more clearly this overlap between lay and clerical jurisdiction and regulations. The imperial vassal Raoul had accused his wife Bava of adultery, and the matter was initially handed over to her relatives to sort out according to Lombard law. However,

Bava's relatives refused to return her to her husband after a year of purgation. The archbishop of Milan, Anspert, was called to convene a meeting of the two parties in the presence of the bishops of Pavia and Piacenza, and Bava's family was threatened with excommunication. We see here the Church becoming established as almost an appeal court, but one which could use ecclesiastical sanctions to enforce secular law.

The ninth century sees a continued disapproval of sexual relations between free women and unfree men, and of widows who, having entered the monastic life, subsequently left to commit 'adultery'. The documents surviving from the abbey of St Clement Casauria in the eastern Abruzzi include the case of the illegal remarriage of the widow Gundi to the Frank Sisenandus in 873. The imperial advocate Maio claimed she had become a nun on the death of her first husband, a statement contested by Sisenandus, who said that he had married her legitimately. A bishop and fifteen witnesses swore she had become a nun, and she and her property were forfeit to the state. Sisenandus was fined 600 solidi and her *mundoald* 150 solidi (citing law 30 of Liutprand), and her goods were confiscated to the royal treasury. However, Sisenandus refused to accept this judgement, and his rebellion earned him condemnation and immortality in the sculpted tympanum or frieze above the door of the abbey, commemorating its history.[37] His goods were subsequently given to Casauria by Louis II in 875, and the abbey held onto them in an agreement with Sisenandus's heirs in 877.

Another marital case which had been referred to Church authorities was that of Ingiltrude, wife of Count Boso, who ran off with one of Boso's vassals in 856.[38] She was ordered to return by Popes Benedict III and Nicholas I and excommunicated in 860. She reached the diocese of Cologne and put her case to Archbishop Gunthar, who consulted other bishops – should he impose a penance on her or send her back to Boso after getting him to promise not to kill her? Ingiltrude apparently threatened to go to the Normans (in this context, the Vikings) if they tried to send her back. Gunthar sheltered her even after Nicholas deposed him 863. All the other churchmen demanded her return – Popes Benedict III and Nicholas I in synods, and Nicholas and John VIII in letters. The *Liber Pontificalis* reports Nicholas's synod, and the statement by the bishops that Ingiltrude had abandoned her husband for seven years and, even when she was excommunicated, bound and anathematised by the godly pope of the supreme see, had shown no concern to return to him. Hincmar of Reims dismissed Gunthar's proposal that she be put under penance because she was part of her husband's flesh and he was in another diocese. Nicholas I had apparently ensured that Boso would not kill his wife if she returned, so for Hincmar this was not the issue. Gunthar was defying the pope. Ingiltrude, more confident, met the papal legate and promised to follow him to Rome

for penance and restoration, but fled on the way and died without returning to Boso.

These two cases of controversial marriages highlight the high stakes that a marital alliance involved at the level of the aristocracy. As well as cementing political associations, marriage involved the transfer of substantial amounts of property, could be high profile and prestigious (and thus messy when they failed), and focused attention on the still loose divisions between secular and ecclesiastical jurisdictions. Indeed, marriage itself was still not a stable institution. Little wonder, then, that the control of women, or more particularly wives, features as a major theme of many of the sources discussed.

Women's land and women's work

With the growing number of charters in the ninth century comes a glimpse at groups other than aristocratic women. The work of women and their role as landowners come into clearer view in charter evidence. Angela Groppi states that the evidence of charters has been used to suggest that women's economic power and ability to work was much greater in the early Middle Ages than later, a thesis which is challenged by Gabriella Piccinni, who calls for an end to such generalisations in Italian medieval history. Galetti's contribution to an older collection of essays on women's work in Italy demonstrates that agricultural contracts of the ninth and tenth centuries vary in the number of women tenants recorded depending on area of custom: in areas of Roman law many women are visible, whilst in Lombard areas they are fewer.[39]

The liberty granted to women by living under Roman law is expressed clearly in surviving southern Italian documents. In 860 Maru, daughter of Leo the count, and her son Leo sold vineyards and lands near Amalfi; in an earlier document of 800–814 from Gaeta, Christopher the count and Herania his wife bought half a field for arable and woodland. In the same city in 839, Elisabeth and Theodosius her son-in-law leased to her brother Constantine, *hypatos* (ruler) of Gaeta two estates at a rent of ten *modia* of corn a year, to be brought to Naples; and in 866 Theodosius conceded further land for the same amount to Constantine and his son Marinus, again with the stipulation to bring the rent to Elisabeth in Naples. Finally, in 887, John the count and his wife Antusa leased a warehouse in Gaeta to a priest.[40]

The women documented in these contracts are clearly of a higher social status than the agricultural workers studied by Galetti, but even their apparent freedom has limits: all four are documented acting with a male

family member. A survey of southern Italian documents from 'Roman law' regions to 1200 reveals few women acting completely alone.

By 867 the Arab attacks on the south were in full flow. Erchempert reports the raiders in the mid-century taking away beyond the sea captives of both sexes and all ages (chapter 17). Later, saints' lives from the region would include sporadic episodes of the disruption caused by continuing attacks in the early tenth century, but the full impact of the raiders was felt in the middle years of the ninth, and it is clear that a favourite tactic was, once again, the capture and ransom of prisoners. Contrary to what might be expected, the victims of the raids, and those ransomed, were not always of high status. In 867, the *coloni* Mauro Botto and Palumbus Bussus and their wives were ransomed from Saracens and freed for 38 solidi. In a dispute between the bishop of Gaeta and some clerics who had put up the ransom, the clerics keep land the *coloni* had lived on.[41] A year later, Peter the tribune and Maria his wife made a gift to the church of San Vincenzo al Volturno (which would itself be sacked by the raiders in 881) for their brother John who had been captured by the Saracens.[42] Was the gift made in the hope that the abbot would intervene with a ransom payment?

Galetti's statement about the absence of women in agricultural contracts is not entirely explained by the presence of Lombard law. Southern examples demonstrate that women could still appear and act in transactions, by simply including their guardians or *mundoalds*. Three documents from Lucera in Apulia, dated by the Byzantine emperor's rule but still Lombard in law, illustrate the point. In 842, three women were able to sell off their quarters of some mills which they had received as *morgengab* when their husbands sold the rest – the document states that they could not sell without their relatives and a judge present, thus echoing almost verbatim Liutprand's law 22. The following year, Risa daughter of Rossemanni had inherited land from her father and wanted to sell it but, again quoting the law regarding women selling on their own, went before a judge with her husband and two other men to do so. Finally, in 845, Peter and Alfarana his wife give themselves, their vineyards and house and moveables to the church of SS Philip and Jacob.[43]

The absence noted by Galetti may have more to do with the type of transactions, mainly leases, she was studying, than with any consideration of the legal background. Perhaps women were squeezed out as agricultural tenants because they had to manage and care for land nearer to their homes, or because the rise of great estates from the ninth century in the north impacted on men and thus doubly so on women (the south was very different in this respect). Women probably dealt with gardens and vineyards close to home, and engaged in textile work and domestic duties. But their absence in one particular type of document does not necessarily mean they

were economically inactive. Bougard highlights a court case of 872 at the court of Empress Angelberga in the presence of Bishop Rorig of Pavia (r. 855–874), in which Gernia daughter of Aelnia was confirmed in possession of the property given to her by Ratcausus, subdeacon of Piacenza, an inquest having demonstrated that the documents she produced in support of her claim were genuine. In 853, a certain Tandeperga, daughter of Talari, bought land at Sopano. Both women lived in regions where Lombard law was prevalent, but it did not prevent them from engaging in the land market.

Muzzarelli[44] emphasises women's important rural role, combining gardening, arable and stock work with managing a house and children and producing cloth. The ninth-century *Life* of St Severus of Ravenna, who lived in the fifth century, says he laboured with his wife and daughter: 'with whom he did women's works ... he was accustomed to weave wool after the manner of women'. The point to note is that the full range of women's work might not appear in certain types of written source simply because those sources were not concerned to record numbers of children (unless they were assets on an ecclesiastical estate), or women's clothing of their household, or the chickens they kept or the garden vegetables they grew (unless the produce of leased gardens was paid as rent). Groppi emphasises the often hidden nature of women's work: whilst men tended to be identified by their trade or occupation in the charter evidence, women might not have seen their primary identity as a worker, but were recorded almost always with their marital status.

Slave labour

According to Frankish law, the right to beat someone, which has strong affinity with the deliberate acts of violence against slaves in the Lombard laws, was sufficient to prove their servile status.[45] Slavery is a continuous presence in medieval Italy, but the myriad of terms used to describe unfree and semi-free people can sometimes mean that the status of many men and women in the documents remains ambiguous. The agricultural contracts studied by Galetti reveal the presence of free cultivators in the north a century earlier than in the south. In the latter region, as we have seen, slave and semi-free families appear quite often in the documents. Slavery persisted but was diminishing, and it is sometimes difficult to determine a person's status since a variety of terms was used to describe them. For example, in 809 the royal official Alipert gave to Montecassino all his lands and one-third of his house in Conversano except one-third of his *familias* who were to be freed for his soul. His son was to receive the other two-thirds.[46]

What is clear is that penal servitude was used and occurs a number of times in the written evidence. In 850, the *pars publica* obtained the person and property of Giseberga, born free but who had married Hisembaldus, a royal slave. In 852 she was given to Seufrid, bishop of Piacenza by Louis II.[47]

However, concern about slaves was centred around more than simply their legal status. The ninth-century Arabic writer Ibn Khurradadhbah's *Book of the Routes and Kingdoms* comments on the Mediterranean trade in Byzantine and Lombard slaves and Roman (Byzantine) girls. This is juxtaposed in Lopez and Raymond's collection of translated texts for Mediterranean trade with the *Pactum Sicardi* (836) between the Lombards and the Neapolitans, which includes a clause in which the latter promise not to buy and export Lombards.[48] This underlines how lucrative the slave trade was (we have already seen a pope unable to dislodge traders from Rome, preferring to buy and liberate their victims), and from the ninth century onwards the value of slaves and the work they did began to be actively assessed by landowners.

Laurent Feller highlights two surviving ninth-century documents recording surveys by the monasteries of San Vincenzo al Volturno and Farfa, both of estates and slaves in the Abruzzo region.[49] Although not as exhaustive as the contemporary monastic surveys or polyptychs known from northern Europe, the lists are informative. The first, for Farfa, dates to the beginning of the century, whilst the San Vincenzo one is later. For our purposes the Farfa survey is the most informative, in that it lists not only male household heads but also women family members, often named. The San Vincenzo list omits women entirely: they are an invisible labour force in this document, and the contrast between the two lists emphasises how arbitrary the nature of written evidence can be in hiding or disclosing women's roles.

Feller notes that despite the fact that some 537 women are listed in the Farfa survey, daughters may be under-represented in the sample. Such disparities in other examples of surveys have given rise to the suspicion that female infanticide was practised among early medieval peasants, but Feller speculates, following Herlihy, that young, unmarried women might instead disappear from the record as they engaged in domestic service in the estate house or, more likely in view of the numbers involved, worked in the estate's *gynaeceum* or women's textile workshop before eventually leaving to marry. Direct references occur to such workshops in both Carolingian and later evidence from various parts of Italy, suggesting that this is a likely explanation.

Women's landowning: the case of Cava

David Herlihy's survey of women's landholding,[50] which examined 63,000 names in over 20,000 charters from Italy between the eighth and twelfth

centuries, shows that the names of women in boundary clauses drops from 6 per cent to 3 per cent of his sample between the eighth and ninth centuries, but that the heirs of women rise from 9 per cent to 10 per cent. As principal donors and alienators in the charters, women figure as principals in 6 per cent in the eighth century, and 7 per cent in the ninth. This suggests that women never made up any more than 10 per cent of the documented landowners of Italy in this period. It does not, however, tell us what proportion of the land they owned. Yet in Lombard areas in particular, their property rights appear to have elevated their potential landownership to 25 per cent of all land. Since exact property dimensions and real estate are rarely included in the charters, it is not possible to assess women's economic power accurately, but a case study of a particularly rich archive may provide useful evidence to test Herlihy's assumptions.

The ninth century is sparsely documented in most regions of Italy, but the abbey of the Holy Trinity at Cava is exceptional in the number of ninth-century local documents (over 100) it preserves. The documents relate to the region around Salerno, where Lombard customs were followed. The documents from the principality reveal that Lombard law was often used and carefully cited in the south long after its promulgation in the north. The earliest document, for example, shows a woman, Cuntruda, receiving her *morgengab* in 792 from her husband 'according to our law [ritum] of the Langobards'.[51]

Of 101 surviving documents, 44 include women in some way, and of these, 21 include women as the main actors or co-actors in the document (see Table 3.1). The remainder feature women as the previous owners of land sold, or as owners of adjoining land or as potential claimants of one-quarter of the property sold (in a clause which is clearly formulaic). The ratio of women as previous owners to women in boundary clauses accords well with Herlihy's figures. Other documents mention male and female slaves or, most interesting of all, show women in this early period signing documents as witnesses, which rather militates against assuming that their status as legal minors was entirely intact. (It is striking that later documents from Cava do not feature women's signatures, suggesting that a tightening of notarial practice led to the law being rigidly enforced.) There are only a handful of such female witnesses, including a certain Walfreda, daughter of Anescausi, who signs in 835, 842 and 848. The feature which links her with the four other named women who sign is that neither she nor they have any apparent interest in the transaction they are witnessing, that is, no relationship can be established between them and the main actors in the document. This may be an accident of the record.

A few documents, like that featuring Cuntruda, record marriages and the transfer of property which accompanied it. Benetruda daughter of Lupus

Table 3.1 Women as main actors in Cava charters to 900

Date	Main actor	Present with her	Selling *morgengab*?	Price
844	Orsa	Husband	Not stated	14 solidi
845	Fredemperga, widow	Not stated	Yes	20 solidi
848	Roda	Husband, son, one other	Not stated	27 solidi
848	Todelperga	Husband	Yes	?
848	Wiseltruda	Husband, brother, uncle	Yes, from first husband	20 solidi
853	Ermeperga	Husband, two others	Yes, from first husband	1 solidus
854	Cussiperga, widow	Brother and one other	Yes	4 tremissi
855	Locerna, widow and nun	Son and one other	Yes	35 solidi
856	Roctruda	Husband, brother, other	Yes	19 solidi
858	Anselgisa	?	Not stated	?
868	Liuperga, widow and nun	Brother (*mundoald*) + 2	Yes	28 tremissi
869	Benetruda	Husband, brother, cousin	Yes	15 tremissi
869	Inielgisa	Husband, uncles	No	10 tremissi
872	Walfa, widow	Relatives for brothers	Yes	gift
874	Wiselperga	Husband	?	?
880	Lupelghisa	?	Yes	?
882	Rodelenda, widow	2 substitutes for sons	Yes	10 solidi
882	Magelchisa, widow and nun	Nephew, relative	Yes, one-eighth	4 solidi
882	Lioperga	Husband	Not stated	3 solidi, 10 denarii
882	Wiletruda, widow	Brother, one other	Yes, one-eighth	6 solidi
883	Teoperga, widow and nun	All relatives dead	Yes	gift

received her *morgengab* in 860, Orsa daughter of Ursus in 882. The latter document is interesting in a number of ways. It records the marriage of Orsa, who was a widow, to John the notary, and because he is also writing the document it is substantially fuller than most *morgengab* records. She has agreed to 'accept' him as her husband, he to 'take' her (the language of marriage matching later iconography where the man holds his bride securely by the wrist), and he has guaranteed to her cousin, who is presumably acting as her *mundoald* although this is not stated, that he will treat her well. The *morgengab* handed over, however, is to be only one-eighth of his property, not the more normal one-quarter. This mirrors two other documents of the same year in which a widow, Magelchisa, sells her *morgengab*, also stated to be one-eighth. In the ninth-century sample these documents appear to be a 'blip' in the more normal pattern, but can they be explained at all?

Morgengab was a thorn in the side of many husbands' families. Their new daughter-in-law had the right to claim up to one-quarter of the property,

and to retain it when widowed (though not usually in outright ownership unless there were no children). Thus men's transactions from this period (for example, in 860, 872, 877 and 882) frequently include a clause, at the end of a transfer of land, which promises the receiver of the property appropriate compensation should the wife of the person alienating it (or, occasionally, his mother in the case of a son selling part of his inheritance) claim that one-quarter belongs to her. The alternative, also quite frequent, was for the woman to include her quarter in his sale, as Todelperga did in 848 as part of her husband Lupus's sale.

Furthermore, all of the women authors documented in the ninth-century Cava sample are shown alienating, usually selling, land, and in almost all these cases the land in question is the *morgengab*. From Table 3.1 we can see that not all women selling *morgengab* were widowed, but the two who sell land from their previous husband may well have been selling it back to their former in-laws (this is not, however, stated in the documents). Walfa's document in 872 and Rodelenda's and Wiletruda's in 882 convey special circumstances in which the sales are taking place: the presence of the Saracens in the area. Walfa's brothers have been captured by them, as has one of Rodelenda's sons; her other son cannot reach her from Nocera because of the siege, which Wiletruda's document refers to explicitly as a reason for selling her eighth for food. These documents are the key to the earlier marriage transaction of John and Orsa: it appears that the Saracen presence in 882 explains the temporary reduction in the size of *morgengab*, as families sought to limit the amount of land they lost, in an emergency situation where it could not easily be replaced.

The other feature thrown up by Walfa and Rodelenda's transactions is the fluidity of the *mundium* in times of disruption. Walfa's brothers cannot oversee her gift to the church of St Maximus, so other relatives step in. In the absence of Rodelenda's sons, two men whose relationship to her is not stated act as substitutes. But in all the alienations a strict notarial and legal form is followed: the women have to appear before a judge, with male relatives, and frequently state that they are making their transaction of their own free will without violence. Teoperga in 883 goes further. In her gift of her *morgengab* to the church of St Maximus, she states that she is a widow and taking the veil, and that the gift is for the soul of her husband and her 'most beloved [amantissimus]' son. But the law, she says, states that a woman may give only one-third of her property to the Church, but since all her relatives are dead and she has come under the *mundium* of the princely court, the prince's representative permits her to make the gift. What is striking here, apart from the legal aside, is that she has a daughter who is to be supported with her mother and is to receive a house in the city.

The church of St Maximus had been founded by prince Guaiferius, and his widow Landelaiche is seen in the documents actively promoting its well-being. Prince Guaiferius had charged it in 868 to care for the poor, widows and the weak, and Walfa's proviso that her mother be cared for and Teoperga's about her daughter suggest that the church was fulfilling this function. In 882, Landelaiche and Guaimarius secured the church's freedom from episcopal control. The prince made a gift to the church in 886 at his mother's request.

This documentary sample reveals many women taking the veil on widowhood. Apart from those listed in Table 3.1 (including Liuperga in 868 'dressed in religious dress [qui vestem sancte religionis sum induta]', Crescentia 'nun and dressed as one [ancella dei ac monasticam beste]' is documented in a land sale of 857. Merola the nun, who with her son won a dispute in 875, was almost certainly a widow. It is unclear where these women ended up: their documents suggest that they lived as vowesses, remaining chaste and wearing monastic dress but continuing to manage their property. It is unclear how much formal provision for claustration existed at Salerno, although the nunnery of St George is thought to trace its origins to the eighth century.[52]

Conclusions

The narrative sources from Italy in this period continue to portray women in a narrow range of roles little changed from earlier patterns. They focus on the deeds of the powerful, often to set formulae, are interested in the unusual and exotic, and present their era as a period of violence and lax morals. Women are seen as pious donors, as passive partners in marriage alliances or as a source of evil intentions. Such limited dimensions are not surprising, given the clear reliance of early ninth-century clerical writers on their precursors. Yet subtle changes are visible, if the evidence is read closely. Localised hagiographies may include women's testimony; women are still seen as transmitters of power and authority; a clear difference is emerging between those citing Roman law and those following Lombard custom, and their continued role as patrons of the church reveals them to have disposable property.

Charters show women as landowners and as family members, but they also allow us to look further down the social scale from the politically active elites, to see choices being made about the management of property, and to see the practical effects of two major traditions of law which circumscribed their actions. Whether Lombard or a mixture of Lombard and Frankish

custom, Germanic laws were more restrictive of women's ability to make decisions about their property, and the only situation in which a little freedom was permitted was when the woman was making a pious donation. Even then, the legislation was sometimes cited to emphasise the legality of her actions. Contrast this with the case of women living in the former Byzantine enclaves where Roman law was predominant. Although not entirely free to choose, and often accompanied by male relatives, they nevertheless seem to have had a degree of independence and, if we take the narrative sources at face value, political power. However, as the stories of Agnellus of Ravenna and John of Naples reveal, along with legal identity came legal responsibility, and women could therefore be held to have colluded in their husbands' actions, suffering the same punishment. Lombard-style protection under the institution of the *mundium* has been seen as oppressive to women, but 'liberal' Roman law arguably made women more vulnerable to attack, and did not offer the opportunities for exploitation of their position that Lombard women might sometimes employ. We return to this issue in the next two chapters.

Notes

1. *Agnelli qui et Andreas Liber Pontificalis Ecclesiae Ravennatis*, ed. O. Holder-Eggar, in *MGH SRL*, pp. 265–391 (hereafter *Agnellus*), chapter 97.

2. G. Musca, *L'Emirato di Bari, 847–871* (2nd edn, Bari, 1967).

3. Particularly Charles E. Odegaard, 'The empress Engelberge', *Speculum*, 26 (1951), pp. 77–103.

4. Chris Wickham, *Early Medieval Italy* (1981), p. 212.

5. Odegaard, 'Empress Engelberge', p. 80, quoting the Annals of St Bertin.

6. T. S. Brown, *Gentlemen and Officers: Imperial Administration and Aristocratic Power in Byzantine Italy, AD554–800* (Rome, 1984), p. 126.

7. François Bougard, *La Justice dans le Royaume d'Italie* (Rome, 1995), pp. 80–108, breaks these down by date, location and transaction type.

8. Bougard, *Justice*, pp. 73–74, 168–169.

9. Raymond Davis (trans.), *The Lives of the Ninth-Century Popes* (Liverpool, 1995), p. 1.

10. Marianne Asmussen, 'The chapel of S. Zeno in S. Prassede in Rome: new aspects on the iconography', *Analecta Romana Instituti Danici*, 15 (1988), pp. 67–86.

11. Most recently by Rotraut Wisskirchen, *Das Mosaikprogram von S. Prassede in Rom* (Münster, 1990), largely omitting the Zeno chapel; G. Mackie, 'The Zeno Chapel: a prayer for salvation', *PBSR*, 57 (1989), pp. 172–199; M. B. Mauck, 'The mosaic of the triumphal arch of S. Prassede: a liturgical interpretation', *Speculum*, 62 (1987), pp. 813–828.

12. H. F. H. Zomer, 'The so-called women's gallery in the medieval church: an import from Byzantium?', in Adalbert Davids (ed.), *The Empress Theophanu* (Cambridge, 1995), pp. 290–306.

13. T. S. Brown, '*Romanitas* and *campanilismo*: Agnellus of Ravenna's view of the past', in C. Holdsworth and T. P. Wiseman (eds), *The Inheritance of Historiography, 350–900* (Exeter, 1986), pp. 107–114.

14. Joaquín Martínez Pizarro, *Writing Ravenna: The Liber Pontificalis of Andreas Agnellus* (Ann Arbor, 1995).

15. G. Da Costa-Louillet, 'Saints de Sicile et de l'Italie méridionale aux VIII, IX et X siècles', *Byzantion*, 29/30 (1959/60), pp. 89–173.

16. *MGH SRL*, pp. 439–449.

17. Ibid., pp. 449–452.

18. Ibid., pp. 463–465.

19. The preservation of women's oral testimony has only recently been addressed: Elisabeth van Houts, *Memory and Gender in Medieval Europe, 900–1200* (Basingstoke, 1999); eadem (ed.), *Medieval Memories: Men, Women and the Past in Europe, 700–1300* (2000).

20. *MGH SRL*, pp. 452–459.

21. Ibid., pp. 459–463.

22. For another example, see below, p. 121.

23. G. Waitz (ed.), *Gesta Episcoporum Neapolitanorum*, in *MGH SRL*, pp. 398–436.

24. *Gesta Episcoporum Neapolitanorum*, ch. 57.

25. G. Waitz (ed.), *Erchemperti Historia Langobardorum Beneventanorum*, in *MGH SRL*, pp. 231–264 (hereafter *Erchempert*).

26. Huguette Taviani-Carozzi, *La Principauté Lombarde de Salerne (IXe–XIe Siècle)*, I (Rome, 1991), pp. 37–62 discusses Erchempert and his work.

27. Wickham, *Early Medieval Italy*, p. 147.

28. *Erchempert*, chapters 48, 50.

29. G. A. Loud, 'Nunneries, nobles and women in the Norman principality of Capua', *Annali Canossani*, 1 (1981), pp. 45–62, reprinted with corrections in idem, *Conquerors and Churchmen in Norman Italy* (Aldershot, 1999).

30. C. Violante, 'Quelques caractéristiques des structures familiales en Lombardie, Émilie et Toscane aux XIe et XIIe siècles', in G. Duby and J. Le Goff (eds), *Famille et Parenté dans l'Occident Médiévale* (Rome, 1977), pp. 87–149, at p. 100.

31. G. Monticolo (ed.), *Cronache Veneziane Antichissime*, I (FSI 1, Rome, 1890).

32. A partial translation is in R. S. Lopcz and I. W. Raymond (eds), *Medieval Trade in the Mediterranean World* (New York, 1955, reprinted 1990), pp. 38–41.

33. Ennio Concina, *A History of Venetian Architecture*, trans. Judith Landry (Cambridge, 1998), pp. 19–22.

34. The following account largely follows Suzanne F. Wemple, 'S. Salvatore/ S. Giulia: a case study in the endowment and patronage of a major female monastery in northern Italy', in Julius Kirshner and Suzanne F. Wemple (eds), *Women of the Medieval World* (Oxford, 1985), pp. 85–102. See also Katherine Fischer Drew, 'The Italian monasteries of Nonatola, San Salvatore and Santa Maria Teodota in the eighth and ninth centuries', *Manuscripta*, 9 (1965), pp. 131–154.

35. A. Valerio, *La Questione Femminile nei Secoli X–XII* (Naples, 1983), p. 27.

36. Suzanne F. Wemple, 'Female monasticism in Italy and its comparison with France and Germany from the ninth through the eleventh century', in W. Affeldt (ed.), *Frauen in Spätantike und Frühmittelalter* (Sigmaringen, 1990), pp. 291–310.

37. Laurent Feller, 'La fondation de San Clemente a Casauria et sa représentation iconographique', *MEFRM*, 94 (1982), pp. 711–728.

38. Discussed by Jane Bishop, 'Bishops as marital advisors in the ninth century', in Kirshner and Wemple (eds), *Women of the Medieval World*, pp. 53–84.

39. Angela Groppi (ed.), *Il Lavoro delle Donne* (Rome and Bari, 1996), p. viii; Gabriella Piccinni, 'Le donne nella vita economica, sociale e politica dell'Italia medievale', in Groppi (ed.), *Lavoro delle Donne*, pp. 5–46; Paola Galetti, 'La donna contadina: figure femminili nei contratti agrari italiani dell'alto medioevo', in Maria G. Muzzarelli, Paola Galetti and Bruno Andreolli (eds), *Donne e Lavoro nell'Italia Medievale* (Turin, 1991), pp. 41–49.

40. *CDA*, II, document 584; *CDC*, documents 1, 5, 12, 14, respectively.

41. *CDC*, document 13.

42. Bartolomeo Capasso (ed.), *Monumenta ad Neapolitani Ducatus Historiam Pertinentia*, I (Naples, 1881), p. 266, document 4.

43. *CodCav*, I, documents 21, 22, 25, respectively.

44. Muzzarelli, Galetti and Andreolli (eds), *Donne e Lavoro*, pp. 15–16.

45. Bougard, *Justice*, p. 251.

46. A. Gallo, 'Il più antico documento originale dell'archivio di Montecassino', *BISIAM*, 45 (1929), pp. 159–164.

47. Bougard, *Justice*, p. 402.

48. Lopez and Raymond (eds), *Medieval Trade*, pp. 31–35.

49. Laurent Feller, 'La population abruzzaise durant le haut moyen age: les conditions de possibilité d'une croissance démographique (VIIIe–IXe siècles)', in Irma Naso and Rinaldo Comba (eds), *Demografia e Società nell'Italia Medievale, Secoli IX–XIV* (Cuneo, 1994), pp. 327–350.

50. David Herlihy, 'Land, family and women in continental Europe, 701–1200', *Traditio*, 18 (1962), pp. 89–120, reprinted in S. Mosher Stuard (ed.), *Women in Medieval Society* (Philadelphia, 1976), pp. 13–45.

51. *CodCav*, I, document 1.

52. L. Cassese (ed.), *Pergamene del Monastero Benedettino di S. Giorgio (1038–1698)* (Salerno, 1950); Maria Galante (ed.), *Nuove Pergamene del Monastero Femminile di S. Giorgio di Salerno*, I (Altavilla Silentina, 1984).

CHAPTER FOUR

The Long Tenth Century, 888–1000

For in the beginning you were called 'virago'[1]

The fragmentation of power

After a period of relative stability in the north under Carolingian rule, the early tenth century is commonly characterised as one of turmoil and political upheaval in Italian history. In the north, as Carolingian rule finally died with the overthrow of Charles the Fat in 887 (and had effectively ceased with the death of Louis II in 875), rival claimants emerged for the kingdom of Italy. The bitter civil wars and their impact on the women of the competing families in this 'national period' up to 951 is relatively well documented, culminating in the intervention of the German king, Otto I, and his assumption of the imperial title in 962. Although the kingship of Italy was still a prize to be competed for, this was also the age of increasing localisation in Italian politics, when the retreat of royal or public authority enabled local families to carve out their own spheres of influence. Military crises might also have unexpected results for women. For example Liutprand, bishop of Cremona (*c*.921–*c*.972) reports that the Hungarian invasion in 923 led to great dearth of knights in the mid-tenth century when he was writing. Might the absence of men provide openings for women to exert power? It is to Liutprand, too, that we owe the enduring image of the papacy in the early tenth century reduced to a Roman 'pornocracy' through the rule of women.

Further south, the dominant trend of fragmentation was repeated, with small, independent territories emerging from loose Byzantine control and

breaking away from the Lombard duchy of Benevento. Among the former were Gaeta, Amalfi and Naples, three cities for which the tenth century was the period of their greatest prosperity and prominence. Benevento, meanwhile, saw first Salerno and then Capua establish themselves as separate Lombard principalities. Later in the century, Otto I attempted to intervene in southern politics, with a marked lack of success.

The sources from this period are shaped by, and shape our perception of, the political changes which were taking place. Narrative sources come from a number of the bishops installed by Otto I and his successors in the dioceses of northern Italy. Chief among them in terms of his influence on subsequent historiography of the period was Liutprand, whose *Antapodosis* ('Tit-for-tat') was openly hostile to the Italian kings and whose corpus of surviving works supports the Ottonian claim to power.[2] A less fortunate beneficiary of Ottonian patronage was Rather, bishop of Verona, who left a substantial collection of works including hagiography, sermons and letters as well as lengthy works detailing his complaints against his own Veronese canons and the *Praeloquia*, an extended sermon on the morals and behaviour of the time.[3] Rather's career underlines the fragility of Ottonian rule when faced with the entrenched local families – he was forced to leave his see three times.

Another Ottonian bishop was Gerbert who, having been a member of Otto I's court, came to Italy in 980 with Bishop Adalbero on a political mission to Otto II. The two bishops met Otto II at Pavia and accompanied him to Ravenna. For his services, Gerbert was made abbot of the monastery of St Columbanus at Bobbio, but, like Rather before him, the death of his patron in 983 led to him fleeing the abbey and seeking refuge with the dowager empress Adelaide, widow of Otto I, at Pavia. By supporting Adelaide and the empress Theophanu (widow of Otto II) in establishing the latter's son, Otto III, on the throne, Gerbert was able to remain abbot of Bobbio until his elevation to the papacy as Silvester II. Gerbert leaves a considerable number of letters, some of which relate to women's roles in Italy.[4]

In the south, the ending of Erchempert's chronicle is partly compensated for by the anonymous, tenth-century *Chronicon Salernitanum*,[5] which deals with the political intricacies surrounding the princes of Salerno from the eighth century (it is clear that the chronicler has read Paul the Deacon and, possibly, Erchempert) to the career of Gisulf I (r. 943–978). Although often uncertain in its factual evidence, it has been cited by Paolo Delogu as a valuable mirror of tenth-century Salernitan society.[6] Its information is supplemented by a series of tenth-century saints' lives from Calabria and Sicily studied by Da Costa-Louillet.[7] To judge from the accounts of their careers, saints were acting as (or, at least, were being portrayed as) alternative leaders

of their communities and diplomatic envoys: in fact fulfilling the functions that their episcopal colleagues further north were expected to perform.

The most dramatic result of the political changes of the period, however, was the further and vast increase in production and conservation of charters. Bougard estimates that some 3,000 survive from the former kingdom of Italy in the north. An additional 900 are available from the south, with Naples (281) and Salerno (388) the major centres of activity.

Charters continue to provide the best evidence of the legal status which women enjoyed during this period, but political acts might radically affect that status. An early imperial (that is, German) concession in the tenth century to all Genoese women, for example, allowed them the legal personality afforded by Roman law. In an age where territorial possession equalled power, it was important for those who aspired to rule to demonstrate their generosity by granting such privileges, property or protection, or confirming the grants of previous rulers. Written evidence had become a necessary corollary to this process, proving ownership once the dust of a political takeover had settled. Families maintained their local position through soliciting confirmations from new rulers, and by patronising ecclesiastical foundations which could act either as repositories of family land or as protectors of the family members themselves. A favourite tactic, not new in the tenth century but arguably more exploited, was patronage of powerful or influential religious houses. In an age of political uncertainty, gifts might require confirmation by each successive family or generation, enabling the reconstruction of family ties in more detail than before.

Women and family politics: sex and the struggle for power

Family relationships were cemented by marriages, themselves incorporating transfers of property. The *Chronicon Salernitanum* includes a digression on why men should take wives, put into the mouth of the ninth-century prince Sicard. A husband, he says, was chosen for his strength, family background, handsomeness and wisdom; a wife for her beauty, family, wealth and dowry, but choosing beauty over wealth was a grave mistake.[8] When political alliances mattered, women become far more visible in the role as wives and mothers, marrying to cement an agreement or defending their children's rights. Against a background of increasing localisation in politics, more might rest on the success of such unions.

Although the role of women as wives, mothers and daughters of major political figures has long been acknowledged (and romanticised), it is only

in the past thirty years or so that their role as active participants in the alliances and strategies of their kin has really begun to be teased out by historians. The pioneering work of Pauline Stafford on the queens and aristocratic women of Anglo-Saxon England, that of Janet Nelson on Carolingian aristocratic women, and the classic studies of Ottonian royal women by Karl Leyser serve as models for the types of study required, and the fruitful results they can produce.[9] Only belatedly have historians of medieval Italy focused on the family politics of the aristocracy here, owing partly, it would seem, to the difficulties of synthesis noted earlier in this study. Particularly in the case of the struggle for the kingship, the bloodlines of women and their role in transmitting legitimacy to those whom they married is apparent.

Prominent figures in Italian politics of the late ninth and tenth century include Berta, widow of Adalbert II of Tuscany and daughter of the Carolingian Lothar II; Gisla and Ermengard, first and second wives of Adalbert of Ivrea; Willa, wife of Berengar II; and Marozia, the ruler of Rome (r. 928–932). Later, after the German interventions of the mid-tenth century, Adelaide, widow of Otto I, and Theophanu, widow of Otto II, would have their own struggle for power. The political role of these women has not been ignored, and their place in the institutional history of Italy has often been examined, as is discussed below. The sheer wealth of documentation which becomes available from this century, however, demands that further studies be undertaken, shifting focus from the institutional to the personal, which in this period was perhaps more relevant to the balance of power.

In her study of the family of King Berengar I (r. 888–924), Barbara Rosenwein emphasises this latter point, proposing that early medieval rulers were far more interested in manipulating alliances than in centralising their rule.[10] Berengar's career exemplifies this, as he sought out allies through key women. He himself married Bertilla of the Supponids, the niece of Empress Angelberga, and his daughter Gisla married into the powerful Anscarii, the marquises of Ivrea. He also used well placed gifts via the female members of his family to further his interests.

Bertilla, in particular, had a wide circle of friends, and her brother Ardingus became Berengar's archchancellor. She had the title *consors*, denoting someone who shared the prerogatives of the ruler but also recalling an earlier title borne by Angelberga, the implications of which are discussed presently. Bertilla never acted as an envoy or soldier, but orchestrated Berengar's gift-giving, thereby buying up allies, especially when threatened by Louis III, grandson of Louis II. Bertilla's one failing, in the familial politics of the time, was that she did not have a son, and once the threat from Louis III was over (Berengar having captured and blinded him), she was charged with adultery and died by poison.

```
                                    ┌─────────────────────────┐
Lothar II                           ?              Angelberga = Louis II
   │                                │                          │
Berta = Adalbert II         Bertilla = BERENGAR I    Ermengard = Boso
   │                                │                          │
┌──────┴──────────┐                 │                          │
HUGH  Boso  Ermengard(?) = Adalbert = (1)Gisla            Louis III
       = Willa            │
         │             Anscarius
       Willa(II)          =         BERENGAR II
```

Figure 4.1 Family ties and the kingship of Italy

Gisla, Berengar's daughter, is a shadowy presence. The date of her marriage to Adalbert of Ivrea, son of Anscarius, is uncertain, but possibly 898. Her husband's support of Louis III, in opposition to Berengar, must have caused difficulties, and raises the question of divided loyalties in women who found themselves in this position. After Louis was blinded in 905, Adalbert appears to have returned to the fold. He appears last in Berengar's charters in 913, and shortly afterwards he married Ermengard, daughter of Adalbert II, marquis of Tuscany and his wife Berta. Whether Gisla had died or was the victim of political expediency is unclear: certainly Adalbert had entered a new political circle. His son by Gisla, Berengar II, would assume the Italian crown in 950, whilst Anscarius, his son by Ermengard, succeeded him as marquis of Ivrea (see Figure 4.1).

The career of Berta, daughter of Lothar II and wife of Adalbert of Tuscany, reveals that women were not simply passive bystanders in the politics of the period. As the transmitter of legitimacy through blood, she was in fact a key player. During her marriage and after the death of Adalbert, she was considered a major force in Italian politics, and her political aspirations may have extended much further than the Tuscan region or even the kingdom of Italy. A surviving tenth-century manuscript reveals her to have sent a letter with an embassy c.906 to the caliph of Baghdad, al-Muktafi. First brought to light by Muhammad Hamidullah, the existence of the letter and Hamidullah's work was further highlighted by Giorgio Levi della Vida in 1954.[11] He demonstrates that from her marriage around 895 until her widowhood in 915 she 'undertook an extraordinary amount of public activity', including sending the embassy.

Della Vida suggests that her motives for contacting the caliph may have been to support her husband's attempt to become king, perhaps by aspiring to extend their Tuscan heartland southwards. Pressure on the Byzantines from the Muslims might help to achieve this expansion. However, her relationship with the Byzantines appears to have been cordial, if we take

the Byzantine emperor Constantine Porphyrogennitus's reference to her as the 'great Berta' at face value. Berta's actions might be better interpreted as an attempt to confer a stateliness on her husband through international contacts which he had largely lacked. In this she demonstrates the ways in which women might not only support their husbands in the political struggle, but also instigate new ways in which to do so.[12]

Berta died in 925 and is commemorated with an elaborate epitaph at Lucca which may have been commissioned by her daughter Ermengard:

> Here, covered by this stone, lie the bodily remains of Berta, countess of renowned descent, kind and pious, she was the wife of Adalbert duke of Italy, and had every embellishment of a royal kind. Noble, of the high stock of the kings of the Franks, the pious king Charles was himself her grandfather. By appearance splendid, by good deeds more splendid, this daughter of Lothar was made more beautiful by her kindnesses. She remained happy whilst in this life, for no enemy was able to conquer her. With learned advice she restrained many rulers, for the great grace of God was always with her, and many counts came from afar to seek her mellifluous conversation. She remained a most dear mother to unfortunate exiles and always gave alms to pilgrims. This wise matron was famed as a pillar of strength, of great virtue, a glorious light throughout the land. She left this life on the Ides of March, she lives with the lord in peace. Her death caused many sadness and pain, and the people wept from dawn to dusk. Now Europe sighs, now all Francia, Corsica, Sardinia, Greece and Italy mourn. Whoever reads this verse, go tell all others: 'The Lord gave her eternal life'. Amen. The year of the Lord 925, the 13th indiction, she left this world.[13]

The inscription provides a valuable testimony to how her contemporaries, at least, wished Berta to be memorialised and is also a powerful political statement. Although her deceased husband is mentioned, it is Berta's nobility of birth which is being emphasised by her daughter.

The connections to be made through women are vividly illustrated in the next chapter of the struggle for royal power in Italy, played out in the middle of the century between Hugh of Provence (926–945), Berta's son, and Berengar II (d. 966). The key fact to note is that the contenders were related to each other: Berengar was married to Hugh's niece Willa (d. 966), the daughter of Willa and Hugh's brother Boso. Both men could claim descent from the Carolingians through the female line (see above, Figure 4.1).

The importance of the female actors and lines of descent in this political drama was acknowledged by contemporary writers such as Liutprand of Cremona. He explains the importance of such women in terms of sexual licence, and has been held up as a prime example of clerical misogyny.[14]

Wickham considers that most of the women are only names to us, the nominal rulers of land alienated by their menfolk, or the counters with which kin groups made alliances through marriages. Yet this seems to play down the importance of the women. When the contest became that between indigenous rulers and the German kings, it was the women who formed the focus of external attack. Only if their authority was undermined could the power of their husbands and sons be challenged. This hints at something more than simple political pawns.

In a recent study of Liutprand's *Antapodosis* ('Tit-for-Tat'), Philippe Buc has shown that Liutprand's main purpose was to serve Otto I, who first came to Italy in 951. His main theme was to discredit all the Italian-based candidates for the kingdom, undermining Otto's rivals by setting up a contrast between morally corrupt Italian hussies and morally virtuous German matrons. Buc's use of anthropological analysis to show how female rank and status could be manipulated to reflect well or badly on their male relatives is particularly effective in revealing the relevance of women.[15] Here they take on the status of more than pawns: they are powerful ideological weapons in the propaganda battle, and Liutprand appears to have been able to play on the fear of the strong woman and on xenophobic sympathies to get his point across. He therefore attacks Queen Willa, her mother Willa, Berta of Tuscany and her daughter Ermengard. Thus Queen Willa, wife of Berengar II, is portrayed as adulterous and as casting spells on her husband. Yet, in charters Queen Willa was highly favoured by her husband and shared as *consors regni* the power of her husband. Dynastic marriages brought these women great wealth as well – charters outline their roles as helpers, associates and warranters of peace.

Berta is another of Liutprand's targets, able to resist Berengar I only through systematic adultery. Her daughter Ermengard (d. 932) is also characterised as sharing her sexual favours, especially with King Rudolf (r. 924–926). However, Liutprand's picture of these women was, Buc argues, based neither on clerical misogyny nor on his own objections to powerful women. This is clearly illustrated by his positive treatment of the Ottonian women. What he was trying to do was to question the legitimacy of descent of the rival claimants Hugh and, in particular, Berengar, whom the *Antapodosis* appears to target. By claiming that Willa was an adulteress the paternity of her children becomes uncertain, undermining Berengar's husbandly authority.[16] He omits to tell us about the Italian women's descent from Carolingians. The women are a way of attacking the men by casting doubt on legitimacy and on relationships. Buc's views have recently been questioned by Ross Balzaretti, who points out that Liutprand's misogyny cannot be easily argued away if one aspect of the *Antapodosis*, its humour, is analysed

with gender in mind. Instead, Balzaretti argues that, 'a writer as clever as Liutprand could easily adopt many literary strategies: he could certainly blacken the reputations of Carolingian women while moralising about the place of women in society at large.'[17]

How, then, can Liutprand's rhetoric be read, and what value, if any, does his highly coloured picture have for our knowledge of women's roles in this period? His treatment of the women rulers of Rome in the early part of the century is often singled out as a good example of his inherent misogyny: can it be read in a different way?

The Roman 'pornocracy'? Theodora, Marozia and Theodora

Liutprand has left a scathing account of the history of Rome in this period which found its way into the secondary literature with little criticism of his clear prejudices. The city was dominated in the first half of the tenth century by the family of Theophylact (see Figure 4.2), including periods when women, most notably Theodora and her daughter Marozia, appear to have ruled (the period being characterised memorably by one historian as a 'pornocracy').

Whilst Liutprand uses vulgar anecdotes and casts sexual aspersions on the Carolingian women discussed above, he saves particularly venomous prose for his attacks on the women of the Theophylactan dynasty: Theodora, the wife of the senator Theophylact and their two daughters Theodora and Marozia. His picture of them has been influential: the foreword to a reissue of Liutprand's translated works in 1993 was still able to call Marozia a 'sinister figure'.[18] The key passage is in Liutprand's *Antapodosis*:

```
                    Theophylact = Theodora I
         ┌──────────────────┴──────────────────┐
    Theodora II                          Marozia  ≈ (1)Sergius III (pope)
    ┌────┴────┐                                   │
Crescentius  John XIII (pope)                John XI (pope)
 (d. 984)
Crescentius                                  = (2)Alberic of Spoleto
    │                                             │
John Crescentius                             Alberic II (d. 954)
                                                  │
                                             Octavian (John XII, pope)

                                             = (3)Wido/Guy of Tuscany
                                             ? = (4)Hugh of Provence
```

Figure 4.2 The Theophylactan dynasty of Rome

> A certain shameless strumpet called Theodora ... at one time was sole monarch of Rome and – shame upon us even to say the words! – exercised power in the most manly fashion. She had two daughters, Marotia and Theodora ... Marotia, as the result of shameful adultery, became the mother by pope Sergius, whom we have mentioned above, of the John who after the death of John of Ravenna won his way to the papacy; by the marquis Alberic she had another son, the Alberic who in our days made himself prince of Rome ...[19]

As a misogynist, Liutprand was showing these women in a distorted light; as a supporter of the Ottonians he had to point up the moral degradation in Rome as a prelude to the shining new reign of Otto; but as a bishop he might have objected most of all not so much to the women's morals, but to the incestuous sexual relationships and nepotism to which the papacy had sunk (and might also, although he does not say so explicitly, have worried about the fact that John XII was too young canonically to be pope). Indeed, read in context we can see that the focus of Liutprand's attack is not actually the women at all, for in the preceding chapter he explains that he is going to tell the story of how John of Ravenna seized the papacy 'by a crime that outraged all law, human and divine'. According to Liutprand, it was at the elder Theodora's instigation that John did this, since they were lovers. It is clear even through Liutprand's distorted lens that Theodora was a powerful woman in the local political scene: it is interesting that he uses the manliness of her rule to condemn her, in direct contrast to the use of the term by other authors as a form of praise.

Marozia's alliances, which Liutprand says are sexual liaisons, may actually have been marriages. She married Berta's son by Adalbert, Wido, and together they are accused of the murder of Pope John (of Ravenna) before putting her own son John on the papal throne (Book III, chapter 43). Wido died soon afterwards, and Marozia invited King Hugh to marry her and take Rome, a plan which Liutprand condemns as incestuous (III, 44). Hugh of Arles (king of Italy, r. 926–947) attempted to marry Marozia in 932, but Marozia's son Alberic drove him off, thereby protecting his own position as her heir and assuming sole rule in Rome.[20] Liutprand presents the expulsion of Hugh and Marozia in Alberic's words:

> The majesty of Rome has sunk to such depths of folly that now she obeys the orders of harlots. Could there be anything viler or more disgraceful than that the city of Rome should be brought to ruin by the impurities of one woman ... ?
>
> (III, 45)

Can Theodora's reputation and that of her family be repaired at all? Bernard Hamilton has tried by focusing attention on the Theophylactans

as patrons of monastic foundations and reforms (see below, pp. 115–116), but this is only one aspect of local family politics and legitimacy. In fact the case of Theodora and Marozia provides ideal evidence of the strategies used when women actively claimed and held onto power in tenth-century Italy.

We must remember firstly that Theodora was only briefly a widow, but with no sons it was imperative that her daughters find suitable husbands. Marozia's liaison with Pope Sergius III has been questioned by Peter Llewellyn,[21] but in fact makes sense when read as part of a strategy of allying the Theophylactans to the other major source of power and prestige in the city, the papacy. Her relationship with Sergius produced a son, but the liaison might well have provoked opposition given the longstanding resistance of the church to bishops having wives or concubines. Marozia therefore contracted a marriage with another local ruler, Alberic of neighbouring Spoleto. Alberic's death at the hands of the Romans and the arrival of King Berengar in Rome temporarily ended the Theophylactans' influence in the city. But in 927 Marozia married Wido/Guy of Tuscany and staged a coup which brought her to power. However, when Wido died three years later, Marozia made the mistake of negotiating with Hugh in an attempt to hold onto power. By now her son, Alberic, was of an age to rule, and he seized power, driving Hugh off, in 932.

However, in her failure to maintain her own status, Marozia ultimately succeeded in what was every mother's aim: to see her child ascend to rulership. Alberic would rule Rome for the next twenty years, and the genealogical table demonstrates the stranglehold that the family exerted on the papacy as well. Viewed from a local, Italian perspective, Marozia's actions in influencing the appointment of the local bishop (as Empress Angelberga had) were entirely understandable. Far from subverting women's expected roles, Marozia had behaved much as any other aristocratic woman would: she sought local allies, and her family fell from power only with outside intervention from the German king, Otto I. Otto's propagandists then set about rewriting the history of the period.

The pressures of female rulership: Theophanu

The story of the Theophylactans at Rome is the best-known of a number of examples of female power in Italy at this time. But it was a story which could only be played out against a background of Roman law and culture. Further south, women in the ducal houses of Gaeta and Naples were also prominent, both in the local political necessity of transmitting power securely

to the next generation via a regency, and in the intellectual and cultural activities of their cities. Contrast this with the picture painted by Huguette Taviani-Carozzi of the family politics of the Lombard princes of Salerno. She characterises their dealings with satellite branches of their family in Capua and Benevento, as an 'exchange of women', conveying the passivity of Lombard women (who, we must recall, had the legal status of minors) as objects in such exchanges.

Marriage away from the natal family is usually considered to have led to immense vulnerability, particularly if the bride was widowed young or produced no children. But such crises might sometimes offer opportunities to women which they might otherwise not have had within their marriage. The Byzantine princess Theophanu, brought to marry Otto II in 972, found herself a widow with five children, including the 3-year-old son and heir Otto III, in 983.[22] Furthermore, Otto was being held by his relatives in Germany whilst Theophanu was in Italy. Collaborating with her mother-in-law Adelaide, Theophanu was able to retrieve her son and ruled as sole regent until her own death 991. Her major rival, ironically, was Adelaide herself, the senior woman in the family and the effective ruler in Italy after her husband's death. Theophanu was forced to share power with her until 987, when Adelaide was granted the full use of her widow's property from Otto I as a form of pension and, by implication, pay-off. It was Adelaide, however, who became regent on Theophanu's own death in 993. She forbade any memorial services for her dead daughter-in-law, an act of spite which was punished when Otto III achieved his majority in 994 and expelled her from court.

Theophanu's presence in Italy survives only fleetingly in the evidence. A wall-painting at St Salvator Maggiore in Rieti depicts her and Otto II with haloes, and she is known to have founded another church dedicated to St Salvator in Rome. Of 107 different stopping places on her itinerary from 972 to 991 (most of which correspond with those of her husband and son), 23 are in Italy, including the royal nunnery of St Maria Cosmedin in Ravenna where she gave birth to at least one of her children. She was certainly in Ravenna in 990 when a diploma was issued in her sole name with the title *augustus*. It was not unusual for the royal chancellery to use this male form of her title, but the omission of her son from her document certainly attests to her confidence in her position by this date. Indeed, it could be argued that Adelaide and Theophanu's success was based on the fact that by the tenth century an institutional mechanism existed to accommodate periods of power by women. Both had been called *consors regni* in documents issued by their husbands, as had Bertilla in Berengar I's charters. What power did this title convey?

Consors regni: title or role?

Mor, in 1948, proposed on the basis of the occurrence of the term *consors regni* in Carolingian and Ottonian documents issued in Italy, that in this region the wife of the ruler had actual co-regnal power with the sovereign. This he dates from the reign of Louis II and Angelberga in 868, and cites as other examples Riccarda, wife of Charles III the Fat, in 881; the two wives of Berengar – Bertilla and Anna – from 890 and in 915 and 923; Alda, wife of Hugh, in 927; Lothar's wife Adelaide in 950; and Willa, wife of Berengar II, from 960. He claimed that the title and status was not a personal inheritance but a feature of public power in Italy, so when Adelaide married Otto in 951 she did not receive the title until Otto was crowned emperor ten years later, losing it when Otto II was declared king. Otto's wife Theophanu was also accorded the title, but only in Italian diplomas. The idea of co-regent, Mor suggests, was applicable only in the absence of children, so when Otto III was born Theophanu became empress again. After Otto III's death Arduin was crowned king and his wife Berta received the title.

Supporting his thesis, Mor cites the *Honorantie Civitatis Papie*, with its references to two royal courts and one-third of the fisc going to the queen. Given the active roles of Angelberga and Theophanu, and Adelaide's role as regent after the death of Lothar and before the crowning of Berengar II, the idea of separate public power for the queen is a seductive one.

Delogu welcomed Mor's idea as a way of distancing women's power in Italy from the 'pornocracy' model, but challenged his assertion that queens had a legal role as consort. Since there was no explicit legislation on the subject, Delogu concentrated on isolating when and in what contexts the term *consors* was used. He concluded that whilst the term had a long history, its use in the ninth and tenth centuries owed more to literary and notarial tradition than to a revival of a legally defined office. The association of a co-ruler with the title conferred no special powers. Rabanus Maurus had used it when he sent his commentary on Esther to the new empress Ermengarda, wife of Lothar. She was likened to Esther, and other poets took up the model – the *consortium* of the queen was like that of the Church with God.

In Italy, however, Angelberga was frequently called *consors*, and Delogu suggests that her activities were instrumental in creating the image of a powerful consort, rather than the other way round: she governed in her husband's absence, called assemblies and appeared on the reverse of Beneventan coins. Her role therefore elevated the real authority of the term. By the end of the ninth century it had become *consortium*, that is, an institution conveying real power, and it is used in the account of the coronation of Ricarda, wife of Charles the Fat. From then on, it had some sort of juridical role which later empresses inherited.

Bishops and women: Rather of Verona

Liutprand of Cremona was not the only pro-Ottonian writer active in Italy in the tenth century, and his invective against the Theophylactan women at Rome and their relationship with individual popes is grounded partly in the older, continuous objection of the Church to bishops with wives or concubines. His older contemporary, Rather, bishop of Verona, was both a victim of and commentator on the political manoeuvrings in northern Italy at this time. His life is outlined by Peter Reid in that author's magisterial translation of the bishop's works. Patronised by both King Hugh and Emperor Otto I, Rather was raised to the see of Verona three times, and ejected each time. The first deposition saw him imprisoned, and he seems to have used this 'leisure' time (his own words in the preface to his *Praeloquia*) to concentrate on his prolific literary output. His works are valuable not only for the picture of women he gives, but also for their jaundiced view of Italy and Italian politics from the perspective of a non-Italian. The *Praeloquia* were written as a guide for Christians in how to live their lives in a manner pleasing to God, and Rather, a Lotharingian, divides Book II of the work into sections addressing men, women, wives and husbands, wives alone, celibates, fathers and mothers, sons and daughters, widows, virgins, children, boys, young men and old men. He emphasises that a man should be strong, avoiding 'feminine softness'. This is predictable enough, but Rather's section on women contains a few surprises:

> Are you a woman? Try to apply the softness, which you bear in name, to the virtue of obedience, not to the vice of sensuality. For in the beginning you were called 'virago' [Genesis 2.23], that is, 'strong women', so you should always remember that you must be strong against vices and compliant and obedient to the Lord's commands ... in the Holy Scriptures there are many examples available to you; in the Old Testament, though all men are consumed with fear (as though with the sleep of death) of the enemy who terrorises the whole world, you may read that many women won a wondrous victory by God's grace, and in the New, many forgetting their feminine weakness fought a manly struggle and, overcoming the enemy, merited with their triumph the palm of glory and the eminent crown of victory.[23]

When read against the political background, this section on 'manly' women evokes the powerful actors whom Liutprand had in some cases attacked. Rather, though, makes it clear that strength comes through obedience, a point which he further emphasises in his discussion of marriage and then in his section addressing wives only: 'In order, therefore, that you may merit

becoming a daughter of the patriarchs in doing right, make sure you obey your husband also using words of humility, preferring submission and solemnity . . .'[24] He does not, however, separate out the roles of mothers and daughters from fathers and sons, simply content to tell parents to discipline their children and children to respect their parents. Widows, though, were to follow the biblical model of Anna, and virgins (i.e. young, unmarried women, and by definition virgo intacta) to aspire to imitating Mary.

Another theme of Rather's work, and one for which he is better known among medieval historians generally, was his implacable opposition to clerical marriage, both on a moral and on an economic level. The earlier *Praeloquia* Book IV is exceptional in that it tries to find an explanation for a woman going to see a bishop:

> The holy canons also forbid bishops any kind of cohabitation with women, excepting those specified there. You may see a woman sometimes talk with a bishop, that is, have a private audience, and it is noised abroad among the people. Do you wish or think that he should at once be deposed as one defamed, as though by this alone he is 'self-evident' (as you said)? How do you know that he is not compelled to hold this audience for some reason of piety that is hidden from you, but clear to God and him, that is, for winning a soul . . . ?

Rather was using this example to defend himself to King Hugh against similar hearsay, but the example he chooses is interesting for the light it sheds on the close attention paid to women's behaviour ('noised abroad among the people'). Later in his life, faced with the uphill task of eliminating clerical marriage and other abuses from his see, he wrote a letter to Bishop Hubert of Parma in 963, which is known as 'On Contempt of the Canons'. Here it is clear that Rather's concerns were for the property of his bishopric, which was being dissipated by clerics looking for 'the wherewithal also to get wives for their sons and husbands for their daughters, and vineyards and fields, and finally so they can serve the mammon of iniquity'.[25] Here he was up against a more localised manifestation of what was going on in other parts of Italy: the political upheaval had allowed a free-for-all on property, and Church property was particularly vulnerable to encroachment.

Rather's concerns are echoed by a later clerical writer, Gerbert, who in 982 berated Empress Adelaide for repeatedly requesting that he make grants of land from Bobbio to her followers.[26] The problems of powerful laypeople securing benefices and Church property run through Gerbert's letter as Pope Silvester to Otto III in 1000, in which he complains about a riot at the church of Orte during the mass, caused, he says, by anger at the fact that a

poor woman had complained about the oppression of the local judge.[27] Gerbert also wrote in a papal capacity to Doge Peter Orseolo II around 1002, urging him to reform the clergy of Venice, complaining that: 'your bishops and priests all openly secure wives and, like money-changers and money-lenders, pursue worldly wealth'.[28]

Returning to Rather's *Praeloquia*, Rather urges King Hugh to be faithful to his wife and avoid concubines: 'That was the practice of former times because of the scanty population'. This sentence has resonance in a period of population growth, but Rather's refusal to condemn concubinage on moral grounds, which one might have expected from a bishop, is again surprising. Perhaps it was still too widely practised, or perhaps Rather was sensitive to the possibility that Hugh himself might still have more than one sexual partner. In comparison with this passage, the final section of Book IV, addressed to the queen, is somewhat lacklustre, offering her the models of Mary; Helen, mother of Constantine; the Frankish queens Radegund and Clotild; and Placilla mother of Theodosius to follow. If women were once viragos, the queen, in Rather's view, had lost that manly quality.

Rather's extensive works are an invaluable snapshot of the views of women held by a somewhat disgruntled (and, we must remember, foreign) bishop of the mid-tenth century. His comments also highlight the continuities and changes in the lives of women he observed. Whilst family-based political power was still clearly to the fore, a greater emphasis than hitherto was placed in his writings on the twin problems of clerical marriage and the keeping of concubines. As Church reform would take hold in Italy, many women fell victim to a new moral code which they had no part in making.

Women and work in the tenth century

Ironically, when married priests were told to put away their wives in the tenth century, they are reported as having protested that they could not do so because they were supported economically by their spouses. It would be simple to dismiss this remark as a piece of rhetoric designed to invoke a charitable response from their bishops, but to do so fails to assess the possibility of some truth in the protests. Of course, we risk a circular argument here: we have seen that an objection to clerical marriage was the need that such clerics had to provide for growing families out of their benefices, leading to a greater demand on Church resources. In this context, a defence that families actually supported *them* would be logical. Whether a larger

benefice (in the form of land) was required or not, it may well have been on wives that the burden of running such an estate fell. Women were the invisible force in the tenth-century economy as they had been in earlier periods; the rhetoric against clerical marriage, therefore, may have had a detrimental economic effect on them as well as attacking their social role.

Away from the ecclesiastical arena, the lives of the vast majority of women continued unchanged, apart from the impact of war and, briefly, the Hungarian and Arab attacks on northern and southern Italy, respectively. We are able in the tenth century to catch more glimpses of women at work, as the same religious houses which were patronised as part of the political game sought to maintain their property and security by means of estate surveys or polyptychs. We have already met examples of prototypes of these in Chapter 3. An inventory surviving from St Salvator/St Julia in Brescia was probably drawn up in 905/906 and listed the monastery's property. Over two thousand people are listed on its estates, engaging in a variety of trades. Carolingian legislation had shown women engaged in textile work, and the tenth century evidence shows this continuing. The St Salvator/St Julia polyptych shows 'a textile workshop with twenty women [genitum in quo sunt feminas xx]', at its estate of Nuvolera. The will of the ruler of the southern duchy of Gaeta, Docibilis I, dated 906, mentions a *gyneceum*, and a tenth-century Cassinese copy of the encyclopaedia of Rabanus Maurus also shows an illustration of two women and a loom, labelled *geneceo*.[29]

It is unclear whether the workers in these establishments were free or unfree. The excerpt of the polyptych of St Salvator/St Julia published in translation by Georges Duby suggests a mixture of slaves, villeins, free men and *aldii* (semi-free workers).[30] Slavery was still a constant element in the economy of Italy, and in the unstable conditions of the period, some free owners became tenants, and free tenants became unfree. Certainly the will of Docibilis I provides evidence that many of his rural workers were slaves, as he manumits several of them in the document. Unfortunately, the role of Formosula, the only female slave freed, is not stated, but to judge from the gift of a house and other property given to her, she may have been a favoured domestic servant, or possibly even nurse to Docibilis's many children.

Nonetheless, there is evidence that the status of the unfree was beginning to change in this period against a background of demographic growth, and once again women were crucial in determining status, which was held to be transmitted through the mother. A famous case at Gaeta before Otto III was argued by a group of men on their mothers' free status – but it was probably the gold they produced which won them their freedom. In the late 990s the same emperor tried to arrest the decline in status in a capitulary 'on slaves gasping for freedom'.

Reform of the religious life

The letters of Gerbert and Rather have already revealed a growing resistance to married clerics in the tenth century, precisely the period when the problems of supporting laypeople from ecclesiastical properties seems to have been at its worst. There is some evidence that lay rulers were sometimes supportive of a move towards clerical celibacy: Docibilis I of Gaeta's will stipulated that unmarried clergy were to be appointed to the churches he left for his children. It would take another effort in the eleventh century to address the problem of married priests head-on.

However, the tenth century monastic reform movement did have repercussions in the Italian peninsula, often at the expense of religious women. The monastery of St Stephen in Genoa, for example, from which the earliest charters of the city survive from 958 onwards, had originally been a double house and was now given over to men.

Elsewhere, female houses might fare better, particularly if they were large, rich or ancient. The struggle for power over the kingdom was not confined to secular affairs, as the royal nunnery of St Salvator/St Julia played a role in conveying authority. It received a donation from King Berengar I in 889. His rule was threatened by the invasion of the Magyars, leading him to allow the abbess (his daughter Berta by 915/916) to fortify the monastery. We do not know if she was member of the community before her election. Berta engaged in transactions which were continued in the tenth century by Abbess Ata in 961 and Abbess Berta in 978–1000. The difficult economic conditions of the time may be reflected in the fact that the abbey's transactions were now mostly exchanges; earlier it had made large acquisitions of land. In 997, Otto III confirmed the monastery's possessions, showing that it remained an important piece in the jigsaw of legitimising political power in the north.

The close links between this house and Empress Angelberga's newer foundation of St Sistus in Piacenza were continued when Abbess Berta of St Salvator/St Julia at Brescia (Berengar's daughter) was made 'domina et ordinatrix atque rectrix [the mistress and ruler and governor]' of St Sistus in 917. Here, she presided over a community of nuns including the daughters of some of Berengar's favourites. Berengar also continued a Carolingian tradition of gifts to the Lombard house of St Maria Theodota in Pavia and its abbess Risinda, with a donation in 899. In 900 he reconfirmed this to her niece Risinda the new abbess, and gave further gifts and the right to build up and fortify the house and its estates in 912, 913 and 920. The elder Risinda was intensely involved in the landed affairs of Pavia, and she and her brother Aimo, bishop of Belluno, never wavered in their support for

Berengar. The king in turn clearly recognised the importance of female houses in maintaining his web of support: 17 per cent of his gifts were to convents in an age when men's houses outnumbered women's by three to one.

That is not to say that the royal monasteries and convents had an entirely smooth ride. The fall-out from Carolingian rule was often a lack of clear claim to the gifts made. In a court case of 903 highlighted by Bougard, St Sistus displayed in the presence of King Berengar a donation of Ermengard, daughter of Louis II, dated 891, in which several properties inherited from Empress Angelberga, the house's founder, were included. It is possible that after the death of Ermengard in $c.902$, attempts were made to recover the empress's dower goods. The house won its case, demonstrating again its influence. However, the king was also concerned to patronise and protect smaller houses. For example, Berengar I gave the church of St John the Baptist in Monza, a Lombard foundation, the nunnery of St Peter in Cremella, obliging it to feed the twelve nuns in the latter house. Like earlier attachments of female houses to male monasteries, this may signal that the convent was in some distress.

Suzanne Wemple's study of nunneries in Italy[31] shows how the Ottonian rulers, who were active in Italy from the 950s, were keen to continue royal patronage of female houses, focusing again on the politically strategic royal foundations. Otto I confirmed all the property of the nunnery of St Sistus in Piacenza to its abbess Berta, gave a charter of protection to St Zaccaria in Venice in 961, and in 964 willed property to St Salvator at Lucca and its abbess Grima. The following year he renewed his protection over St Maria Theodota in Pavia and its abbess Regengarda, and issued a letter of protection to St Sophia in Benevento, which was placed under male protection. Otto II honoured the convent of St Mustiola in Pavia in 977, giving it a charter and goods. Webb highlights that communal records from the same city recorded its receipt of the Virgin Mary's ring in 959.[32] In 965, Otto III reaffirmed his grandfather's charters to St Maria Theodota and to St Salvator in Pavia and Abbess Geppa. Two diplomas were issued protecting St Salvator/St Julia in Brescia under Abbess Berta and St Zaccaria in Venice under Abbess Petronia. The interest of the Ottonians in the latter abbey and in St Sophia at Benevento was clearly political and presented a none-too-tacit challenge to the local rulers of these cities.

Just as St Salvator/St Julia played an important role in the family politics of Berengar and his clan, so we see the nunnery of St Zaccaria in Venice continuing to perform a similar function in the turbulent tenth-century politics of that city and its doges. Restored after a rebellion against him in the late 950s, Peter IV Candianus put aside his wife Joanna: 'forbidding her the marriage bed, he drove her by force to take the nun's habit in St

Zaccaria; the son he had had by her, named Vitalis, he made a cleric and later promoted him to the patriarchate of Grado.' He then appears to have sought political allies via a new marriage: 'Then he received as his wife the sister of marquis Hugh, named Hwalderada, and having received with her the greatest amount of dowry in slaves, female slaves and treasure, sought with these to acquire soldiers from the kingdom of Italy with which to defend and possess these treasures'. His son by Hwalderada was, however, killed in 977 when a renewed rebellion caused the city to be set alight – the child's nurse rescued him from the flames but both were then killed by the rebels.[33]

The nunnery, therefore, functioned in the family politics of the Venetian rulers as a place for discarded wives and spare daughters. Such a purpose can have done little for the monastery's smooth running or spirituality. The tenth century appears to have seen an upsurge in the criticism of female houses as the influence of the Cluniac reformers spread into Italy.

Nowhere is this influence clearer than in the monastic patronage of the rulers of Rome, the family of Theophylact, in the first half of the tenth century. Bernard Hamilton argues that although Theodora and her daughters have been written up hostilely by Liutprand, they receive a more sympathetic treatment from Theodora's contemporary, Eugenius Vulgarius the priest. He suggests that we can revise the 'shameless harlot' picture of Theodora by looking at her family's religious patronage.[34] The *Liber Pontificalis* had recorded 47 male and female religious communities in Rome in 806: by 900 only about 19 still existed. Hamilton credits Alberic, Marozia's son, with the revival of religious life in the city.

One convent, St Maria in Tempuli, certainly survived to the late ninth century. It was comparatively poor, but its survival in 900 was probably owing to the acquisition of a miraculous icon of the Virgin and to the support of Pope Sergius III (r. 904–911), a supporter of Theophylact and almost consistently blackened by historians. Despite comparative poverty, the convent had noble inmates, and this, too, may have contributed to its continuance until the thirteenth century.

Theophylact and Theodora had a particular devotion to the Marian cult: they buried two of their children at, and donated to, the church of St Maria Maggiore. The antiphonary (psalm book) of St Maria in Via Lata tells of the cure of their paralytic son by an icon at that shrine, which they rebuilt and endowed.

Another legend in the same source tells of the convent of SS Cyriacus and Nicholas, originally St Stephen, founded by Marozia, Theodora and Stephania, granddaughters of Theodora and Theophylact, and cousins of Alberic. Its necrology commemorates their relatives. The three women did not become nuns, but the foundation may have been intended for their

mother to retire to on the failure of her and her sister Marozia's opposition to Alberic's seizure of power in 932. It was sited near St Maria in Via Lata and was rich (the first redaction of its necrology lists 117 nuns) and prestigious, deriving its prestige from Theophylact's family.

Another convent was St Maria in Campo Martis, first mentioned in a document of 937. It is assumed that Marozia, mother of Alberic, was a nun or the abbess there, possibly after the annulment of her marriage to Hugh of Provence in 932. This marriage is thought to have been annulled because Alberic married Hugh's daughter. Liutprand does not refer to the death of Marozia, so her claustration is likely. A postscript to this picture of flourishing female monasticism under the patronage of Theophylact's family, however, is the failure of some houses. Wemple points out that Odo of Cluny's reform of St Agnes on the Via Nomentana was shortlived: the house was soon afterwards transferred to secular priests.

The evidence for the patronage of northern Italian convents is considerable, and Anna Valerio comments that a northern bias has seriously hampered scholarship on the histories of southern Italian convents before the arrival of the Normans in the eleventh century.[35] She also highlights the loss of records: a seventeenth-century history written by the abbess of St Gregory Armeno in Naples says privileges were granted to the nunnery, founded in the ninth century, privileges which are now lost. Similarly, St Paul in Sorrento has a history stretching back to the ninth century, but records survive only from the sixteenth century.

Valerio's pessimism is misplaced, however, and the tenth century sees a significant rise in information from charters, particularly about female houses in Campania. In 990, St Maria de Fontanella near Amalfi was left goods and books by a certain John the priest, and an inventory of the goods of St Lucia Ravello reveals its ownership of books and treasures. The best documented cities of southern Italy in the tenth century were Naples and Salerno. The former city appears to have been enjoying something of a religious and cultural highpoint during this period, in which women were active participants. Duchess Theodora was said to have 'meditated sacred scriptures day and night [diu noctuque sacrae scripturae meditabatur]'. We also know of women who entered the *staurites* – mixed groups of lay and cleric men and women with their own patrimony[36] – but their role in confraternities was marginal.

The major female house in Naples was St Gregory Armeno, which continued to receive ducal patronage into the eleventh century and enjoyed its greatest period between the tenth and twelfth centuries. Tenth-century documents surviving from the house show the abbesses as active managers of the convent's estates, whose produce presumably fed the inmates and recipients of the convent's charity. In 921, Abbess Maria leased out land at a rent of

wheat, millet and half the wine produced. Later abbesses are also documented engaging in such leases.[37] In 929, in a case reminiscent of St Salvator/ St Julia's earlier negotiations over aqueducts, Abbess Militu won a dispute over a water cistern from which, the nuns claimed and swore, the house had drawn water for forty years.[38] The house also owned duck traps, again leased out at a rent of 60 'good ducks' a year.[39] It is clear from such evidence that the nuns of St Gregory did not exist on a frugal diet, and the house attracted donations from the local aristocracy as well.

In Salerno the tenth century sees the first surviving material from the house of St George, an eighth-century foundation. The convent's charters have been the focus of two publications by Cassese and Galante.[40] The only tenth-century document highlights some of the conflicting claims on religious women, as Abbess Laita agreed to lease land from her sister, Romelgaita, also a nun, at a rent of one-quarter of the produce. The land had been inherited from their father, and the arrangement suggests that Romelgaita was not enclosed, or that the problems of lay control of ecclesiastical property, the focus of complaints by bishops further north, also existed in the south. Certainly not all nuns in tenth-century Salerno were enclosed: Giovanni Vitolo has studied the growth of the penitential and vowess movement at Salerno,[41] and cites early examples, such as Adelbona 'velamen induta [dressed in a veil]' who received permission from Radelchis of Benevento to alienate all of her goods instead of the usual one-third in 898.

Graham Loud's work on Capua seems to indicate the tenth century as a busy period in the number of convents founded, but one of varying fortunes. A Beneventan council in 900 had felt it necessary to legislate on women entering houses, and an air of decline is suggested by the *vita* of the reforming Saint Dominic of Sora when the nuns of a Sora convent were replaced by monks.[42] St Sophia Benevento also became a male house at some point in the tenth century, though its history is obscure in the crucial central decades of the period. The change may plausibly be connected with the Ottonian intervention in the house's affairs mentioned above, but this is speculation. Three more women's houses were founded in and around Capua in the period: the optimism of their success does not appear to have been dented by the waves of Cluniac reform reaching Italy.

The nunnery of St John in Capua has documents from the tenth century onwards recording its life. Sichelgarda, the first abbess, requested permission of the abbot of Montecassino in 966 for the community to elect its own abbesses and to have power over its goods. A thrice-yearly payment to Montecassino secured this and provided the springboard for the abbey's power.

In the far south, a female presence in monastic life is documented in accounts of both sexes at the Mercurion as well as in two convents: Armaris

in the Rossano mountains, where Abbess Theodosia is known, and that founded by Balsamius and Fantinus in the province of Reggio di Calabria. In the absence of charter material, the evidence for women's religious life comes largely from the flourishing Greek hagiographical tradition in Calabria and Sicily,[43] and the theme of reform noted in the more northern sources does not appear to have affected the southern hagiography until right at the end of the century.

Women and the saints: the southern hagiography

The earliest of the lives, apart from that of St Leo of Catania studied in Chapter 3, is that of St Elias the Younger of Sicily (823–903). Born in Enna of rich parents, he was captured by the Saracens and taken to Africa as a slave. The wife of his Christian master tried in vain to seduce him, whereupon she accused him of raping her, causing him to be beaten. Elias succeeded in buying himself out of slavery and returned to Palermo where he lived with his mother for a long time. Then he travelled in Greece, curing a sick woman on his way home. Arriving in Amalfi, he cured the sister of the prefect, then returned to Salinas where a woman complained that her son-in-law had been captured by the Saracens – he performed a miracle to free the man.

The life of St Leo-Luke of Sicily (810–910) is rather more brief. Again, his birth to virtuous parents is highlighted; his mother is named Theoctista and his father Leo. As an adolescent he asked the advice of a wise Calabrian woman, and she told him to stop wandering and enter a monastery.

St Elias Speleotis (860/870–960) was born in Reggio to rich parents named Peter and Leontia. He travelled with a master, Arsenius, who reproached a slave merchant. The merchant ignored the monks and subsequently died. His wife gave a nomisma (a Byzantine gold coin) to Arsenius to celebrate a mass for her dead husband – he refused at first but then agreed to do so at her persistence. Immediately, an angel appeared and prevented Arsenius from saying the dead man's name. He returned the money on a pretext (he did not have time for the mass) and performed a mass free for a dead pauper. This story picks up a theme we met much earlier in the *Liber Pontificalis*. This time, an attempt is made to discourage the slave merchant, rather than buying and freeing his victims, but it is interesting that Arsenius stops short of transferring his disapproval to the man's widow, preferring instead to lie to her. Elias meanwhile cured the monk John of withered limbs and John's mother of tertian fever, both cures related by John himself to the hagiographer. Elias's post-mortem miracles

included: a monk named Jacob obtaining a cure for his insane niece by disguising her as a man to enable her to sleep at the saint's tomb and receive a cure; the wife of Theodore, the saint's godson, healed of an invading demon; and a young woman totally paralysed restored on visiting the tomb. Leontous, daughter of Licastros, the saint's cousin, prayed to Elias, who sent a cup of wine for Leontous to drink to enable her to visit the tomb. She came in the retinue of a noblewoman, Eleuthera, whose servants prevented her entering, so she slept outside and was cured, having a vision in her dream that Eleuthera had defiled the tomb. The saint's shoe cured the daughter of John the Priest (who had lived chastely with his wife for a long time), who had been assailed by a demon and become crazy to the point of wanting to kill her own children (note here the theme used as a measure of the seriousness of her condition): she was cured after drinking water touched by the shoe, and the same cure was administered to a woman unconscious for eighteen years.

St Vitalis of Sicily (d. 990; the life was translated into Latin in 1194 at the order of the bishop of Tricarico) was born to rich parents, Sergius and Chrysonica. He entered a monastery, and the life tells us that men and women were cured by him, although no details are given. He founded a male monastery in Bari where the following miracle took place. A woman had sworn by Christ ('as it is women's wont to mix lies with the name of God') that she had no bread for a poor woman. But when she went to fetch bread for her own meal a serpent came out of the basket and wrapped itself around her neck. She consulted with doctors and other saints in vain, so she came with other women to the church of St Adrian in Bari. The saint was absent and the women slept outside the church. The saint returned and reproached his monks for not letting the women in. He sent them to his own cell to warm by the fire, and whilst there one of the women used the saint's belt on the head of the sick woman to heal her and free her from the serpent.

St Sabas the Younger (d. 990/991) came from a family of saints: his father Christopher and brother Macarius also have a brief life devoted to them. The background of his life is the German invasion of southern Italy and all its uncertainties. Sabas was born in Sicily to Christopher and Kalè. While she was pregnant a light penetrated her to signal the grace of her son. Christopher entered a monastery with his elder son, abandoning Kalè and Sabas. (In the lives of Christopher and Macarius, written possibly slightly later, she becomes a nun.) A famine struck the province so that children were being eaten. Sabas fed the people during the Saracen invasions so that even women came to him, renouncing their shame. He went to Amalfi and restored a 4-year-old child thought dead by his parents. On his death in Rome the huge crowd of mourners is supposed to have included Empress

Theophanu. In Christopher's life, an *illustris* of Rossano asked him to cure his wife of her sterility. Initially refusing, he then blessed her and she became pregnant.

St Luke of Demena (d. 993) was born of the noble parents John and Thedibia. He had a sister, Catherine, who married and had two children. One, Antony, probably became the *oikonomos* or steward of Luke's monastery and was of exemplary obedience, sweetness and humility. The other was named Theodore. When Catherine was widowed she came to Armento and asked her brother to accept her and sons to a monastic life. She founded a convent to the Theotokos, and her virtue equalled that of her brother.

The best-known of the Calabrian saints was Nilus of Rossano (910–1005), whose life was probably written by his disciple and fellow-saint Bartholomew (d. 1050). His life is of particular interest in that he did not, as his contemporaries, move straight into a monastic situation. Brought up by his elder sister, a pious woman whose son would eventually become a monk in Nilus's own monastery, he initially behaved as any other young man of illustrious family, attracting young women and having a daughter by one, who is said by the life to have been of humble birth (and is not named). Nilus's subsequent pursuit of the religious life without further reference to her suggests the liaison was a casual one (a parallel might be inferred with the life of Augustine). However, the story of a young man called Stephen, who left his mother and sister to ask Nilus to allow him to become a monk and rebutted the saint's concern for his family by saying 'God feeds them and God will feed them', shows the strong theme of asceticism running through the text. Stephen was sent to Theodora, abbess of the monastery of Arinianum not far from Rossano, an old, pious woman who was the leader of several nuns and who, still young, had taken the monastic habit and loved Nilus as her own son. She agreed to take in Stephen's mother and sister.

But there is a marked difference in the attitude in this later life towards women. Whilst St Vitalis had reproached his monks for leaving women out of his church, Nilus was angered by the presence of a young girl who had entered the church seeking an interview with him. He was not entirely oblivious to the needs of women, however, as his care for the convent of St Anastasius in the upper town of Rossano, and admonishment to the citizens to care for the place, demonstrate.[44]

Like his earlier colleagues, Nilus spent much time travelling through southern Italy, and his travels brought him into contact with two powerful women, Princess Aloara of Capua and Duchess Emilia of Gaeta. Aloara had persuaded her two sons to kill her nephew, and then asked Nilus for forgiveness for this sin: he refused on the grounds that he could not give penance, and instead correctly forecast her downfall. It is interesting that

the life portrays Aloara in this light: it serves as a corrective to assuming all Lombard women were political pawns. In Capua he found that convents had fallen into dissolute ways. A deaconess acting as abbess of one convent had her eldest son living there – despite Nilus's reproaches, the young man was found in a nun's bed the next morning. In Gaeta, meanwhile, Duchess Emilia insisted on an interview with Nilus and began to build him a rich tomb for when he died, causing him to flee the duchy. This story strongly echoes ninth-century ones of wealthy patronesses seeking to secure special relationships with a chosen saint through their major donations or building works.

There are common features running through these lives – most of the saints are born of noble families, all spend some time wandering, many making the pilgrimage to Rome, most perform cures and miracles either during their lifetime or after death. The lives over a century reveal changing concerns: the earliest are caught up in the anxiety about Saracen attacks (St Elias of Sicily frees a captive at the request of the captive's mother), whilst later ones seem to focus on the powerful rulers of mainland southern Italy. All the lives are of men, and reveal ambivalent attitudes towards women. Whilst St Leo-Luke's and Nilus's lives feature old, wise women (the earlier life not specifying whether the old woman in question was a nun), many include moments of attempted seduction, for example St Elias of Sicily. It appears that women have little choice in this region if their men wish to enter the monastic life. This recalls the letters of Pope Gregory I cited in Chapter 1: it was acceptable to abandon a mother and sister but not a wife. This suggests, firstly, that Nilus was not married to the mother of his child, and secondly, that the life of Christopher and Macarius responded partly to a need to show Kalè becoming a nun, a loose end in the life of Sabas.

Women's access to churches varies. St Vitalis's life shows them being welcomed, but in the life of Elias Speleotis only a male disguise gains the niece of Jacob access to the tomb of the saint, and Nilus, too, berates his monks for allowing a woman into church.

The miracles in these lives often reveal the social background, and can be quite mundane in their concerns. Freeing captives from the Saracens was a pious act whether or not accompanied by miraculous interventions. The relationships between married couples are dealt with in a variety of situations, with a wife giving money for a mass for her husband, and couples shown concerned both to conceive and for the health of their child. A married priest, it is emphasised, has lived chastely with his wife.

The attitude to slavery varies between lives, but they are strong evidence that slavery persisted in the south. St Elias of Sicily buys himself out of slavery and frees another captive; Elias Speleotis and his master Arsenius reproach a slave merchant, but do not, it appears, have sufficient influence to confront his widow with the real reason for refusing to say a mass. Is this

a merciful act, sparing her further grief as she is not to blame for her husband's actions? Or does it represent the men's fear of a wealthy and possibly powerful local woman? In that respect the hagiography reveals social divisions: most of the saints are of noble birth we are told, but St Elias Speleotis's cousin Leontous travels in the party of a noblewoman and is maltreated by the woman's servants.

Family is a strong and recurrent theme in these lives: members of the saints' families are, with the exception of Nilus's daughter, taken care of either spiritually or materially. Several lives feature the saints' parents entering monastic life, as in the case of Sabas. Elias of Sicily spends considerable time with his mother; Elias Speleotis cures his godson's wife and his cousin; the nephews of Luke of Demena and Nilus both become monks in their uncles' houses.

This group of lives, though, is male in genre and outlook. Nilus's, in particular, shows the filtering through of reformist aims as the tenth century moved into the eleventh. The lives are overtly critical of the state of the female monasteries in Capua and Rossano, but the different hagiographical tradition may explain why these 'dissolute' nuns are not replaced with monks by the saint. Another interesting feature is the way in which St Luke of Demena's life is used as a shell in which to recount the virtue of his equally saintly sister Catherine. She is as virtuous as he is, we are told, but the world in which she lives is one of wandering male saints, and such vagrancy is not an option for women (note that Leo-Luke's life includes a woman urging him to settle in one place).

The minority view: female sainthood

There is at least one example of a female saint's cult being taken up and popularised in southern Italy at this time. The legend of St Trofimena, centred on the Amalfitan peninsula, has been studied by Massimo Oldoni as a valuable insight into hagiographical compilation in ninth- and tenth-century Italy.[45] Her life has parallels with the Neapolitan cults of St Patricia and St Restituta, in that all fled some threat such as marriage or persecution.[46] The story of Trofimena's invention and translation to her church at Minori has significant dating clues within the text relating to the political history of Amalfi and Salerno. It dates between 877 and 974. Originally buried in Minori, her relics had been taken away by Bishop Peter of Amalfi to that city. The bishop died as a result, and when Prince Sicard of Benevento sacked Amalfi he took the relics to Benevento. The text we have celebrates the saint's return to Minori.

For our purposes, the legend of St Trofimena is useful as a barometer of tenth-century social attitudes to, for example under-age marriage, and it includes a lengthy story set in the time of the prefect Pulchari of Amalfi (c.867–877). A certain Theodonanda was married to Mauro, but the couple, despite their attempts, failed to consummate the marriage as she had not reached puberty. Failing to find a medical cure from the doctor in Salerno, at the intercession of a nun the girl's parents left her to sleep by St Trofimena's tomb in Minori, where a vision of the saint cured her (by, apparently, starting her menstrual flow). The story explicitly punished the couple for the under-age marriage, and points up the continued phenomenon of very young brides in Italy, as the Lombard rulers had noted three centuries before.

Conclusions

The tenth century has been called the iron century, conveying the sense of insecurity and hardship that constant warfare in many parts of Europe brought to its population. It is certainly a century of political struggle in Italy. Conflicting claims to political authority seem to have brought to the fore anxieties about women's roles which dominate the narrative sources and permeated into other spheres of activity. Ruling women were praised or chastised for their manliness, and in both secular and hagiographic sources the powerful, aggressive female ruler is viewed with ambivalence.

At the same time, clerical anxiety about the upheavals in the ecclesiastical economy, caused by the uncertainties of patronage when rulers were being displaced, found their outlet in tirades against women's roles as the wives and concubines of priests. Further down the social scale, the polyptych material of the period reveals similar concern over the status and control of the agricultural workers on the estates remaining in monastic hands. The pressures on monastic houses, both economically and through the burgeoning popularity of monastic reform in Italy, seem to have impacted on female houses more than on male ones, and this period sees the disappearance of several female foundations, either turned into men's houses or subsumed under the protection of larger, male establishments.[47] Even powerful foundations such as St Salvator/St Julia seem to have been feeling the economic pinch as transactions turned from large-scale acquisitions to prudent exchanges.

All of these themes continue into the eleventh century, when more female rulers are visible, but resistance to them, and to lay interference in ecclesiastical affairs, escalated. Eleventh-century ruling women may have been

more high profile, as we shall see, but their heyday at the centre of the wider political scene (for example, their constant presence in discussions of the tenth-century struggle for kingship) was largely over.

Notes

1. Rather of Verona, *Praeloquia*, trans. P. L. D. Reid, in *The Complete Works of Rather of Verona* (Binghamton, NY, 1991), p. 64.

2. F. A. Wright (trans.), *The Works of Liudprand of Cremona* (1930); reprinted as J. J. Norwich (ed.), *Liudprand of Cremona: The Embassy to Constantinople and other Works* (1993).

3. See above, n. 1.

4. Harriet Pratt Lattin (trans.), *The Letters of Gerbert with his Papal Privileges as Sylvester II* (New York, 1961).

5. U. Westerbergh (ed.), *Chronicon Salernitanum* (Stockholm, 1956).

6. Paolo Delogu, *Mito di una Città Meridionale* (Naples, 1977), p. 71.

7. G. da Costa-Louillet, 'Saints de Sicile et de l'Italie méridionale aux VIIIe, IXe et Xe siècles', *Byzantion*, 29–30 (1959/60), pp. 89–173.

8. Westerbergh (ed.), *Chronicon Salernitanum*, chapter 69.

9. Stafford: see above, Chapter 2, n. 5; Janet Nelson, 'Women at the court of Charlemagne: a case of monstrous regiment?', in John Carmi Parsons (ed.), *Medieval Queenship* (New York, 1993), pp. 43–61, reprinted in Janet Nelson, *The Frankish World, 750–900* (1996), pp. 223–242; Karl Leyser, 'Maternal kin in early medieval Germany', *Past and Present*, 49 (1970), pp. 126–134, reprinted in Karl Leyser, *Communications and Power in Medieval Europe: The Carolingian and Ottonian Centuries*, ed. Timothy Reuter (1994), pp. 181–188.; idem, *Rule and Conflict in an Early Medieval Society* (Oxford, 1979), pp. 48–73.

10. B. H. Rosenwein, 'The family politics of Berengar I, king of Italy (888–924)', *Speculum*, 71 (1996), pp. 247–289.

11. G. Levi della Vida, 'La corrispondenza di Berta di Toscana col califfo Muktafi', *Rivista Storica Italiana*, 66 (1954), pp. 21–38.

12. Ross Balzaretti, 'The power of the feminine in tenth-century Italian society' (unpublished paper delivered at the conference 'Forms and Images of Power in Medieval Italy', London, 3 October 1992) analyses Berta's life and those of her contemporaries. I am grateful to Dr Balzaretti for permitting me to cite his paper and his translation of Berta's epitaph which follows.

13. *MGH Poetae Latini Aevi Carolini*, vol. 4, tom. 4, p. 1008; translation from Balzaretti, 'Power'.

14. Jon Sutherland, *Liudprand of Cremona, Bishop, Diplomat, Historian: Studies of the Man and his Age* (Spoleto, 1988), pp. 16–20, including the statement on p. 20 that 'Liudprand plainly hated women'. A useful survey of earlier views is included in Enza Colonna, 'Figure femminili in Liutprando di Cremona', *Quaderni Medievali*, 14 (1982), pp. 29–60.

15. P. Buc, Italian hussies and German matrons: Liutprand of Cremona on dynastic legitimacy, *Frühmittelalterliche Studien*, 29 (1995) pp. 207–225.

16. The issue of masculine images and roles in this period is addressed by Ross Balzaretti, 'Men and sex in tenth-century Italy', in D. M. Hadley (ed.), *Masculinity in Medieval Europe* (1998), pp. 143–159.

17. Ross Balzaretti, 'Liutprand of Cremona's sense of humour', (forthcoming). I am grateful to Dr Balzaretti for allowing me to see this paper in advance of publication and for his generosity whilst writing this chapter.

18. Norwich (ed.), *Liudprand*, p. viii.

19. Liudprand, *Antapodosis*, II, 48.

20. The clearest account of the period is still L. Duchesne, *The Beginnings of the Temporal Sovereignty of the Popes, AD754–1073* (London, 1908), pp. 204–252.

21. Peter Llewellyn, *Rome in the Dark Ages* (1971, new edn 1993), p. 300.

22. This and the following paragraph are based mainly on the papers collected in Adalbert Davids (ed.), *The Empress Theophanu: Byzantium and the West at the Turn of the First Millennium* (Cambridge, 1995).

23. Rather, *Praeloquia*, II.3.

24. Ibid., II.11.

25. Rather, *On Contempt of the Canons*, 4.

26. Lattin (ed.), *Letters*, letter 13, p. 52.

27. Ibid., letter 246, p. 330.

28. Ibid., letter 256, p. 350.

29. St Salvator/St Julia: Bruno Andreolli, 'Tra podere e gineceo: il lavoro delle donne nelle grande aziende agrarie dell'alto medioevo', in Maria G. Muzzarelli, Paola Galetti and Bruno Andreolli (eds), *Donne e Lavoro nell'Italia Medievale* (Turin, 1991), pp. 29–40, at p. 34; will of Docibilis I: *CDC*, I, document 19; Rabanus: G. Cavallo, *L'Universo Medievale: il Manoscritto Cassinese del 'De rerum naturis'di Rabano Mauro* (Ivrea, 1996), p. 31.

30. Georges Duby, *Rural Economy and Country Life in the Medieval West*, trans. Cynthia Postan (1968), p. 378.

31. Suzanne Fonay Wemple, 'Female monasticism in Italy and its comparison with France and Germany from the ninth through the eleventh century', in W. Affeldt (ed.), *Frauen in Spätantike und Frühmittelalter* (Sigmaringen, 1990), pp. 291–310.

32. D. Webb, *Patrons and Defenders: The Saints in the Italian City-states* (1996), p. 228.

33. G. Monticolo (ed.), *Cronache Veneziane Antichissime*, I (FSI, 1, Rome, 1890), pp. 137–138.

34. Bernard Hamilton, 'The house of Theophylact and the promotion of the religious life among women in tenth-century Rome', *Studia Monastica*, 12 (1970), pp. 195–217.

35. A. Valerio, *La Questione Femminile nei Secoli X–XII* (Naples, 1983), pp. 41–47.

36. Patricia Skinner, 'Urban communities in Naples, 900–1050', *PBSR*, 62 (1994), pp. 279–299.

37. Jole Mazzoleni (ed.), *Le Pergamene del Monastero di S. Gregorio Armeno di Napoli*, I (Naples, 1973), documents 2, 9, 11.

38. Ibid., document 3.

39. Ibid., document 8.

40. L. Cassese (ed.), *Pergamene del Monastero Benedettino di S. Giorgio, 1038–1698* (Salerno, 1950); Maria Galante (ed.), *Nuove Pergamene del Monastero Femminile di S. Giorgio di Salerno I (993–1256)* (Altavilla Silentina, 1984).

41. G. Vitolo, 'Primi appunti per una storia dei penitenti nel salernitano', *Archivio Storico per le Province Napoletane*, 17 (1978), pp. 393–405.

42. John Howe, *Church Reform and Social Change in Eleventh-Century Italy: Dominic of Sora and his Patrons* (Philadelphia, 1997).

43. See above, n. 7.

44. On which Patricia Skinner, 'The widow's options in medieval southern Italy', in Sandra Cavallo and Lyndan Warner (eds), *Widowhood in Medieval and Early Modern Europe* (1999), pp. 57–65.

45. M. Oldoni, 'Agiografia longobarda tra secoli IX e X: la leggenda di Trofimena', *Studi Medievali*, 3rd series, 12(2) (1971), pp. 583–636.

46. On St Patricia, see below, p. 179.

47. Alessandra Veronese, 'Monasteri femminili in Italia settentrionale nell'alto medioevo: confronto con i monasteri maschili attraverso un tentativo di analisi "statistica"', *Benedictina*, 34 (1987), pp. 355–416, illustrates the problems of tracing individual houses, but does not quite succeed in its statistical analysis.

CHAPTER FIVE

The Age of Great Women or a Great Age for Women? 1000–1115

> And I, provided with such sisters, would most gladly cross the sea and place my life, if need be, at the service of Christ...[1]

The political, social and economic developments in Italy in the eleventh century were some of the most profound in Europe. As a territory which no longer had any indigenous pretensions to centralised monarchy, it was politically the most diverse. In the north, aristocratic duchies and counties took the place of any central ruler. The royal palace at Pavia had symbolically been burnt down by the city's inhabitants in 1024. Some regions still looked towards the German kings as their sovereigns, but all were virtually autonomous. Further south, the papal territories bordered Lombard principalities which in turn included and shared boundaries with monastic enclaves and areas whose political affiliations were far from clear. In the far south, Byzantium still held sway over parts of Puglia and most of Calabria, with Sicily remaining under Muslim control. To complicate matters still further, the German emperors still attempted to enforce their hegemony on the northern half of the peninsula, whilst Norman adventurers were beginning to expand their power in the south.

A unique relic of attempts to crystallise royal rights in the north comes in a document dating to the early eleventh century, just prior to the destruction of Pavia, which records some of the exactions that merchants coming to the city had been made to pay to the royal treasury. The *Honorantie Civitatis Papie* dates to 1010–1020 but is based on older sources.[2] Its clauses represent wishful thinking in the eleventh century, but may be accurate in testifying to the continued trade in and use of slaves in Italy: all persons coming from beyond the mountains into Lombardy were to pay a tax of one-tenth of their value on horses, male and female slaves.

One of the most interesting features of the document for the history of women is the stipulation, in clauses 5 and 6, that the Venetians and men of Salerno, Gaeta and Amalfi should hand over an ivory comb, mirror and set of accessories or 20 solidi to the wife of the master of the treasury. This was a substantial payment which, if carried out, would have meant a regular income for this woman. The clauses are also worthy of interest for the evidence they provide of specialised trade in luxury goods. All four cities mentioned had direct, if sporadic, links with Byzantium, the source of much carved ivory in tenth-century Italy, but the south was also beginning to develop its own ivory industry, as surviving eleventh-century pieces demonstrate. The treasurer's wife, therefore, may have been receiving more than simply honorific gifts for her chamber, and instead might be posited as the agent for the distribution of such luxury items through Pavia's markets. Even if we do not push the limited evidence this far, the clause hints at the 'grey' market of gifts as facilitators of business transactions, with wives considered an important link or managing such distributions as Bertilla had for King Berengar in the tenth century.

This appears to be borne out in another clause, in which the *ministeria* (guilds) of shipmen and boatmen, when in Pavia, were obliged to build and fit out two large vessels, one for the king and one for the queen. Again, an honorific right could perhaps become a valuable asset which Mor, as we saw in Chapter 4, thought to represent the perquisites of formal office.

Women's economic power behind the scenes is mirrored, in the work of David Herlihy, by their economic prominence in charter evidence of the period. For Herlihy, the eleventh century was the highpoint of women's landowning and management.[3] This may be related to the fact that the same century sees the rise of many new aristocratic families whose origins lay a century before, but who were now pressing for autonomy or a share of the power that their erstwhile lords had held. There is some evidence that this trend occurred slightly earlier in the south than in the north, particularly around those towns which had established ducal dynasties, such as Naples, and dominated maritime commerce, such as Amalfi and Gaeta.[4] In such cities, ducal power came under threat both from local opposition and through external pressure as the Normans began to encroach into areas such as Capua. In Gaeta the crisis came with two minorities soon after each other, which threw into prominence in the record two duchesses, Emilia and Maria. Amalfi succumbed not to the Normans initially, but to the growth in power of the princes of Salerno (who also briefly ruled Gaeta). By the mid-eleventh century, Salerno was the major player in the power politics of the south, and its eventual cession to the Normans was facilitated by the marriage of another local woman, Princess Sikelgaita, to the Norman leader Robert Guiscard.

The latter part of the century in the north sees the first evidence of urban-based communal government, in which both old aristocracies and new men collaborated in forming oligarchical institutions which became progressively more exclusive. Diane Owen Hughes, citing the work of Herlihy, shows how small family nuclei joined together in the eleventh century into 'corporate aristocratic families', both for protection and to limit the division of family properties into ever less economic portions.[5] In an urban context, this led to such groups prioritising their own concerns over those of individual members or the city. Major victims of this shift of power in the north were the bishops, and the cry of church reform was often evoked to remove them from office. Ecclesiastical reform was accompanied by campaigns to remove married clergy as well, although as we saw in the previous chapter, the eleventh century was not the first time that anxiety had been expressed on this score. Rather of Verona had bewailed the fact that false accusations were laid for political, not pious, reasons.

These three areas of change – political upheaval, economic and familial developments, and ecclesiastical reform – had a profound impact on women of all social classes, although it is as usual the elites who are most visible in the surviving evidence.

Sources

The eleventh century is not short of sources to illuminate its history. Indeed, the fact that major political and economic developments in western Europe, such as the contest between the pope and the German emperor for supremacy over the western Church, the rise of Norman power, the beginnings of the crusade movement and the rapid development of urban-based economies, had their focus in Italy at this time means that many of the source materials are familiar to historians through having been studied for many decades. However, it is only recently that the potential of these for the study of Italian women's lives has begun to be exploited.

Since the peninsula continued to be fragmented politically, no single narrative source conveys the complexity of the social developments taking place at the time. At the same time, the sources themselves multiply exponentially. The range used for this chapter can be considered only a broadly representative sample.

Chroniclers continued to record the histories of their localities, and a new development towards the second half of the century was the emergence of the urban chronicle, although this would reach its fullest potential in the twelfth century. The early eleventh century saw the composition of John

the Deacon's Venetian chronicle, which we have already used to reconstruct earlier episodes in the history of Venice. Monastic writers such as Amatus, a monk of Montecassino, continued to dominate the historiographical scene. Amatus was one of the earliest chroniclers of the arrival of the Normans in southern Italy, and although his work does not survive in the original and has some flaws in its information, it is of prime interest for the history of women. It can plausibly be suggested that Amatus's sponsor in his work was a woman, and this subtly reshapes our reading of a much-used piece.[6]

Another, lesser known monastic chronicler was Donizo, biographer of Countess Matilda of Tuscany. His work is surprisingly under-used in studies of the countess, and yet presents us with a version of female power radically different from other contemporary accounts of her rule.[7]

Matilda's involvement in the so-called investiture dispute between papacy and emperor ensures that she also appears in the letters of one of the protagonists, Pope Gregory VII.[8] As staunch supporters of Gregory, Matilda and her mother Beatrice regularly feature in his correspondence, including his letter urging her to join his planned crusade in 1074, from which the opening lines of this chapter are taken. However, Gregory's letters also deal with pastoral matters closer to home, in particular the vexed questions of episcopal office and uncanonical second marriages. The latter issue, as we shall see, was central to many of the major political upheavals of the period.

As well as oddities such as the *Honorantie Civitatis Papie*, discussed above, a substantial amount of charter material survives to illuminate both property transactions and also, often in passing, the changing administrative and political scene. The ecclesiastical changes are most visible in contemporary saints' lives, such as St Peter Damian's *Life of St Romuald*.[9] Such texts reflect and contribute to the prevailing atmosphere of reform, but throw interesting light on how the tightening of canonical laws (particularly on the indissolubility of marriage) might benefit women. Peter's other writings convey a variety of images of women in this period.[10]

All of the sources mentioned here deal with women's power in one form or another, and the eleventh century might be seen as the moment of transition in Italy from older forms of family-based power centred on landownership in which women shared, to more rigid and male-centred forms of power and wealth.

Women and power: the early eleventh century

Sources describing women's power early in the eleventh century use traditional ideals such as marriage and motherhood as the measure of their

subjects' status, and, as Paul the Deacon, Agnellus and Rather had done, create and maintain boundaries which women were not supposed to transgress. (Indeed, Paul's work was influential and used many times in subsequent sources.)

A good example of this trend appears in the chronicle of John the Deacon of Venice.[11] The only woman described at length in the entire text is Felicia, wife of Doge Peter II Orseolo in the early eleventh century, when John was writing. She was, he says, 'Felicia in name and merit and, having given birth to a son named after his father, also in her labours'. John, however, takes this description further, saying that once Felicia had conceived, 'which the holy mother knew through the introduction of an angel', she kept her bed chaste. A rather awkward parallel is being set up here with the Virgin Mary, an impossible model of womanhood.

But why does John focus on Felicia? We might posit several reasons external to the text. Perhaps Felicia or her son (whom John is implicitly comparing to Christ, if we follow the imagery to its logical conclusion) were still alive when he wrote. Or perhaps the reason is simply the close relationship which John and Peter Orseolo enjoyed, with John serving as the doge's ambassador to Emperor Otto III on more than one occasion and thus writing to please a powerful patron.

Either of these reasons is plausible, but neither explains why it should be Felicia who is singled out rather the doge. The answer seems to lie in the text itself: the description of Felicia follows immediately from that of the career of the earlier doge, Peter Candianus, and his wife Joanna, discussed above, pages 114–115. Felicia's fortunes, therefore, are clearly being contrasted to those of her predecessor Hwalderada, a wife who had supplanted a legitimate spouse and heir.

The pressures of dynastic marriage became apparent in widowhood. The contrasting fortunes of two duchesses of the still autonomous duchy of Gaeta reveal how female power was exerted in widowhood. Emilia, wife of Duke John III, has already featured as the strong-willed woman who wished to ensure St Nilus's burial in the duchy of Gaeta (see above, p. 121). Her subsequent career, documented in the charters of Gaeta, reinforces this image of power. Her husband and son having died in quick succession in 1008 and 1011/1012 respectively, she became regent for her young grandson, John V. Despite clearly facing competition from her son, Leo, for the regency, Emilia emerged to rule until the fall of Gaeta to Capuan aggression in 1036. Two factors seem to have contributed to her success. The first was the fact that Gaetan women largely followed Roman/Byzantine law, which gave widows extensive rights to manage their deceased husbands' estates and thus could be used to argue the legality of the regency. The second was the clear support of the bishop of Gaeta, Bernard, for Emilia's

regime. Given that he was the brother of John III, his motives for supporting the continuation of the family's power are clear.

Matters were slightly different under the next female regency at Gaeta. By 1062 the city had been ruled by non-indigenous rulers for almost thirty years, most recently by Atenolf of Aquino. His death in that year led to his widow, Maria, taking the regency for her young son Atenolf II. However, Maria had little family support to call upon in Gaeta, and as a Lombard widow may have had fewer rights to call upon to defend her position. Certainly, the Norman rulers of Capua rapidly took advantage of the situation to take over at Gaeta, initially including the child Atenolf in their dating clauses. Maria vanishes from view, but it is interesting to note that when a rebellion occurred within the Norman ranks, the rebel leader, William of Montreuil, sought to marry the former duchess, suggesting that she could still convey some form of legitimate title to the duchy.[12]

Marriage and power: repudiation and remarriage

Even if women did not rule, they were important in diplomatic marriage alliances, as the Venetian chronicle tells us. In 1004 John, the son of Doge Peter, travelled to Constantinople to marry a Byzantine bride of the imperial house. Remaining there for some time, he was then welcomed back to Venice where Maria, the 'greca ducatrix', gave birth to a son conceived in Constantinople. They named him Basil, after his uncle the emperor. The couple's lives in Venice were cut short, however, by a plague which hit the city in 1006. It is interesting to note the contrast between the Venice chronicle's treatment of this episode, which laments the deaths, and that of Peter Damian, who ascribes the deaths to divine punishment for Maria's excessively luxurious lifestyle in the West.[13]

The Venetian chronicle is illuminating in its treatment of male and female figures. Whilst the careers and names of Doge Peter's five sons are listed carefully, only one of his four daughters, Hicela, is identified – she went on to marry the son of Stephen, king of the Slavs, underlining again the importance of women family members for international diplomacy. Of the other three, it is merely recorded that they were sent into a nunnery – possibly St Zaccaria, although it is not stated explicitly. After nine children, Peter decided that Maria, his wife, should have a separate bed, since 'familiarity should not change into divorce'.[14]

Marriage thus had an important role in creating alliances, but wives could be vulnerable to replacement if their husbands saw an opportunity for stronger support. This seems to have become a live issue in eleventh-

century texts, with a number of examples occurring. That is not to say that wives had not been put aside before this period – we saw in Chapter 4 how Doge Peter Candianus forced his wife into a nunnery, and numerous similar cases exist from all over early medieval Europe – but the difference in the eleventh century appears to have been the need for more careful justification of such an action. The main argument put forward to justify a separation, with much greater effect in the eleventh century, was that of a consanguineous marriage having taken place.

For example, in his *Life of St Romuald*, Peter Damian describes how Rainerius, marquis of Tuscany, duke of Spoleto after 1012, repudiated his wife on the grounds of consanguinity, but then promptly married the wife of his brother, whom he had killed.[15] Further south, Alberada of Buonalbergo (*fl.* 1049–d. after 1122) suffered a similar fate on the same grounds. She was the first wife of Robert Guiscard, leader of the Norman conquest of southern Italy, and mother of his son Bohemond, born in 1055. However, marriage to Alberada could not bring the same rich rewards as those offered by Prince Gisulf of Salerno when he sought an alliance with the Norman leader by offering his sister Sikelgaita. Repudiated by Robert in 1058, Alberada remarried twice more and in 1122 turned to religious patronage when she helped endow a Benedictine house near Salerno. What her relationship with Robert was like after their separation is unclear, although the chronicler Amatus of Montecassino records his gift of properties to her, and she was buried in Robert's family foundation of St Trinity at Venosa, as an extant inscription records.

The letters of Pope Gregory VII deal at some length with second marriage, which was clearly a sensitive problem. Because marriage was by now securely the business of the Church, the pope found himself advising local bishops on what action to take in such cases. In 1074, he berates bishop William of Pavia for having allowed the marriage of William's sister Matilda to Marquis Azzo of Este despite the fact that the marriage fell within the prohibited degrees of relationship. Pending a full hearing, he also writes to Matilda herself ordering her to refrain from marital relations until the situation is settled.[16] In 1079 another case had arisen provoking Gregory's horror. Writing to the bishops of Asti and Turin and the bishop-elect of Acqui, he urged them not to allow Marquis Boniface del Vasto to marry the fiancée of his brother Anselm, whom he had just murdered.[17]

The language and iconography surrounding marriage in the eleventh century is striking and harks back to earlier centuries. In the south, illustrated exultet or sermon rolls, where the illustrations were visible to the congregation whilst the priest read the text, show women depicted mainly as submissive wives – even held by the wrist – and as mothers.[18] Their economic role and prominence might suggest that this was iconographic wishful thinking, and

it is often argued by historians of medieval marriage, as Pereira points out, that the late eleventh and early twelfth centuries were a positive period for wives' fortunes.[19] The jurist Gratian's compilations of canon law in 1140 would be the culmination of a century of movement in favour of firm marriage ties: marriage was stressed by the Church as indissoluble and formed by the consent of both spouses. Gratian recognised the rights of wives, who were subject in most things, to dispose of their dowry, make wills and take responsibility for their own actions in court. This owed much to the renaissance of Roman law in secular life and the growing influence of the Church.

In effect, however, the cases of repudiation discussed above illustrate how the Church was now having to deal with a problem of its own making. We noted in earlier chapters how marriage could be a fluid institution, and that concubinage was a common occurrence alongside or instead of marital relations. We also saw how, by the tenth century, writers like Rather were already consigning concubinage to the past as a relic, despite the fact that it still existed. At the same time, marriage was being affirmed as a permanent institution, with only limited opportunities for separation, almost all of them afforded to men. By the eleventh century, it is clear that the legitimate reasons were well known and being exploited by powerful men in search of new political opportunities. Even lower down the social scale, such exploitation could take place. In 1074, Gregory was forced to write to the bishop and people of Genoa ordering that a woman cast aside on grounds of adultery should at least be allowed to put her case.[20]

Ironically, therefore, even though they had more security in their marriages supported by the Church, women's situation had worsened from the earlier one of competing with a concubine for their husband's favour. For now they risked losing everything to a competing woman who had to supplant them as the legitimate wife in order to stay with her partner. But the existence of wife and ex-wife, particularly if there were children of each marriage, could lead to extreme tension when the father died, as the career of Sikelgaita, Alberada of Buonalbergo's replacement, illustrates.

Sons and mothers: Sikelgaita of Salerno

Sikelgaita was the daughter of Guaimarius IV, prince of Salerno.[21] By the mid-eleventh century, he was the most powerful ruler in southern Italy, controlling extensive territories and assuming power in a number of formerly independent duchies, including Gaeta and Amalfi. However, from the 1030s onwards, a new power was emerging in the south as Normans and other

northern French adventurers began to appear in the region, either exiled from their own country or simply drawn by the prospect of conquest of new lands. Chief among them was the Hauteville family, whose military talents made them both valued allies and feared enemies.

Guaimarius had been a successful and ruthless ruler; his son and heir, Gisulf, does not appear to have matched his talents and, faced with the growing Norman menace, contracted a series of marriages between women of his own family and Hauteville husbands in an attempt to align Norman interests with his continued rule. Sikelgaita's marriage in 1058 to the youngest Hauteville and Norman leader, Robert Guiscard, was the culmination of this policy.

Compared with other regions of the south, however, Salerno was by far the most desirable territory for the Normans to capture, and it is clear that Robert's repudiation of Alberada to marry Sikelgaita was done in the hope of laying his hands on the prize. It is difficult to see, however, what claim the marriage itself gave him: as the daughter of a Lombard prince, Sikelgaita is documented in contemporary charters as having some inherited wealth, but since she had male siblings she could not be said to have brought with her any direct claim to the Salernitan throne. Unlike the earlier examples of Amalasuntha and Marozia, marriage to Sikelgaita was not the key to power. Robert therefore embarked on a campaign of conquest further south, putting pressure on his brother-in-law before finally ousting him in 1073. Gisulf fled to Rome, where he appears to have died years later.

Apart from the military pressure which had been brought to bear, another factor allowed Robert into Salerno as quasi-legitimate ruler in 1073. By this time, Sikelgaita had given birth to two sons by him. If Robert's aggression had caused the defeat of Sikelgaita's male siblings, then her elder son, Roger, was notionally the next in the male line of succession to Salerno. It was the birth of his sons which enabled Robert to secure his claim on the principality.

On Robert's death in 1085, however, a new problem arose, for Roger had competition for his father's patrimony from his elder half-brother Bohemond, son of Robert and Alberada. That he was eventually able to win out against a man who was already feared as a warrior had much to do with Sikelgaita's work behind the scenes to secure his position. For she seems to have sponsored a propaganda campaign against her stepson (according to one source, she even tried to poison him), in order to discredit him as a worthy successor. She ensured that she and Roger were at Robert's deathbed, and from the 1070s she appears to have collaborated in the writing of Amatus of Montecassino's chronicle of the arrival of the Normans in southern Italy, which culminates in Robert's takeover at Salerno. It is this text which reports Robert's consanguineity with Alberada, opening the

way to his second marriage (conveniently ignoring the fact that marriage to Sikelgaita could also have been viewed as incestuous). It is also here that a letter of Pope Gregory VII, recognising Roger as Robert's heir, is reproduced (the letter itself does not survive in the papal registers). I have discussed the detailed evidence elsewhere, but Amatus's text can be read throughout as not only a panegyric to Robert, but also as Sikelgaita's attempt to ensure that Bohemond was passed over in favour of the younger Roger.

Ultimately, however, Sikelgaita's lengthy career in power derived not from her own position or rank but from her marriage, which she made the most of in a mutually beneficial way with Robert, and the fact that she had sons. To that extent she fits into a familiar pattern of female rulership in the early and central Middle Ages. The career of her later contemporary, Matilda of Tuscany, was radically different.

Women as rulers: Matilda of Tuscany

The careers of Theodora and Marozia in Rome had demonstrated some of the possibilities of female rulership, although the image of these women surviving in written sources also points up some of the dangerous accusations that female rulers could face. The pattern of a mother and daughter in power was repeated further north in the case of Beatrice of Tuscany and her daughter Matilda.

The Canossa family of Tuscany had been founded by Adalbert/Atto in the 950s (see Figure 5.1). His grandson, the violent Marquis Boniface II (c.1013–1052) extended the family's power as landowners from Cremona and Mantua into the fringes of Tuscany, and he became marquis of Tuscany in 1037.

Born in 1046, Matilda of Tuscany was the daughter and sole heir of Boniface and his second wife Beatrice.[22] Boniface was assassinated in 1052, and Beatrice (*fl.* 1030–d. 1076) remarried. Her second husband was Godfrey

```
                    Adalbert/Atto = Ildegard
                            |
          ┌─────────────────┼─────────────────┐
       Godefrid      Tedaldus = Guillia     Rodulf
                            |
                  ┌─────────┴─────────┬──────────┐
    (2)Beatrice = Boniface = (1)Richildis    Tedaldus   Conrad
                  |
         (1)Godfrey = Matilda = (2)Welf V
```

Figure 5.1 The Canossa family

IV the Bearded of Lorraine. Beatrice is not portrayed in many sources as an outright ruler, but her reign with Godfrey between 1052 and 1069, and sole rulership from his death in the latter year to 1076, are held by Elke Goez to be the foundation for her daughter's later achievements.[23] In 1069, Matilda married Godfrey V the Hunchback of Lorraine. Thereafter, Beatrice and Matilda were active in supporting the papacy in its fight against the German emperors Henry IV and V over the investiture of bishops.[24] They were present at synods in Rome 1074/1075 which led to Church reform.

Alongside the investiture controversy was the fight between Matilda and her husband – Godfrey was trying to get her to move to Germany and she refused. In February 1076 he was assassinated, and in April of the same year Beatrice died. Matilda was now about 30 years old. She tried to continue her mother's work of reconciliation between the pope and the emperor, but most of Tuscany and Lombardy was hostile to papal reform and Gregory. Matilda was constantly at the head of her troops, and her castle of Canossa 'soon became the symbol of this resistance of one woman against the emperor, impeding Italy's complete submission to the imperial cause'.[25] Matilda took Gregory to Canossa because it was safe and remote, and it became the venue for Henry IV's penance before Pope Gregory VII, with Matilda as intermediary.[26]

Matilda was acting from piety, and it was probably in 1077 or 1079/1080, when she accompanied Gregory to Rome, that she gave all her private goods to the papal see. She faced revolts at Mantua and Lucca 1080 and at Pisa, and gradually lost ground to the advancing emperor. Matilda probably gave up her goods to avoid their being seized, and in 1081 Gregory interceded for her with the German kings. Henry IV, however, invaded and condemned Matilda to lose the marquisy: Tuscany was closed to her for the next fifteen years. She continued to give moveables and gold to the papacy, and offered refuge to bishops ejected from their sees. She had a victory against a group of imperial troops and retook Nonantola, but was unable to continue her defence of Gregory, who was exiled and died in Salerno.

The new pope was an imperial candidate. Matilda continued to act as a rallying point, but she also had a hand in the new pope's election and in 1087 participated in the military expedition which took Abbot Desiderius of Montecassino to the papal throne at Rome. She was represented at Terracina when, after Desiderius's death, Urban II was elected. There followed revolts against imperial bishops, and once again reformist principles were cited in their deposition. Urban's best weapon in the continued struggle against the emperors was Matilda, who knew him as he had been present at Canossa in 1077.

In 1089, Urban asked Matilda to marry the 17-year-old Welf V of Bavaria. Her first marriage had been imposed by her mother and stepfather, but the

terms of the second are unclear. Henry was alarmed (as his father had been when Beatrice had married the rebel Godfrey of Lorraine) and besieged Matilda at Mantua. She and Welf fled and were captured in 1092. In 1093, however, an anti-imperial league of Milan, Cremona, Lodi and Pavia, and the revolt of Conrad, Henry's son, against Henry, changed things dramatically. Conrad had been sent in 1092 to occupy Piedmont, his grandmother Adelaide's inheritance. He was crowned king of Italy in the presence of Matilda and Welf, and they went on to recapture some castles. Urban, meanwhile, came north, and Matilda accompanied him in his travels in northern Italy in 1095. She and Welf split in April 1095, and Welf rejoined the imperial side. Henry returned to Germany, and by 1099 Matilda was marchioness again. She continued her donations to the new pope, Paschal II, elected in 1099, and confirmed earlier ones in 1102.

In 1110, Henry V came to Italy; Matilda did homage to his envoys and received confirmation of her territories. Matilda's role had been to prevent a complete imperial takeover in 1080. Contemporaries saw her action in every movement of resistance to the German kings. This contrasts with her relationship with Henry V between 1111 and 1115, but 'the time of heroic warfare was at an end'.[27] Matilda died in 1115.

Some, but not all, of the above life story appears in the lengthiest work about Matilda, written by a cleric named Donizo. He wrote, he said, on the occasion of Matilda's reinterment of her ancestors (1111–1112) and to celebrate Matilda herself,[28] and he intended to present the whole book to her, but before he had a chance to do so he heard of her death. The work is therefore a eulogy with few of the painful episodes in her life. Her ancestors are similarly idealised – Beatrice is written about in glowing terms. Donizo was a monk in the monastery of St Apollonius at Canossa which she had refounded, so this is a work written for patrons. But it is extremely interesting for the image it creates of Matilda as the culmination of her line, and as a ruler.

Matilda was as well known to contemporary German writers and historians as she was to those in Italy, and in some contemporary German historiography the portrayal of her is anything but glowing.[29] She has also functioned as a symbol with fluctuating meanings in modern historiography of the twelfth century, as Diane Owen Hughes has shown.[30] For all the attention she has received, little analysis has been done on the image of Matilda as a ruler. Donizo's life of the marchioness, however, is an ideal example of the use of language and descriptions to construct images of female biographical subjects, and his picture of Matilda is extensive.

Donizo was most concerned to extol Matilda's support of the popes in their epic struggle against lay control of the Church, in particular that of the German emperors. At the same time, he could not simply portray

Matilda's actions as uniformly hostile, and indeed at one point characterises her relationship with Henry IV as a 'love–hate' one. Therefore he concentrates on emphasising Matilda's piety in the context of Gregory VII's reformist aims, including the patronage of reformist clerics, charitable donations, gifts to the Church and the transfer of relics to Canossa.

By her very actions, interceding at the pinnacle of medieval diplomacy over a space of forty years, Matilda inevitably had a high public profile, and Donizo's picture of her creates an image to match. His use of descriptive phrases largely adheres to the norms of ruler imagery, but in a departure from earlier descriptions of female rulers he places great emphasis on Matilda's intellectual abilities. She knows how to speak German and French, is wise and, like her mother and great-grandmother, is described as learned. This description of Matilda's talents mirroring those of her ancestors is an intriguing and perhaps unparalleled picture of a family of educated medieval women. Donizo uses learning as the link between his patron and her female ancestors, and presents her as the culmination of a long tradition, becoming a teacher and an example to others.

What, though, did 'educated' represent for Matilda and her biographer? Modern scholars appear to agree, on scant evidence, that Matilda would not have had the necessary degree of erudition to appreciate the works she commissioned or to compose the letters she is credited with,[31] and Donizo provides few clues as to what education Matilda (and her mother, for that matter) had received, beyond referring to her possession of books (none is identified, and ownership does not imply readership) and his praise of the marchioness's linguistic abilities, already highlighted. Even the latter seem to belong to the category of ruler skills rather than to education.

The portrait of Matilda when compared with her male ancestors bears this out, for the person with whom she shares most qualities is not her mother, Beatrice, but her great-grandfather, Atto. Donizo stops short of describing Matilda, like Atto, as a warrior, but the comparability of the two descriptions is quite striking. Instead, Matilda is portrayed supporting the Church with her arms and treasure, inspiring terror among her enemies and leading her army by night against the emperor. Her credentials as a warrior, therefore, are implicitly underlined. This is by no means a unique description of a woman's military abilities. The Byzantine writer Anna Komnena had famously described the martial activities of Princess Sikelgaita of Salerno.[32]

Thus far, therefore, we might say that Matilda is portrayed as inheriting family traits from both male and female lines, but there is one area in which Donizo differentiates quite markedly in his descriptions of men and women. Of Matilda's personal qualities and appearance we hear very little (in marked contrast to her populist modern biography, which makes much of her red-blonde hair[33]). Men, by contrast, are extensively described.

This omission is perhaps unsurprising when we remember that Donizo was a monk writing in a remote abbey and was not even a member of Matilda's retinue. But his omission of any female physical descriptions at all might also give some indication of the character of the woman to whom he was dedicating his work. The twelfth century was a time of great intellectual revival, both secular and ecclesiastical, and Donizo's work, with its emphasis on learning, gives us a sense of being on the threshold of that rediscovery.

Secondly, the purpose of Donizo's work was to glorify Matilda through commemoration of her birth (via the first half of the book on her ancestors) and her actions in defending and supporting the papacy (in the second half). To do so required that he present her as eloquent, clever, politically astute and skilled in rulership. Her looks, therefore, did not matter. For male rulers, on the other hand, a splendid physical presence does seem to have been an essential element of ruler imagery (compare in Chapter 2 the anger of the Herule leader ridiculed for his shortness in Paul the Deacon).

Finally, the biography could do nothing but compare Matilda with stock models of good rulership, even if the models of description available to him were mostly male. Italy could not really boast any suitable female precedents for Matilda, at least not any that Donizo seems to have known about. He plays her down as a woman in order to extol her as a ruler, in stark contrast to even contemporary Italian and favourable German chroniclers, all of whom focus on her position as woman, wife and widow. For example, the anonymous life of Bishop Anselm of Lucca, whilst entirely favourable to Matilda and using biblical similes to comment on her 'virile' actions, nevertheless circumscribes her capabilities as ruler by emphasising her reliance on the subject of the biography, Anselm. Summing up its attitude, Pásztor comments: 'Matilda detiene il potere, ma Anselmo governa [Matilda held power, but Anselm governed]'.[34] And whilst Donizo paints Matilda's support of the German prince Conrad's defection as kin solidarity, the anonymous life of Henry IV instead portrays the situation as one of a vulnerable young man fallen into the clutches of an astute woman.[35] Even the pro-Gregorian Bernold of Constance, who eulogises Matilda, nevertheless identifies her in relation to her father and former husband Godfrey when she marries Welf, whom he later describes as 'her master'. Only for the year 1097, by which time she had separated from Welf, is she mentioned alone.[36] The Saxon Annalist, drawing on the earlier Saxon world chronicle, focuses on Matilda's childlessness despite two marriages, and Cosmas's chronicle of the Bohemians includes a lengthy excursus on her marital difficulties with Welf, despite again calling her actions 'virile'.[37]

In all of these works, therefore, Matilda is treated primarily as a woman; Donizo instead wrote of her as a ruler, and had to make strategic choices about the elements which could still be used in order to reconcile her

position with her sex. Donizo also used new ideas of intellectual abilities, and the marchioness's position and his writing create an image far removed from that of powerful women in the narrative sources earlier in the eleventh century. Comparisons with other authors' treatments of Matilda suggest that he found original ways to do this, and perhaps strengthens the argument that he did indeed write for Matilda's own consumption.

Women, property and power

Much of Matilda's power and influence derived from her status as the sole heiress to her patrimony, with relatively weak husbands. In many of the cases cited so far, women were valuable marriage partners for the rights they transmitted to power or property. But female inheritance rights were not limited to the upper reaches of the aristocracy. The eleventh century sees the highpoint of recorded female landowning activity in Italy, something in which elite women shared. Similarly, David Herlihy has identified a peak in this century of people using their mother's name for identification, in 6 per cent of all the documents he sampled. This owed something to notarial procedures, but could also have expressed the remarriage of a father, or illegitimacy, or higher status deriving from a mother, or the fact that the father was a cleric in an age increasingly hostile to clerical marriage, or the fact that property had been inherited from the mother if she was noble. The use of matronymics thus provides an index of social visibility of women. In Genoa, Diane Owen Hughes found several examples of matronymics persisting into the twelfth century, but none by the thirteenth.[38]

We see a rare example of the persistence of a matronymic in one of the most prominent Bolognese aristocratic families of the ninth to twelfth centuries, studied by Tiziana Lazzari.[39] The de Ermengarda clan retained its female-derived surname even when the family began to trace its lineage through the male line. Ermengarda herself is documented from 1013 to 1021 as the daughter of Adalbert the count, but her husband, her son Lambert's father, was never named. In 1017 her son made a gift for his soul, that of John, bishop of Bologna, and his relatives – it is likely therefore that he was related to John. Lazzari suggests that he might have been John's son but that, in a climate of disapproval towards clerical marriage or concubinage and offspring, Lambert took his mother's name: unless he was illegitimate, why would he use her name and not his father's? There was no reason to suppose she was particularly prominent. The de Ermengarda were filopapal supporters and associates of Matilda of Tuscany during the investiture dispute.

The family continues to be documented in the twelfth century, but was facing new pressures relating to the rise to power of city-based authorities. In 1200, Peter de Remingarda, son of the late Taurelli de Ferrara, sold the houses of the family to the commune of Bologna with the consent of his widowed mother. The use of a matronym to cover up a clerical union was not unusual, but the peculiar thing about this family was the length of time it remained in use. No more documents record the surname after the early thirteenth century.

What is clear about the de Ermengarda is that the family was wealthy and that women shared in that wealth. Herlihy also finds that in boundary perambulations in Italy in the eleventh and twelfth centuries, female landowners made up 3 per cent and 4 per cent, respectively, of the over 63,000 names recorded, and the heirs of women 20 per cent and 15 per cent. The figure for women is low in comparison with other areas of Europe, but the incidence of heirs of women is higher. Concentrating solely on directly documented women owners, therefore, may mask the much larger figure produced by indirect evidence of inheritance from women. Turning to women as the principal donors and alienators in over 20,000 charters with lay principals from Italy, women made up 13 per cent in the eleventh century compared with 9 per cent in the twelfth. Herlihy notes that looking at percentages here risks the danger that the figures express women as *pious* landowners (as most transactions are to or with the Church) than as landowners, that is, as a subgroup, but his figures are still informative.

That transfer down the female line was happening is indicated obliquely by an edict of Emperor Conrad II in 1037 for Italy, which expressly excluded women and cognate relatives from inheriting feudal land. Conrad's measure was part of a shift in familial structures occurring in the eleventh century. As the century progressed, there is more evidence of agnatic linear descent rather than lateral kin groups: Diane Owen Hughes highlights the tightening of lineage bonds and and increasing emphasis on agnatic descent in the Genoese documents.[40] The value of Lazzari's study of the de Ermengarda, however, is that it indicates a possible persistence of memory of a female ancestor, which may in other cases have translated into actual inheritance down the female line. Such a situation appears to have arisen in Bari in the latter part of the eleventh century. The Alfaraniti of that city, too, owed their surname to a female ancestor, and their prominence in the Barese documents culminated in one of their number briefly becoming prince of Bari in the early years of the twelfth century.[41] Another Alfarana, whose relationship to the clan is unclear but who is highly likely to have been a member of the family, was clearly of high status: the document recording the transfer to her of her morning-gift on her marriage to a certain Mel, son of Natalis, in 1027 includes her name picked out in large and

ornate letters and, uniquely in this archive, a miniature of the transfer taking place, with the woman in full Byzantine-style dress, earrings and a crown.[42]

Women, property and law

David Herlihy's work attempts to draw together the Italian evidence in a synthetic way to provide a statistical picture of women's lives in the Middle Ages. However, such analysis is only possible where charters have been published or have been the subject of intensive research, and there is still some way to go in this area before a more than impressionistic synthesis can be compiled. Studying the charters themselves on a more localised level can not only produce statistical analyses, but also give a more precise picture of the conditions under which women could and did hold property.

Some examples from the register of the central Italian abbey of Farfa underline this point, with many documents recording women's gifts to the monastery. They usually acted with a *mundoald* or advocate (which Camillo Giardina has demonstrated are interchangeable terms in central-southern Italy[43]), and the value of moving from the general to the particular is demonstrated by a charter of Itta, wife of Domenicus, dated 1039. Giving land near Assisi to Farfa, she states that she acted willingly with the consent of her husband, just as 'in the edict of the emperor, which says that women might with the consent of her husband or *mundoald* sell or leave property for her soul'.[44] In the eleventh century, we see that law is still being cited, but the clarity of citation which accompanied earlier women's transactions was becoming largely lost.

A startling example of this blurring of legal profession comes from the published charters of Matilda of Tuscany. In an early document of 1072, both Beatrice and Matilda are said to 'live according to the Salic law of their nation', a citation repeated in 1073. However, in a document of 1078, Matilda ascribes her use of Salic law to her marriage to Godfrey of Lorraine; and a year later there is even less clarity, despite an attempt to make her situation clear, when she says, 'I live according to Lombard law by birth, but now because of Godfrey, who was my husband, I live according to Salic law'. From then on until her death in 1115, Matilda's citations are of Salic law with exceptions in 1095 and 1099, when she professes the 'Lombard law of her nation' again.[45] What is important to note is that in neither of the exceptions does she act with a Lombard *mundoald*, nor is any difference apparent between her actions under Salic and Lombard law. So did such citations have any real effect or meaning by the eleventh century?

Federica Rosi's survey of 1582 charters from the abbey of St Croce di Sassovivo near Foligno in Umbria,[46] which provides a basic outline of women's activities and presence in those documents, is a fine example of the results that can be obtained through close reading of individual transactions, and suggests a similar blurring of the edges in legal definitions surrounding women. In a substantial article, Rosi reveals the activities of a range of women across a broad social spectrum, from small, rural landholders to aristocratic heiresses. One-third of the documents feature women; one-third of the women are active participants in the land transactions carried out (as opposed to being simply mentioned, for example, in boundary clauses or as matronyms). Characteristically, Rosi finds little mention of women's work activities; like other charter samples, these charters are concerned with property, not actions, and women's identities were drawn from their relationship to husband or father in preference to an artisanal surname.

The eleventh-century sample studied by Rosi numbers 122 documents, of which 27 per cent include women. Over half of the women, however, are active participants in the transaction recorded. As we shall see in Chapters 6 and 7, female activity dwindles in the Sassovivo sample even as the documentary sample grows (the major drop in female activity occurring in the thirteenth rather than the twelfth century). Given that Sassovivo lay in a relatively unurbanised area of Umbria, Rosi is right to cite Maria Teresa Guerra Medici's statement that in an agrarian setting in the tenth and eleventh centuries, there was little which clearly demarcated male and female roles. What was important was the effective exploitation of the family holdings. Although the family itself revolved around a usually male head, its women were far more actively engaged in such exploitation, and stood to benefit as heiresses, dowry-holders and recipients of marriage gifts from their husbands' families and their own.

Their ability to exploit their property was limited only by the presence of their *mundoald* or legal guardian, usually the husband or father. The area covered by the Sassovivo archive appears to have retained largely Lombard laws and customs (although Rosi comments on the commingling of legal traditions and thus the difficulties of identifying a consistent set of norms for this documentary sample). Thus women were, legally, subject to their *mundoald* when wishing to make transactions. In practice the *mundium* does not appear to have restricted women from participating in land transactions (particularly those with their husbands), and documents include the standard phrase that they have not suffered any violence or coercion to engage in the business being transacted. Often, members of their own family would be present too, and this must have offered a safeguard of sorts. Rosi notes that

whilst *mundoalds* become less frequent in the Sassovivo charters, relatives remain a constant presence. Nevertheless, across her entire sample, fifty-three of the active women, or over 17 per cent of them, are acting alone. These are not broken down by century, but represent a significant sample in an area of supposedly Lombard law – they indicate the dangers of categorising regions too baldly.

A final point to note is that, of the sole women, almost half are alienating property by sale or donation. In this the Sassovivo study mirrors other parts of Italy, where female piety, economic pressure or simply the difficulties of managing estates appear to have induced women to cede their property. In any monastic archive it may well be that donations are over-represented. Rosi comments that donations to Sassovivo and other religious foundations in the area involving women overall cluster predominantly in the eleventh and early twelfth centuries. The more numerous land sales tell many stories; liquidation for commercial purposes may be another explanation. Again, frustratingly, Rosi does not break this sample down by century to enable any analysis of change over time.

Rosi's study features with two others in a useful survey by Giovanna Casagrande of the Umbrian picture as a whole. Comparing largely Lombard Sassovivo with areas of Roman law around Gubbio and Montelabate, the striking statistic which emerges is that all three areas have roughly similar percentages of documents with women as the main or co-actors, that is, Lombard law is not in itself a bar to activity in land transactions, and Casagrande notes that lone women are present in all three samples.[47]

Epstein's study of Genoa and the Genoese reveals that focusing on the domestic history of Genoa can have dramatic effects: 'as the city receives more attention, half of its population emerges from the obscurity to which generations of indifference have consigned them'.[48] Here, as elsewhere, the documents of laypeople show a mixture of laws from an early date, for example the couple Ingone and his wife Richelda, living according to Roman and Lombard law, respectively, documented in 1019. In 1056, Marquis Alberto Malaspina confirmed the customs of the city including the right of its Lombard women to sell or give away property according to their custom, but such confirmations are themselves an indicator that women's legal status was by no means clear in the city by this date.

It is evident from the examples cited above that the legal profession recorded in women's charters was having less and less practical effect on their freedom of action in northern and central Italy in this period, and even in the more conservative south the boundaries were becoming blurred, as recent studies of their activities in connection with making wills and bringing court cases illustrate.[49]

Women and inheritance rights: the beginnings of exclusion

That there was tension over female inheritance rights is suggested by a document of the early eleventh century cited by François Bougard, in which a man was sentenced to losing one-third of his own property for killing his sister 'out of greed for her goods [pro rerum suarum cupiditate]'. The striking feature of the case is that the penalty was decided citing a Carolingian capitulary issued at Worms in 829. The legal framework might still be defending women's lands – but this would be one of the last instances where we see this happening.

The major tendency identified by historians of different parts of Italy in this period was for an increasing emphasis on male inheritance and non-partible patrimonies. This affected younger sons as well as women, and the histories of the Arduinici of Turin and the Attonids of Canossa show that non-partible inheritance did not automatically exclude women. Giovanni Tabacco shows the process of tightening the inheritance happening in the case of the Frankish Arduinici: the second generation of the family, which had arrived in Italy in the tenth century, saw all the sons treated equally with the heir designated marquis, but by the third generation the marquis was being favoured in the distribution of the inheritance. At the same time, as we have already seen in the case of Genoa cited above, families might co-operate more closely with each other, developing societies of *consortes*, where shared economic and political interests focused family actions and drew into their sphere further members who were unrelated by blood.[50]

Cinzio Violante, working on Lombardy, Emilia and Tuscany,[51] explains this upsurge in interest among families themselves in their genealogies (such as that drawn up by Anselm the Peripatetic) by the new severity which ecclesiastical reform had brought against consanguineous marriage. The need to marry outside the kin group meant that women were, in effect, leaving their natal family, and this is expressed in Anselm's genealogy by the noticeable lack of names assigned to women.

On the death of her husband, his wife kept her quarter or third (depending on whether Lombard or Frankish custom was being followed) of her husband's property as well as the counterdowry or *antefactum* given to her by her husband. She might also be designated the manager of her husband's estate, or receive usufruct of it for a specified period. Violante is of the opinion that in the regions of Lombardy, Emilia and Tuscany, the widow's portion was only an ideal, that is, she did not have sole control over specific properties but simply one-third or quarter-share in the whole. It was for this reason that she had to appear in all of her children's transactions giving her

consent. Whilst her children were minors, she and they had common interests, but tension could arise from her continued hold on such a substantial portion when they reached adulthood.

Violante characterises eleventh-century widows in Lombardy as having considerable autonomy. They could dispose of their third if they became nuns, and could thus escape the *mundium* of their sons. The flow of lands out of the family could be dramatic, and at the end of the eleventh century Violante notes a gradual conversion of the dowry to moveables to prevent the dissipation of landed property. In the following century, measures to reduce or abolish the one-third or *morgengab* would be introduced.

Economic opportunities: women and work

As in earlier centuries, women's work continues to be patchily documented, and appears to have remained largely connected to the domestic sphere. Iconographic sources, such as exultet rolls from the south and the tenth-century Cassinese manuscript of the illustrated encyclopaedia of Rabanus Maurus show one of the major economic functions of women: clothmaking.[52] Rabanus shows both spinning and weaving being done in the *gyneceo* or women's workshop, but the bulk of such work may well have been done at home. Spinning, in particular, was an occupation which offered flexibility of location. In addition, the encyclopaedia shows a woman drawing water at a well.[53] This underlines the fact that 'women's work' covers a multitude of domestic tasks which were crucial to the survival of the household.

Because women's identity in charters was more often than not derived from their marital status, very few had professional names denoting an occupation. This, though, should not surprise us: women's work was an extension of their domestic identity, rather than an identity in itself. Add to this the frequent observation by historians about the likelihood of a woman spending half her life pregnant or nursing, and perhaps it could be speculated that those (rare) women documented as active in commerce or artisanal activities from the eleventh century onwards were those with fewer domestic responsibilities. Narrative sources, however, can provide evidence of the extended domestic work which women undertook. Diana Webb has shown how effectively eleventh-century and later saints' lives can be exploited for information of this type.[54] The eleventh-century collection of the miracles of St Prospero around Reggio Emilia, for example, includes the tale of an impious man who snatched some 'shining white loaves' from the women of his household. The loaves had been intended for the saint as alms for the poor, and so the offender suffered distressing results when he ate them

instead. The value of this tale lies in the tangential evidence it provides for extra baking being done for the poor, an important economic function which not only enhanced the pious credentials of the women concerned, but would also have contributed to their local standing in the community as purveyors of a charitable act.

Work could also have negative connotations. Peter Damian relates the controversy which surrounded a new feast day of St Rufinus instituted by Bishop Ugo of Assisi (d. 1059). The saint punished those men who failed to observe the new day and with their wives audaciously engaged in weaving. Their houses were set on fire with inextinguishable flames as punishment. Webb comments on the rural background to many of Peter Damian's stories. St Romuald punished the lord of a poor woman whose cow he had seized. Again there is peripheral evidence to be gleaned from the tale: the woman offered two chickens to the saint when she prayed for help. Small livestock were a regular feature in and around both rural and urban houses, and women seem to have been charged with their care.

The bulk of women's work would take place in a rural context in this period: an eleventh-century sculpture of women's work portrays a group in a field.[55] Written evidence of their presence often comes in the form of monastic landlords continuing to record the slave and subject workers on their estates, and attempting to maintain their servile status. In Violante's study of Lombardy, Emilia and Tuscany, the author draws attention to the way in which the monastery of SS Flora and Lucilla in Arezzo drew up an eleventh-century genealogy of its servants, going back to the tenth century in order to maintain their status as its slaves. The monastery argued that when one of its female slaves or *ancillae* married the slave of another master, the husband should fall under the monastery's power. Further afield, monastic surveys from Sardinia reveal the women slaves on monastic estates making wine, acting as domestic servants and cleaning. It has also been suggested that they participated in Sardinia's emerging merino wool industry.[56]

Charters are not entirely absent of useful information regarding women's work in this period. Padrone Nada has usefully highlighted the potential of dowry and testamentary documents in revealing moveable items related to work and belonging to women.[57] In the south, examples include flax combs (for the preparation of linen), wool combs, stone washboards and cooking utensils.[58] Work on northern charters has yet to be done on this aspect of women's property, and would surely provide rich results. Domestic service is also occasionally documented in the charters, although as yet there is little evidence of many arrangements beginning with a formal, contractual agreement.

The charter evidence is concerned with property, and female property-owners are a continuous presence, as we have seen. However, in one or two

cases it is possible to see women actively working on or managing their lands for economic profit. Among the land leases issued by the female monastery of St George at Salerno is one dated 1090 in favour of a certain Amata, who took on land to plant with vines. Eight years later, she and the monastery split the ownership of the land equally, with the only restriction being that Amata was to give the monastery first refusal on any resale of her portion. In neither document is it indicated that anyone other than Amata had worked the land.[59] Women could also be involved in investment opportunities. At Genoa in 1012, Amerada and her son Conrad collaborated with partners to build a mill on their land. She and Conrad received one-quarter of the income; the others provided materials, and built and ran the mill.[60]

Religious life: reform, revival and resistance

There are several interlinking themes to women's religious life during the eleventh century. The pressure for Church reform brought with it not only an increasing desire to free the clergy from lay control, which would bring the papacy and the German emperors onto a collision course over the investiture of bishops, but also a wish on the part of the laity for new forms of religious expression which might or might not be mediated by a clergy tarred with the sins of office-buying (simony) and marriage (nicholaism). As the papacy attempted to tighten doctrinal and pastoral control in this period (as evidenced by Gregory VII's letters to various Italian bishops), certain groups either resisted or found themselves outside the new guidelines: both were labelled heretics, and northern Italy provides rich evidence of how the Church dealt with this perceived threat.

At the same time, this was a period of renewed monastic foundations, alongside older houses which continued to survive and thrive through adapting to the shifting political and religious landscape. Suzanne Wemple's study of St Salvator/St Julia at Brescia expresses perfectly how the strands came together: during the eleventh century the abbey received a series of gifts from the popes and emperors. It was clearly still sufficiently important to figure in the gift-giving strategies of both sides as they sought to win influence in the north. Henry II gave gifts to Abbess Rolinda in 1014, Henry III to Abbess Otta in 1046, both transactions being confirmed by Henry IV 1085. The papacy, for its part, was determined to maintain the abbey under its patronage: Nicholas II issued a decretal in 1060 taking the house under papal protection.

Wemple's wider study of female monasteries[61] in this period shows how the German emperors sought to build and continue links with other

houses as well in this sensitive period of ecclesiastical reform. Henry II gave his protection and immunity, along with the right to elect an abbess, to St Salvator at Lucca and its abbess, Alperga. He also offered protection and immunity without election rights to St Zaccaria at Venice and its abbess, Vita, and in 1014 he presided over a dispute involving St Salvator at Pavia and its abbess, Eufraxia, over land near Lake Maggiore. Emperor Conrad II, particularly active in Italy, repeated his predecessor's protection of the Lucchese and Venetian convents, confirmed imperial protection over St Sistus in Piacenza, and gave protection and immunity to St Andreas in Ravenna. He also guaranteed the possessions of the convent of St Martin in Pavia, which had received them from Empress Adelaide.

The influence of reform could have negative effects. Perhaps as a result of the reform movement, Emperors Henry III and Henry IV do not appear to have concerned themselves with many Italian female houses apart from the older, royal foundations. Whilst the reform of monastic life which had started in the tenth century and continued in the eleventh did not target women's houses, it does seem to be the case that women's houses were considered to contain a disproportionate number of inmates whose vocation was not as genuine as their male counterparts, hardly surprising when one of the earlier functions of convents had been as places of protection for aristocratic daughters. Thus, when the Berardenghi of Siena refounded their monastery of Fontebuona in the city in 1003, they installed monks there instead of the nuns which their ancestor, Count Winigis, had supported in 867. In his *Life of St Romuald*, Peter Damian says that the saint founded a community of monks in Valle de Castro (modern province of Ancona). The 'number of converted women [conversarum quarundum mulierum]' who were already in that place relinquished their church and new cells were built for the monks. Romuald later founded a female house.[62] However, this story effectively shows women's spontaneous expression of their wish to live in a community being taken over and turned into male-controlled claustration in a regular nunnery. This would be a recurring theme in the relations of the Church with religious women.

Family foundations, however, did not end with monastic reform. They also provided another focus for the recuperation of family property which had gone out of the family through women's marriages. Around the year 1000, Violante notes that Tuscany, in particular, saw a sharp rise in such foundations. This is echoed in a study by Picasso and Spinelli, cited by Wemple, which states that of forty-five convents existing in Lombardy to the beginning of the twelfth century, some seventeen had been founded in the eleventh century, including three in Cremona after 1060, and three founded by the Cluniacs: St Mary de Laveno and St Mary de Cantù in the diocese of Milan in 1081 and 1086, and St Peter in Cavaglio Mezzano (diocese of

Novara). The relatively high number of foundations in the eleventh century was probably owing to the investiture controversy, and the pressure on the wives and concubines of married priests to withdraw from public view.

Other foundations and reorganisations in the eleventh century were clearly motivated by piety. For example, Marquis Olderico Manfred and his wife Berta established the abbey of Caramagna in Piedmont in 1028, and Berta of Florence established Vallombrosan houses there in the latter part of the century. Most female houses remained small, with only fifteen to twenty inmates. This, plus the continued strict enforcement of claustration, is considered by Lynch to be the reason why female houses were economically vulnerable throughout the Middle Ages.[63] In Naples, this may be illustrated by the amalgamation of the older convents of St Gregory and St Pantaleo into one house by Duke Sergius IV in 1009; the new institution subsequently entered into the period of its greatest wealth and power.[64] One or two southern houses achieved exceptional influence within their communities: the abbess of St Maria Veterana in Brindisi, founded in 1090, had authority over thirty-six parishes around the convent, with the right to nominate their priests. The house was granted immunity and protection by Pope Paschal II (r. 1099–1118), but unfortunately few documents survive to chart how the abbess wielded her power.[65]

Statistical surveys and high political manoeuvres, however, ignore the essence of women's personal piety in this period of immense change. Although Pásztor agrees with the commonly held view that it was the twelfth century which saw the major surge in women's piety (at least as far as the written record reveals), she argues that the real renaissance came in the preaching of reformist mystics a century before, leading to movements of personal piety both within and outside the established Church.[66] One such was the penitential movement, whereby individuals sought to lead a monastic life but did not necessarily wish to be cloistered to do so. Vitolo notes that the documents from the abbey of Holy Trinity, Cava, mention uncloistered monks from the mid-tenth century, but the same archive shows that uncloistered women are more numerous from the late eleventh century onwards, with mentions of nuns who were at home not in a monastery ('qui non degent in monasterio sed domi').[67] Thirteen of the fourteen women mentioned are of modest social status, and seven are widows. Valerio speculates that such evidence may reveal how women without the necessary dowry to enter a monastery responded to their wish to pursue a religious life.[68] However, in the case of widows, such a penitential stance may well have protected them against pressure to remarry and enabled them to retain control of a significant amount of property.

The growing number of penitents choosing to remain at home is part of a wider movement, felt first in the eleventh century, for the laity to have

more active spiritual links with the Church (as opposed to the economic and patrimonial ones of earlier centuries). This manifested itself also in the rise of pious fraternities and lay congregations around churches, often connected with the production of documents recording the close relationship and commemorating active donors in the form of necrologies. One of the earliest surviving examples comes from St Matthew in Salerno, dating to this century, but the twelfth century would see a sharp rise in the number of books of this type.[69]

However, some movements of uncloistered and unattached collective piety fell outside the Church's own (still ill defined) boundaries of orthodox worship, and attracted the label of heresy. An early episode is reported by the later chronicle of Milan as having occurred in the castle of Monforte around 1028. The case itself is included in most standard histories of heresy,[70] but a key factor to note is the involvement of the countess of the castle. It is entirely possible, as in earlier cases of bishops being deposed for resisting reform, that the accusation of heresy could be used to eliminate political rivals. In this particular case it was not the archbishop of Milan, but the local secular lord, who ordered the burning of the heretics. Cinzio Violante, however, whilst highlighting the changing social conditions and the shifting relationship between cities and countryside (including rural castles) in this period, is firmly convinced that new religious movements, heretical or not, were primarily religious in their motivation and cannot be used as signs of resistance or revolution.[71]

The attractions of the religious life are vividly conveyed in Peter Damian's account of the life of St Romuald, where the domestic tensions caused by religious enthusiasm are also evident. Inspired by the saint, a secular man named Arduin decided to become a monk. He went home to sort out his possessions, and his furious wife confronted him: 'Here you are come from that heretic and old seducer, and I suppose you're all set to leave me in misery and deprived of all human consolation!' Now technically, she had right on her side, for as we have seen, the Church forbade wives and husbands from entering the Church unless the other spouse agreed. A miracle of the saint duly intervened: eating bread blessed by Romuald, the wife calmed down, gave thanks for her husband's vocation and allowed him to go.[72]

Conclusions

The eleventh-century story is one of immense change in the lives of women, often only beginning to have effects which would be felt and seen more clearly in the twelfth century. This was the last time, until the latter part of

the thirteenth century, that powerful female rulers would be seen actively engaging in the politics of the peninsula. Such women of aristocratic birth, and those of more modest status, still had a substantial amount of discretion over their property ownership, but the pressures on families to pass on viable inheritances to their children led to the beginnings of exclusion of all but the oldest male child, reflected in the movement towards agnatic lineage patterns. Women were still managing property, but their access to it would gradually be closed off, especially in northern Italy. Further south, older patterns of power and property remained quite strong, and, if anything, the transformation of the restrictions of Lombard law into the practicalities of local custom provided more opportunities for women under the new Norman regime.

At the same time, the growing power of the Church, and the determination of Church reformers, had both positive and negative effects on women's status. The increasing hostility towards married clergy is thought to have had its fall-out in the number of new female monastic houses which appeared in this century. These were founded according to newer, reformist principles, and several older female houses seem to have fallen victim to the zeal of the reformers in having their female communities replaced by male monks.

The Church as a whole was beginning to actively support as never before the indissolubility of formal, legitimate marriages and the undesirability of concubines. The latter trend has been viewed as a positive step by historians of marriage, but could have detrimental effects on wives put aside by husbands eager to remarry for political gain. Such dissolutions were justified with recourse to Church strictures on consanguineous marriage, again not a new phenomenon, but one which was being more rigidly imposed along with other steps towards conformity and control.

These steps extended particularly into religious life, where pious individuals and communities, seeking alternatives to cloistered communal life, followed charismatic leaders or set up their own groups, or simply took personal vows to remain chaste and penitent. Such movements already threw up heretical sects in the eleventh century, and the twelfth century would see non-conformist groups burgeoning in the northern half of the peninsula and taking a wide diversity of forms.

Notes

1. Ephraim Emerton (ed.), *The Correspondence of Pope Gregory VII* (New York, 1932, reprinted 1990), p. 60.

2. C.-R. Brühl and C. Violante (eds), *Honorantie Civitatis Papie* (Cologne and Vienna, 1983); partial English translation in Robert S. Lopez and Irving W. Raymond (eds), *Medieval Trade in the Mediterranean World* (New York, 1955, reprinted 1990), pp. 56–60.

3. David Herlihy, 'Land, family and women in continental Europe, 701–1200', *Traditio*, 18 (1962), pp. 89–120, reprinted in S. Mosher Stuard (ed.), *Women in Medieval Society* (Philadelphia, 1976), pp. 13–45.

4. P. Skinner, *Family Power in Southern Italy: The Duchy of Gaeta and its Neighbours, 850–1139* (Cambridge, 1995).

5. Diane Owen Hughes, 'Urban growth and family structure in medieval Genoa', *Past and Present*, 66 (1975), pp. 3–28. See also David Herlihy, 'Family solidarity in medieval Italian history', in D. Herlihy, Robert S. Lopez and Vsevolod Slessarev (eds), *Economy, Society and Government: Essays in Memory of Robert L. Reynolds* (Kent, Ohio, 1969), pp. 173–184.

6. V. de Bartholomeis (ed.), *Storia de' Normanni di Amato di Montecassino* (Rome, 1935).

7. L. Simeoni (ed.), *Vita Mathildis Celeberrimae Principis Italiae* (Bologna, 1940) (hereafter *VM*).

8. Emerton (ed.), *Correspondence*.

9. Giovanni Tabacco (ed.), *Pietri Damiani Vita Beati Romualdi* (FSI 94, Rome, 1957).

10. J. Leclercq, 'S. Pierre Damien et les femmes', *Studia Monastica*, 15 (1973), pp. 43–55.

11. G. Monticolo (ed.), *Cronache Veneziane Antichissime*, I (Rome, 1890), pp. 59–174 (hereafter *Chron. Ven.*).

12. Skinner, *Family Power*, p. 150 onwards, deals with the period in greater depth.

13. Adalbert Davids, 'Marriage negotiations between Byzantium and the West', in Adalbert Davids (ed.), *The Empress Theophann: Byzantium and the West at the Turn of the First Millennium* (Cambridge, 1995), pp. 99–120, at p. 110.

14. *Chron. Ven.*, p. 171.

15. Tabacco (ed.), *Pietri Damiani*, chapter 40, p. 82.

16. Emerton (ed.), *Correspondence*, p. 59.

17. Ibid., p. 146.

18. See the two articles by L. Fuiano: 'Principi e nobiltà nelle arte figurative dell'Italia meridionale longobarda nei secoli X e XI', *Archivio Storico Pugliese*, 33 (1980), pp. 109–126; and 'Ceti rurali, donne, bambini, angeli e diavoli nelle arte figurative dell'Italia meridionale longobarda nei secoli X e XI', *Archivio Storico Pugliese*, 35 (1982), pp. 3–20.

19. M. Pereira, 'Introduzione', in M. Pereira (ed.), *Né Eva né Maria: Condizione Femminile e Immagini della Donna nel Medioevo* (Bologna, 1981), pp. 9–22, at p. 13.

20. Emerton (ed.), *Correspondence*, p. 24.

21. I have dealt with Sikelgaita at some length in P. Skinner, '"Halt! Be men": Sikelgaita of Salerno, gender and the Norman conquest of southern Italy', *Gender and History*, 12 (2000), pp. 622–641.

22. The following biographical details are culled largely from A. Valerio, *La Questione Femminile nei Secoli X–XII* (Naples, 1983), and L. Simeoni, 'Il contributo della contessa Matilde al papato nella lotta per le investiture', *Studi Gregoriani*, 1 (1947), pp. 353–372.

23. E. Goez, *Beatrix von Canossa und Tusczien: Eine Untersuchung zur Geschichte des 11 Jahrhunderts* (Sigmaringen, 1995).

24. Simeoni, 'Il contributo'; D. B. Zema, 'The houses of Tuscany and of Pierleone in the crisis of Rome in the 11th century', *Traditio*, 2 (1944), pp. 155–175; H. Fuhrmann, *Germany in the High Middle Ages* (Cambridge, 1986), p. 65 onwards.

25. Valerio, *Questione Femminile*, p. 22 (my translation).

26. The penance is recorded in a famous miniature included in the manuscript life of Matilda, on which more presently. On Matilda as intermediary, see T. Reuter, 'Unruhestiftung, Fehde, Rebellion, Widerstand: Gewalt und Frieden in der Politik der Salierzeit', in S. Weinfurter (ed.), *Die Salier und das Reich*, 3 vols (Sigmaringen, 1991), vol. 3.

27. Simeoni, 'Il contributo', p. 372 (my translation).

28. *VM*, prologue.

29. T. Struve, 'Matilda di Toscana–Canossa ed Enrico IV', in Paolo Golinelli (ed.), *I Poteri dei Canossa da Reggio Emilia all'Europa* (Bologna, 1994), pp. 421–454, at p. 422, highlights a letter from German bishops who scorn the 'female senate' helping Gregory VII to run the Church. The chronicle of Lampert of Hersfeld for 1077 highlights rumours about Matilde's sex life: G. H. Pertz (ed.), *MGH SS*, V (Hanover, 1844), p. 145.

30. Diane Owen Hughes, 'Invisible Madonnas?: The Italian historiographical tradition and the women of medieval Italy', in Susan Mosher Stuard (ed.), *Women in Medieval History and Historiography* (Philadelphia, 1987), pp. 25–58 at pp. 35–36, 47.

31. G. Severini, 'La "vita metrica" di Anselmo di Lucca', in Cinzio Violante (ed.), *Sant'Anselmo Vescovo di Lucca (1073–1086) nel Quadro delle Trasformazioni Sociali e della Riforma Ecclesiastica* (Rome, 1992), pp. 223–271, at p. 229; R. Ferrara, 'Gli anni di Matilda (1072–1115): osservazioni sulla "cancelleria" canossiana', in Golinelli (ed.), *I Poteri dei Canossa*, pp. 89–98, at p. 90.

32. Skinner, '"Halt! Be men!"'.

33. V. Fumagalli, *Matilde di Canossa: Potenza e Solitudine di una Donna del Medioevo* (Bologna, 1996).

34. E. Pásztor, 'La "vita" anonima di Anselmo di Lucca', in Violante, (ed.), *Sant'Anselmo*, pp. 207–222, at p. 220.

35. Struve, 'Matilde', p. 449.

36. Pertz (ed.), *MGH SS*, V, pp. 449, 454, 465.

37. *Annalista Saxo*: G. H. Pertz (ed.), *MGH SS*, VI (Hanover, 1844), p. 706; B. Bretholz (ed.), *Die Chronik der Böhmen des Cosmas von Prag* (Berlin, 1955), Book II, 32.

38. Owen Hughes, 'Urban growth', p. 13.

39. T. Lazzari, 'I "de Ermengarda": una famiglia nobiliare a Bologna (secc. IX–XII)', *Studi Medievali*, 32(2) (1991), pp. 597–658.

40. Owen Hughes, 'Urban growth', p. 13.

41. P. Skinner, 'Room for tension: urban life in Apulia in the eleventh and twelfth centuries', *PBSR*, 66 (1998), pp. 159–175.

42. Reproduced in Maria Cannataro, 'Un insolito documento privato barese', *Annali della Facoltà di Lettere e Filosofia della Università degli Studi di Bari*, 19/20 (1976/77), pp. 201–223.

43. Camillo Giardina, '*Advocatus* e *mundoaldus* nel Lazio e nell'Italia meridionale', *Rivista di Storia del Diritto Italiano*, 9 (1936), pp. 291–310.

44. Giardina, '*Advocatus*', p. 293.

45. Elke Goez and Werner Goez (eds), *Laienfürsten- und Dynastenurkunden der Kaiserzeit II: Die Urkunden und Briefe der Markgräfin Mathilde von Tuszien* (*MGH*, Hanover, 1998), documents 6, 9, 26, 28 (combining Lombard and Salic law), 36, 40, 46 and 55 (citations of Lombard law), 76, 98, 111, 122, 127 and 133.

46. F. Rosi, 'Donne attraverso le carte dell'abbazia di S. Croce di Sassovivo (1023–1231)', in *Donne nella Società Comunale: Ricerche in Umbria* (= *Annali della Facoltà di Lettere e Filosofia dell'Università degli Studi di Perugia. 2. Studi Storico-Antropologici*, vols XXXI–XXXII, new series vols XVII–XVIII, 1993/94–1994/95), pp. 49–85.

47. G. Casagrande, 'Donne in Umbria nei secoli XI e XII: le carte di Sassovivo, Montelabate, Gubbio', *Annali della Facoltà di Lettere e Filosofia, Università degli Studi di Perugia*, 34–35 (1996/97–1997/98), pp. 9–26, at pp. 13, 22.

48. S. Epstein, *Genoa and the Genoese, 958–1538* (Chapel Hill, NC, 1996), p. xviii.

49. P. Skinner, 'Women, wills and wealth in medieval southern Italy', *Early Medieval Europe*, 2 (1993), pp. 133–152; eadem, 'Disputes and disparity: women

in court in medieval southern Italy', *Reading Medieval Studies*, 22 (1996), pp. 85–104.

50. G. Tabacco, 'Le rapport de parenté comme instrument de domination consortiale: quelques exemples piémontais', in Georges Duby and Jacques Le Goff (eds), *Famille et Parenté dans l'Occident Médiéval* (Rome, 1977), pp. 153–158.

51. C. Violante, 'Quelques caractéristiques des structures familiales en Lombardie, Émilie et Toscane aux XIe et XIIe siècles', in Duby and Le Goff (eds), *Famille et Parenté*, pp. 87–149.

52. Fuiano, 'Ceti rurali'.

53. A. M. Amelli, *Miniature sacre e profane dell'anno 1023 illustranti l'encyclopaedia medioevo di Rabano Mauro* (Montecassino, 1896), p. 287. The Cassinese manuscript is now usefully discussed, with full-colour plates, in Guglielmo Cavallo, *L'Universo Medievale: Il Manoscritto Cassinese del 'De Rerum Naturis' di Rabano Mauro* (Ivrea, 1996).

54. Diana Webb, *Patrons and Defenders: The Saints in the Italian City-states* (1996).

55. V. Maugeri, 'Immagini del lavoro femminile nel medioevo', in M. G. Muzzarelli, P. Galetti and B. Andreolli (eds), *Donne e Lavoro nell'Italia Medievale* (Turin, 1991), p. 171.

56. B. Fois, 'Il lavoro femminile nei condaghi sardi dell'età giudicale (secc. XI–XIII), in Muzzarelli, Galetti and Andreolli (eds), *Donne e Lavoro*, pp. 55–66.

57. A. Padrone Nada, 'La donna', in G. Musca (ed.), *Condizione Umana e Ruoli Sociali nel Mezzogiorno Normanno-svevo* (Bari, 1991), pp. 103–130.

58. Skinner, 'Women, wills and wealth'.

59. M. Galante (ed.), *Nuove Pergamene del Monastero Femminile di S. Giorgio di Salerno, I (993–1256)* (Altavilla Silentina, 1984), p. 20, document 8.

60. Epstein, *Genoa and the Genoese*, p. 19.

61. Suzanne Fonay Wemple, 'Female monasticism in Italy and its comparison with France and Germany from the ninth through the eleventh century', in W. Affeldt (ed.), *Frauen in Spätantike und Frühmittelalter* (Sigmaringen, 1990), pp. 291–310.

62. Tabacco (ed.), *Pietri Damiani*, chapter 35, pp. 74–76.

63. Joseph Lynch, *The Medieval Church: A Brief History* (1992), p. 213.

64. Valerio, *Questione Femminile*, p. 49.

65. Ibid., p. 51.

66. E. Pásztor, 'Aspetti della mentalità religiosa nel medioevo: la donna tra monachesimo e stregoneria', in B. Vetere and P. Renzi (eds), *Profili di Donna* (Galatina, 1986), pp. 103–120, at p. 114.

67. G. Vitolo, 'Primi appunti per una storia dei penitenti nel Salernitano', *ASPN*, 17 (1978), pp. 393–405.

68. Valerio, *Questione Femminile*, p. 13.

69. Hubert Houben, *Il 'Libro del Capitolo' del Monastero della SS. Trinità di Venosa (Cod. Casin. 334): una testimonianza del Mezzogiorno normanno* (Naples, 1984); C. A. Garufi (ed.), *Necrologio del Liber Confratrum di S. Matteo di Salerno*, FSI 66 (Rome, 1922).

70. A translated account appears in both R. I. Moore, *The Birth of Popular Heresy* (1975, reprinted Toronto, 1995), pp. 19–21, and W. L. Wakefield and A. P. Evans (trans.), *Heresies of the High Middle Ages* (New York, 1969, reprinted 1991), pp. 86–89.

71. C. Violante, 'Eresie urbane e eresie rurali in Italia dal XI al XIII secolo', in O. Capitani (ed.), *Medioevo Ereticale* (Bologna, 1977), pp. 185–212.

72. Tabacco (ed.), *Pietri Damiani*, chapter 59, p. 101.

CHAPTER SIX

The Twelfth Century: Renaissance or Repression?

> It would be possible to write the political history of medieval city-states, for example, Florence or Venice, and scarcely mention women.[1]

The twelfth century witnessed the maturation of political and social developments begun in the previous century. Politically, the peninsula continued to experience the fall-out from the major foreign interventions of the eleventh century. The Normans consolidated their hold on the south, with the establishment of Roger II as king in 1130, and the north was faced with the continuing aspirations to real authority of the German emperors, in particular Frederick I. But the emperors' lengthy struggle with the papacy over episcopal investiture had left something of a power vacuum in the north for fifty years from c.1070, and in this period we see the emergence of what has been called the 'best moment'[2] in Italian civilisation, the autonomous city-states or communes of northern Italy.

The establishment of city-states resulted in the generation of legal codes, the earliest emanating from Pisa and Genoa. As family life continued to develop towards more defined male lineages and inheritance strategies, so the same families in their new political positions as leaders of the communes brought forward laws which gradually restricted women's property. Against a background of rising economic prosperity, the documentary collections at our disposal reach new heights, as civic governments became more concerned to keep official records. Copies were kept as never before, and preserved in cartularies by both secular and ecclesiastical notaries. Some cartularies of the twelfth century were compiled from earlier archives. Indeed, one of the major problems with the period is the tendency to 'tidy up' older charters into newly copied cartularies, which were concerned not to preserve the entire document but simply its salient information.

One cartulary which has received a great deal of study is that of the Genoese notary Giovanni Scriba,[3] a record of over 1,300 acts written in the period 1154–1164. Some of these are discussed below, but the sheer quantity of material in this single decade of one city's history provides a sense of how great is the task of undertaking a synthesis of the developments of the twelfth century in the whole of Italy. Genoa looms large in the history of twelfth-century Italian women because its sources have formed the subject of intensive editing and translation campaigns. Other regions are far less well served.

The establishment of the Norman kingdom in the south, meanwhile, produced an initially fragmented picture, but one in which women might continue to hold power in a way similar to the wives and widows discussed in Chapter 5 above. In 1114, the city of Bari rose against the widow of Bohemond, Constance, and her son Bohemond II, but the 'prince' who replaced her traced his own lineage from an illustrious female ancestor. This moment of southern civic pride owed much more to older patterns of aristocratic rule based in cities than to new models visible further north.

Does the pattern of repressive legal measures and the removal of women from the public arena in the north, whilst they continued to have prominence in the south, mark the real point at which the histories of women in the north and south diverge? And did the traditional 'conservatism' of the latter region actually benefit its female inhabitants? A comparison of dynastic politics in both regions may provide some answers.

Dynastic politics: the south

The Norman rulers of the south, as in so many earlier takeovers, established and consolidated their rule by a series of marital alliances amongst themselves and with external powers. King Roger II's first wife was Elvira of Castile, who bore him seven children including his heir, William I, before dying in 1135. His third wife was Beatrice of Rethel, whom he married in 1152 and who died bearing his posthumous daughter Constance. The intricacies of internal marriage alliances are revealed by the career of Matilda, Roger's half-sister. Married to Count Rainulf of Alife (d. 1139), she fled with her son from Rainulf's cruelty in 1131, which led to Rainulf rebelling. Her obviously close relationship with the king has given rise to the theory that she commissioned Alexander of Telese's biography of him.

King William I (r. 1151–1166) continued his father's links with the Spanish royal houses when he married Margaret of Navarre. On his premature death she reigned as regent for their young son William II, dying just six

years before him in 1183. In 1177, William II married the Angevin princess Joanna, daughter of King Henry II of England and Eleanor of Aquitaine. After her husband's death in 1189 she went on crusade, dying a decade later.

William II's death in 1189 ended the direct male line from Roger II, and the throne was claimed by Tancred of Lecce, the illegitimate son of Roger's son Roger, duke of Apulia. On Tancred's death in 1194, his wife Sibylla of Acerra briefly ruled as regent for their under-age son William III. By this time, however, the marriage of King Roger's daughter, Constance, to the German king, Henry VI, had created a powerful new claimant to the Sicilian throne. By the end of the twelfth century, the Normans' attempts to stave off a German/Swabian takeover in the south appeared doomed. Dione Clementi has shown how Constance initially resisted her husband's takeover of the kingdom on the grounds that it was not subject to papal interference but was hers by paternal succession.[4] After the imperial annexation through Henry VI's marriage to her, imperial and royal rights often clashed: Constance's documents reflect Sicilian practice whilst Henry's are drafted in the style of the imperial chancery. Henry also faced resistance from Tancred of Lecce. Constance was held prisoner by Tancred in 1192, but Henry turned down a papal attempt to mediate. Tancred died in 1194, leaving William III with Sibylla his mother as regent. The emperor sent envoys to negotiate with the queen, offering her son the county of Lecce and principality of Taranto. Sibylla was in an impossible situation, and so she accepted and surrendered the crown. Henry was crowned on Christmas Day 1194.

Henry's position in relation to his wife was an uneasy one, however. His arrangements before he returned to Germany in 1195 'suggest that he was anxious to minimise his consort's importance'.[5] He even drafted four joint grants by the emperor and empress to the city of Benevento, the archbishop of Palermo, who had supported Sibylla, the archbishop of Monreale and the archbishop of Capua. Highly placed churchmen therefore seem to have needed confirmation of the empress's rights over the kingdom, or at least that may have been the impression Henry wanted to convey. Constance's actions after Henry's departure show little autonomous authority but deal only with grants made by him. The majority of the inhabitants of the kingdom must have continued to support her royal Norman claim, however, for a rebellion in 1197 made much of her name, implicating her in the plot. After its suppression, joint grants were made to cities which had remained loyal, but a grant to imperialist Messina was made in emperor's name alone. The feudal south continued to be dominated by dynastic concerns, so women here remain prominent. For Villari, a native of the south, women's rule explained why the south had been kept enslaved.[6]

Dynastic politics: the north

Hughes is of the opinion that women held together Italian society further north while state bonds were still far away. A system of virilocal marriage, in which the wife moved into the husband's family house, formed 'the civilising, peace-giving links on which social and political union depended'.[7] Civil government ignored this history, seeing such ties as a threat to its stability.

In Hughes's view, the absence of women from communal history was a part of communal policy seeking to crush the social and political world over whose territories women often ruled. A woman like Matilda of Tuscany would not be seen again in the north for over two centuries. Yet Hughes's own work and that of Epstein on Genoa reveal that this by no means relegated women to invisibility.[8] Vetere is rather more optimistic about women's lives in the medieval communes which, he says, 'conferred on women a significant role not only in a society going towards an economy based on capital and thus on the exchange of goods . . . but also in that complex mechanism codifying the ethical values and religious foundations of the people'.[9] Or, to put it another way, Vetere sees women as a central focus of the commune's social and cultural life, even if they were not publicly active in its political offices.

The relationship between civic authority and aristocratic families, however, was one of ambivalence rather than outright hostility. This is illustrated by the cases highlighted by Epstein of aristocratic families in the Genoese hinterland being forced to take up residence in the city. For example, in 1140 the Malaspina family promised that at least one of their number or his wife would live in the city for two months a year in wartime and one month a year in peacetime. Six years later, the count of Ventimiglia made peace with the city: he and his sons were to swear to the *compagna* or adult, male, political community of the city, his sons had to marry Genoese women and it was intended that his daughter would find a Genoese husband. However, as Hughes points out, the aristocratic families rapidly came to dominate the city's trade in the twelfth century, making links with each other through further marriages and dominating certain sectors of the city with their properties.

In the twelfth and thirteenth centuries the still fragile commune had to negotiate with aristocratic families, with women prominent in their marriage and inheritance strategies. But the two Genoese cases suggest that the city's response was to use those same familial politics to create biological ties between the outlying nobility and the citizens, thereby pulling the former more fully into the city's orbit. This approach is not without irony, for at

the same time women's centrality in private family politics and patronage, which to communal leaders seemed dangerous, were attacked with public law and contract.

Hughes contrasts the Genoese situation with the earlier model proposed by Herlihy, based on Tuscan evidence, which suggested that cities tried to dissolve family bonds and did so successfully by the thirteenth century with the triumph of the *popolo*.[10] On the contrary, in Genoa, family ties were strong and longlasting, especially among the aristocracy. The Della Volta and Venti families, for example, 'seem . . . to have pursued a unified marriage policy' to hold onto their property and power.[11] Family districts were established within the city through buying up plots and building houses and shops, a pattern repeated in other cities in both north and south.[12] The central focus for aristocratic families was the family tower, often over the prescribed eighty-feet maximum, and the family church. The central house and the tower usually formed the inheritance of the eldest son, but he often remained under paternal control, even when marrying. The intense competition between families could spill over into feud. In this situation marriages do not seem to have been successful methods of making peace. Marriage could not compete with loyalty to the lineage, and at best 'it simply neutralised the two parties'.[13] One can only speculate on what life must have been like for women at the centre of such uneasy unions, particularly given the often young ages at which marriages were contracted and consummated (both partners were usually in their teens, with the minimum age for brides being 12 years). The wife of Sorleone Pevere left her husband after her kin, the di Castello, had murdered his father. She subsequently married one of the murderers, but the price for her defection was to disinherit and leave her children in her husband's family enclave.

The striking feature of the Genoese evidence is the close patriarchal control which was exerted. The male head of the family kept hold of its property and had authority over his children, male and female, well into their adulthood. Sons might marry early, bringing their brides into the family compound, but their legal emancipation, and with it the right to control their own property and their wife's dowry, did not happen until they were 25 years old (an abortive attempt was made to legislate for the lower age of 18 in 1130, but rescinded in 1147). Hughes speculates that this lengthy period of subjection may explain the outbreaks of violence within the city, and the attractions of long-distance commercial voyages for these young men. For their wives there was no such outlet, and their actions were closely controlled by their kin.

In contrast, the movement of artisans into the city broke family ties and produced a very different pattern of gender relations. Since payment of the dowry was often a heavy burden, marriages within the artisan class might

happen later, after the deaths of the couple's fathers. A marriage before the death of the bride's father might result in the young couple being forced to live with and support her ageing parents. Artisan marriage was thus far more a co-operative venture, with a high level of partnership between husband and wife. This led to wives being left as heirs to their husbands' estates in some 10 per cent of documented wills: among the aristocracy, where the wife was a temporary stranger tolerated for her childbearing capacity, she was never made the heir of her husband.[14]

That Hughes is able to reconstruct women's role not only in aristocratic but also in artisan households in Genoa is owing to the sheer volume of medieval urban documentation from Italy. Several factors can be posited for this explosion in evidence. Herlihy cites the fact that Roman law was subsuming earlier customs, and privileged the written document. The urban milieu was a highly literate one.[15] But Herlihy argues that these records are less fulsome about women and ascribes this to the effects of both Lombard and Roman law requiring women to have some form of male tutelage. Of Lombard law he says that, 'no other code of Germanic law was as restrictive on women'.[16]

However, by focusing on the appearance of legal prescriptions and other institutional barriers to women, such as the fact that the guilds excluded them, he glosses over the point that the charter evidence tells a rather different story. Because of the requirements of tutelage or *mundium*, women *had* to appear in documents, and the regulation of women's economic and moral behaviour is our best clue to the fact that women were often able to transcend these paper boundaries. Indeed, geographical and legal variations could often make significant differences to women's visibility: in the age of communal government elsewhere in the north, Venice offers a contrast at the very top level. Here, the doge was elected but ruled in the style of an aristocratic duke, and his wife had an important role. The importance of the family as the controlling element in Venetian political life helps to explain the comparative visibility of its women.

Marriage, lineage and property

Steven Epstein illustrates how the commune took an active interest in marriage to tie the aristocratic families to Genoese interests, and also altered the laws to reflect changing economic and social circumstances. The underlying trend was to reduce the amount of property in the hands of women.

Up to 1130, marriages in the city comprised three separate property transactions: the dowry was handed over by the daughter's parents; the

antefactum or counter-dowry by the groom or his family; and the promise was made that the wife would enjoy the *tertium* (the Frankish third, equivalent to the Lombard *morgengab*) to support her in her widowhood. By that year, any woman marrying according to the custom of Genoa had the right to make any agreement she wished with her husband concerning the *antefactum* and *tertium*. The *antefactum* normally amounted to about half the dowry. 'By introducing formal bargaining into these marriage pacts, the consuls may have intended to reduce the size of the marriage-gift and allow the husbands the chance to persuade their wives to settle for less than the third.'[17] If so, they failed, and in 1143 the notorious law was passed in Genoa which deprived wives of their right to the *tertium* and limited the *antefactum* to less than 100 lire. The law has attracted attention not least because of a graphic illustration in the Genoese chronicle of Caffaro of women with outstretched hands, lamenting the *tertie ablate* ('the third taken away').[18] The abolition of the *tertium* led to children inheriting more property straightaway on the death of their father, or, if there were no children, the property would go to the father's family. By 1140, therefore, marriage had come full circle and become an issue for secular legislation focused on the property transactions surrounding the union and curbing women's economic power, just as it had been under the Lombards four centuries previously.

The net result of such measures was to fix inheritance more firmly through the male line; it could be argued that the legal framework was catching up with social reality, rather than the reverse, as Paolo Cammarosano shows in his study of family structures. Civic legislation in other cities mirrored the early measures of Genoa. The customs of Alessandria (1179) clearly preferred agnate relatives to cognate ones. Those of Milan (1216) emphasise paternal inheritance. As such, 'les coutumes urbaines du premier âge communale accueillirent et sanctionnèrent ce qui était depuis longtemps un aspect fondamental des structures familiales [urban customs of the early communal age embraced and sanctioned what had been for a long time one of the fundamental aspects of family structure]'.[19]

As Cammarosano points out, however, the growth of agnatic lineage was in direct opposition to Germanic law on marital property: Milanese law was structured, he says, by the 'hatred of the quarter [odium quartae]'. Communes also took steps to ensure that the dowry was considered a loan, susceptible to being revoked – by the thirteenth century we see cases of husbands being forced to return nuptial goods. With the dowry, the woman's actions and those of her family were circumscribed, and she was also cut out of any inheritance rights on the basis that she had received a dowry (the *exclusio propter dotem*).

A generation without male offspring could extinguish a family. The focus therefore became more intense on women's childbearing capacity and the

producing of legitimate heirs. Her role was hedged round with restrictions, and only when widowed did she take on any role as proprietor.[20] In 1164, for example, one Lanfranco of Genoa had emancipated his daughter and renounced his right of usufruct over the property he gave her. It is unclear from this whether the daughter was in fact widowed.[21]

We are not yet in an age where town government was producing the surveys for which late medieval Italy is justly famous, for example the Florentine *catasto* (fiscal register) of the fifteenth century. But private documents take on a new character, often much more detailed in their coverage of property. The most informative are wills and inventories, which serve to provide a glimpse into the more private world of their authors. A document cited by Violante shows that private charters were also sometimes concerned to halt the flow of property to women. Handing over the *donatio propter nuptias* or counter-dowry to his fiancée Adelaxia, Fulcherius of Besate reserved the right of first refusal to his own family should she subsequently want to alienate the land.[22] Court cases, too, expand in the record to include more in the way of annotated witness statements (see below, Chapter 7). These in turn often recorded more about property arrangements, which were the subject of intense dispute. Even if women were being increasingly excluded from the outright ownership of landed property, they might have a pivotal role in remembering its transfer down a family line, as a court case highlighted by Chris Wickham underlines. A peasant named Compagno based much of his claim on a disputed piece of land south of Florence on his grandmother's recollection of how it had come to her from her father.[23]

Women's limited public function means they have little role in histories written of the communes, but as Groppi and others have emphasised, the charter evidence suggests a significant difference between what statutes laid down and what women were actually able to do. They were often left as managers of property in cities including Bologna, Ravenna and Genoa. As Violante points out, however, widows occurred as managers of their deceased husbands' estates far more frequently in the two coastal towns than in Bologna.[24] This is mirrored by southern Italian patterns.

The southern situation, studied by Padrone Nada, again varied between regions, but she identifies some general themes. Marriage terminology in the charters of the period refer to 'taking' a wife, and emphasise the subjection of the woman to her husband. Marriage could be contracted by a kiss, a ring or in a verbal exchange, but the latter was considered a secret marriage in law and disapproved of both by Roger II and Frederick II in their legislation. The marriage day was 'il momento del trionfo della donna [the woman's moment of triumph]', and later evidence suggests that the Church was increasingly involved in its celebration, as in a case at Trani in 1180.

Whilst women in the north were losing their rights to property, however, the more conservative legal traditions of the south ensured that they continued to benefit substantially from marriage. Charters recording betrothals in areas where Lombard law was still dominant speak of the protection that the husband was to give to his wife, and his promise not to keep a concubine. He also agreed to ransom her if captured (perhaps a more pressing issue in the war-torn south at this time) and to pay her *meta/meffio* (the counter-dowry), and guaranteed her right to her *morgengab*. In return, her family agreed to hand over their daughter with her dowry. The latter could be substantial, consisting of moveable goods for the house and, often, one or two slaves. Its value was such that it might be listed in detail.[25]

Contracts of the period underline the indissolubility of the marriage. Only on widowhood did a woman become more than a commodity. Many young widows remarried or entered nunneries, but the documents are very dry when trying to assess their experiences. Padrone Nada points out that dissolution could occasionally happen, as we saw in examples from the eleventh century discussed in Chapter 5. Such breakdowns were not always due to the wish of husbands to remarry: a certain Iaquinta, documented in 1151 after her husband had been away a long time, returned to live in her brothers' house and retrieved her dowry.[26]

This raises an interesting issue relevant in both north and south, for long-distance commerce out of ports like Genoa, Venice, Pisa and, increasingly in the twelfth century, Bari and Brindisi, brought with it the lengthy absences just discussed. In his survey of canon law, James Brundage shows that popes and canonists up to Innocent III held that no partner could unilaterally decide to enter religious life, vow continence or go on crusade, thereby depriving their partner of the sexual debt, without the partner's consent.[27] Was this also true of commercial voyages? Further detailed work is needed to reveal whether, along with the economic boom, came more divorces like Iaquinta's. A useful starting point might be to compare the Italian situation with that of contemporary Jewish traders, documented in the rich archive of the Cairo *genizah*, who issued their wives with conditional documents of divorce before going on a long commercial voyage;[28] or with the wills of men embarking on long journeys, who set their affairs in order should they not return.[29]

Women's property and women's work

It is quite difficult to draw a rigid distinction between the role of women as property-owners within the family and their wider economic role, but

recent work finds major economic participation by women in twelfth-century Genoa, Venice and Piacenza.[30] Piccinni highlights the economic boom in the twelfth and thirteenth centuries as a major factor in the production of charters recording ever-more complex business transactions, and the increasing presence of women in those transactions. She wonders whether the fast-growing economy might have opened up more economic opportunities for women to work outside the household, a question to which we shall return.[31] Guerra Medici's study of statutes from the northern cities identifies a strong trend of female economic participation in the twelfth century, but one which the laws do not explicitly discuss.[32]

Furthermore, Diane Owen Hughes cites historiographical barriers to understanding women's economic role: a focus on great business and legal prescriptions largely ignores women's role as workers and investors. Female labour as household slaves or workers has been overlooked, as has the role of women as consumers, despite the fact that later medieval and Renaissance tastes can be understood far better through the consumption patterns of women.[33] Goitein, for example, shows that Sicily was a production centre of silk robes, women's hoods, carpets, prayer carpets, sleeping carpets, pillow, brocade bed covers, many of which were ordered by Jewish brides in the Middle East to form parts of their trousseaux.[34]

In his survey of women's property-owning, Herlihy notes a drop in women as principal donors or alienators from 13 per cent in the eleventh century to 9 per cent in the twelfth. This suggests that the combination of changing familial inheritance strategies and legal prescriptions was beginning to bite. Padrone Nada takes the use of matronymics, one of Herlihy's indicators of women's property-owning, as a sign of illegitimacy by the twelfth century. Herlihy's figures mask regional variation, but might serve as a useful antidote to the very positive pictures of women's economic power emerging from city-specific studies.

Once again, the evidence from Genoa provides some of the clearest examples of women's continuing economic participation. Steven Epstein highlights that well into the twelfth century some Genoese women were still claiming to be living by Roman or Lombard law, which suggests the tactical use of these codes' respective provisions for protection. Epstein doubts whether women entered the sworn political association of most adults in Genoa known as the *compagna*, the 'subset of adult Genoese men' from which the city officials were drawn. As relatives of members, however, they could engage in trade, and consuls swore to make their wives swear that they would not accept anything which might pertain to the consulate worth more than 3 solidi. Nor was any citizen, inhabitant or foreigner living in Genoa permitted to bring any commodity into Genoa which had been obtained in Pisan territory. The breve of 1157 further stated that no

member of the *compagna* was to buy or sell in the city's jurisdiction any sable fur worth more than 40 solidi, and they were to ensure that their wives and children did not either. This is a strong indicator that alongside the regulated markets of the city there was the suspicion of a less formalised, 'grey' market in certain goods which the dependants of merchants were engaged in. Further work is required, but it may prove instructive to investigate instances of women selling or buying single items in the documentation, within and outside Genoa.

Marriage still facilitated agreements, politics and trade: Solomon of Salerno (a Jew?) married his daughter into the Mallon family of Genoa. His wife Eliador managed their business on her own.[35] Another example was that of Ingone della Volta, consul between 1158 and 1162: his daughter Sibilia married Oberto Spinola in 1156 with a dowry of 200 lire. In Genoa, Epstein states, people co-operated within their family, not outside it, and the guilds were weak.

David Herlihy has suggested that in this period women were 'hidden in their homes', whilst Groppi pinpoints women's maternal role as central to their ability or scope for work. At Genoa, however, they were extremely active in the commercial life of the city, involved in some 24 per cent of commenda contracts made there from 1155 to 1216. So visible are they that their role has attracted substantial attention in the secondary literature.[36] This is explained by the survival at Genoa of Roman law within Genoese custom, enabling women to inherit, act as Romans and administer their property themselves. In contrast to their menfolk, however, women were the static partners in business. The sea provided social mobility 'but did so in a stark division of labor between men and women'.[37] Women prepared provisions for ships or worked on cotton or canvas sails, but the sea was a barrier, taking their men. Nevertheless, women in Genoa had more economic opportunities than their counterparts in inland cities such as Milan or Florence.

Venice, too, saw a number of female traders and merchants, and women are recorded making sea-loans from the eleventh century onwards. In 1209, Maria Ziani, wife of the doge, made a sea-loan of 120 ducats to Thomas Viadro.[38] Of those women whose marital status can be identified, a large proportion engaged in trade were widows.

Women and the guilds

Thus far we have discussed women's economic function largely in terms of their management of real estate and participation in commercial enterprises.

The two often meshed in with each other. Eleanor Riemer discusses the slightly later case of Siena, pointing to the major factors allowing women's fuller economic participation. These were the commune's adoption of Roman law and practice in 1176 and a reluctance to allow women access to landed property, features we have already met elsewhere. The latter issue resulted in women's dowries consisting of liquid assets which were thus more easily invested. Two major activities in which Sienese women engaged were investment in business ventures by *società* or groups of investors, and moneychanging and lending. Freed of the control imposed by Lombard law, Riemer argues, women in Siena appear to have been very active in the local economy to the extent that their transactions 'conflicted with the interest of Siena's patriarchal and patrilineal order'.[39] How the authorities reacted is discussed in the next chapter.

It is often stated that women's opportunities were gradually closed off in the north with the rise of civic trade guilds and organisations. But Roberto Greci has shown that despite this common assumption, it is in fact impossible to define a model which works for all guilds in all cities. Genoa allowed substantial parity of opportunity before tightening its regulations in the thirteenth century, and in Venice, where guilds and corporations had 'una scarsa autonomia e un debole ruolo politico [little autonomy and a weak political role]', city magistrates supported women's work as a political move against the Arti, allowing women's membership. Greci suggests that symbols of power correlate badly with women's work, but that there is a fluid relationship between work and power when the guilds took on a political role. In Bologna, women participated in the textile trade in significant numbers until the guilds controlling it became politicised. In Piacenza there was considerable activity by women.[40]

Guilds did not so much exclude women from work as hide the evidence for it and marginalise women's role as membership was denied to them. Exceptions identified by Guerra Medici include women sailmakers at the Venetian Arsenal, some widows, and female medical practitioners retained by cities to attend female patients and pregnancies. But Groppi urges us to see this marginality as a potential source of income and power. Women's work, she argues, could be not simply an addition to that of men, but 'an autonomous experience' even for married women. Research into female medical practice, for example, has demonstrated that much more fruitful results can be obtained by looking both within and outside the regulated sector. Another area which has still to be fully investigated is the work undertaken by women in monastic communities, which must have fed into at least the local economy (but see below, p. 176).

This is particularly true of southern Italy, where the lack of overlying institutions allows us to see women workers rather more clearly. The south

by the twelfth century was renowned throughout Europe for its medical expertise centred around Salerno. A number of contemporary texts refer to medical practice by women there, especially 'Trotula', whose legend expanded into even Chaucerian texts by the fourteenth century. Whilst John F. Benton was keen to suggest that a woman named Trota existed, but that surviving texts on women's problems were ascribed to women to gain them greater acceptance, rather than being the product of female writers,[41] Monica Green's meticulous reconstruction of the manuscript tradition of these texts has produced a forceful argument not only for a woman named Trota, but also for her authorship of much of the text later drawn upon for women's practical medicine.[42] Green's work supersedes Kate Campbell Hurd-Mead's 1933 study of women in medicine, which was at best a mixture of poor chronology and outright fantasy.[43]

As well as medical practitioners, Padrone Nada's survey of women's working opportunities in the south includes spinning, weaving (for which there is evidence of plenty of equipment in dowry lists), and making clothes, soap and perfume. Women could also be maids, concubines or nurses, and are named as artisans and merchants in the charter evidence, first in Amalfi in the twelfth century, then elsewhere. They may also have been acting as investors in trade ventures, if evidence of their taking out of loans is significant. In Bari in 1153, a certain Domnula asked her husband to take out a loan on her behalf and for her use ('ad faciendum suam utilitatem') because she was a woman and could not do so alone.[44] In 1141, a woman is recorded having lent money, although since it was to her father-in-law for the purchase of clothes this may not fall into the category of commerce. Nevertheless, it does indicate that she, in the absence of her husband, was able to lay her hands on ready cash.[45] Later examples of artisan women cited by Nada Patrone include a baker at Salerno in 1202, and a thirteenth-century female shoemaker and wineseller, both in Palermo. Although the examples are few, Padrone points out that southern women appear to have been able to participate in trades outside the normal 'female' sphere, in contrast to the situation in the north at this time. Greci's inverse correlation model between the strength of guilds and the opportunities for women to enter the labour market may therefore work for the south as well.

One group of working women who do emerge in the documentation as a result of their increasing regulation is prostitutes. Prostitutes were tolerated then regulated as better than sodomy. It was prohibited to give hospitality to a women whom 'pubblica fama indicava come meretrici [public fame held to be prostitutes]'; prostitutes came to be regulated in where they lived and what they wore. In Pisa they were forbidden to live in certain parts of the city and were only permitted to visit the public baths on Fridays. This opens up the issue of the increasing regulation of city spaces, and

women's access to them, which still has not formed the focus of any systematic study.[46]

So far we have explored some specifically urban environments for women's work, but Guerra Medici's work has been influential on Federica Rosi's study of the archive of the central Italian monastery of St Croce di Sassovivo.[47] Rosi's work is valuable for its illustration of how the more visible social changes in urban statutes affected those 'on the ground' and in a more rural setting. Umbria, like the rest of Italy, underwent great social change in the twelfth and thirteenth centuries. The economy diversified as commercial and artisanal interests joined agrarian ones (we should perhaps be careful not to overemphasise this – both artisans and merchants needed to eat and trade with something). Cities grew, and developed their own forms of government, often at the expense of local seigneuries in the form of aristocratic families or religious entities. The counts of Uppello (and their countesses) were the wealthiest inhabitants of the region and are particularly well documented at the beginning of the twelfth century.

Sassovivo suffered a marked drop in donations to the abbey from the middle of the twelfth century onwards, as new foci of religious life attracted patronage. It would remain the dominant economic force in the countryside around Foligno until the early thirteenth century, but the signs of weakness were already apparent. And as urban life developed, Rosi argues, so families began to organise themselves in order to permit their male members to participate in urban politics and public life. Prestige demanded property, and the major losers, according to statute evidence at least, were female family members.

However, the documentary evidence from Sassovivo reveals that late in the twelfth century women were still receiving both elements of the property due to them on marriage, that is, the dowry from their own family and *morgengab* (the Sassovivo documents show a clear tendency to cite Lombard customs and practices) from their husband. For example, Adelasia received a dowry from her brothers and one-quarter of her husband Bonifazio's goods on her marriage in 1179. Other Sassovivo examples from the first third of the thirteenth century reveal the persistence of the *morgengab*.

Lombard law also persisted in other rural landscapes. In 1181, Mauro and Poisia his wife (professing Lombard law) sold three pieces of land for 8 pounds of Milanese denarii to the monastery of St Maria de Monte Velate, and received them back from the monastery to work at a rent payable in kind. Mauro further invested his wife with three fields, a wood and a house in Velate which constituted her dowry, worth 15 pounds in total.[48] The relationship between Mauro, Poisia and the monastery mirrors that of Sassovivo with its tenants.

THE TWELFTH CENTURY

Nevertheless, as we shall see in the next chapter, the encroachment of urban life into the countryside, undermining the power of monasteries such as Sassovivo and their entourages, would markedly affect women's property rights even in rural families.

Marginal workers: slaves and children

Guerra Medici identifies another strand of women residents and workers: domestic labour was usually female and servile. In 1147, Genoese ships had captured Almeria, and the Genoese chronicler Caffaro reports that some ten thousand women and children were transported to Genoa as slaves. Whilst this may be an exaggeration, slaves clearly did play a role in the households of the city. In 1157, Martina and Enrico Como manumitted the son of their slave Antonia and a certain John, about whom we know nothing, for a payment of 5 pounds of gold. A certain Sibilia left her husband 30 lire to free his slave Gazella and have her baptised; should he fail to do this he would receive only 20 lire.[49] Could this be an oblique way for Sibilia to regularise a longstanding situation in which the slave had been a rival for her husband's affections?

The notary Giovanni Scriba's own will benefited his female servant Adalasia, her son Ribaldino and her mother Serra, who received furs and skins, 17 solidi and a bed, and clothing, respectively. One might speculate that these three made up Giovanni's family, and that his relationship with Adalasia had been rather more intimate than the contents of his will reveal.

The commercial cities of the south provide parallel cases of merchants with concubines, with some 9 per cent of wills drawn up by men to 1,200 mentioning bequests to the children of their concubines. One of the most detailed shows that a certain Urso of Ravello avoided competition within his household by having his concubine, Maria, living in what was presumably a second home and commercial base in Trani.[50] Pregnancy of female labour, often by the master of the household, was an occupational hazard, and men were held to have a responsibility for the child. North and south diverge here. In the south, where Lombard law was still prevalent, the offspring of such liaisons had some right to their father's estate alongside his legitimate children. In the north, natural children had no such automatic right to part of the patrimony. The children of concubines were to be supported but not to supplant any legitimate ones. Increasingly, however, the co-existence of a wife and a concubine was viewed as bigamy.

Slavery persisted in the south, and the charters reveal different groups of unfree women. In 1137, for example, the royal judges at Taranto upheld St Peter Taranto's ownership of a woman, her child and tributes against the claims of a certain Guarino de Bella.[51] It is tempting to characterise children as an adjunct to their mother's activities throughout the period, but when girls as young as twelve and boys in their teens were already being married in aristocratic families, it is clear that the group 'children' needs breaking down into its constituent parts according to both class and sex.

Children appear most frequently from the twelfth century onwards because of the localised and still poorly understood attempts to provide them with shelter in cases of abandonment. Brenda Bolton cites the example of St Spirito in Rome, founded for abandoned children by Pope Innocent III *c.*1198 and whose aims were set out in a letter of 1204.[52] The house would look after abandoned children and poor pregnant women, also any children born to female pilgrims. It spent a staggering amount on poor orphans and widows in the first ten years of Innocent's pontificate. Children could also be used and supported in other ways. In 1180, a Venetian father redeemed his daughter, whom he had left as security (*pegno*) for a loan of 40 solidi, from a certain Michael of Padua. Presumably the child had been placed in service for a period, which is not specified.[53] Padrone Nada gathers together the fragments of evidence from the Norman/Swabian south. Care for infants was depicted on an 1186 bas-relief from Monreale showing Cain and Abel. Some private documents also shed hints on childhood. The most common forms of children's work, however, must have revolved around domestic and agricultural tasks, neither of which shows up in the historical record unless, as in one or two cases, a contract regarding the child's service was drawn up between its parents and the new guardians.[54]

Religious life

Penco argues that the history of religious women in Italy has often been treated as a neglected appendage to male experiences. Yet between the eleventh and thirteenth centuries it underwent intense development, with nuns, hermits, recluses and penitents emerging as varieties of religious expression. The increase in ecclesiastical and lay documentation in this period enables us to trace some of these movements in detail. An attempt was made in 1215 by the Lateran council to fix the acceptable forms of female claustration, but whilst male Benedictine houses experienced decline, female ones flourished and modified. Women also acquired a role in key religious festivals, such as Easter rituals and local saints' days. One might say that

women, dissatisfied with the role society allocated to them, found expression in religion.

It is often argued that the 'woman question' which arose in twelfth-century Europe was owing to the increasing repression of women's opportunities in a century when economic, political and intellectual activity reached new heights. Valerio has discussed the problem and has identified two opposing views. Was female religious expression a protest against the closing off of political influence caused by the growth and re-establishment of Roman law and jurisprudence in the peninsula in the twelfth and thirteenth centuries, as Penco and Pernoud argue? Even if it was not a twentieth-century style consciousness-raising exercise, the growth of the Marian cult emphasised women's good qualities. Other scholars disagree and argue that, as a group, women in the Church were still disadvantaged, and this is how we can explain their participation in heretical movements.[55] Daniel Bornstein has recently reiterated the view that religious outlets were not merely 'a case of placating an excluded and powerless group'.[56]

What outlets existed for women's religious enthusiasm in this century, and how did the Church react to them? This section examines several themes, examining first the traditional route of women's monastic enclosure, then other forms of piety in which women are visibly participating.

The cloistered life

For many women, the decision to enter a convent was in itself a positive proclamation of the liberty of their person and autonomy in decisions, but could be seen negatively as a mortification of sexuality which was often tolerated rather than borne with joy. Abbesses had quasi-episcopal power in spiritual leadership, especially in houses with immunities. They had power over lands and people belonging to the house, exercised without causing consternation and with full papal approval.

The oldest and richest houses continued to thrive in this period, but were joined by another wave of new foundations. The twelfth century was perhaps the last in which St Salvator/St Julia at Brescia retained its prominence.[57] In 1106 and 1123, Popes Paschal II and Calixtus II issued decretals to Abbess Ermengard taking the abbey under papal protection and forbidding episcopal interference. Breaches of the convent's jurisdiction happened anyway, with contests over the church of Cicognaria against the bishop of Cremona and over the port of Piacenza against a certain Hugh Speronus. The war between Emperor Frederick I and the papacy prolonged the latter dispute. In 1184, Pope Lucius III issued a definitive order to Abbess Gatia confirming the convent's ownership of the port. This was one of its final

victories, however, and the once-powerful royal abbey experienced a gradual decline as the Middle Ages advanced.

The pattern of outside interference was repeated in southern Italy, where Raffaele Iorio cites the atmosphere of political uncertainty in the late twelfth century as the cause of more localised unrest, particularly in the Apulia region, expressed in attacks on nunneries.[58] In 1177/1178, for example, a papal commission visited the nunnery of St Cecilia outside Foggia, which was dependent on the priory nearby and subject with it to St Mary at Pulsano on Mount Gargano. The commissioners found the nuns living in extreme poverty, owing to the priory's own actions. The priory, they explained, had asked to be taken under the protection of Elias, bishop of Bari, instead of Pulsano's. The monks had also been depriving the nuns of their property (presumably to make the priory a more attractive object for the bishop to take over); the nuns could not pay labourers to till their land and so had had to go out into the fields themselves to collect their beans, chickpeas and vegetables. They had also had to fetch their own water, and living in such cold and hunger were becoming ill and dying. The cloths they wove were taken (and sold?) by the monks, and instead of making themselves new clothes they were forced to make sheets, bags and belts for the monks. Finally, the dowries of new entrants to the convent were being appropriated by the monks.

The outcome of this lengthy complaint is not recorded, but the same theme of coveting the property of small, female houses recurs in another case. In 1195, in collaboration with the *vicarius* (vicar) of Barletta, the prior of Montepeloso attacked the nunnery of St Thomas in that city, where a widow and her nuns lived, to try to force her to hand over the church and its properties to Montepeloso. She refused, so they tied her up and occupied the convent. The pope then intervened and began excommunication proceedings against those responsible for the violation. Another, similar case seems to have occurred in Sicily: in 1184, King William conceded the convent of St Maria Maddalena, whose abbess and nuns had fled 'on account of the dangers of war [propter guerrarum discrimina]' to St Maria Nuova in Monreale.[59]

It would be easy to characterise these incidents as an outbreak of attacks against female houses, but the men's house of St Benedict Bari is also recorded as being in dire financial straits in 1188. What seems to have been happening in the late twelfth century in northern and southern Italy, as the example of Sassovivo discussed earlier illustrates, may have had as much, or more, to do with shifting patterns of patronage.

Recipients of such patronage included new female monastic houses. In the south, one of the most prominent in terms of its speed of growth and wealth was St Salvator at Goleto, a quite exceptional case.[60] Owing to its

close relationship with Norman and Angevin patrons in the twelfth and thirteenth centuries, it came completely to overshadow the economic, religious and social life of Irpinia, Basilicata and Puglia.

Although many documents relating to the convent's history were lost by fire in 1760, its outline history can be traced. It was founded by William of Vercelli (1085–1142), a poor preacher, as a double house with both monks and nuns. According to the sources, William founded Goleto in 1135 on land given by Roger of Monticchio, who wanted to create a refuge for poor widows and virgins. It was close to a major commercial route, water and fertile woodland, and received a diploma of protection from King Roger in 1140. The house was under the control of its abbess, elected by the chapter of nuns. The monks had their own prior but served the nuns, as did eight priests and sixty-two male choristers.

In keeping with their vow of poverty, the nuns were not allowed white habits, meat, cheese, eggs or wine. They ate three times a week and took bread, water and greenstuff. Despite this asceticism, many women entered the house in the twelfth and thirteenth centuries. The external relations of Abbesses Febronia (1151–62), Marina I (1163–93) and Agnes (1194–1200) are visible in land transactions. Under Febronia a tower was built to protect the house, perhaps reflecting the same concerns which were affecting the Apulian monasteries discussed by Iorio. Attempts to free the convent from the jurisdiction of the bishop of St Angelo dei Lombardi were successful in 1182, when the house was taken under papal protection. It achieved complete freedom from control in 1191.

Continuous donations to the new abbey made it one of most important economic and feudal powers of the region. The abbess of Goleto came to supervise both male and female houses in the vast territory under her authority. The abbot of Montevergine succeeded in taking over Goleto in 1505, after a campaign lasting since 1230, and many of the convent's charters are preserved in its archives.

Goleto may have had a major impact on the south, but the work of Padrone Nada on the region shows that alongside longstanding houses such as St Gregory and St Patricia in Naples, more modest new houses were being founded in an attempt to systematise women's piety.[61] For example, St John in Lecce was founded in 1133: the first and second abbesses were sisters of the founder, the third the orphan daughter of the founder. On Sicily, the Martorana was founded by Lady Aloisia and her husband in 1194. Their niece was the abbess and she set out the clothing needs of the sisters.[62] It is worthy of note that in this post-reform context, familial patronage was still very strong.

One of the striking features of twelfth-century foundations, owing partly to the increase in surviving documentation, is that we can get a glimpse of

the way founders intended the nuns to live through the rules often included in foundation documents. We have already seen this in the case of Goleto. Further south still, the foundation charter survives of St Maria Latina in Palermo, built by Matthew the Vicechancellor and confirmed in its rules in 1174 by Pope Alexander III.[63] The house was to have an abbess and twenty-four nuns and a school for girls. No laywomen were to be admitted to the monastery, nor were the nuns to bathe outside its walls. The Rule of St Benedict was to be observed in daily life, and no more nuns were to be admitted unless the landholding of the house increased. The abbess was only permitted to alienate lands for the support of the nuns. The house was to be suitably endowed, but any of Matthew's relatives who wished to become nuns were to be received without payment ('sine percuntactione qualibet'). Finally, the house was to have two old and honest chaplains to administer mass, and a doorman to guard the exterior gate. Even he, though, was not to enter the cloister. It is interesting to note the specific concern in this document for the economic health of the house, a sign that founders were well aware, in the twelfth century, of the conflicting claims on potential donors' money as new outlets for patronage emerged.

The surge in foundations in the south was mirrored in the north as well. The convent of St John the Evangelist was founded *c.*1100 at Mantua. A sharp rise has also been identified in women's monasticism in Liguria, especially at Genoa where the burgeoning urban environment encouraged patrons to make substantial donations (see below, p. 180). It also led to the development of another strong theme of female monasticism in this period: that of hospitality. St Salvator/St Julia in Brescia had a hospice at a relatively early date, and St Thomas in Reggio Emilia, founded in the eleventh century, had two *xenodochia* or hostels. This signals one of the important shifts in the evidence about women's relationship with the Church in this period, as more sources document not only their claustration as nuns, but also other ways in which they supported or sought links with a local foundation.

Necrologies, donations and uncloistered groups

A major development in source materials of the twelfth and thirteenth centuries, adhering to the same sense of tidying up that we have seen in the case of charters, was the creation of necrologies or lists of those for whom the inmates of a particular monastery or convent were expected to pray. Hubert Houben usefully lists those surviving from the south, including from St Petronilla Piumarola near Montecassino (thirteenth century), another now in the archive of Montecassino and probably used by a convent near Gaeta, a twelfth-century example from St Laurence in Benevento, one

from the Holy Trinity at Venosa, with some 1,100 names listed in the twelfth century, and one from the nunnery of St Cecilia in Foggia dating to the twelfth or thirteenth century.[64]

Anna Maria Facchiano has made a study of one twelfth-century example, whose origins date to the tenth century.[65] The convent of St Patricia at Naples had its roots in the monastery of SS Nicander and Marcian, documented from 914 as having a diptych or two-leaved record of donors' names. The earliest life of St Patricia is lost, but the second was probably written in the ninth century, two centuries after the saint's death in Naples after fleeing from an unwanted marriage, or around the time when SS Nicander and Marcian's title began to include Patricia's name in 971.

St Patricia was the niece of Emperor Constans II of Byzantium (r. 641–668). She refused marriage and fled from Constantinople to Naples, where she died. The lives written about her cast her flight in romantic terms, and were designed to appeal to a female readership. The hagiographers tell how her nurse Aglaia obtained a solemn funeral for the saint after a vision, and the oxen pulling the bier made their way unbidden to the monastery of SS Nicander and Marcian. The presence of the tomb at this monastery attracted many women, causing the monks to move from the house to the nearby monastery of St Sebastian. Tales of the miracles at the tomb continued from that point on, and twelfth-century reports included the cure of a deaf-mute child from Aversa in 1191/1198, during the abbacy of Melegaita Capece.

SS Nicander and Marcian was clearly a nunnery by 914, when its charter history begins. We have several tenth-century documents relating to the house, but only two eleventh-century examples. The house (now known as SS Nicander, Marcian and Patricia) clearly had an infirmary by 1065, when it received property to support it, and was patronised by Normans into the twelfth century. The highpoint of its history, however, was under the Angevins in the thirteenth century.

How did St Patricia's house survive? Its necrology provides the evidence: it had close and continuing links with the major aristocratic families of Naples whose wives and daughters entered the house and, like the inmates of the convent of St Gregory Armeno in the city, continued to own and manage property even as nuns. The commemoration of Galia, abbess of St Gregory (1166–1189), in the St Patricia necrology, is perhaps indicative of their shared social milieu, and certainly a nun of St Gregory's, Mira Capece, is also recorded in the St Patricia necrology through her family's close connection with the latter house.

The necrology itself survives now only in a sixteenth-century manuscript, transcribed from a fourteenth-century copy and a calendar of entries beginning in the eleventh century (itself the heir of the original diptych). Its use,

therefore, presents some difficulties, as Facchiano highlights. Of some 2,500 names entered, around 70 per cent are those of women. But only 39 of those entries which Facchiano thinks can be recognised are pre-1200 in date, and the percentage of women drops dramatically (44 per cent). This is a not unexpected result, if the monastery's early history was as a male house. Of the 39 identified persons, 9 women belong to the wealthy Capece family (documented as Cacapice in early charters); and a further 2 from the equally aristocratic Brancacci house. Other nuns listed in the necrology included Regale de Donna, securely identified with a certain John of Naples between 1176 and 1182, and Maria Gizzio, possibly the same as the eponymous daughter of John Gizzio and wife of John Pullastrello who sold a house in 1132.

The twelfth-century sample of women is made up almost entirely of nuns, whilst the male sample includes more laymen. This suggests that lay benefactresses might often have chosen to retire to convent life, and it is possible that the label 'nun' in this context covers a wide variety of conditions.

Necrologies would also preserve the names of major benefactors, whether they entered the monastic environment or not. Epstein highlights Genoese women's piety in the form of charitable donations, which he usefully analyses for the period 1155–1204.[66] Using 190 wills of men and women, he showed that there was still only one female house in the city in the twelfth century, St Andrea de Porta, which was close to the walls in the old city centre. And with male and female wills roughly equal in number, women tended to pay for more commemorative masses for their souls, mirroring the desire to be commemorated expressed by the St Patricia necrology. Later on, they are seen taking a more active role than men in directly funding charitable causes such as hospitals, and Epstein interprets this as showing how women's piety within the urban environment might take a more practical approach than men's in targeting charitable donations.

So far we have explored women's attachment in some way to religious houses, but whilst female houses were clearly flourishing in the twelfth century (against a background of retrenchment in male houses), they still clearly did not fulfil the needs of all sectors of Italian society. Hospitals, already mentioned, were often founded for specific purposes: a preoccupation with repentant prostitutes is visible in some cities, whilst in others poor women's hospitals were founded, as, for example, at Veroli.

Penco sums up the situation by suggesting that a wider social spectrum was represented in convents and religious life than had been the case in previous centuries. As we have seen, however, even some new foundations were socially exclusive, demanding an entry dowry from all but the founder's family in the case of St Maria Latina in Palermo. Anna Benvenuti

Papi comments that reformed Benedictine houses in fact often 'prided themselves on the nobility of their recruits, at least on the female side', and highlights the difficulty that even noble abbesses had in imposing stricter austerity on their well-born inmates.[67] Many did not have the dowry to enter a convent – in northern Europe this led to beguinage, in Italy to penitents.

If women wished to pursue an ideal of perfection rooted in humility and poverty, they could do so equally well in their own homes as in a convent. We have already charted this phenomenon at Salerno in the eleventh century, where it grew and developed; penitents are also visible in Veroli and near Vicenza. Often they banded into groups to live an unregulated but otherwise communal life, and at this point the Church intervened. The 1139 Lateran council condemned 'the detestable custom of certain women who pretend to be nuns, but do not submit to any of the three recognised rules; refuse the regime of the refectory and the dormitory and continue to prefer their own shelters and private houses'.[68] If women resisted the pressure to enclose them, they might fall into being classed as heretics.

Another way in which women might express their piety without becoming fully professed was through becoming *conversae*. In essence, male and female *conversi* tied themselves to a particular religious foundation, but were not permanently cloistered, and engaged in prayer and/or charitable work. They were closely akin to the penitents who had preceded them, but might be distinguished in their level of wealth: they balanced their religious desires with often heavy secular responsibilities. Duane Osheim emphasises the variety of experiences within the movement as a whole, including being members of prayer societies, widows in religious habits and donors who reserved the use of their property prior to entering a monastery, often on their deathbed.[69] One example of the latter tendency is the case of a wealthy man from Pisa who, in 1199, donated a piece of land to build a hospital for women. He attached the condition that he might be admitted to the hospital 'as a *conversus* or a monk as he chooses'.[70]

Related again to these were the confraternities which emerged in the twelfth and thirteenth centuries. Two wills from Amalfi, dated 1172 and 1176, mention the *fraternitate de Amalfi*, each testator paying 40 solidi for the fraternity to say prayers for them.[71] Both testators were male, but it is unclear whether the confraternity they paid into included women. Larner comments that these built on older models (we might remember the mixed groups of *staurites* documented in tenth-century Naples),[72] but revitalised their sense of community in the twelfth and thirteenth centuries through their functions of prayer and social support, such as forming burial societies and building hospitals.[73]

Heresy

By the thirteenth century,[74] it is often argued, women's roles were confined to areas sanctioned by the Church and so they responded by joining heretical movements. McLoughlin is sceptical of this theory of women flooding to heretical movements, and points out that few figures are ever given to qualify this.[75] Lambert identifies a shift from isolated outbreaks of heresy, such as that of Monforte in the early eleventh century, to a more sustained and continuous presence of heresy in the records from the early twelfth century onwards. The chief groups were the Cathars, appearing in Italy in the 1160s, and the Waldensians who appear at the end of the century. Allied to the latter were the Humiliati.

This is not the place to go into depth about the beliefs of each group. Their presence challenged the Church authorities through their preaching, rather than their poverty, which they shared with orthodox penitential movements. Lambert argues that the heretics received more tolerance in the Italian cities of the north because the cities preferred to accommodate heresy rather than submit to outside, even papal, authority. The papal bull *Ad Abolendum*, issued in 1184, was the first attempt to fight the heretics, but was largely ineffectual unless secular help was given in seeking out guilty individuals and groups. The exception occurred in Milan at the end of the century, when a Waldensian school was destroyed.

The (questionable) popularity of heretical movements with women is ascribed to the greater opportunities they found within such sects to gain prestige and a worthwhile role: Catharism, therefore, is often presented as attractive to those 'dissatisfied with the circumscribed opportunities for religious service for women within orthodoxy'.[76] But if the ideology of, for example, the Cathars is confronted, it is clear that the female *perfectae* were not actually equal to the male *perfecti*, and whilst Waldensian women were active up up 1270, it was only in the absence of a male that women Waldenses were able to celebrate the Eucharist.[77] We see women reported as administering the sacraments in a letter of the bishop of Piacenza, dated 1192/1199.[78] Another factor to take into account is that sources hostile to the heretics – for which we must read the majority of evidence about them – highlighted women's presence as a way of denigrating the movements. Women outside the cloister were demonised in such writings as little better than whores.

On the margins of orthodoxy were the Humiliati, who look very much like other penitential and confraternal movements we have met.[79] They gathered in religious communities but often remained married and worked in some way. Condemned as heretics in 1184, this movement had a remarkable rehabilitation, when Pope Innocent III allowed three branches:

clerical, laymen and women in communities, and married couples remaining with their families. The movement remained exclusively Italian, and was integrated into the Church by the early thirteenth century, when it was praised for its preaching against heresy.[80]

Female saints; women and civic rituals

Some urban holy women successfully resisted the cloister and came to be revered within their communities. St Rosalia of Palermo (d. 1160) was the patron saint of that city and its sailors. A recluse who lived in caves overlooking the sea, her prayers saved the city from plague twice. However, Valerio points out that William of Vercelli (1085–1142) founded St Salvator in Palermo for the saint to live in. It is unclear when this development occurred in the saint's life, but the underlying theme is once again the claustration of an unorthodox woman.[81] Valerio also cites the example of St Hercula (d. 1127), preaching and exhorting those who visited her to lead a purer life.[82] The real surge of female saintly figures of this type in Italy would not be until the late thirteenth and early fourteenth centuries, and Webb stresses how few of the new saints of the era transcended their intensely localised cults.

Living female saints were a phenomenon of the thirteenth century rather than the twelfth, as some of these unorthodox women acquired a following and ecclesiastical legitimisation. Contemporaries in canonisation investigations saw more importance in holy women than public historians, and women are visible participating in civic saints' cults as well as providing some of the saintly figures. 'Saintly women became, in a sense, antidotes to history, their power able to protect those bruised by historical event.'[83]

Given this flourishing of women's autonomy in religious matters, the hagiographic theme of the woman saint entering a men's house disguised as man disappeared, also that of the young female saint preferring to die than marry against her will. Female sanctity began to be detached from the saint's family line as saints increasingly came from the merchant and artisan classes. The female liturgical role of antiquity was also apparently rediscovered in this period: twelfth-century frescoes at Ferrara reveal deaconesses.

In one of his trademark articles using statistics to illustrate women's history, David Herlihy commented on the chronological and typological distribution of female saints in medieval Italy.[84] By judicious use of periods of varying length, he was able to demonstrate a dramatic decline in the number of female saints in the period 1000–1150, and ascribed this drop to the effects of Church reform, removing women from positions of influence in the Church. He also suggested that the republican regimes of the Italian

city-states from the early twelfth century would have further limited women's opportunities. The result, he states, was a different form of female spirituality, with mysticism becoming increasing popular, and resulting in a sharp upsurge of holy women from 1151 to 1347.

If contemporary female saints were still quite rare, women's participation in rituals surrounding their local saints was frequent and increasingly visible. Quite apart from their functions as donors and workers discussed above, women participated in civic rituals involving the saints, studied by Diana Webb. Webb reveals the use of old and new saints, but very few female ones until the fourteenth century. In the latter part of the twelfth century, Sicard of Cremona was promoting the city's saints and recounted the major liturgies, for example, around Easter, when all men and women abstained from work to join in civic processions. There were also vigils over saints' relics, with monks, nuns and laypeople protecting them when newly translated. For example, the arrival of St Ansanus, brought to Siena in 1107, was believed to bring with it the fertility and prosperity of its previous site, and so would help the city to grow. Saints were believed to have protective powers over their new homes. Another example of such beliefs occurs in an episode at Modena in 1106. Matilda of Tuscany had patronised the building of the new cathedral of Modena, 1100–1106, but St Geminiano's relics had to be removed. A huge crowd of both sexes gathered to oppose the bishop's wish to reveal the relics. In the ensuing stand-off, Matilda referred the matter to Pope Paschal.

The importation of new relics led to building work to accommodate them. A new chapel was built at Pistoia in 1144–1145 to house a relic of St James, and immediately the miracles started – a boy brought on a wagon by his mother from Florence was cured. As a result, Contarinus the Pistoiese cleric recounts, many Florentines came 'barefoot and clad in wool especially women in compunction of heart as if inspired from heaven'.[85] It is interesting to note the description of the pilgrims; we have returned full circle to the images adopted by the new penitential movements of the period, with women noticeably prominent.

Conclusions

Although it forms the focus of many more secondary studies than earlier periods, the twelfth century still presents a patchy and sometimes subjective picture of women's opportunities. The cases discussed in this chapter should at least alert historians to the fact that women's history in this century has been reconstructed very much from institutional and prescriptive literature,

whether in the form of statutes or of measures taken to control the outburst of religious enthusiasm which undoubtedly occurred after 1100. Yet such sources, despite often revealing the lives of artisan and peasant women, can produce only a partial and distorted picture of women's experience. The concentration of much historiography on the commercial upsurge of the period, too, focuses all too often on the most successful cities and the most successful (that is, wealthy) members of their communities. The Genoese historiography is a case in point, and tends to dazzle the uninitiated. In such surroundings, it is relatively easy to find significant female participation in the records of commercial transactions, but only rarely are the circumstances of one city compared with those of others. The current wave of archival work being done for rural communities and smaller urban centres may well provide a more nuanced view of women's contribution to the economy in this period of expansion.

What happened to women in Italy in the twelfth century, whilst their male counterparts were setting up autonomous civic government from which women were excluded, voyaging abroad as traders, crusading, studying the Church Fathers, redacting the canons of the Church and reviving Roman law in what has been termed a renaissance? Put succinctly, they stayed at home and often filled in for the male absences, engaging in their own transactions, finding different ways of expressing their piety and, it is argued in more than one context, benefiting from the relative freedom that the Roman law gave them. At the same time, however, they suffered from legislation and structural changes in the family which excluded them from many property rights they would have enjoyed in Germanic custom. This is one of the ironies of the period: in the south, which retained that custom in many areas, women continue to feature as property-owners and begin to exploit the fuzziness of law to their advantage in legal disputes. But north and south diverge also in their religious histories: the south does not appear to have taken so rapidly or strongly to the new forms of religious expression documented in the urban centres of the north. This may reinforce the view that women in the south did not need to find an outlet for their 'frustrations' at having opportunities closed off by increasingly repressive property legislation; but it is far more likely to be due to the less urbanised landscape of the region, and the different political regime in place in the south.

Notes

1. David Herlihy, 'Did women have a renaissance? A reassessment', *Medievalia et Humanistica* (1985), pp. 1–22; reprinted in David Herlihy, *Women, Family and Society in Medieval Europe* (Oxford, 1995), pp. 33–56, quote on p. 41.

2. B. Vetere, 'La donna nella società e nella cultura medioevale: temi e itinerari di ricerca', in B. Vetere and P. Renzi (eds), *Profili di Donna: Mito, Immagine, Realtà fra Medioevo ed Età Contemporanea* (Galatina, 1986), pp. 21–102, at p. 62.

3. M. Chiaudano and M. Moresco (eds), *Il Cartolare di Giovanni Scriba*, 2 vols (Turin, 1935).

4. D. Clementi, 'Some unnoticed aspects of the emperor Henry VI's conquest of the Norman kingdom of Sicily', *Bulletin of the John Rylands Library*, 36 (1953/54), pp. 328–359.

5. Clementi, 'Some unnoticed aspects', pp. 333–334.

6. Discussed in D. Owen Hughes, 'Invisible Madonnas? The Italian historiographical tradition and the women of medieval Italy', in S. Mosher Stuard (ed.), *Women in Medieval History and Historiography* (Philadelphia, 1987), pp. 25–57, at pp. 40–41.

7. Owen Hughes, 'Invisible Madonnas?', p. 42.

8. D. Owen Hughes, 'Urban growth and family structure in medieval Genoa', *Past and Present*, 66 (1975), pp. 3–28; S. Epstein, *Genoa and the Genoese, 958–1528* (Chapel Hill, NC, 1996).

9. Vetere, 'La donna', p. 62 (my translation).

10. Owen Hughes, 'Urban growth', pp. 3–4.

11. Ibid., p. 7.

12. See P. Skinner, 'Room for tension: urban life in Apulia in the eleventh and twelfth centuries', *PBSR*, 66 (1998), pp. 159–176.

13. Owen Hughes, 'Urban growth', p. 12.

14. Ibid. See also S. Epstein *Wills and Wealth in Medieval Genoa, 1150–1250* (Cambridge, Mass., 1984).

15. D. Herlihy, 'Women and the sources of medieval history: the towns of northern Italy', in J. T. Rosenthal (ed.), *Medieval Women and the Sources of Medieval History* (Athens, Ga., 1990), pp. 133–154, at p. 133.

16. Ibid., p. 134.

17. Epstein, *Genoa and the Genoese*, p. 45.

18. L. T. Belgrano (ed.), *Annali Genovesi di Caffaro e de' suoi Continuatori*, vol. 1 (FSI 11, Genoa, 1890), p. 31.

19. Paolo Cammarosano, 'Les structures familiales dans les villes de l'Italie communale XIIe–XIVe siècles', in G. Duby and J. Le Goff (eds), *Famille et Parenté dans l'Occident Médiévale* (Rome, 1977), pp. 181–194, at p. 182.

20. See P. Skinner, 'The widow's options in medieval southern Italy', and, on a slightly later period, I. Chabot, 'Lineage strategies and the control of widows

21. M. T. Guerra Medici, *L'Aria di Città: Donne e Diritti nel Comune Medievale* (Naples, 1996), p. 98.

22. C. Violante, 'Quelques caractéristiques des structures familiales en Lombardie, Émilie et Toscane aux XIe et XIIe siècles', in Duby and Le Goff (eds), *Famille et Parenté*, pp. 87–149.

23. C. J. Wickham, 'Gossip and resistance among the medieval peasantry', *Past and Present*, 160 (1998), pp. 3–24; on Italian court cases in general in this period, idem, 'Ecclesiastical dispute and lay community: Figline Valdarno in the twelfth century', *Mélanges de l'École Française de Rome, Moyen Age*, 108 (1996), pp. 7–93.

24. Violante, 'Quelques caractéristiques', p. 115.

25. A rich survey, based on the Cava archive, is Joanna Drell, 'Marriage, kinship and power: family structure in the principality of Salerno under Norman rule, 1077–1154', PhD thesis (Brown University, 1996), pp. 222–249.

26. A. Padrone Nada, 'La donna', in G. Musca, ed., *Condizione Umana e Ruoli Sociali nel Mezzogiorno Normanno-Svevo* (Bari, 1991), pp. 103–130, at p. 114.

27. J. A. Brundage, 'Sexual equality in medieval canon law', in Rosenthal, ed., *Medieval Women*, pp. 66–79.

28. S. D. Goitein, *Letters of Medieval Jewish Traders* (Princeton, NJ, 1973), pp. 220, 224, 316 (from the eleventh century): 'I wrote her a bill of divorce fearing the vicissitudes of fate'.

29. *SNN*, document 36 (will of a sailor); 144 (will of notary leaving Bari for Bologna to study law); 155 (will of cleric prior to travelling from Bari to Palermo); *Molfetta*, document 17 (will of Molfetta man gone to Santiago di Compostela is executed).

30. M. G. Muzzarelli, 'Un'introduzione alla storiografia', in M. G. Muzzarelli, P. Galetti and B. Andreolli (eds), *Donne e Lavoro nell'Italia Medievale* (Turin, 1991), pp. 13–28, at p. 20.

31. G. Piccinni, 'Le donne nella vita economica, sociale e politica dell'Italia medievale', in A. Groppi (ed.), *Il Lavoro delle Donne* (Bari and Rome, 1996), pp. 5–46, at p. 15.

32. Guerra Medici, *L'Aria*, p. 108.

33. Owen Hughes, 'Invisible Madonnas?', pp. 48–49.

34. S. D. Goitein, 'Sicily and southern Italy in the Cairo Genizah documents', *Archivio Storico per la Sicilia Orientale*, 67 (1971), pp. 9–33, at pp. 13–14.

35. D. Abulafia, *The Two Italies: Economic Relations between the Norman Kingdom of Sicily and the Northern Communes* (Cambridge, 1977), pp. 237–238.

36. See G. Jehel, 'Le role des femmes et du milieu familial à Gênes dans les activités commerciales', *Revue d'Histoire Économique et Sociale*, 53 (1975), pp. 193–215; M. Angelos, 'Women in Genoese *commenda* contracts, 1155–1216', *Journal of Medieval History*, 20 (1994), pp. 299–312.

37. Epstein, *Genoa and the Genoese*, p. 101.

38. Guerra Medici, *L'Aria*, p. 120.

39. Eleanor S. Riemer, 'Women, dowries and capital investment in thirteenth-century Siena', in Marion A. Kaplan (ed.), *The Marriage Bargain: Women and Dowries in European History* (New York, 1985), pp. 59–79, at p. 68.

40. Roberto Greci, 'Donne e corporazioni: la fluidità di un rapporto', in Muzzarelli, Galetti and Andreolli (eds), *Donne e Lavoro*, pp. 71–91.

41. J. F. Benton, 'Trotula, women's problems and the professionalization of medicine in the Middle Ages', *Bulletin of the History of Medicine*, 59 (1985), pp. 30–53.

42. M. Green, 'Estraendo Trota dal *Trotula*: ricerche su testi medievali di medicina Salernitana', *Rassegna Storica Salernitana*, n.s. 12 (1995), pp. 31–53.

43. Kate Campbell Hurd-Mead, 'An introduction to the history of women in medicine', *Annals of Medical History*, n.s. 5 (1933), pp. 484–504, 584–600.

44. *SNN*, document 106.

45. *PC*, document 141, drawn up in Monopoli.

46. The later period is discussed by Francesca Bocchi, 'Regulation of the urban environment by the Italian communes from the twelfth to the fourteenth century', *Bulletin of the John Rylands Library*, 72 (1990), pp. 63–79, and by Robert C. Davis, 'The geography of gender in the Renaissance', in Judith C. Brown and Robert C. Davis (eds), *Gender and Society in Renaissance Italy* (1998), pp. 19–38.

47. F. Rosi, 'Donne attraverso le carte dell'abbazia di S. Croce di Sassovivo (1023–1231)', in *Donne nella Società Comunale: Ricerche in Umbria* (= *Annali della Facoltà di Lettere e Filosofia dell'Università degli Studi di Perugia. 2. Studi Storico-Antropologici*, vols XXXI–XXXII, new series vols XVII–XVIII, 1993/94–1994/95), pp. 49–85.

48. Georges Duby, *Rural Economy and Country Life in the Medieval West* (1968), pp. 440–441.

49. Epstein, *Genoa and the Genoese*, p. 61.

50. Skinner, 'Room for tension', pp. 168–169.

51. T. Leccisotti, 'Le pergamene latine di Taranto nell'archivio di Montecassino', *Archivio Storico Pugliese*, 14 (1961), pp. 3–49, at p. 8.

52. Brenda Bolton, '"Received in his name": Rome's busy baby box', in D. Wood (ed.), *The Church and Childhood* (Oxford, 1994), pp. 153–167.

53. Guerra Medici, *L'Aria*, p. 74.

54. Much of the salient evidence is now gathered in P. Skinner, '"The light of my eyes": medieval motherhood in the Mediterranean', *Women's History Review*, 6 (1997), pp. 391–410.

55. A. Valerio, *La Questione Femminile nei Secoli X–XII* (Naples, 1983), pp. 15–18, surveys the literature.

56. D. Bornstein, 'Women and religion in late medieval Italy: history and historiography', in D. Bornstein and R. Rusconi (eds), *Women and Religion in Medieval and Renaissance Italy* (Chicago, 1996), pp. 1–27, at p. 1.

57. S. F. Wemple, 'S. Salvatore/S. Giulia: a case study in the endowment and patronage of a major female monastery in northern Italy', in J. Kirshner and S. F. Wemple (eds), *Women of the Medieval World* (Oxford, 1985), pp. 85–102.

58. Raffaele Iorio, 'Violenze e paura nella Puglia normanna', *Quaderni Medievali*, 17 (1984), pp. 88–113.

59. C. A. Garufi (ed.), *Catalogo Illustrato del Tabulario di S. Maria Nuova in Monreale* (Palermo, 1902), document 51.

60. Its history is traced by Valerio, *Questione Femminile*, pp. 53–62.

61. Padrone Nada, 'La donna', p. 122.

62. C. A. Garufi (ed.), *I Documenti Inediti dell'Epoca Normanna in Sicilia* (Palermo, 1899), p. 257, document 107.

63. Garufi (ed.), *Documenti Inediti*, p. 155, document 64.

64. H. Houben, *Il 'Libro del Capitolo' del Monastero della SS. Trinità di Venosa (Cod. Casin. 334): Una Testimonianza del Mezzogiorno Normanno* (Naples, 1984), pp. 13–20.

65. Anna Maria Facchiano, *Monasteri Femminili e Nobiltà a Napoli tra Medioevo ed Età Moderna: il Necrologio di S. Patrizia (secc. XII–XVI)* (Altavilla Silentina, 1992).

66. Epstein, *Genoa and the Genoese*, pp. 93–95.

67. Anna Benvenuti Papi, 'Mendicant friars and female *pinzochere* in Tuscany: from social marginality to models of sanctity', in Bornstein and Rusconi (eds), *Women and Religion*, pp. 84–103, at pp. 89–90.

68. Valerio, *Questione Femminile*, p. 69.

69. Duane J. Osheim, 'Conversion, *conversi* and the Christian life in late medieval Tuscany', *Speculum*, 58 (1983), pp. 368–390, at p. 371.

70. Ibid., p. 378.

71. *CDA*, I, documents 185 and 190.

72. See above, p. 116.

73. John Larner, *Italy in the Age of Dante and Petrarch, 1216–1380* (1980), p. 246.

74. For an overview see C. Violante, 'Hérésies urbaines et hérésies rurales en Italie du 11ᵉ au 13ᵉ siècle', in J. Le Goff (ed.), *Hérésies et Sociétés dans l'Europe pré-Industrielle, 11ᵉ–18ᵉ Siècles* (Paris and The Hague, 1968), pp. 171–198, reprinted as 'Eresie urbane e eresie rurali in Italia dall'XI al XIII secolo', in O. Capitani (ed.), *Medioevo Ereticale* (Bologna, 1977), pp. 185–211.

75. E. McLoughlin, 'La presenza delle donne nei movimenti ereticali', in M. Pereira (ed.), *Né Eva né Maria: Condizione Femminile e Immagine della Donna nel Medioevo* (Bologna, 1981), pp. 82–91.

76. Malcolm Lambert, *Medieval Heresy: Popular Movements from the Gregorian Reform to the Reformation* (2nd edn, Oxford, 1992), p. 69.

77. Valerio, *Questione Femminile*, p. 38.

78. G. Koch, 'La donna nel catarismo e nel valdismo medioevali', in Capitani (ed.), *Medioevo Ereticale*, pp. 245–272, at p. 272.

79. The latest work on the movement is Frances Andrews, *The Early Humiliati* (Cambridge, 2000). See also L. Paolini, 'Le Umiliate al lavoro', in Muzzarelli, Galetti and Andreolli (eds), *Donne e Lavoro*, pp. 141–158.

80. Lambert, *Medieval Heresy*, pp. 92, 95.

81. On claustration in a different geographical context, P. D. Johnson, 'The cloistering of medieval nuns: release or repression, reality or fantasy?', in Dorothy O. Helly and Susan M. Reverby (eds), *Gendered Domains: Rethinking Public and Private in Women's History* (Ithaca, NY, 1992), pp. 27–39.

82. Valerio, *Questione Femminile*, p. 12.

83. Stuard, 'Invisible Madonnas?', p. 38.

84. Herlihy, 'Did women have a renaissance?'.

85. Diana Webb, *Patrons and Defenders: The Saints in the Italian City-states* (1996), p. 79.

CHAPTER SEVEN

The Thirteenth-century Epilogue

Thus the history of women in the Middle Ages is above all characterized by its juridical formalism, the unrepresentative nature of the examples eternally cited and discussed and the unexplained acceptance of the traditional roles judged as natural. To the simplicity of the juridical norms that established their condition . . . has been opposed the diversity of their actions, and an attempt has been made to discover . . . the margin for manoeuvre enjoyed by women . . . their own strategies and the networks of affiliation they recognized and sought to perpetuate.[1]

Communal laws and women's status

Maria Teresa Guerra Medici's study of statute material emanating from northern Italian cities in the thirteenth century identifies profound changes in Italian society and politics between the twelfth and thirteenth centuries.[2] Women's role was increasingly circumscribed to that of family and home – the first time that the structural notion of public-male/private-female can really be said to have worked as an analytical tool. At the same time, it is difficult to separate public and private spheres when the legal statutes promulgated by cities in this period had such an impact of the feminine, supposedly private, arena. In communal society, the citizen and his family were expected to contribute to the state: thus the state came to have considerable influence over their lives.[3] We must not forget either that legislation extended into the countryside, with landlords recording their tenants' obligations in their own sets of statutes, for example those of Count Guido Guerra III for the Val d'Ambra in 1208; and rural communes also issued laws, as for

example those made by the commune of Montaguloto dell'Ardinghesca between 1280 and 1297.[4]

Despite Isabelle Chabot's statement that the laws form 'a polychrome mosaic which defies generalisation',[5] Guerra Medici identifies a three-pronged undermining of women's rights. Firstly, women were not recognised in their own right as citizens of the new polities which had emerged in the previous century: they did not swear the oath to the commune and were not permitted to attend civic assemblies. Secondly, the distinction between Roman and Germanic law became increasingly blurred (if it had ever been all that distinct), and both were replaced by an ideology of the *paterfamilias* – the family was subject to its dominant male head. Thomas Aquinas had famously equated good order within the family as a microcosm of good order in the state. This has been a persuasive model for successive generations of commentators and historians even though, as Diego Quaglioni has pointed out, Aquinas's statement has been taken completely out of context and in fact represents a view he was trying to refute.[6] Women's role within this structure was to bear and rear children, whose legitimacy and identity was located firmly within the male line. As such they were not a durable element in the family structure and when they died 'their memory was lost along with their name [la loro memoria si perdeva, come il loro nome]'.[7] Thirdly, at the same time, daughters' right to inheritance was closed off and the dowry became the sole means by which property was transferred to them from their natal families – this to be managed by their husband during their marriage. To fulfil the role of mother, education, property and liberty were not necessary.

Even where we have seen women negotiating such restrictions through economic transactions in the twelfth century, their opportunities were being closed off by the thirteenth. In Siena, studied by Riemer, the business successes enjoyed by women through using their dowries as capital were attacked by statutes of 1262 and 1285. These sought to limit women's use and disposal of their property, ostensibly to protect the rights of their children.[8]

This situation, Guerra Medici argues, was in stark contrast to some smaller cities and to rural communes, where women retained an active role in the community. Nevertheless, if women were not citizens, marriage to them might still bring citizenship or civic rights to a husband, as we have already seen in the case of twelfth-century Genoa.

The corollary to this location of woman within family was that she became a symbol of its probity and respectability – adultery and sexual sin were heavily punished – and only two categories existed for locating women in statutes: honest woman or whore. This was later symbolised too with statutes regulating dress and behaviour in the street. (Spinning and carrying children in public, particularly in the market, seem to have been particularly

frowned upon.) Because of the greater stress laid on reputation, we begin for the first time to hear women's voices as they defended themselves from defamation. Epstein quotes from a dispute recorded extensively in the cartulary of a certain Martino at Savona dated 1203/1204, a fight between Berta Mazzalina and a certain Bonenata over slanderous language and the class distinctions it revealed.[9]

This concern with respectability went hand-in-hand with the growing esteem in which motherhood was held, reflecting and reflected by the rising cult of the Virgin from the twelfth century onwards. Guerra Medici reads this rise in maternal status as a compensation for women's exclusion from the outside world of politics, a theme we have already met in other forms of religious expression in the twelfth century.

A woman's property consisted of her dowry; when widowed she had this to live on. Jurists of the thirteenth century debated long and hard over widows' rights over their husbands' property and the tutelage of minor children; the majority appear to have been in favour of a mother having her children and some kind of usufruct of the property, but widows must have found themselves under constant pressure to remarry or return to their own families, particularly if young. Children were in fact a widow's insurance – her chances of remaining in her marital home after her husband's death with no children seem to have been slim.

Guerra Medici's work surveys and condenses a great deal of legal material, and is thus of great value in trying to look at general patterns in women's lives in later medieval northern Italy. She herself remarks on the homogeneity of the picture emerging from the study of some fifty published statute collections (a point which Chabot contests, contrasting Florence with Venice). What is less satisfactory about the work, however, is her lack of commentary on why such statutes cluster around the thirteenth century. We might argue that the communes themselves reached a level of political maturity which enabled them to turn to issuing their own legislation in place of pre-existing (and often conflicting) laws. This coming to maturity would certainly fit in with what we know of the chronology of the emergence of the communes, with Genoa and Pisa early and thus legislating earlier. But this is not sufficient as an explanation. A closer examination of a set of statutes from thirteenth-century Bologna might provide a few clues.

Case study: Bologna

We are fortunate in having surviving from the city of Bologna, one of the cities studied by Guerra Medici, two sets of mid- to late-thirteenth-century

statutes, one regulating the societies of arms in the city, the other the trade and artisan associations.[10] Each had its own regulations, and these can be informative about how women were seen. For example, the statute of the society of arms of the Lombardi reveals the close-knit nature of the family. On the death of any of the society's members or their father, mother, wife, son or daughter, sister, nephew or niece, male or female relative, 'if they die at home and are family/household members [si moriantur in domo sua, et sunt de familia]', the society's members were to attend the funeral and then to return to the deceased person's house and 'to stay there until the women return from the church [ibi sedere donec mulieres reddeant ab ecclesia]'. Note here the emphasis on the society's obligations to its (male) members but also to their families (an obligation repeated, though not in such detail, by the statutes of the society of the Toschi). Also note the primary role which the women of the family appear to have taken in the funeral proceedings.

Admission to the society, however, does not appear to be limited to agnatic lineages as proposed by Guerra Medici – sisters' sons could be admitted at the same lower entry fee as charged to members' sons, brothers or brothers' sons. The society of the Toschi in their statutes of the same year admitted anyone who themselves were Tuscans or who had a Tuscan father, mother, grandfather or grandmother, provided that they had lived in Bologna with their family for three years or more – again we have a rather looser interpretation of the family line than that envisaged by Guerra Medici, and the same emphasis on settled family life.

The point here, however, is to decide why the societies of arms and those of the arts issued such customs. Might the minute detail of membership criteria and obligations (expressed even more clearly in the recorded oaths that members and officials of the society had to take), the emphasis on morality, the stress on family life, not be the expression of some anxiety over all of these things and a desire to firm up the boundaries of civic life? That is, when Guerra Medici finds cities regulating women, prohibiting them from attending public gatherings or entering the communal palace, imposing sanctions on women spinning in public or carrying their babies, is it not precisely because women were doing these things? Normative materials are almost always reactive (compare the Lombard laws studied in Chapter 2, where King Liutprand explicitly explains that he has added another clause because 'we have heard that . . .'). The society of arms of the Lombardi in Bologna is the only one in that city with a statute against public keeping of prostitutes. It imposes heavy penalties and ultimately expulsion on any member who 'publicly keeps prostitutes (*meretrices*) in his house'. What scandal had erupted to cause such a clause to be included in its 1256 code?

Ironically therefore, and in stark contrast to traditional historiography on the subject, the communes might not have been the repressive places for

women that the legislative material gives the impression of. Indeed, looking back at the discussion in the previous chapter of women's engagement in the economic life of the cities, it might be suggested that their exclusion from the pinnacle of civic politics has very little relevance to our understanding of their lives. If anything, the statutes convey an impression of trying to keep a lid on an already uncontrollable situation as far as women and work were concerned. Women were certainly crucial to economic life and apparently knew this – the statute of the *arte della lana* in Bologna of 1256 includes close regulation of women workers and wool-combers, working in their homes, and limits the amounts they could work on. The cotton-workers, also, were not permitted to take stuff home to be worked on by their families – here we may see women subverting the process again. Legislation is only aspirational: it cannot be taken as the measure of women's actual limitations. When women were forbidden from selling food from their homes, it was probably because that was precisely what they were doing.

As the records change in their nature, so women's consciousness of their roles appears to emerge more clearly in the thirteenth century. As we have already seen, fuller records of depositions in court cases can preserve a version of women's testimony in writing. Women themselves were conscious of their power and its limitations. Their enhanced status as wives and mothers produced a new type of source which they themselves are sometimes found creating: one of the earliest books of domestic memory (*ricordanze*) written by a woman was that of Moscada, widow of Spinello of Siena, written in the 1230s. Cammarosano cites it as an example of a woman's self-conscious decision to record her family (she was caring for Spinello's children) and the economic power she now enjoyed.[11]

A slightly different example of women's conscious action is cited by Epstein, and took place in 1230 in Genoa. A pirate ship operating out of the city had been captured, and the crew sentenced to lose a hand. In what Epstein characterises as 'the first recorded instance of Genoese women taking concerted political action on the streets, the only possible venue for their protest',[12] the wives of the crewmen and a group of friars gathered around the city prison to prevent the sentences from being carried out, throwing stones and pushing the guards around. They apparently succeeded in preventing a sentence which would have left the crewmen unable to continue their livelihood, and would have spelt economic disaster for themselves.

City and countryside: the case of Umbria

Moving further south, Giovanna Casagrande and Maria Grazia Nico Ottaviani's study of the urban statutes of the city of Perugia appears to

support Guerra Medici's findings.[13] Casagrande and Nico Ottaviani, however, also strike a note of caution about taking the legal prescriptions at face value. Such statutes, they argue, provide a framework and little more for investigations into the 'reality' of women's lives. Provisions regarding women focus on the family, on work, on moral behaviour and habits and customs. An example of the slippage between the laws and practice is the disparity between the marriageable age for girls in the Umbrian statutes (averaging 12–14), and the actual figure of around 17 documented in Tuscan and Umbrian sources. This may have depended on the social class of the participants. Diane Owen Hughes's study of Genoa reveals aristocratic marriage contracts where the girl might still be very young. For example, in 1255, Pasqualino Usodimare promised to marry Alasina, daughter of Luca Grimaldi, when she was of marriageable age, 'that is, when she is twelve'.[14] At the other end of the scale, a woman of 20 to 25 (variable between statutes) was able to determine her own marriage partner.

Central to marriage transactions was the question of dowry. Already in the twelfth century, as we have seen, there had been growing resistance to the wife's claim of up to one-third of her husband's property as a marriage gift, and the *odium quartae* (hatred of the quarter) was a strong theme of thirteenth-century legislation. At the same time, legislation focused even more attention onto dowry levels, and civic legislators were quick to regulate its transfer. Chabot's study of north-central Italian statutes shows husbands being able to keep some or all of his predeceased wife's dowry:[15] only Bolognese statutes restored it to her family. A woman's will, of course, could threaten the husband's right to inherit this valuable property, and some cities therefore began to limit women's testamentary rights.

It is likely that the victims of such limitations may have included daughters. Very soon a daughter's right to inherit from her family was replaced by the dowry – she had no further claim. The statute of Todi of 1275 has a clause titled 'How daughters may not succeed'. Perugia (1279) and Spoleto (1296) had similar provisions.

As with all legal prescriptions, however, there were ways around the problem. The statute of Perugia of 1279 allowed women to inherit if a will specifically admitted them; if they were destitute; if they had no male children; or indeed if they had no dowry. Since the dowry could often form the focus of bitter struggle between a widow and her husband's family on his death, the plea of poverty might well be relevant in allowing her to inherit from her own kin. Chabot highlights exceptions from other cities: in Venice, the thirteenth-century legislation admitted daughters to the inheritance if there were no sons. At Florence, however, all the male relatives had to have died out before women might be admitted to the patrimony.

Moving from marriage to morality, the statute of Perugia of 1279 regulates prostitution in the city, forbidding prostitutes from plying their trade near religious houses and tavernkeepers from accommodating them. In Spoleto, too, the space which prostitutes were able to live and operate in was delimited in the statute of 1296. Apart from this legislation, the Umbrian study, as elsewhere, finds very little record of women's other paid working activities: those which do appear are the positions of *fornaria* (a baker using an oven), *panicocula* (a bread-seller) and *tabernaria* (a seller of foods, cooked and otherwise). In a direct parallel to the provisions made at Bologna, women who sold food were not permitted to spin or hold children whilst at work.

If the thirteenth century sees a closing-off of women's property rights and opportunities in the legal statutes, a more nuanced picture emerges from fiscal sources, where individual women are visible. Claudio Regni's study of the fragmentary *catasto* or fiscal return from Perugia of 1260, and the more complete revision of 1285, reveals a significant number of female heads of household – approximately 6 per cent of the total hearths listed.[16] At the same time, they account for a mere 2.22 per cent of the wealth recorded in the returns – Regni notes that women cluster at the lower end of the assessments, and only eight are identified with a trade or occupation (which are: innkeeper, baker, bread-seller, food-sellers and weaver, thus mirroring the findings in Umbrian legal statutes on the essentially extended domestic labour of women).

The rural situation: Sassovivo

Guerra Medici identified a distinct difference between the urban and rural situation in the statute material. A way of examining the situation in the countryside is through charter material. The Sassovivo archive, studied by Federica Rosi, offers some alternatives to the Umbrian legal and fiscal material discussed above.[17] Her key statistic for the thirteenth century is the dramatic drop in the proportion of women mentioned in the documentation who are active participants in the land transactions as opposed to simply mentioned. Whilst the proportions remain relatively stable in the eleventh and twelfth centuries, female actors drop by almost a half, from 57 per cent and 47 per cent in the eleventh and twelfth centuries to 27 per cent of total recorded women. Thus although the Sassovivo archive offers evidence that women retained their marriage portions (in contrast to the *odium quartae* of the urban legal prescriptions discussed above), they may not have had nearly so much opportunity to exploit it. Similarly, the Sassovivo

archive reveals thirteenth-century examples of husbands flouting the ancient *lex Iulia* forbidding them from alienating their wife's dowry, by using it in transactions and compensating their wives with equivalent properties. Women's control over their lands was diminishing.

One of the major trends visible in the Sassovivo sample is the gradual encroachment of urban families from Foligno into the surrounding territory (*contado*) and its land market. The judge Angelario is documented in the early years of the thirteenth century buying up property, particularly from women, and married off his own daughter Theodora in 1222 with a large dowry. Rosi speculates that this effectively ended Theodora's right to inherit from her father, as more and more urban families sought to maintain their patrimony intact by excluding dowered daughters from inheritance rights. Some of the major themes of this period in the Sassovivo material are represented in the archive by documents tracing the life of one local woman, Bonafemmina.

In 1223 an important citizen of Foligno, Bonagiunta, had married his daughter Bonafemmina to a certain Jacob de Befanio, who had given property as security for her dowry. Jacob appears to have remained obligated to his father-in-law for at least the next six years, and his repeated guarantees to repay lands for the dowry appear to be connected to the fact that he and Bonafemmina were divorcing.

The circumstances of the divorce are unclear. From papal documents of 1229 and 1231 it seems that the sentence of divorce between the couple had already been pronounced by the bishops of Camerino and Todi and the prior of St Nicholas in Foligno. What is interesting about the papal document of 1229 is that Bonafemmina is represented by Maccarino di Passaro, father of Bonafemmina's second husband, another Jacob. In the same year, Bonafemmina appears to have remarried, and her father Bonagiunta drew up a document handing over her dowry and also constituting her his sole heir, with Maccarino charged with the administration of the property this would give her. The language he uses in making Bonafemmina his heir, and the minutely detailed inventory of the property itself, suggests the difficulties inherent in passing on land to a female heir by the third decade of the thirteenth century.

Soon afterwards, Bonafemmina donated the lands to the priory of St Maria *infra portas*, retaining the usufruct for life, and bought the lands donated to the the priory by her father. Later documents show Bonafemmina, now widowed, becoming an oblate of the monastery of Sassovivo and willing her extensive properties in a series of documents in the 1270s and 1280s to a variety of religious foundations in Umbria. Bonafemmina's fragmentary life story as an adult is emblematic of the changes in women's status taking place in this period, particularly summed up in the initial difficulty in

passing property to her as a female heir, and her eventual decision, after a complicated marital career, to become an oblate or *conversa*. Only by exploring such individual lives can the vivid realities of well known structural changes in medieval life be fully understood.

A different framework? The south

A useful comparison can be made between these northern Italian examples and the legal statutes emanating from the south in the thirteenth century. When the German emperor Frederick II issued the *Liber Augustalis*, or Constitutions of Melfi, in 1231,[18] he too prefaced it with an explanation that the laws needed revision and codification, and was underlining the political maturity of the Norman state he had inherited. Some of the laws he incorporated were by earlier, Norman kings; many of the provisions in the code reflect a concern with women's status and honour similar to that in the northern statutes.

It is hard to see the laws explicitly protecting women having any real effect, however. On rape the emperor was clear: capital punishment was substituted for the older custom whereby the rapist could escape punishment by marrying his victim or causing her to be married off. But other offences were not so clear cut. For example, Frederick ended the custom whereby anyone accused of violence against a woman was able to defend himself through trial by combat. Instead, if the perpetrator were caught in the act of intercourse with the woman – 'which cannot happen very often' – he was to suffer capital punishment. If, however, the 'real truth' of the matter could not be proven, the woman or her representative was obliged to denounce the culprit three times *and* the culprit had to be caught either with the woman struggling and screaming, or beneath him in the act of intercourse, or loitering near her house. At this point he would be placed in jail or in the custody of his pledges. The abuses that such arrangements were open to are clear: the burden of proof lay heavily with the woman, and the custody into which the man was placed might be little more than returning to his family.

To reinforce the barriers to such denunciations still further, the next two clauses allowed anyone who failed to help the screaming woman to claim that they were asleep; and placed a sentence of death on a woman found to make false accusations. In the context of medieval society, it is all too easy to see that an accusation, if not proven, could rapidly be seen as false. These laws taken together then reveal the difficulties that a raped or violated woman might have in pursuing her attacker.

Such a model only works, however, if we take the legal codes to be genuine reflections of the emperor's will, as laws which were designed to be obeyed and referred to. David Abulafia, in his study of Frederick, attacks historians who believe that the Constitutions represent an attempt to turn Sicily into a model state, but also believes that they were 'designed to fit the urgent needs of the Sicilian kingdom'.[19] Taken to its logical conclusion, this argues that the laws promulgated and reissued in 1231 addressed real situations. That Frederick was keen to undertake the juridical and commercial reordering of the kingdom is without doubt, and some of these provisions addressed women's actions or the impact upon them of their husbands' deeds, for example the law allowing women to pursue court cases through a representative; or another protecting the wives and mothers of those sent into exile; or another still which held a wife and family responsible on oath for passing on a summons to court if the intended recipient was absent, and for allowing the letter to be left on the doorstep if they would not open the door to the official delivering it.[20]

Nevertheless, taking into account the rhetoric accompanying the prologue to the laws, which establishes Frederick as an ideal ruler in making these laws, it is difficult to conclude that, in his statutes protecting women from violence and other harm, the emperor is doing anything other than fulfilling a model of rulership with an ancient pedigree. The care of the weak in society was a model which most codes of law influenced by Christian ideals upheld, and Fredrick's justiciars were charged with the responsibility of providing the protections outlined.

This model extends into the protection of women's property and legal rights. The laws on the duties of the masters of the finance bureau, for example, show that daughters could inherit from an intestate person, and a later and fuller statement condemns the 'evil custom' whereby daughters of a man without male heirs were excluded from inheriting in favour of more distant male relatives. And Frederick modified a law of William to enable knights to create a dowry for their wives from land held as a fief, unless only one fief was held, in which case the dowry had to be in moveables. The motive behind such protection was not hard to see: daughters who were still minors fell, with their property, into the wardship of the court, which also took responsibility for marrying them off at the age of 15. Parallels with other medieval states, where such marriages became almost an auction to the highest bidder, are not hard to find. In the south, then, legislation on women's property seems to have opposed the disinheritance of women. This may suggest that families were nevertheless moving in the same direction as those in the north had two centuries previously, and trying to limit their daughters' rights to property. If this is so, it was late; and even in the twelfth century a case study of the charters of Cava has not found

definitive evidence of this phenomenon, nor of an exclusively agnatic lineage emerging.[21]

An important provison in Book II, however, defines limits to women's rights. According to Lombard law, women were subject to the *mundium* or legal guardianship of a male relative or the king's representative, and the *mundoald* or guardian should forfeit this responsibility if he mistreated her. King Roger had offered his officials' help to women in this position who had been restored to legal status, that is, allowed to act in their own right. This had apparently caused a certain amount of confusion. Frederick therefore ordered that a woman should be restored to legal status only when it had been proven that she had suffered mistreatment or loss as a result of her *mundoald*'s actions. At that point, however, a woman was expected to act alone, and the emperor did not see that it was necessary to offer state support to women engaging in contracts unless 'through the weakness of their sex' they were found to have agreed to illegal actions or had been in some way defrauded through their agreement. This appears to be aimed at ending the ambiguity between the status of a woman who was in the *mundium* of the state, and a legally independent woman who nevertheless claimed the state's help. The net effect of the law, however, seems to be to reinforce the common prejudice that women were by and large incapable of dealing effectively with their own affairs. Women were not to be forced to come to court, unless the case concerned an incident which had taken place in women's spaces, for example in a convent or *gynecea*, at the communal ovens or baths, or at weddings or deliveries of babies (thereby at a stroke revealing what the legislators thought the most common female spaces were). An extension of this was the protection afforded the women of the family of a lord or vassal against the felony or violence of either party.

Case study: Sicily

Although Guerra Medici's study of legal codes appears to support a widening gap between public and private spheres of activity in late medieval Italian society, the Constitutions of Melfi still suggest that the state could attempt to regulate the personal life of its subjects. And yet, as in the north, there is a suspicion that the legislation again paints too black a picture of women's possibilities in the Regno. Using Sicilian notarial registers from Palermo dating to the latter part of the thirteenth century, Maria Rita Lo Forte Scirpo argues that there was a 'small group of women whose appearance was by no means that of a weak, delicate and reserved being', but of a woman who sought to free herself from the 'everyday monotony' and create

a space in which she could resist the 'rigid schemes impose by current mentalities and customary norms'.[22]

These women invested in commercial and artisanal enterprises, using both money and moveable items. They are also documented selling slaves, vineyards, cotton to the cotton-weavers of the city, and renting shops. Leonetta, the widow Joanna and the widow Pagana are seen engaging in trade contracts with, respectively, Catalans from Barcelona, a Jewish merchant and a group of merchants from Messina. Pagana's case is particularly interesting, as she invested a legacy from her deceased husband. The young woman Antonella, via her mother's husband, is seen investing in a shipment of salted meat and cheese to Genoa. Lo Forte Scirpo stresses that these are by no means isolated cases.

How were these women able to participate so freely in Palermo's dynamic commercial life? Were they, like Genoese women a century before, simply taking advantage of the fluidity of an expanding economy which enabled them to transcend the social limits imposed upon them before legislation closed off their opportunities? The Sicilian evidence would not appear to fit this pattern, for other sources beside the contracts support a picture of self-confident women who were not prepared to accept injuries done to them. The contemporary records of the court of Palermo include women taking actions as well as defending them. Unfortunately, Lo Forte Scirpo does not provide a statistical breakdown to enable a comparison with the earlier situation in southern Italy, but her examples are suggestive of a greater female presence and success rate.[23]

Women's work and opportunity: a regional picture

The studies of individual regions in this and the previous chapter have revealed a wide variety of opportunities for coastal and inland women, and urban and rural ones, to manage property, engage in trade or become workers.

Women living in ports and other thriving commercial centres appear to have enjoyed a certain freedom of action with regard to economic transations. Amalfi in the tenth and eleventh centuries, Genoa, Siena (and, to a lesser extent, the Apulian cities) in the twelfth, and Palermo in the thirteenth were all burgeoning centres of trade, and the fact that many of the male inhabitants often travelled away from their homes on trading ventures may initially have left a space for women to occupy as their agents. This is particularly

noticeable in the documents from Amalfi. What is clear about the pattern is that it is less connected to legal customs than might have been thought: not all the examples are from regions where Roman law was professed.

This is clearly not the whole story. A woman with disposable wealth in a trading community would be likely to want that wealth put to work in the commercial ventures that surrounded her. But the disparate political and economic developments in each of the cities mentioned meant differing periods of this female activity. Amalfi went into commercial decline under pressure from Genoa and Pisa in the eleventh century; Genoa's progression to communal forms of government led to the restriction of women's property that we have discussed above; the Apulian cities clung onto their Lombard customs, which meant that only exceptional women emerge in any kind of trade; the Sienese government used the argument of children's rights to close off women's use of their dowries. Only in Sicily, the centre of Norman-Swabian royal activity and thus of the richest commerce, could women continue to participate in trade. The correlation between economic pressures and restriction of female activity appears clear. The sample surveyed attracts attention *because* of the documented presence of women: what is needed are further local studies of the type pursued by the Umbrian study group, testing the models for smaller towns, for other coastal cities (no full-length study has yet appeared on women in Pisan trade, for example), and for other rural areas. Alongside the charters, statute material can reveal far more about women at work in the community than might be expected: legislation on markets, on food standards and on the 'grey' economy of bribes and illegal purchases might all bring women's activities into focus, even if they are not explicitly mentioned (and, mostly, they are).

Marginal workers: slaves

Although they appear less frequently in the thirteenth-century literature, slaves still formed part of the workforce. Franco Angiolini suggests that slaves were being replaced by free servant labour only from the fifteenth century,[24] but it is clear that the process began much earlier. Epstein cites the Genoese example of the *pedisca* or servant Pauleta, placed for fourteen years' service with a family by her mother Benvenuta in January 1256. She would work in return for food and shelter for that period, and would probably end up doing the dirty and dangerous jobs around the house that a slave – a valuable piece of property – would not be risked on.[25] Mosher Stuard nuances the picture by arguing that the persistence of the use of female domestic slaves was the main cause of lingering slavery in the later

Middle Ages in the Mediterranean. Only in male terms was there a decline.[26] This is supported by the documented examples: in 1214, Simone Barlaria of Genoa left his wife a slave named Alda and Alda's daughter Maria.[27]

Marginal groups: prostitutes

With the growth of regulatory materials, another group of women, prostitutes, becomes far more visible, as we have seen above. They often appear in unusual contexts: in 1259, the regulation of Bologna's grain supply included the statement that the city's prostitutes were a drain on the city, consuming its food but contributing nothing, and threatened any prostitute who refused to leave with losing her nose.[28]

But they also appear in another context, studied by Diana Webb. On civic saints' festivals, the people of the city were often obliged to gather and attend, and statutes relating to festivals often tell us more about the urban environment than simply the festivities. For example, on the feast of St Antony in 1257, the city of Padua issued statutes to clear the piazza in front of the church of 'ruffians, gamblers and women of ill fame'. The same city instituted a race or *palio* in honour of the saint in 1275. Several races might be run, involving different groups of citizens, but it is striking that whilst the city of Pavia had a race for *mulieres publice* (that is, the prostitutes), respectable women would not normally have participated. Indeed, the behaviour of the latter was regulated to such an extent that even nursing their children was forbidden before receiving communion at Easter in the city. We meet here yet again a concern for modesty and propriety: the act of baring legs (holding skirts up to run) or breasts was only to be tolerated in women who already lacked honour.

Indeed, visible signs of honour or its lack might feed into other aspects of women's urban lives. In an evocative article, Diane Owen Hughes has pointed up the class, religious and regional differences in the wearing of earrings by women in the later Middle Ages.[29] The evidence she marshals suggests that earrings, once a popular and widespread form of jewellery among wealthy women from antiquity onwards, became in this period the preserve of Jewish and southern women (the south continued to be influenced by Byzantine and eastern traditions), and were used to denote the prostitute and the socially excluded. Hughes notes that mid-thirteenth-century sumptuary legislation does not list earrings: they had already become obsolete among northern, aristocratic, Christian women.

THE THIRTEENTH CENTURY EPILOGUE

Religious life

Prostitutes' foot-races were just one manifestation of the many-faceted expression of religious devotion by the thirteenth century. The movements which had emerged in the twelfth century were, by the thirteenth, increasingly subject to ecclesiastical and secular regulation. For example, whilst the penitential life remained popular, as is evidenced by documented communities across Italy,[30] there is some indication that it was becoming more enclosed in its nature: in 1255 a papal bull of Alexander IV recognised the penitential sisters of St Mary Magdalen in Salerno.[31] When St Clare of Assisi set up a female equivalent of St Francis's group, emphasising poverty, it is noticeable that certain conditions applied to the women which had not been applied to the male friars.[32] Nevertheless, new saints' cults were often attached to the emergence of the mendicant orders. We have already seen that a wider range of classes was represented among the new saints of the twelfth century, a trend which gained pace in the following period. St Zita of Lucca, for example, was a servant whose employers promoted her cult within a generation of her death in 1272. Her life is also important for the light it sheds on the world of the young servant, placed at the age of 12 into service.[33]

As well as regularising movements which fell within its approved scope, the Church went on the offensive against heretics in the thirteenth century, with the institution of the inquisition, staffed mainly by Dominican monks, to actively seek out heresy in 1233. However, it is clear that in many Italian cities this move was viewed with ambivalence or outright hostility: a Dominican convent at Orvieto was sacked in 1239, and the burning of a citizen's wife as a heretic at Parma in 1299 provoked an attack on the community of friars there.[34]

The Waldensians, known in Italy as the Poor Lombards, continued to flourish as an underground movement throughout the century and extended their activities southwards when, in the latter half of the period, they moved as textile workers into the kingdom of Naples and took up residence in Calabria.[35] The Cathars, however, were gradually undermined not by inquisition, but by the emergence of other penitential movements such as the Flagellants whose activities won ecclesiastical approval.

Alongside Church regulation, however, civic communities began to become involved in the control of religious movements within their territories, and there is a strong theme of civic legislation on religious matters in thirteenth-century legal sources. For example, the *conversi*, whose popularity grew immensely in the thirteenth century, came to be viewed with some

205

suspicion on account of being exempt from certain civic fiscal obligations. Cities therefore began to issue legislation with their definition of what the status of *conversus/a* entailed. In Bologna they were described as 'those who live in the *familia* of the church, wearing the attire and following the customs of *conversi* working for the good of the church and sustained in the vestments and by the bread of the church'.[36] By the late thirteenth century, new movements themselves were issuing guidelines for their members. For example, the period saw the start of pious confraternities invoking the Virgin Mary as their leader and protector. In 1262, the Dominican Marian confraternity in Arezzo declared: 'We citizens of Arezzo have voluntarily come together to seek the divine mercy by works of mercy, to relieve the manifold necessities of the decent poor especially, and of widows and orphans, also to assist as suitable opportunity arises religious places, impoverished monasteries, hospitals and prisoners'.[37]

Having acquired patron saints, cities were also keen to ensure that everyone honoured the feast-days and holidays that were kept for them. The statutes of Ravenna required all men and women to attend the festivities of St Vitale and of SS Ursicinus and Barbatianus, and processions were held in all cities to mark their saints, again involving male and female inhabitants in their displays of devotion.

Despite the popularity of the uncloistered and public movements of devotion which had their origins in the twelfth and thirteenth centuries, uneasiness about women's participation in them remained, culminating in the papal bull *Periculoso*, issued by Pope Boniface VIII in 1298. This in effect imposed claustration on all women's religious groups, and its success is debatable. However, such a suppressive measure indicates the direction in which the Church was moving on women's spirituality in the fourteenth century; ironically, that was precisely the period when female sanctity and mysticism had their highpoint.

Epilogue: women in medieval Italian society

This book has attempted to trace some of the most visible lines of women's history in medieval Italy from the sixth to thirteenth centuries. It has become apparent that the lines are sometimes yet to be traced in any great detail, and there continues to be an urgent need for monograph studies of regional pictures based on archival work. There is also a clear need for more work on the early Middle Ages: the book has moved chronologically from heavily source-based chapters where very few studies had been made, to the later chapters based on more recent and intense historiography. The

book set out with few preconceptions about the themes in women's lives that it sought to study, instead allowing the sources to shape the themes. The outcome has been predictable in one sense: in an age where the vast majority of the sources are concerned with landed property, powerful rulers and the Church, these three areas have formed the focus of many of the discussions.

However, we can refine these categories a little to produce themes worth further investigation. For example, women are highly visible as transmitters of property and power throughout our period, even in the latter part of it when that role began to be undermined in northern Italy at least. They did so in a number of ways, either as rulers whose marriages thus took on major significance, or as regents whose task was rather to ensure that their children succeeded them. Female rulers in this study were often judged according to male yardsticks, and 'virile' could be used as an adjective of praise or abuse. Their roles, however, could be direct, such as leading armies and issuing their own documents, or more subtle, as in diplomatic exchanges and gift-giving on their own behalf or that of their husbands.

Marriage and the transfer of property which accompanied it in Germanic or Roman custom, however, could bring its own risks: of divided loyalties between natal and marital kin, of competition with a concubine or, worse still, replacement by another wife as the Church sought to tighten up rules on monogamy and indissolubility. Religious vocation clearly put a strain on marital relations, and women who sought to offer their property along with themselves to the Church might face barriers to doing so. However, it is interesting to see how many of the forms of religious vocation documented in the sixth-century sources emerged again in a renewed form in the eleventh: women setting up nunneries in their own houses were not all that far from vowesses later on.

Monasteries have loomed large in this study, if only because of their capacity to create and preserve records. They acted as the main focus for female religiosity until the eleventh century, but throughout their history there seems to be a tendency for them to be small, get into economic difficulties and be allied with male houses for support. Their recorded existence, therefore, can be patchy, and only major foundations attracted constant donations and thus remain visible to the historian. We need to be careful here of overinterpreting the available evidence: documents often record the exceptional, or when things went wrong, rather than the normal, everyday life of such houses.

A major theme still awaiting a satisfactory study is the educational and cultural life of the female monasteries of medieval Italy, or indeed of any educational opportunities for women in the peninsula at all. A few sources allude to the literacy and educational skills of their subjects, but it is difficult

to assess the level of female education or literacy in a region which is commonly held to be one of the most literate in medieval Europe. Even if we do not have women's direct testimony through their own writing, however, there is still a rich seam of research to be done on women commissioning texts and thus shaping documents to reflect their own views and voices.

As in other parts of Europe, women are seen functioning as social barometers, that is, the level of disasters in narrative sources is often judged by the effect they had on the women of the community. Similarly, women's good or evil actions are judged by authors on a clear scale of whether such an action should even be performed by a woman. Some sense of the scale being used can be gleaned from legislative sources. These, while always aspirational in their content, nevertheless display considerable care over shameful deeds perpetrated by and against women, centring on dress, violence and the body. Again, a comprehensive study of such sources might reveal another important facet of medieval Italian society which is known currently only through studies of late medieval sumptuary legislation.

This opens up the world of women's consumption practices and their participation in the medieval economy, which is still imperfectly understood in many parts of Europe. A strong theme to emerge in this book has been women's participation in a 'grey', unregulated economic world which, owing largely to its informality, only occasionally attracts the notice of the sources which we have. I have suggested that detailed work might be done on women's wills and inventories, but also on their transactions in moveable goods, which might not always have been for their own personal use, and on the most normative of sources, legislation, which has not yet been systematically exploited to reveal instances of women's (illegal) work.

This may seem an exercise in consigning women to the margins again; rather it should be seen as a means of measuring their adherence and resistance to the boundaries that an undoubtedly patriarchal society imposed upon them. In essence, it may restore a women's voice to the pages of Italian history. If we cannot access that voice directly until the thirteenth century, we need to look for spaces which women filled in the absence of men, and gather together instances of when they used and exploited legal barriers to gain their objectives. Only then will the role of women in medieval Italian society be better understood.

Notes

1. Christiane Klapisch-Zuber, 'The medievalist: women and the serial approach', in Michelle Perrot (ed.), *Writing Women's History* (Oxford, 1992), p. 27.

2. M. T. Guerra Medici, *L'Aria di Città: Donne e Diritti nel Comune Medievale* (Naples, 1996).

3. The problems of what was public and what private when legislating exercised contemporary legal compilers and the later commentators of the fourteenth century. For a summary see F. Calasso, '*Ius publicum* and *ius privatum* nel diritto comune classico', *Annali di Storia del Diritto*, 9 (1965), pp. 59–87.

4. G. Duby, *Rural Economy and Country Life in the Medieval West* (1968), pp. 503–504 and p. 407, respectively.

5. I. Chabot, 'Risorse e diritti patrimoniali', in A. Groppi (ed.), *Il Lavoro delle Donne* (Bari and Rome, 1996), pp. 47–70, at p. 49.

6. D. Quaglioni, '"Quilibet in domo sua dicitur rex": in margine ad alcune pagine di Francesco Calasso', *Studi Senesi* 39, 3rd series, 26 (1977), pp. 344–358, at p. 347.

7. Guerra Medici, *L'Aria*, p. 50.

8. Eleanor S. Riemer, 'Women, dowries and capital investment in thirteenth-century Siena', in Marion A. Kaplan (ed.), *The Marriage Bargain: Women and Dowries in European History* (New York, 1985), pp. 59–79, at pp. 73–75.

9. S. Epstein, *Genoa and the Genoese, 958–1528* (Chapel Hill, NC, 1996), pp. 108–109.

10. A. Gaudenzi, ed., *Statuti delle Società del Popolo di Bologna, I: Società delle Armi* (Rome, 1889); A. Gaudenzi (ed.), *Statuti delle Società del Popolo di Bologna. II: Società dell Arti* (Rome, 1896).

11. Paolo Cammarosano, 'Les structures familiales dans les villes de l'Italie communale XIIe–XIVe siècles', in G. Duby and J. Le Goff (eds), *Famille et Parenté dans l'Occident médiévale* (Rome, 1977), pp. 181–194, at p. 193.

12. Epstein, *Genoa and the Genoese*, p. 121.

13. G. Casagrande and M. G. Nico Ottaviani, 'Donne negli statuti comunali: sondaggi in Umbria', in *Donne nella Società Comunale: Ricerche in Umbria* (= *Annali della Facoltà di Lettere e Filosofia dell'Università degli Studi di Perugia. 2. Studi Storico-Antropologici*, vols XXXI–XXXII, new series vols XVII–XVIII (1993/94–1994/95), pp. 15–36.

14. Diane Owen Hughes, 'Urban growth and family structure at Genoa', *Past and Present*, 66 (1975), pp. 3–28, at p. 27.

15. Chabot, 'Risorse', pp. 61–62.

16. C. Regni, 'Le donne nelle fonti fiscali: prime note', in *Donne nella Società Comunale*, pp. 37–47.

17. F. Rosi, 'Donne attraverso le carte dell'abbazia di S. Croce di Sassovivo (1023–1231)', in *Donne nella Società Comunale*, pp. 49–85.

18. J. M. Powell (ed. and trans.), *The Liber Augustalis or Constitutions of Melfi promulgated by the Emperor Frederick II for the Kingdom of Sicily in 1231* (New York, 1971).

19. D. Abulafia, *Frederick II: A Medieval Emperor* (Oxford, 1988), p. 208.

20. Powell (ed. and trans.), *Liber Augustalis*, pp. 57–58. (Law is Book I, title 98 by the standard edition, title 72 by Powell.)

21. J. Drell, 'Marriage, kinship and power: family structure in the principality of Salerno under Norman rule, 1077–1154', PhD thesis (Brown University, 1996).

22. M. R. Lo Forte Scirpo, 'La donna fuori di casa: appunti per una ricerca', *Fardelliana*, 4 (1985), pp. 85–95, at p. 86 (my translation).

23. The situation in the tenth to twelfth centuries is documented in P. Skinner, 'Disputes and disparity: women at court in medieval southern Italy', *Reading Medieval Studies*, 22 (1996), pp. 85–105.

24. F. Angiolini, 'Schiave', in Groppi (ed.), *Il Lavoro delle Donne*, pp. 92–115.

25. Epstein, *Genoa and the Genoese*, p. 102.

26. S. Mosher Stuard, 'Ancillary evidence for the decline of medieval slavery', *Past and Present*, 149 (1995), pp. 3–28.

27. Epstein, *Genoa and the Genoese*, p. 101.

28. D. Owen Hughes, 'Distinguishing signs: ear-rings, Jews and Franciscan rhetoric in the Italian Renaissance city', *Past and Present*, 112 (1986), pp. 3–59, at p. 28.

29. Ibid.

30. For example A. Rigon, 'A community of female penitents in thirteenth-century Padua', in D. Bornstein and R. Rusconi (eds), *Women and Religion in Medieval and Renaissance Italy* (Chicago, 1996), pp. 28–38.

31. G. Vitolo, 'Primi appunti per una storia dei penitenti nel Salernitano', *ASPN*, 17 (1978), pp. 393–405, at p. 395.

32. C. Gennaro, 'Clare, Agnes and their earliest followers: from the Poor Ladies of S. Damiano to the Poor Clares', in Bornstein and Rusconi (eds), *Women and Religion*, pp. 39–55; P. Ranft, 'An overturned victory: Clare of Assisi and the thirteenth (*sic*) church', *Journal of Medieval History*, 17 (1991), pp. 123–134.

33. A. Guerra, *Istoria della Vita di Santa Zita Vergine Lucchese* (Lucca, 1895).

34. M. Lambert, *Medieval Heresy* (2nd edn, Oxford, 1992), p. 143; J. Larner, *Italy in the Age of Dante and Petrarch, 1216–1380* (1980), p. 231.

35. Lambert, *Medieval Heresy*, p. 164.

36. D. Osheim, 'Conversion, *conversi* and the Christian life in late medieval Tuscany', *Speculum*, 58 (1983), pp. 368–90, at p. 374.

37. D. Webb, *Patrons and Defenders: The Saints in the Italian City-states* (1996), p. 260.

BIBLIOGRAPHY

Primary sources

Primary sources in print

The primary sources used in this book are all published. The main source of Italian material is the enormous Fonti per la Storia d'Italia (FSI) series, begun in the late nineteenth century, and continuing the work of the great Italian archivist Muratori, whose *Rerum Italicarum Scriptores* (*RIS*), edited in the eighteenth century, remains the only edition of many sources to this day. Some Italian material is also edited in the *Monumenta Germaniae Historica* (*MGH*) series, reflecting the central role that medieval Italy often played in the politics of German emperors.

Amari, Michele (ed.), *Biblioteca Arabo-Sicula* I (Rome and Turin, 1880).

Belgrano, L. T. (ed.), *Annali Genovesi di Caffaro e de' suoi continuatori*, I (Rome, 1890).

Bethmann, L. and Waitz, G. (eds), *Pauli Historia Langobardorum*, in *MGH SRL*, pp. 12–187.

Brühl, C.-R. and Violante, C. (eds), *Honorantie Civitatis Papie* (Cologne and Vienna, 1983).

Capasso, Bartolomeo (ed.), *Monumenta ad Neapolitani Ducatus Historiam Pertinentia*, I (Naples, 1881).

Caraballese, F. (ed.), *Codice Diplomatico Barese VII: Le Carte di Molfetta* (Bari, 1912).

Cassese, L. (ed.), *Pergamene del Monastero Benedettino di S. Giorgio (1038–1698)* (Salerno, 1950).

Chiaudano, M. and Moresco, M. (eds), *Il Cartolare di Giovanni Scriba*, 2 vols (Turin, 1935).

Chronica Sancti Benedicti Casinensis, in *MGH SRL*, pp. 467–489.

Chronicon Vulturnense del Monaco Giovanni, 3 vols (FSI 58–60, Rome, 1925).

Cioffari, G. and Lupoli Tateo, R. (eds), *Antiche Cronache di Terra di Bari* (Bari, 1991), provides an Italian translation of the three main Bari chronicles, together with reprints of the original editions: the Bari Anonymous in *RIS* V, ed. L. A. Muratori (Milan, 1724) and the Annals and Lupus in *MGH* V, ed. G. H. Pertz (Hanover, 1846). The latter are useful, as the translations can sometimes be rather wayward.

Codex Diplomaticus Cajetanus, I–II (Montecassino, 1887, 1891).
Codex Diplomaticus Cavensis, I–VIII, ed. M. Morcaldi *et al.* (Milan, Naples and Pisa, 1873–1893); IX–X, ed. S. Leone and G. Vitolo (Badia di Cava, 1984, 1990).
Coniglio, G. (ed.), *Codice Diplomatico Pugliese, XX: Le Pergamene di Conversano* (Bari, 1975).
Continuatio Casinensis, Continuatio Romana, Continuatio Tertia and *Continuatio Lombarda*, in *MGH SRL*, pp. 198–219.

De Bartholomeis, V. (ed.), *Storia de' Normanni di Amato di Montecassino* (Rome, 1935).
De Nava, L. (ed.), *Alexandrini Telesini Abbatis Ystoria Rogerii Regis Siciliae, Calabriae atque Apuliae* (FSI 112, Rome, 1991).
Del Re, G. (ed.), *Falconis Beneventi Chronicon*, in *Cronisti e scrittori sincroni napoletani*, I (Naples, 1845), pp. 161–252.

Facchiano, Anna Maria, *Monasteri Femminili e Nobiltà a Napoli tra Medioevo ed Età Moderna: Il Necrologio di S. Patrizia (secc. XII–XVI)* (Altavilla Silentina, 1992).
Filangieri di Candida, R. (ed.), *Codice Diplomatico Amalfitano*, I (Naples, 1917), II (Trani, 1951).

Galante, Maria (ed.), *Nuove Pergamene del Monastero Femminile di S. Giorgio di Salerno*, I (Altavilla Silentina, 1984).
Gallo, A., 'Il più antico documento originale dell'Archivio di Montecassino', *BISIAM*, 45 (1929), pp. 159–164.
Garufi, C. A. (ed.), *I Documenti Inediti dell'Epoca Normanna in Sicilia* (Palermo, 1899).
Garufi, C. A. (ed.), *Catalogo Illustrato del Tabulario di S. Maria Nuova in Monreale* (Palermo, 1902).
Garufi, C. A. (ed.), *Necrologio del Liber Confratrum di S. Matteo di Salerno* (FSI 66, Rome, 1922).
Gaudenzi, A. (ed.), *Statuti delle Società del Popolo di Bologna. I: Società delle Armi* (Rome, 1889).
Gaudenzi, A. (ed.), *Statuti delle Società del Popolo di Bologna. II: Società dell'Arti* (Rome, 1896).
Goez, Elke and Goez, Werner (eds), *Laienfürsten- und Dynastenurkunden der Kaiserzeit II: Die Urkunden und Briefe der Markgräfin Mathilde von Tuszien* (*MGH*, Hanover, 1998).
Guerra, A., *Istoria della Vita di Santa Zita Vergine Lucchese* (Lucca, 1895).

Hoffmann, H. (ed.), *Die Chronik von Montecassino (Chronica Monasterii Casinensis)* (*MGH SS* 34, Hanover, 1980).
Holder-Eggar, O. (ed.), *Agnelli qui et Andreas Liber Pontificalis Ecclesiae Ravennatis*, in *MGH SRL*, pp. 265–391.
Houben, Hubert, *Il 'Libro del Capitolo' del Monastero della SS. Trinità di Venosa (Cod. Casin. 334): Una Testimonianza del Mezzogiorno Normanno* (Naples, 1984).

Leccisotti, T., 'Le pergamene latine di Taranto nell'archivio di Montecassino', *Archivio Storico Pugliese*, 14 (1961), pp. 3–49.

Mathieu, M. (ed.), *Guillaume de Pouille, La Geste de Robert Guiscard* (Palermo, 1961).
Mazzoleni, Jole (ed.), *Le Pergamene del Monastero di S. Gregorio Armeno di Napoli*, I (Naples, 1973).
Monticolo, G. (ed.), *Cronache Veneziane Antichissime*, I (FSI, Rome, 1890).
Nitti, F. (ed.), *Codice Diplomatico Barese V: Le Pergamene di S. Nicola di Bari, Periodo Normanno* (Bari, 1902).
Norberg, D. (ed.), *S. Gregorii Magni Registrum Epistularum*, 2 vols (Corpus Christianorum Series Latina CXL and CXLa, Turnhoult, 1982).
Pontieri, E. (ed.), *De Rebus Gestis Rogerii Calabriae et Siciliae Comitis auctore Gaufredo Malaterra* (Bologna, 1927/1928).
Schiaparelli, L. (ed.), *Codice Diplomatico Longobardo*, I–II (FSI 62–63, Rome, 1929, 1933).
Simeoni, L. (ed.), *Vita Mathildis Celeberrimae Principis Italiae* (Bologna, 1940).
Tabacco, Giovanni (ed.), *Pietri Damiani Vita Beati Romualdi* (FSI 94, Rome, 1957).
Troya, C. (ed.), *Codice Diplomatico Longobardo dal 568 al 774*, appendix to his *Storia d'Italia nel Medio Evo*, vol. IV (4 parts, Naples, 1852–1854).

Vita Sancti Barbati, in *MGH SRL*, pp. 557–563.

Waitz, G. (ed.), *Erchemperti historia Langobardorum Beneventanorum*, in *MGH SRL*, pp. 231–264.
Waitz, G. (ed.), *Gesta Episcoporum Neapolitanorum*, in *MGH SRL*, pp. 398–436.
Westerbergh, U. (ed.), *Chronicon Salernitanum* (Stockholm, 1956).

Primary sources in English translation

Amalasuntha, four letters: Thièbaux, M., *The Writings of Medieval Women: An Anthology* (2nd edn, New York and London, 1994), pp. 71–84.
Amt, Emilie (ed.), *Women's Lives in Medieval Europe: A Sourcebook* (1993).

Cassiodorus: Barnish, S. J. B. (trans.), *Cassiodorus: Variae* (Liverpool, 1992).

Emerton, Ephraim (ed.), *The Correspondence of Pope Gregory VII* (New York, 1932, reprinted 1990).

Goitein, S. D., *Letters of Medieval Jewish Traders* (Princeton, NJ, 1973).

Larrington, Carolyne (ed.), *Women and Writing in Medieval Europe* (1995).
Liber Pontificalis: Davis, Raymond. (trans.), *The Book of Pontiffs* (Liverpool, 1989); *The Lives of the Eighth-Century Popes* (Liverpool, 1992); and *The Lives of the Ninth-Century Popes* (Liverpool, 1995).
Liutprand: Wright, F. A. (trans.), *The Works of Liudprand of Cremona* (1930), reprinted as J. J. Norwich (ed.), *Liudprand of Cremona: The Embassy to Constantinople and Other Writings* (1993).
Lopez, R. S. and Raymond, I. W. (eds), *Medieval Trade in the Mediterranean World* (New York, 1955, reprinted 1990).

Lombard laws: *The Lombard Laws*, trans. K. F. Drew (Philadelphia, 1973).
Loud, Graham A. and Wiedemann, Thomas (trans.), *The History of the Tyrants of Sicily by 'Hugo Falcandus'*, *1154–69* (Manchester, 1998).

Moore, R. I. *The Birth of Popular Heresy* (1975, reprinted Toronto, 1995).

Paul the Deacon: Foulke, William D. (trans.), *History of the Langobards by Paul the Deacon* (Philadelphia, 1907).
Powell, J. M. (ed. and trans.), *The Liber Augustalis or Constitutions of Melfi promulgated by the Emperor Frederick II for the Kingdom of Sicily in 1231* (New York, 1971).
Pratt Lattin, Harriet (trans.), *The Letters of Gerbert with his Papal Privileges as Sylvester II* (New York, 1961).

Rather: Reid, Peter L. D. (trans.), *The Complete Works of Rather of Verona* (Binghamton, NY, 1991).

Thorpe, L. (trans.), *Gregory of Tours: The History of the Franks* (Harmondsworth, 1974).

Wakefield, W. L. and Evans, A. P. (trans.), *Heresies of the High Middle Ages* (New York, 1969, reprinted 1991).
Watson, Alan (ed. and trans.), *The Digest of Justinian*, 2 vols (Philadelphia, 1998).
Williamson, G. A. (trans.), *Procopius: The Secret History* (Harmondsworth, 1966).
Wright, F. A. (trans.), *Select Letters of St Jerome* (Cambridge, Mass., 1963).

Commentaries and articles on primary sources

Amelli, A. M., *Miniature sacre e profane dell'anno 1023 illustranti l'encyclopaedia medioevo di Rabano Mauro* (Montecassino, 1896).

Brown, T. S., '*Romanitas* and *campanilismo*: Agnellus of Ravenna's view of the past', in C. Holdsworth and T. P. Wiseman (eds), *The Inheritance of Historiography, 350–900* (Exeter, 1986), pp. 107–114.
Buc, P., 'Italian hussies and German matrons: Liutprand of Cremona on dynastic legitimacy', *Frühmittelalterliche Studien* 29 (1995), pp. 207–225.

Cavallo, G., *L'Universo Medievale: Il Manoscritto Cassinese del "De rerum naturis" di Rabano Mauro* (Ivrea, 1996).
Colonna, Enza, 'Figure femminili in Liutprando di Cremona', *Quaderni Medievali*, 14 (1982), pp. 29–60.

Goitein, S. D., 'Sicily and southern Italy in the Cairo Genizah documents', *Archivio Storico per la Sicilia Orientale*, 67 (1971), pp. 9–33.

Leclercq, J., 'S. Pierre Damien et les femmes', *Studia Monastica*, 15 (1973), pp. 43–55.
Loud, G. A., 'The genesis and context of the chronicle of Falco of Benevento', *Anglo-Norman Studies*, 15 (1993), pp. 177–198.

Martínez Pizarro, Joaquín, *Writing Ravenna: The Liber Pontificalis of Andreas Agnellus* (Ann Arbor, 1995).

Sutherland, Jon, *Liudprand of Cremona, Bishop, Diplomat, Historian: Studies of the Man and his Age* (Spoleto, 1988).

Wickham, C. J., 'The sense of the past in Italian communal narratives', in P. Magdalino (ed.), *The Perception of the Past in Twelfth-Century Europe* (1992), pp. 173–189.

Secondary reading

One of the main purposes of this book was to fill a gap in the scholarship on women in medieval Europe. Consequently, the number of works in English on Italian women remains very low. In comparison with the later medieval and Renaissance eras, when rich civic documentation permits the detailed investigation of family and community life, coverage of the earlier Middle Ages remains patchy. Italian work on medieval women has been somewhat limited up until relatively recently, owing largely to its failure to find a place in university curricula. This is now beginning to change, and recent years have seen several excellent collections of essays published in addition to some important monographs.

Women's history: historiographical and theoretical surveys

Bennett, Judith, 'History that stands still: women's work in the European past', *Feminist Studies*, 14 (1988), pp. 269–283.

Bennett, Judith, 'Feminism and history', *Gender and History*, 1 (1989), pp. 251–272.

Bennett, Judith, 'Women's history: a study in continuity and change', *Women's History Review*, 2 (1993), pp. 173–184.

Cicioni, M. and Prunster, N. (eds), *Visions and Revisions: Women in Italian Culture* (Oxford, 1993).

Duby, Georges and Perrot, Michelle (eds), *A History of Women in the West*, 5 vols (Cambridge, Mass., 1992–1996).

Helly, Dorothy O. and Reverby, Susan M. (eds), *Gendered Domains: Rethinking Public and Private in Women's History* (Ithaca, NY, 1992).

Herlihy, David, 'Women and the sources of medieval history: the towns of northern Italy', in J. T. Rosenthal (ed.), *Medieval Women and the Sources of Medieval History* (Athens, Ga., 1990), pp. 133–154.

Herlihy, David, 'Did women have a renaissance? A reassessment', *Medievalia et Humanistica* (1985), pp. 1–22; reprinted in David Herlihy, *Women, Family and Society in Medieval Europe* (Oxford, 1995), pp. 33–56.

Hill, Bridget 'Women's history: a study in change, continuity or standing still?', *Women's History Review*, 2 (1993), pp. 5-22.

Kelly, Joan, *Women, History and Theory* (Chicago, 1984).

Lerner, Gerda, *The Creation of Patriarchy* (Oxford, 1986).
Lerner, Gerda, *The Creation of Feminist Consciousness* (Oxford, 1993).

Padrone Nada, A. 'La donna', in G. Musca (ed.), *Condizione Umana e Ruoli Sociali nel Mezzogiorno Normanno-Svevo* (Bari, 1981), pp. 103-130.

Nelson, Janet, 'Gender and genre in women historians of the early Middle Ages', in *L'Historiographie Médiévale en Europe (CNRS, Paris, 29 March-1 April 1989)* (Paris, 1991), pp. 149-163.

Owen Hughes, Diane, 'Invisible Madonnas? The Italian historiographical tradition and the women of medieval Italy', in Susan Mosher Stuard (ed.), *Women in Medieval History and Historiography* (Philadelphia, 1987), pp. 25-57.

Pelizzari, M. R. (ed.), *Le Donne e la Storia: Problemi di Metodo e Confronti Storiografici* (Naples, 1995), especially Pelizzari's introduction, de Clementi's survey of the development of women's studies in Italy, and Rao's essay on medieval women.
Pereira, M. (ed.), *Né Eva né Maria: Condizione Femminile e Immagini della Donna nel Medioevo* (Bologna, 1981) reprints in Italian translation essays by a number of prominent scholars including Brenda Bolton and David Herlihy: most useful for Italy and not accessible elsewhere in English are Pereira's introduction, Bellomo's essay on women and law, and McLoughlin on heresy. The volume draws heavily on essays from *Cahiers de Civilisation Médiévale* (1977) on women's history.

Rosenthal, J. T. (ed.), *Medieval Women and the Sources of Medieval History* (Athens, Ga., 1990).

Scott, Joan (ed.), *Feminism and History* (Oxford, 1996).
Shahar, Shulamith, *The Fourth Estate: A History of Women in the Middle Ages* (1983).

Valerio, Anna Maria, *La Questione Femminile nei Secoli X-XII* (Naples, 1983).
Van Houts, Elisabeth, *Memory and Gender in Medieval Europe, 900-1200* (Basingstoke, 1999).
Van Houts, Elisabeth (ed.), *Medieval Memories: Men, Women and the Past in Europe, 700-1300* (2000).
Vetere, B. and Renzi, P. (eds), *Profili di Donna* (Galatina, 1986), especially Vetere's introduction to the historiographical problems.

General works on Italian and regional history

Abulafia, D., *The Two Italies: Economic Relations between the Norman Kingdom of Sicily and the Northern Communes* (Cambridge, 1977).

BIBLIOGRAPHY

Brown, T. S., *Gentlemen and Officers: Imperial Administration and Aristocratic Power in Byzantine Italy, AD554–800* (Rome, 1984).

Christie, Neil, *The Lombards* (Oxford, 1995).

Clementi, D., 'Some unnoticed aspects of the emperor Henry VI's conquest of the Norman kingdom of Sicily', *Bulletin of the John Rylands Library*, 36 (1953/54), pp. 328–359.

Concina, Ennio, *A History of Venetian Architecture*, trans. Judith Landry (Cambridge, 1998).

Delogu, Paolo, *Mito di una Città Meridionale* (Naples, 1977).

Drell, Joanna, 'Marriage, kinship and power: family structure in the principality of Salerno under Norman rule, 1077–1154', PhD thesis (Brown University, 1996).

Duchesne, L., *The Beginnings of the Temporal Sovereignty of the Popes, AD754–1073* (London, 1908).

Epstein, S., *Genoa and the Genoese, 958–1538* (Chapel Hill, NC, 1996).

Ferorelli, N., *Gli Ebrei nell'Italia meridionale dall'Età romana al Secolo XVIII* (Bologna, 1966).

Gelichi, Sauro (ed.), *I [Primo] Congresso Nazionale di Archeologia Medievale* (Florence, 1997).

Golinelli, Paolo (ed.), *I Poteri dei Canossa da Reggio Emilia all'Europa* (Bologna, 1994).

Harrison, D., 'The invisible wall of St John: on mental centrality in early medieval Italy', *Scandia*, 58 (1992), pp. 177–211.

Harrison, D., *The Early State and the Towns: Forms of Integration in Lombard Italy, 568–774* (Lund, 1993).

Howe, John, *Church Reform and Social Change in Eleventh-Century Italy: Dominic of Sora and his Patrons* (Philadelphia, 1997).

Iorio, Raffaele, 'Violenze e paura nella Puglia normanna', *Quaderni Medievali*, 17 (1984), pp. 88–113.

Johns, Jeremy, *Early Medieval Sicily* (1994).

Larner, John, *Italy in the Age of Dante and Petrarch, 1216–1380* (1980).

Llewellyn, Peter, *Rome in the Dark Ages* (1971, new edn 1993).

Loud, G. A., *Conquerors and Churchmen in Norman Italy* (Aldershot, 1999).

Mack Smith, Denis, *A History of Sicily. 2: Medieval Sicily, 800–1713* (1968).

Musca, G., *L'Emirato di Bari, 847–871* (2nd edn, Bari, 1967).

Naso, Irma and Comba, Rinaldo (eds), *Demografia e Società nell'Italia Medievale* (Cuneo, 1994).

Skinner, P., *Family Power in Southern Italy: The Duchy of Gaeta and its Neighbours, 850–1139* (Cambridge, 1995).

Skinner, P., 'Room for tension: urban life in Apulia in the eleventh and twelfth centuries', *PBSR*, 66 (1998), pp. 159–175.

Taviani-Carozzi, Huguette, *La Principauté Lombarde de Salerne (IXe–XIe Siècle*, 2 vols (Rome, 1991).

Violante, Cinzio (ed.), *Sant'Anselmo Vescovo di Lucca (1073–1086) nel Quadro delle Trasformazioni Sociali e della Riforma Ecclesiastica* (Rome, 1992).

Ward-Perkins, Bryan, *From Classical Antiquity to the Middle Ages: Urban Public Building in Northern and Central Italy, AD300–850* (Oxford, 1984).

Wickham, C. J., *Early Medieval Italy* (1980).

Wickham, C. J., 'Ecclesiastical dispute and lay community: Figline Valdarno in the twelfth century', *Mélanges de l'École Française de Rome, Moyen Age*, 108 (1996), pp. 7–93.

Wickham, C. J., 'Gossip and resistance among the medieval peasantry', *Past and Present*, 160 (1998), pp. 3–24.

Family and marriage

Balzaretti, Ross, 'Men and sex in tenth-century Italy', in D. M. Hadley (ed.), *Masculinity in Medieval Europe* (1998), pp. 143–159.

Bolton, Brenda, '"Received in his name": Rome's busy baby box', in D. Wood (ed.), *The Church and Childhood* (Oxford, 1994), pp. 153–167.

Brundage, James, *Law, Sex and Christian Society in Medieval Europe* (Chicago, 1987).

Cavallo, Sandra and Warner, Lyndan (eds), *Widowhood in Medieval and Early Modern Europe* (1999).

Duby, G. and Le Goff, J. (eds), *Famille et Parenté dans l'Occident Médiévale* (Rome, 1977).

Herlihy, David, 'Family solidarity in medieval Italian history', in David Herlihy, Robert S. Lopez and Vsevolod Slessarev (eds), *Economy, Society and Government: Essays in Memory of Robert L. Reynolds* (Kent, Ohio, 1969), pp. 173–184.

Lazzari, T., 'I "de Ermengarda": una famiglia nobiliare a Bologna (secc. IX–XII)', *Studi Medievali*, 32(2) (1991), pp. 597–658.

Marongiu, A., *Matrimonio e Famiglia nell'Italia Meridionale (secc. VIII–XIII)* (Bari, 1976).

Owen Hughes, Diane, 'Urban growth and family structure in medieval Genoa', *Past and Present*, 66 (1975), pp. 3–28.

Rosenwein, B. H., 'The family politics of Berengar I, king of Italy (888–924)', *Speculum*, 71 (1996), pp. 247–289.

Skinner, P., 'Urban communities in Naples, 900–1050', *PBSR*, 62 (1994), pp. 279–99.

Skinner, P., '"The light of my eyes": medieval motherhood in the Mediterranean', *Women's History Review*, 6 (1997), pp. 391–410.

Skinner, P., 'The widow's options in medieval southern Italy', in Sandra Cavallo and Lyndan Warner (eds), *Widowhood in Medieval and Early Modern Europe* (1999), pp. 57–65.

Work and property

Angelos, M., 'Women in Genoese *commenda* contracts, 1155–1216', *Journal of Medieval History*, 20 (1994), pp. 299–312.

Benton, J. F., 'Trotula, women's problems and the professionalization of medicine in the Middle Ages', *Bulletin of the History of Medicine*, 59 (1985), pp. 30–53.

Cannataro, Maria, 'Un insolito documento privato barese', *Annali della Facoltà di Lettere e Filosofia della Università degli Studi di Bari*, 19/20 (1976/77), pp. 201–223.

Casagrande, G., 'Donne in Umbria nei secoli XI e XII: le carte di Sassovivo, Montelabate, Gubbio', *Annali della Facoltà di Lettere e Filosofia, Università degli Studi di Perugia*, 34–35 (1996/97–1997/98), pp. 9–26.

Epstein, S., *Wills and Wealth in Medieval Genoa, 1150–1250* (Cambridge, Mass., 1984).

Green, M., 'Estraendo Trota dal *Trotula*: ricerche su testi medievali di medicina Salernitana', *Rassegna Storica Salernitana*, n.s. 12 (1995), pp. 31–53.

Groppi, Angela (ed.), *Il Lavoro delle Donne* (Rome and Bari, 1996).

Herlihy, David, 'Land, family and women in continental Europe, 701–1200', *Traditio*, 18 (1962), pp. 89–120, reprinted in Susan Mosher Stuard (ed.), *Women in Medieval Society* (Philadelphia, 1976), pp. 13–45.

Jehel, G., 'Le role des femmes et du milieu familial à Gênes dans les activités commerciales', *Revue d'Histoire Économique et Sociale*, 53 (1975), pp. 193–215.

Lo Forte Scirpo, M. R., 'La donna fuori di casa: appunti per una ricerca', *Fardelliana*, 4 (1985), pp. 85–95.

Mosher Stuard, S., 'Ancillary evidence for the decline of medieval slavery', *Past and Present*, 149 (1995), pp. 3–28.

Muzzarelli, Maria G., Galetti, Paola and Andreolli, Bruno (eds), *Donne e Lavoro nell'Italia Medievale* (Turin, 1991). Most useful here are Muzzarelli's historiographical essay (building on an earlier version, 'Tematiche della storiografia italiana recente dedicata alla donna medievale', *Studi Medievali*, 30(2) (1989), pp. 883–908); essays by Andreolli and Galetti on rural women; and Paolini's study of the work done by the Umiliate. The remaining essays are mostly late medieval in focus.

Owen Hughes, Diane, 'From brideprice to dowry in Mediterranean Europe', *Journal of Family History*, 3 (1978), pp. 263–296.

Riemer, Eleanor S., 'Women, dowries and capital investment in thirteenth-century Siena', in Marion A. Kaplan (ed.), *The Marriage Bargain: Women and Dowries in European History* (New York, 1985), pp. 59–79.

Rosi, F., 'Donne attraverso le carte dell'abbazia di S. Croce di Sassovivo (1023–1231)', in *Donne nella Società Comunale: Ricerche in Umbria* (= *Annali della Facoltà di Lettere e Filosofia dell'Università degli Studi di Perugia. 2. Studi Storico-Antropologici*, vols XXXI–XXXII, new series vols XVII–XVIII, 1993/94–1994/95), pp. 49–85.

Skinner, P., 'Women, wills and wealth in medieval southern Italy', *Early Medieval Europe*, 2 (1993), pp. 133–152.

Piety and the Church

Andrews, Frances, *The Early Humiliati* (Cambridge, 2000).

Bishop, Jane, 'Bishops as marital advisors in the ninth century', in Julius Kirshner and Suzanne F. Wemple (eds), *Women of the Medieval World* (Oxford, 1985), pp. 53–84.

Bornstein, D. and Rusconi, R. (eds), *Women and Religion in Medieval and Renaissance Italy* (Chicago, 1996).

Capitani, O. (ed.), *Medioevo Ereticale* (Bologna, 1977).

Cloke, Gillian, *'This Female Man of God': Women and Spiritual Power in the Patristic Age, AD350–450* (1995).

Da Costa-Louillet, G., 'Saints de Sicile et de l'Italie méridionale aux VIII, IX et X siècles', *Byzantion*, 29/30 (1959/60), pp. 89–173.

Fischer Drew, Katherine, 'The Italian monasteries of Nonatola, San Salvatore and Santa Maria Teodota in the eighth and ninth centuries', *Manuscripta*, 9 (1965), pp. 131–154.

Hamilton, Bernard, 'The house of Theophylact and the promotion of the religious life among women in tenth-century Rome', *Studia Monastica*, 12 (1970), pp. 195–217.

Loud, G. A., 'Nunneries, nobles and women in the Norman principality of Capua', *Annali Canossani*, 1 (1981), pp. 45–62, reprinted with corrections in idem, *Conquerors and Churchmen in Norman Italy* (Aldershot, 1999).

Lynch, Joseph, *The Medieval Church: A Brief History* (1992).

Oldoni, M., 'Agiografia longobarda tra secoli IX e X: la leggenda di Trofimena', *Studi Medievali*, 3rd series, 12(2) (1971), pp. 583–636.

Osheim, Duane J., 'Conversion, *conversi* and the Christian life in late medieval Tuscany', *Speculum*, 58 (1983), pp. 368–390.

Penco, G., 'Antico e nuovo nel mondo monastico femminile dei secoli XI e XII', *Benedictina*, 40 (1993), pp. 281–295.

Ranft, P., 'An overturned victory: Clare of Assisi and the thirteenth (*sic*) church', *Journal of Medieval History*, 17 (1991), pp. 123–134.

Rossi, Mary Ann, 'Priesthood, precedent and prejudice: on recovering the women priests of early Christianity', *Journal of Feminist Studies in Religion*, 7 (1991), pp. 73–94.

Scaraffa, Lucetta and Zarri, Gabriella (eds), *Donne e Fede* (Rome and Bari, 1994).

Shaw, Brent, 'Women and the early church', *History Today*, 44(2) (1994), pp. 21–28.

Veronese, Alessandra, 'Monasteri femminili in Italia settentrionale nell'alto medioevo: confronto con i monasteri maschili attraverso un tentativo di analisi "statistica"', *Benedictina*, 34 (1987), pp. 355–416.

Vitolo, G., 'Primi appunti per una storia dei penitenti nel salernitano', *Archivio Storico per le Province Napoletane*, 17 (1978), pp. 393–405.

Webb, Diana, *Patrons and Defenders: The Saints in the Italian City-states* (1996).

Wemple, Suzanne F., 'S. Salvatore/S. Giulia: a case study in the endowment and patronage of a major female monastery in northern Italy', in Julius Kirshner and Suzanne Wemple (eds), *Women of the Medieval World* (Oxford, 1985), pp. 85–102.

Wemple, Suzanne F., 'Female monasticism in Italy and its comparison with France and Germany from the ninth through the eleventh century', in W. Affeldt (ed.), *Frauen in Spätantike und Frühmittelalter* (Sigmaringen, 1990), pp. 291–310.

Zema, D. B., 'The houses of Tuscany and of Pierleone in the crisis of Rome in the 11th century', *Traditio*, 2 (1944), pp. 155–175.

Female rulers

Balzaretti, Ross, 'The power of the feminine in tenth-century Italian society', paper delivered at the conference 'Forms and Images of Power in Medieval Italy', London, 3 October 1992.

Balzaretti, Ross, 'Theodolinda "most glorious queen": gender and power in Lombard Italy', *The Medieval History Journal* (forthcoming).

Davids, A. (ed.), *The Empress Theophanu: Byzantium and the West at the Turn of the First Millennium* (Cambridge, 1995).

Fumagalli, V., *Matilde di Canossa: Potenza e Solitudine di una Donna del Medioevo* (Bologna, 1996).

Goez, E., *Beatrix von Canossa und Tusczien: Eine Untersuchung zur Geschichte des 11 Jahrhunderts* (Sigmaringen, 1995).

Levi della Vida, G., 'La corrispondenza di Berta di Toscana col califfo Muktafi', *Rivista Storica Italiana*, 66 (1954), pp. 21–38.

Odegaard, Charles E., 'The empress Engelberge', *Speculum*, 26 (1951), pp. 77–103.

Reuter, T., 'Unruhestiftung, Fehde, Rebellion, Widerstand: Gewalt und Frieden in der Politik der Salierzeit', in *Die Salier und das Reich*, ed. S. Weinfurter, 3 vols (Sigmaringen, 1991), vol. 3.

Simeoni, L., 'Il contributo della contessa Matilde al papato nella lotta per le investiture', *Studi Gregoriani*, 1 (1947), pp. 353–372.

Skinner, P., '"Halt! Be men": Sikelgaita of Salerno, gender and the Norman conquest of southern Italy', *Gender and History*, 12 (2000), pp. 622–641.

Women and the law

Balzaretti, R., '"These are things that men do, not women": the social regulation of female violence in Langobard Italy', in Guy Halsall (ed.), *Violence and Society in the Early Medieval West* (Woodbridge, 1998), pp. 175–192.

Bellacosa, Diego, *Il 'Mundio' sulle Donne in Terra di Bari dall'anno 900 al 1500* (Naples, 1906).

Bellomo, Manlio, *Profili della Famiglia Italiana nell'Età dei Communi* (Catania, 1966).

Bougard, François, *La Justice dans le Royaume d'Italie* (Rome, 1995).

Calasso, F., '*Ius publicum* e *ius privatum* nel diritto comune classico', *Annali di Storia del Diritto*, 9 (1965), pp. 57–87 (first published in 1943).

Casagrande, G. and Nico Ottaviani, M. G., 'Donne negli statuti comunali: sondaggi in Umbria', in *Donne nella Società Comunale: Ricerche in Umbria* (= *Annali della Facoltà di Lettere e Filosofia dell'Università degli Studi di Perugia. 2. Studi Storico-Antropologici*, vols XXXI–XXXII, new series vols XVII–XVIII (1993/94–1994/95), pp. 15–36.

Delogu, P., '*Consors regni*: un problema carolingio', *Bullettino dell'Istituto Storico Italiano*, 76 (1964), pp. 47–99.

Giardina, Camillo, '*Advocatus* e *mundoaldus* nel Lazio e nell'Italia meridionale', *Rivista di Storia del Diritto Italiano*, 9 (1936), pp. 291–310.

Guerra Medici, Maria Teresa, *I Diritti delle Donne* (Naples, 1986).

Guerra Medici, Maria Teresa, *L'Aria di Città: Donne e Diritti nel Comune Medievale* (Naples, 1996).

Leicht, P. S., *Storia del Diritto Italiano*, 5 vols (Milan, 1948–1960).

Mor, C. G., '*Consors regni*: la regina nel diritto pubblico italiano dei secoli IX–X', *Archivio Giuridico*, 35 (1948), pp. 7–32.

Quaglioni, D., '"Quilibet in domo sua dicitur rex": in margine ad alcune pagine di Francesco Calasso', *Studi Senesi* 39, 3rd series 26 (1977), pp. 344–358.

Skinner, P., 'Disputes and disparity: women in court in medieval southern Italy', *Reading Medieval Studies*, 22 (1996), pp. 85–104.

Secondary works on later periods

Bocchi, Francesca, 'Regulation of the urban environment by the Italian communes from the twelfth to the fourteenth century', *Bulletin of the John Rylands Library*, 72 (1990), pp. 63–79.

Brown, Judith C. and Davis, Robert C. (eds), *Gender and Society in Renaissance Italy* (1998).

Klapisch-Zuber, Christiane, *Women, Family and Ritual in Renaissance Italy*, trans. Lydia G. Cochrane (Chicago, 1985).

Owen Hughes, D., 'Distinguishing signs: ear-rings, Jews and Franciscan rhetoric in the Italian Renaissance city', *Past and Present*, 112 (1986), pp. 3–59.

Comparative works on non-Italian regions

Bitel, Lisa, *Land of Women: Tales of Sex and Gender from Early Ireland* (Ithaca, NY, 1996).

Davies, Wendy, 'Celtic women in the early Middle Ages', in Averil Cameron and Amélie Kuhrt (eds), *Images of Women in Antiquity* (1983), pp. 145–166.

Fell, C., *Women in Anglo-Saxon England and the Impact of 1066* (1984).

Goldberg, P. J. P. (ed. and trans.), *Women in England, c.1275–1525* (Manchester, 1995).

Harrington, Christina, 'Women of the Church in early medieval Ireland, *c*.450–1150', PhD thesis (University of London, 1997).

Jesch, Judith, *Women in the Viking Age* (Woodbridge, 1991).

Jewell, Helen, *Women in Medieval England* (Manchester, 1996).

Klinck, Anne L., 'Anglo-Saxon women and the law', *Journal of Medieval History* 8 (1982), pp. 107–121.

Leyser, Karl, 'Maternal kin in early medieval Germany', *Past and Present*, 49 (1970), pp. 126–134, reprinted in Karl Leyser, *Communications and Power in Medieval Europe: The Carolingian and Ottonian Centuries*, ed. Timothy Reuter (1994), pp. 181–188.

Leyser, Karl, *Rule and Conflict in an Early Medieval Society* (Oxford, 1979), pp. 48–73.

Macnamara, Jo Ann, Halborg, John E. and Whatley, E. Gordon (eds), *Sainted Women of the Dark Ages* (Durham, NC, 1992).

Meyer, Marc A., 'Land charters and the legal position of Anglo-Saxon women', in Barbara Kanner (ed.), *The Women of England from Anglo-Saxon Times to the Present* (Hamden, Conn., 1979), pp. 37–82.

Nelson, Janet L., 'Queens as Jezebels: Brunhild and Bathild in Merovingian history', in Derek Baker (ed.), *Medieval Women* (Oxford, 1978), pp. 31–77.

Nelson, Janet, 'Women at the court of Charlemagne: a case of monstrous regiment?', in John Carmi Parsons (ed.), *Medieval Queenship* (New York, 1993), pp. 43–61, reprinted in Janet Nelson, *The Frankish World, 750–900* (1996), pp. 223–242.

Nelson, Janet L., 'The wary widow', in Wendy Davies and Paul Fouracre (eds), *Property and Power in the Early Middle Ages* (Cambridge, 1995), pp. 82–113.

Nicholson, Joan, '*Feminae gloriosae*: women in the age of Bede', in Derek Baker (ed.), *Medieval Women* (Oxford, 1978), pp. 15–30.

Rivers, Theodore J., 'Widows' rights in Anglo-Saxon law', *American Journal of Legal History*, 19 (1975), pp. 208–215.

Rosenthal, J. T., 'Anglo-Saxon attitudes: men's sources, women's history', in J. T. Rosenthal (ed.), *Medieval Women and the Sources of Medieval History* (Athens, Ga., 1990), pp. 259–284.

Stafford, Pauline, 'Sons and mothers: family politics in the early Middle Ages', in Derek Baker (ed.), *Medieval Women* (Oxford, 1978), pp. 79–100.

Stafford, Pauline, 'The king's wife in Wessex, 800–1066', *Past and Present*, 91 (1981), pp. 3–27.

Stafford, Pauline, *Queen Emma and Queen Edith: Queenship and Women's Power in Eleventh-Century England* (Oxford, 1997).

Wemple, Suzanne F., *Women in Frankish Society: Marriage and the Cloister, 500–900* (Philadelphia, 1981).

INDEX

abbesses, 25, 26, 28, 48, 50, 51, 52, 53, 61, 62, 80, 81, 82, 113, 114, 116, 117, 118, 120, 121, 149, 150, 151, 175, 176, 177, 178, 179, 181
Adelaide, Empress, 98, 100, 107, 108, 110, 150
adultery, 20, 27, 29, 40, 41, 55, 57, 59, 83, 84, 100, 103, 105, 134, 192
age of consent *see* marriage, age at
agnates, 142, 153, 165, 192, 194
 see also lineage
Agnellus of Ravenna, 9, 12, 71, 74–6, 78, 93, 131
agriculture, 13, 48–9, 85, 86, 87, 123, 144, 148, 172, 174
 see also peasants
Aistulf, King, 34, 37, 42, 47, 69
Alberada, 133, 135
aldia/us (semi-free), 38, 42, 46, 49, 87, 112
Alfaraniti family, 142
Aloara, Princess, 120–1
Amalasuntha, Queen, 18, 20–2, 40, 54, 55, 135
Amalfi, 85, 98, 116, 118, 119, 122, 123, 128, 134, 171, 181, 202, 203
Amatus of Montecassino, 9, 130, 133, 135–6
ancilla (female slave), 20, 27, 34, 38, 39, 43, 45, 47–8, 49, 57, 58, 63, 72, 88, 89, 115, 121, 127, 148, 168, 173, 174, 203, 204
 see also slavery
Angelberga, Empress, 69–70, 80, 82, 87, 100, 106, 108, 113, 114

Ansa, Queen, 52, 68
antefactum (counter-dowry), 146, 165
Apulia, 86, 161, 176, 177, 202, 203
Arabs, 2, 69, 71, 72, 77, 80, 86, 88, 91, 101, 112, 118, 119, 121, 127
Arechis, Prince, 52, 54, 68, 80
artisans, 144, 147, 163, 164, 171, 172, 183, 185, 194, 202
Athalaric, King, 20, 21, 41

Barbatus, St, 10, 58
Bari, 9, 69, 119, 142, 160, 167, 171, 176, 179, 204
Beatrice of Tuscany, 130, 136–7, 138, 139, 143
benefices, 28, 53, 82, 110, 111, 112
Benevento, 9, 10, 34, 49, 52, 53, 54, 57, 58, 59, 68, 69, 70, 71, 79, 80, 83, 98, 107, 108, 114, 117, 122, 161, 178
Berta of Tuscany, 100, 101–2, 103
Bertilla, Queen, 100, 107, 108, 128
bishops, 1, 9, 10, 21, 22, 23, 25–30, 49, 51, 52, 53, 58, 70, 74–6, 77, 78, 83, 84, 86, 87, 88, 97, 98, 105, 106, 109–11, 113, 117, 119, 122, 129, 131, 133, 134, 137, 140, 141, 148, 149, 152, 161, 175, 176, 177, 182, 184, 198
Bohemond, 135, 160
Bologna, 52, 81, 141, 142, 166, 170, 193–5, 196, 197, 204, 206
breastfeeding, 79, 147, 204
Brescia, 52, 55, 59, 68, 69, 82, 112, 113, 114, 149, 175, 178
brideprice, 19, 20

225

INDEX

Byzantine/Byzantium, 11, 18, 21–4, 29, 30, 31, 56, 58, 68, 72, 76, 88, 93, 97, 101, 107, 127, 128, 132, 139, 143, 170, 193

Caffaro, 9, 165, 173
Calabria, 10, 26, 98, 118, 120, 123, 205
Canossa, 1, 137, 138, 139, 146
captivity, 23, 26, 30, 34, 54, 56, 70, 72, 77, 79, 86, 91, 118, 121, 167
see also ransom
Capua, 52, 57, 70, 79, 80, 98, 107, 117, 120, 121, 122, 128, 131, 132, 161
Carolingian law *see* law, Carolingian
cartularies, 159, 160, 193
Cassiodorus, 13, 18, 19–23, 24
Catharism, 182, 205
charity, 27, 46, 47, 50, 53, 60, 74, 91, 116, 139, 148, 174, 180, 181, 206
Charlemagne, 54, 68, 69, 70, 82
charters, 7, 12, 13, 24, 35, 43–54, 59, 71, 72, 82, 83, 85, 87, 88–92, 99, 103, 107, 113, 114, 116, 117, 118, 128, 130, 135, 142, 143, 144, 145, 147, 148, 159, 164, 166, 167, 168, 171, 174, 177, 178, 179, 197, 200, 203
children, 23, 24, 27, 36, 37, 38–41, 43, 44, 46, 47, 48, 49, 56, 63, 73, 75, 76, 79, 87, 99, 103, 106, 107, 108, 110, 112, 113, 115, 119, 120, 121, 134, 138, 146, 147, 153, 160, 163, 165, 169, 173, 174, 192, 193, 195, 196, 203, 204, 207
see also infanticide
Chronicle of Venice, 80, 130, 132
Chronicon Salernitanum, 9, 69, 98, 99
church reform, 113, 122, 129, 137, 139, 149, 150, 153, 183
citation of law *see* profession of law
civic legislation, 11, 165, 166, 168, 185, 191, 192, 193, 194, 195–6, 199, 204
claustration, 29, 92, 114, 116, 150, 151, 174, 178, 183, 206

clothing, 41, 45, 62, 76, 87, 91, 117, 143, 168, 169, 171, 173, 176, 177, 181, 184, 192, 206, 208
clothmaking *see* textiles
cognates, 142, 165
communes, 129, 142, 159, 162, 163, 164, 165, 166, 185, 191, 192, 193, 205
concubines, 20, 30, 39, 40, 59, 106, 109, 111, 120, 123, 134, 141, 151, 153, 166, 167, 171, 173
confraternities, 116, 181, 206
see also lay congregations
consanguineity *see* marriage, consanguineous
consors regni, 100, 103, 107–8
Constance, Empress, 161
convents *see* nunneries
conversae/i, 181, 199, 205, 206
cotton *see* textiles
court cases, 11, 12, 50, 83, 87, 114, 145, 160, 166, 195, 200, 201, 202
see also disputes

Deeds of the Bishops of Naples, 70, 78
Desiderius, King, 18, 52, 54, 68, 70, 82
diplomacy, 21, 69, 78, 99, 101, 132, 139
disputes, 25, 27, 92, 117, 150, 166, 175, 193
see also courtcases
divorce *see* marriage, repudiation of
domestic labour, 47, 48, 86, 88, 112, 147, 148, 168, 171, 173, 174, 203, 205
donations, 25, 26, 28, 44, 45, 51, 52, 62, 69, 71, 72, 87, 92, 93, 113, 114, 117, 121, 138, 145, 168, 172, 177, 178, 179, 180, 181, 184, 198, 207
see also gifts
Donizo, 130, 138–41
dowry, 36, 37, 47, 48, 99, 115, 134, 144, 147, 151, 163, 164, 165, 166, 167, 170, 171, 172, 176, 180, 181, 192, 193, 196, 198, 200, 203
dress *see* clothing

226

education, 8, 19, 20, 21, 139, 178, 192, 207
 see also literacy
Emilia, Duchess, 120, 121, 128, 131
epitaphs, 8, 13, 19, 54, 59–61, 102
Erchempert, 9, 70, 71, 79, 86, 98
de Ermengarda family, 141, 142
estate surveys, 13, 88, 112, 123, 148
exultet rolls, 133, 147

faderfio, 36, 40
famine, 23, 119
Farfa, 51–2, 53, 88, 143
Felicia, Duchess, 131
fertility, 35, 37, 57, 59, 70, 120, 165, 184
fidelity, 46, 59, 111
flax *see* textiles
food, 27, 46, 87, 117, 119, 147, 148, 152, 176, 177, 195, 197, 202, 203, 204, 206
funerals, 60, 61, 76, 78, 81, 119, 133, 179, 194
 see also mourning; tombs

Gaeta, 85, 98, 106, 112, 113, 120, 121, 128, 131, 132, 134, 178
gardens, 53, 86, 87
genealogy, 59, 106, 146, 148
Genoa, 9, 11, 99, 113, 134, 141, 142, 145, 146, 159, 160, 162, 163, 164, 165, 166, 167, 168, 169, 170, 173, 178, 180, 185, 192, 193, 195, 196, 202, 203, 204
Gerbert, 13, 98, 110–11, 113
gifts, 12, 13, 19, 20, 24, 25, 26, 27, 28, 43, 44, 47, 50, 51, 52, 54, 57, 62, 73, 80, 82, 86, 87, 92, 99, 100, 112, 113, 114, 128, 133, 141, 144, 149, 207
 see also donations
Giovanni Scriba, 160, 173
Gregory I, Pope, 11, 18, 23, 24–31, 42, 51, 53, 78, 121
Gregory VII, Pope, 1, 130, 133, 134, 136, 137, 139, 149
Grimoald, King, 37, 39
guilds, 128, 164, 169–70, 171, 194
gynaeceum, 88, 112, 147, 201

hagiography, 10, 70, 76–9, 83, 92, 98, 118–23, 130, 133, 147, 179, 183
 see also saints
heresy, 23, 57, 149, 152, 153, 175, 181, 182–3
Honorantie Civitatis Papie, 13, 103, 127, 130
hospitals, 178, 179, 180, 181, 206
Humiliati, 182
Hwalderada, Duchess, 115, 131

iconography, 3, 13, 72–3, 90, 107, 133, 147, 165
illegitimacy, 39, 103, 141, 161, 168
incest *see* consanguineity
infanticide, 23, 24, 88, 119
Ingiltrude, 84–5
inheritance, 11, 36, 39, 42, 46, 47, 81, 91, 142, 146–7, 159, 165, 192, 196, 198, 200
investors, 149, 168, 169, 170, 171, 202, 203

jewellery, 76, 114, 143, 166, 204
Jews, 27, 28, 61, 79, 167, 168, 169, 202, 204
John the Deacon (Venice), 9, 80–1, 129, 131
justice *see* courtcases

law, 6, 10, 11, 12, 30, 35–43, 44, 45, 48, 49, 59, 62, 63, 82–5, 89, 91, 108, 112, 134, 143–5, 165, 166, 167, 168, 185, 191, 192, 193, 195, 196, 197, 199–201, 203, 208
 Carolingian, 11, 83, 87, 112, 146
 Lombard, 3, 11, 34, 35–43, 44, 45, 46, 47, 49, 51, 62, 83, 85, 86, 87, 89, 143, 144, 145, 153, 164, 167, 168, 170, 172, 173, 194, 201
 profession *see* profession/citation of law
 Roman, 3, 10, 11, 18, 26, 28, 29, 39, 43, 44, 71, 76, 78, 83, 85, 86, 92, 93, 99, 106, 131, 134, 145, 164, 168, 169, 170, 175, 185, 192, 203
 Salic, 143

lay congregations, 73, 152, 180
 see also confraternities
learning *see* education
leases, 53, 71, 85, 86, 116, 117, 149, 172
 see also tenants
Liber Pontificalis, 10, 18, 19, 21, 22, 23, 28, 31, 34, 43, 49, 54, 62, 70, 71, 72–4, 75, 76, 78, 80, 84, 115, 118
limits on movement, 53–4, 73–4, 121, 194, 197
lineage, 19, 61, 102, 141, 142, 153, 159, 160, 163, 164–5
 see also genealogy
liquid wealth *see* moveable property
literacy, 8, 19, 20, 26, 31, 61, 116, 207, 208
 see also education
Liutprand of Cremona, 9, 97, 98, 102–5, 109, 115, 116
Liutprand, King, 9, 36, 37, 40, 41, 42, 43, 44, 47, 49, 51, 59, 70, 83, 86, 194
Lucca, 45, 46, 47, 48, 50, 51, 54, 71, 102, 114, 137, 140, 205
Lucera, 86
luxury goods *see* moveable property

manly women *see* virile women
manumission, 27, 39, 45, 47, 48, 49, 51, 112, 173
Maria, Duchess, 128, 132
maritime trade, 88, 162, 163, 167, 168, 171, 202
Marozia of Rome, 100, 104–6, 115–16, 135, 136
marriage, 19, 44, 57, 62, 75, 79, 81, 83–5, 89–90, 99, 100, 103, 107, 109–10, 121, 130, 132, 134, 142, 149, 152, 160, 162, 163, 164–7, 192, 196, 198, 207
 age at, 42, 62, 123, 163, 174, 196, 200
 clerical, 30, 54, 75, 106, 110, 111–12, 113, 129, 141, 148, 151, 153
 consanguineous, 42, 105, 133, 135, 136, 146, 153, 167

 consummation of, 37, 123, 163
 indissolubility of, 58, 130, 134, 167
 repudiation of, 40, 79, 82, 114, 132, 133, 134, 167
 second, 40, 44, 47, 55, 84, 115, 130, 133, 136, 137, 198
 see also remarriage
Matilda of Tuscany, 1, 130, 136–41, 143, 162, 183
matronyms, 141, 144, 168
mediation, 1, 101
medical practice, 170–1
memory, 102, 142, 166, 192
meta (meffio), 37, 40, 47, 167
Milan, 13, 23, 31, 47, 50, 51, 80, 84, 138, 152, 165, 169
misogyny, 57, 102, 103
modesty, 76, 205
monasteries (male), 9, 18, 53–4, 69, 80, 117, 119, 138, 150
monastic reform, 82, 106, 113–18, 122, 150
morgengab (morning-gift), 37, 40, 44, 47, 50, 81, 86, 89, 90, 91, 142, 146, 147, 164, 167, 172, 196
morning-gift *see morgengab*
motherhood, 19, 72, 77, 106, 112, 130, 193
mourning, 76
moveable goods, 45, 76, 115, 116, 128, 137, 139, 143, 148, 167, 168, 169, 171, 173, 200
mundium, 35–7, 39, 40, 43, 45, 46, 48, 62, 84, 86, 90, 143, 144, 145, 164, 201
murder, 133, 136, 146

Naples, 25, 30, 53, 60, 61, 70, 77–9, 80, 85, 88, 98, 99, 106, 116, 122, 128, 151, 179–80, 181
necrologies, 82, 115, 152, 178–80
Nicholas I, Pope, 70, 84
Nilus, St, 120–2, 131
Normans, 127, 128, 129, 130, 132, 133, 134, 159, 161, 179
nunneries, 19, 25–6, 28–30, 42, 49–53, 72–3, 80–2, 113–18, 133, 149–51, 174, 175–8, 205, 206, 207

228

nunneries (*continued*)
 poor, 28, 51, 73, 80, 116, 117, 151
 St George, Salerno, 117, 149
 St Gregory Armeno, Naples, 116–17, 151, 177, 179
 St Maria Theodota, Pavia, 50, 58, 113, 114
 St Patricia, Naples, 177, 179–80
 St Salvator/St Julia, Brescia, 52–3, 68, 69, 82, 112, 113, 114, 117, 123, 149, 175, 178
 St Sistus, Piacenza, 69, 80, 113, 114, 150
 St Sophia, Benevento, 52, 80, 114
 St Zaccaria, Venice, 81, 114, 132, 150
 see also claustration

papacy, 10, 18, 34, 43, 72–4, 84–5, 97, 105–6, 115, 137, 149, 159, 182–3
patronage, 28, 51, 52, 72, 77, 99, 115, 121, 130, 133
Paul the Deacon, 9, 54–9, 62, 70, 75, 76, 79, 80, 98, 131, 140
Pavia, 13, 45, 48, 49, 50, 57, 58, 61, 80, 84, 87, 113, 127, 128, 133, 138, 150, 205
peasants, 45, 48–9, 86, 191
penitents, 117, 151, 174, 181, 184, 205
Peter Damian, St, 10, 130, 132, 133, 148, 150, 152
Piacenza, 44, 46, 70, 71, 80, 84, 87, 168, 175, 182
pilgrimage, 50, 121
Pisa, 11, 45, 48, 137, 159, 167, 171, 181, 193, 203
plague, 132
poison, 41, 55, 100, 135
polyptych *see* estate survey
pornocracy, 97, 108
poverty, 27, 50, 51, 92, 148, 174
power, transmission of, 21, 54, 55, 56, 57, 62, 77, 81, 100, 101, 102, 135, 141, 161, 207
presbytera, 30, 54
profession/citation of law, 12, 29, 30, 44, 45, 46, 71, 83, 86, 89, 90, 91, 143, 144, 145, 172

queens, 52, 54, 55, 57, 100, 102, 108, 111, 128
 see also Amalasuntha, Ansa, Bertilla, Sibylla, Theodelinda, Willa
quoting law *see* profession of law

Rabanus Maurus, 108, 112, 146
rape, 24, 29, 30, 34, 43, 56, 74, 199–200
Ratchis, King, 40, 54, 70
Rather of Verona, 13, 98, 109–11, 131, 134
Ravenna, 12, 23, 24, 26, 27, 30, 34, 43, 44, 55, 68, 70, 71, 74–6, 166, 206
rectrix, 81, 113
regency, 20, 57, 58, 107, 131, 132, 160, 161
relics, 25, 28, 122, 184
remarriage, 40, 47, 55, 115, 141, 193, 198
repudiation *see* marriage
ricordanze, 195
Robert Guiscard, 128, 133, 135–6
Rome, 13, 23, 24, 27, 28, 34, 50, 54, 73–4, 88, 104–6, 109, 115–16, 121, 135, 137
Romilda, 56, 57
Romuald, St, 10, 130, 133, 148, 150, 152
Rosemund, 55, 57, 59, 75
Rothari, King, 11, 34–43, 49, 57
rules, monastic, 177, 178, 205
Rumetruda, 55, 57

St Prassede, Rome, 72–3
saints, 10, 58, 76–8, 87, 98, 117, 118–23, 147, 179, 183–4, 204, 205, 206
 see also Barbatus, Nilus, Peter Damian, Romuald, Trofimena
Salerno, 71, 89, 98, 99, 107, 116, 122, 123, 128, 133, 134, 151, 152, 171, 205
Sardinia, 2, 25, 29, 148
Sassovivo, 144–5, 172, 197–9
servants, 122, 148, 173, 203, 205
shame, 41, 62, 76, 192
Sibylla, Queen, 161

INDEX

Sicily, 2, 10, 25, 26, 27, 28, 30, 69, 77, 98, 117, 118, 119, 127, 168, 171, 177, 183, 200, 201–2, 203
Siena, 170, 183, 192, 195, 202, 203
Sikelgaita, Princess, 128, 133, 134–6
slavery, 20, 34, 38–41, 45, 46, 47–8, 49, 57, 58, 87–8, 89, 112, 115, 118, 121, 127, 148, 168, 173–4, 202, 203
 slave-free unions, 22, 39–40, 46, 71, 84
spinning *see* textiles
Spoleto, 30, 34, 51, 53, 74, 106, 197
staurites, 116, 181
sterility, 120, 140
survey, estate *see* estate survey

tenants, 85, 86, 112, 117, 149, 172
 see also leases
tertium, 146, 147, 165, 196
testimony, women's, 77, 193, 195, 199, 202, 208
textiles, 86, 87, 88, 112, 147, 148, 168, 169, 170, 171, 176, 192, 194, 195, 196, 197, 202, 205
Theodelinda, Queen, 31, 55–6, 57, 58
Theoderic, King, 10, 18–20, 36, 60
Theodora, Duchess (Naples), 116
Theodora *episcopa*, 72–3
Theodora of Rome, 6, 104–6, 115–16, 136
Theophanu, Empress, 98, 100, 106–7, 108, 120
Theophylactans, 104–6, 109, 115–16
tombs, 59–61, 77, 81, 102, 119, 121, 123, 133, 179, 181
transmission of power *see* power, transmission of
Trofimena, St, 122–3

Umbria, 144, 145, 172, 195–9, 203
underage marriage *see* marriage
usufruct, 37, 46, 146, 193, 198

Venice, 9, 80–1, 111, 114, 128, 130, 131, 132, 164, 167, 168, 169, 170, 174, 193, 196
Verona, 9, 13, 45, 47, 50, 51, 98, 111
violence
 against women, 41, 43, 45, 56, 58, 176, 199
 of women, 41, 55, 195
 see also rape
virginity, 19, 23, 81
virile women, 21, 22, 62, 105, 107, 109–10, 139, 140, 207
vowesses, 43, 92, 117, 150, 151, 181, 198

Waldensians, 182, 205
warfare, 21, 55, 67, 135, 139
weaving *see* textiles
wergild, 35, 41
whore *see* prostitute
widowhood, 27, 37, 40, 44, 45, 50, 51, 53, 60, 72, 81, 83, 91, 92, 118, 120, 131–2, 147, 166, 169, 181, 193, 196
Willa, Queen, 100, 102, 103, 108
wills, 12, 46–7, 48, 49, 69, 81, 145, 148, 164, 166, 167, 173, 180, 196
wise women, 121
witchcraft, 42
witnesses, female, 89
 see also testimony, women's
wool *see* textiles
work, 5, 85–8, 111–12, 144, 147, 168, 169, 170, 171, 176, 194, 197, 201–4